Constantino Brumidi:
ARTIST OF THE CAPITOL

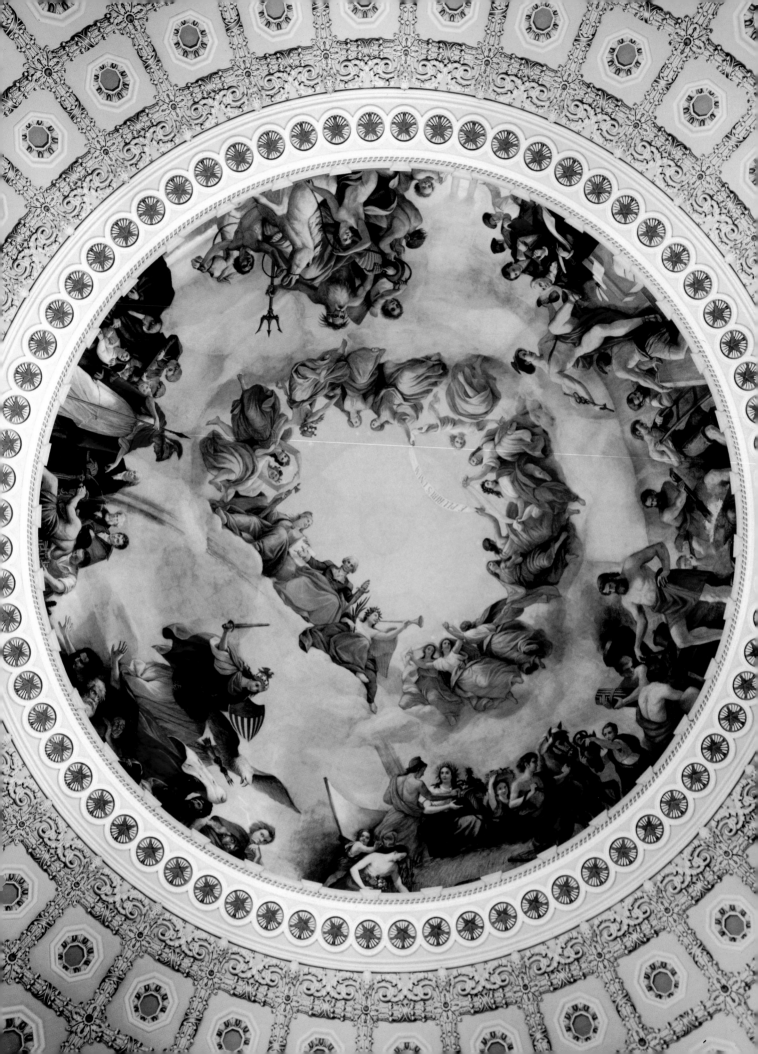

Constantino Brumidi:
ARTIST OF THE CAPITOL

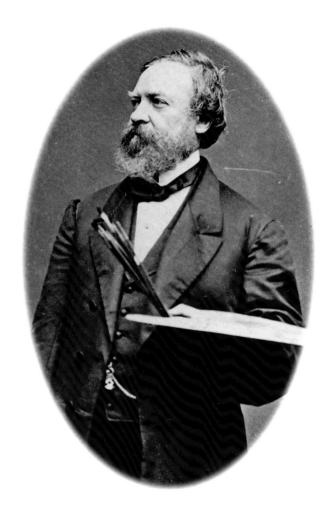

Prepared under the Direction of

The Architect of the Capitol

by Barbara A. Wolanin, Curator

U.S. Government Printing Office
Washington: 1998

103d Congress, 2d Session Senate Document 103–27
Printed pursuant to S. Con. Res. 40

Library of Congress Cataloging in Publication Data

Wolanin, Barbara A. (Barbara Ann)
 Constantino Brumidi : artist of the Capitol / prepared under the
direction of the Architect of the Capitol by Barbara Wolanin.
 p. cm.
Includes bibliographical references and index.
 1. Brumidi, Constantino, 1805–1880—Criticism and interpretation.
2. Mural painting and decoration, American—Washington (D.C.)
3. Mural painting and decoration—19th century—Washington (D.C.)
4. Mural painting and decoration—Conservation and restoration—
Washington (D.C.) 5. United States Capitol (Washington, D.C.)
6. Painters—United States—Biography. I. Brumidi, Constantino,
1805–1880. II. Title
ND237.B877W65 1998
759.13—dc21 97–51999
 CIP

FRONT COVER: View of the Capitol Rotunda. *Brumidi's canopy over the eye of the dome with The Apotheosis of Washington and frieze encircling the base of the dome dominate the central space of the Capitol.* Rotunda.

PAGE ii: *The Apotheosis of Washington. The canopy fresco in the eye of the Capitol dome is Constantino Brumidi's masterpiece.* Rotunda

PAGE iii: *Constantino Brumidi, c. 1866. This detail of a photograph taken by Mathew Brady shows the painter holding his palette.*

BACK COVER: Brumidi cherubs. *These cherubs holding the fasces and ribbon with motto, on the ceiling of the President's Room, exemplify the hundreds of cherubs Brumidi painted in the Capitol.* S–216.

Table of Contents

Introduction

I am pleased to introduce this new book about Constantino Brumidi, the artist whose accomplishments in the United States Capitol are unparalleled.

Since taking office as Architect of the Capitol in February 1997, my appreciation of the history and beauty of this national landmark and this painter's contributions to it has grown.

I am conscious that my writing this introduction is symbolically apt. This book was begun under the direction of my predecessor, George M. White, FAIA, and was completed during the first year of my tenure. This continuity is central to the very nature of the Architect's responsibilities—individuals may come and go, but the Capitol and its art endure. Projects such as the ongoing conservation in the Brumidi Corridors epitomize the importance of the stewardship with which the Congress has entrusted this office. Similarly, the publication of this book is an important contribution to our educational mission, informing the people of America and the world about the Capitol and its significance. With the continued support and interest of the Congress, I am confident that our work will enrich the understanding of our nation's architectural and artistic heritage.

Alan M. Hantman, AIA
Architect of the Capitol

Foreword

Each year many of the millions of people who visit the United States Capitol are surprised and delighted to discover that the building is not only the home of the Congress but also a museum and gallery of fine art. Among the most remarkable works in the Capitol are the paintings of Constantino Brumidi, who devoted much of the last twenty-five years of his life to decorating the building. Indeed, his contributions to the Capitol are unsurpassed by those of any other artist. I am pleased to have had the privilege to direct the preparation of the first scholarly, in-depth publication on Brumidi as part of the celebration of the bicentennial of the Capitol.

The book is an outgrowth of the mural conservation program. It was apparent to me in my first years as Architect of the Capitol that much of the beauty of Brumidi's work was hidden under grime and overpaint, and that some murals were threatened by cracking plaster. In 1981, I engaged Bernard Rabin, a dean of American conservation who has also spent many years working on frescoes in Italy, to conduct a survey of all the mural paintings in the Capitol. His report described the conditions of the various works and recommended priorities for treatment; it has since served as the foundation for the mural conservation program that I began in 1984 with the support of special appropriations from the Congress. I enjoyed my personal involvement in these projects and making final decisions when a judgment call was needed.

One of the most thrilling and gratifying projects of my tenure as Architect was the conservation of the canopy in the Rotunda, whose progress I followed closely in 1987 and 1988. While examining the conservator's progress from the scaffold, almost 200 feet above the Rotunda floor, I gained first-hand experience of the conditions under which Brumidi worked and, thus, new appreciation for the magnitude of his achievement.

The Brumidi Corridors on the first floor of the Senate wing are being conserved as part of an ongoing incremental program, beginning in 1985 with the frescoed lunettes that were in the worst condition. Now, all of Brumidi's original compositions can be seen, and a long-range program to restore the decorative painting that surrounds them has been launched.

For their work in uncovering Brumidi's paintings, I would like to thank Bernard Rabin, Constance Silver, Larry Keck, Perry Hurt, Christiana Cunningham-Adams, and Catherine Myers. I would also like to recognize Elliott Carroll, formerly my Executive Assistant, who brought his knowledge of and experience with conservation to directing the first years of the mural conservation program. For envisioning, organizing, researching, and writing this book, my thanks go to Dr. Barbara A. Wolanin, Curator for the Architect of the Capitol, who has effectively and sensitively managed the conservation program since 1985. Museum Specialist Pamela Violante McConnell has played an important supporting role under three curators. Thanks are due also to our agency photographers, Wayne Firth and Stephen Payne, for their documentation of the art before and after conservation for our permanent records. Most importantly, necessary and practical support for the preparation of the book was provided by the Congress with the allocation of funds appropriated for the celebration of the bicentennial of the Capitol.

George M. White, FAIA
Architect of the Capitol, 1971–1995

Preface

Constantino Brumidi, who proudly described himself as "the artist of the Capitol" and was later dubbed "the Michelangelo of the Capitol," left an indelible mark on the interior of the United States Capitol in Washington, D.C. My challenge in preparing this book has been to create a three-dimensional picture of the painter who was so skilled in creating the illusion of three dimensions in his paintings. The primary focus is on Brumidi's murals in the Capitol: their history, artistic harmony, symbolism, and meaning. To show the breadth and complexity of Brumidi's achievement, I have included background on his training and experience in Italy; pointed out his church and private commissions; and explained the architectural, political, and technical contexts in which he worked at the Capitol. No longer can Brumidi be seen as if he were working in isolation. The careful compilation and analysis of the historic documents has yielded a much more accurate picture of the creation of the murals in the Capitol and has helped dispel a number of widely held misconceptions about the artist. In addition to providing scholarly description and interpretation, this book is designed to be accessible and useful to those who work in or visit the Capitol and are intrigued by Brumidi's paintings and curious about their history.

The secondary focus of the book is the way conservation has made possible the full appreciation of Brumidi's art. The ongoing Capitol mural conservation program, based on the 1981 survey and begun in 1984 by Architect of the Capitol George M. White, has contributed greatly to the understanding of Brumidi's work, which can now accurately be seen for the first time in many decades. Brumidi's paintings are being restored as nearly as possible to their original appearance, and photographs taken during treatment demonstrate the dramatic difference that conservation has made. The reader will learn about new insights into his technique and working methods acquired during the conservation process and will also gain a sense of the principles and various tactics employed by professional conservators today.

Brumidi's work is described in numerous early guidebooks, such as *Keim's Capitol Interiors and Diagrams*, 1874, and George C. Hazleton's *The National Capitol*, first published in 1897. It was Hazleton who suggested that Brumidi could be called "the Michelangelo of the Capitol." Curator Charles E. Fairman included brief summaries of Brumidi's life and work in his 1913 *Works of Art in the United States Capitol* and his 1927 *Art and Artists of the United States Capitol*.

This book builds on the pioneering monograph *Constantino Brumidi: Michelangelo of the Capitol*, by Myrtle Cheney Murdock, published in 1950. Mrs. Murdock became curious about Brumidi when she arrived in Washington in 1937 as the wife of an Arizona congressman; while giving tours of the Capitol, she discovered how little was known about the artist. She gathered letters and other documents, located his wife's descendant Mildred Thompson, found works by him in private collections, and marked his grave. Without claiming to be a scholar, Mrs. Murdock summarized Brumidi's life and work, often by quoting primary documents. Her book was the first publication to include color images of the artist's work. The most recent editions of *Art in the United States Capitol* (1976 and 1978) include lists and numerous color illustrations of Brumidi's murals. However, only since their publication was the extent to which his designs had been altered by overpaint and grime recognized.

Information about Brumidi was gathered for many years by Florian H. Thayn, head of the Art and Reference Division for the Architect of the Capitol, and by curators Dr. David Sellin and Dr. Anne-Imelda M. Radice. A program of five conference-seminars, "Constantino Brumidi and the Interior Decorations of the Nation's Capitol," was organized by history professor Pellegrino Nazzaro at the Rochester Institute

of Technology in 1976. Dr. Nazzaro was the first to describe Brumidi's work in Italy and to uncover details of his arrest and trial; his research in the Vatican and other archives in Rome is summarized in chapter 2. Brumidi was included in the 1983 exhibition *The Capitol Image* at the National Museum of American Art, curated by Andrew J. Cosentino and Henry H. Glassie. In 1985, a small exhibition about Brumidi in the Crypt of the Capitol was prepared for the United States Senate Commission on Art and Antiquities by the Senate Curator, in cooperation with the Architect of the Capitol. A case featuring Brumidi's work is part of the permanent exhibit on the Capitol prepared by the Architect of the Capitol and installed in 1990. Recently, serious attention has been given to Brumidi by art historians in Italy, including Barbara Steindl, who wrote her dissertation on the Palazzo Torlonia, and Alberta Campitelli, curator of the villas of Rome, who with Marco Fabio Apolloni and others has published a book on the Villa Torlonia. They have elevated his status to "Michelangelo of the United States." Overall, however, the number of scholarly articles published on Brumidi is small, as is evident from the bibliography in this volume.

I first proposed a book on Brumidi in 1987, to focus on the conservation of the Rotunda frescoes. With the support of funds for the bicentennial appropriated by Congress, intensive work on this more comprehensive publication began in late 1991. With the able research assistance of Julie Aronson and Ann Kenny, hundreds of documents pertaining to Brumidi's life and work were gathered and organized. We compiled a comprehensive chronology of over 700 entries, of which the one included is a synopsis. A significant new resource was the transcription of the journals of Montgomery C. Meigs, Supervising Engineer of the Capitol Extension and Dome from 1853 to 1859. The transcriptions from archaic Pittman shorthand were made by William Mohr and edited by Ellen McDougall under the auspices of Senate Historian Dr. Richard A. Baker for the United States Senate Bicentennial Commission. Among the most thrilling sections of the journals for art historians and conservators have been Meigs's description of his first meeting with Brumidi and his eyewitness account of the execution of the first fresco in the Capitol; these are excerpted in Appendix A.

This book is organized chronologically, with chapters by the contributing authors interspersed as appropriate. I have provided an overview of Brumidi the artist and person, an explanation of his painting techniques, a sense of the artistic and political context in which he worked, and a history of his work at the Capitol. The rooms are discussed chronologically in the order in which Brumidi first began painting on the wall, although in many cases he was still trying to complete his design many years later. Following the history of the decoration of each room is a description intended to serve as a guide to someone standing in the space.

Supplementing and complementing this history are Dr. Pellegrino Nazzaro's background on Brumidi's life in Rome and the description by William C. Allen, Architectural Historian for the Architect of the Capitol, of the architectural and political context in which Brumidi worked during the construction of the Capitol extensions and the new dome. He focuses on the often conflicting roles, tastes, and personalities of architect Thomas U. Walter and engineer Montgomery C. Meigs, and their influence on the Capitol's decoration. Independent art historian Dr. Francis V. O'Connor explicates his theory about the ways in which Brumidi's subjects and symbols in the canopy and frieze take into account the themes already existing in the Rotunda and how they fit into a complex three-dimensional scheme. Conservators Bernard Rabin and Constance S. Silver describe their treatment of Brumidi's major frescoes in the Rotunda; their chapter, derived from the detailed reports submitted to the Architect of the Capitol, offers new information about the artist's working methods and achievement as well as providing a sense of the restoration process itself. Conservator Christiana Cunningham-Adams and her husband and partner George W. Adams summarize insights gained from their study of original techniques and later changes in the Brumidi Corridors.

The text is supplemented by Appendix A, the entries in Montgomery C. Meigs's journal pertaining to Brumidi's first work in the Capitol; Appendix B, a list of artists working with or under Brumidi; and Appendix C, a list of the works by Brumidi in the Capitol, and his known works in private collections and churches. This list is a work in progress; additional information about his paintings is eagerly sought and will be added to the files and the computerized chronology maintained in the Office of the Curator of the Architect of the Capitol. Finally, the chronology and bibliography are in themselves significant new contributions to Brumidi scholarship.

All of the documentation that has been gathered, however, still provides us with only a skeleton. Surviving correspondence relates almost exclusively to work assignments and payments. Brumidi left no journal nor any records of his creative ideas, thoughts, and feelings. Lack of personal correspondence leaves many questions about his personal life and motivations unanswered. Thus, intriguing mysteries and gaps remain.

Tellingly, even the issue of Brumidi's first name is confusing. The conflicting pieces of documentary evidence about this single detail suggest the challenge that this research has entailed. The Italian name "Costantino" appears in the records found in Rome. His Greek father, however, may have combined the Greek Konstantinos and the Italian Costantino into "Constantino," the name the artist inscribed in the Bible given him on landing in New York. (However, Brumidi also recorded anglicized versions of his Italian children's names in the same Bible.) "Constantino" would have been more easily understood by Americans who were familiar with "Constantine," a version which the artist also occasionally used. The majority of his letters and paintings are signed simply "C. Brumidi," yet "Constantine," "Costantino," and "Constantino" also appear on letters and other documents. The last will and testament of "Constantino Brumidi" was signed with the Italian version "Costantino," showing that the names were interchangeable to him; both were also used in a single document written by his son. Such variance in the spelling of names was common in the period, especially in the case of immigrants. For consistency, the first name most frequently appearing in manuscripts and published references, "Constantino," is used in this book.

This book was prepared under the direction of now retired Architect of the Capitol George M. White, whose commitment to and personal interest in the mural conservation program has been key to its success. I owe my deepest thanks for direction and support to him and to his former Administrative Assistant William F. Raines, Jr., and Staff Assistant L. Gail Stanley. The preparation of the book was supported with funds allocated for the commemoration of the bicentennial of the United States Capitol and the encouragement of Dr. Raymond Smock, former Historian, U.S. House of Representatives; Dr. Richard A. Baker, Historian, United States Senate; and James R. Ketchum, former Curator, United States Senate. The publication was sponsored by the Commission for the Bicentennial of the United States Capitol, co-chaired by the majority and minority leaders of both bodies. Former Secretary of the Senate Walter J. Stewart took particular interest in seeing a new book on Brumidi and was a key player in making it a reality. Insightful comments on the draft were made by my colleagues Dr. Richard A. Baker, Cynthia Pease Miller, James R. Ketchum, Diane K. Skvarla, and Dr. Donald R. Kennon. A number of outside experts contributed to knowledge of Brumidi. Thanks are particularly due Henry Hope Reed and his researcher Dr. Maria Antonietta de Angelis for providing copies of many documents from Italian archives. Marco Fabio Apolloni and Alberta Campitelli were generous in sharing information about Brumidi's Italian projects. For assistance during my visit to Rome, I am also grateful to Sabina Marchi, Pio Baldi, Rosso di Gaspari, and Daniella Muratori. Other researchers who have shared their knowledge are Kent Ahrens, Father George Anderson, Andrew J. Cosentino, John Dumvill, Eloise Quiñones Keber, Franco Lancetti, Edna W. Macomb, Keith Melder, Colonel Merl Moore, Arthur J. Phelan, Gwenda Smith, and John Trunnell. In addition to the conservators who contributed to the

text, Larry Keck, Perry Hurt, and Arthur Page offered helpful comments. Other readers to whom I owe thanks are Elizabeth W. Fisher, Dr. Percy North, David Ransom, and Peter Byrd, in addition to all of the outside authors, who deserve thanks for their contributions and their patience through numerous revisions.

In addition to research assistants Julie Aronson and Ann Kenny, my staff has been enthusiastic in assisting with the preparation of the book. Special thanks are due Sarah Turner, Pamela McConnell, Deborah Neal, and former staff members Linnaea Dix and Kim Soucy. Substantive editing was provided by Cynthia Ware, while Eric Paff diligently carried through on copy editing and many final details. The majority of the photographs so essential to this book were skillfully produced by the Photography Branch headed by Wayne Firth, assisted by Stephen Payne, Loretta Beasley, and Chuck Badal. I was gratified by the enthusiasm with which Government Printing Office staff John Sapp, Lyle Green, Technical Review Section and designer Deborah Rhode greeted this project and thankful for their expertise in piloting the book through the publication process. *Constantino Brumidi: Artist of the Capitol* is the product of the team efforts of my unfailingly supportive staff and co-authors and of the interest and faith of many individuals in the office of the Architect of the Capitol and in numerous congressional offices.

NOTE: Works of art illustrated are by Constantino Brumidi unless otherwise indicated. Information regarding their medium, dimensions, dates, and location or collection can be found in Appendix C. Room numbers are given in the captions for mural paintings in the Capitol. Photographs included in this book are in the records of the Architect of the Capitol unless other collection or photo credits are given.

Key to Abbreviations in Notes

AAA Archives of American Art, Smithsonian Institution, Washington, D.C.

AOC Records of the Architect of the Capitol, Washington, D.C.

 AR Annual Reports of the Architect of the Capitol
 CO Curator's Office
 EXT Capitol Extension Records
 LB Capitol Extension and New Dome Letterbooks
 Architect's Letterbooks

ASR Archivio di Stato di Roma (Italian State Archives), Palazzo della Sapienza, Rome

 SC Records of the Tribunale Supremo della Sagra Consulta, Processi Politici, 1849–1851, busta 231, posiz. n. 373. (Records of Brumidi's imprisonment and trial from the Vatican Archives)

CB Constantino Brumidi

EC Edward Clark

LC Library of Congress, Washington, D.C.

MCM Montgomery Cunningham Meigs

MCMJ Journals, Montgomery C. Meigs Papers, Manuscript Division, Library of Congress, transcribed by William Mohr for the United States Senate Bicentennial Commission (alphanumeric codes are keys to the transcription)

NARA National Archives and Records Administration, Washington, D.C.

 RG 21 Records of the District Courts of the United States
 RG 36 Records of the U.S. Customs Service
 RG 42 Records of the Office of Public Buildings and Public Parks of the National Capital
 RG 48 Records of the Office of the Secretary of the Interior
 RG 217 Records of the Accounting Officers of the Department of the Treasury

NMAA National Museum of Amerian Art, Smithsonian Insitution, Washington, D.C.

TUW Thomas Ustick Walter

TUW/PA Thomas U. Walter Papers, Athenaeum of Philadelphia, Philadelphia, Pennsylvania (most microfilmed by the Archives of American Art)

USSC United States Senate Collection (Senate Curator), Washington, D.C.

 MTP Mildred Thompson Papers

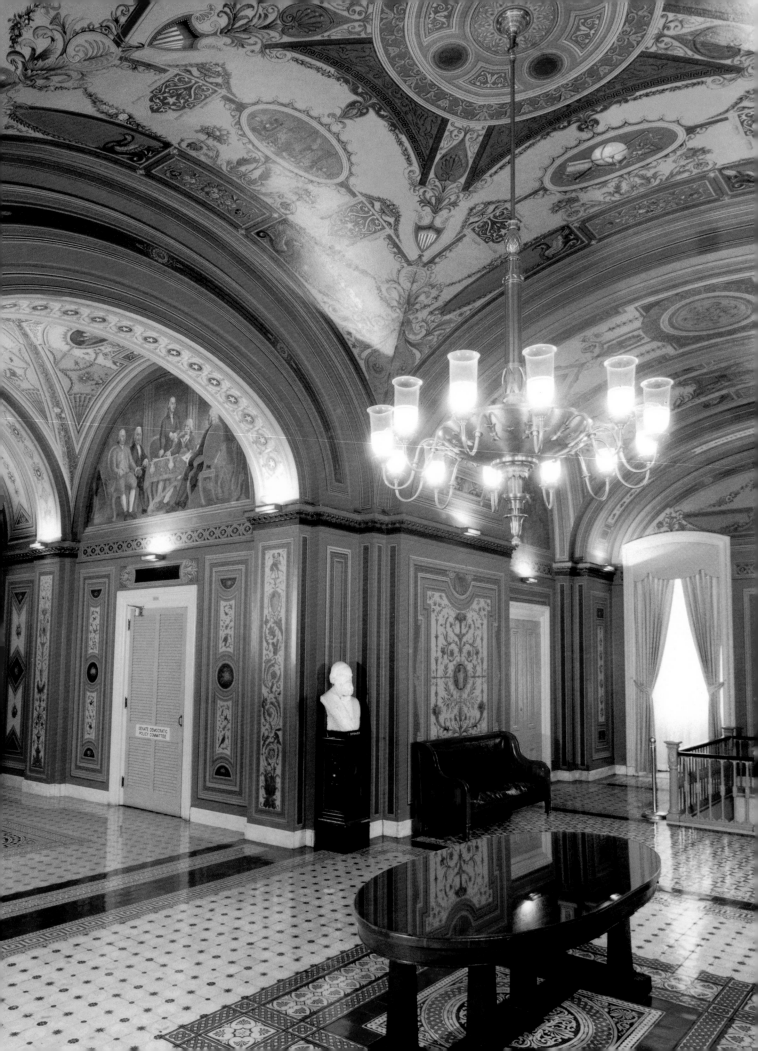

CHAPTER 1

"C. Brumidi
Artist Citizen of the U.S."

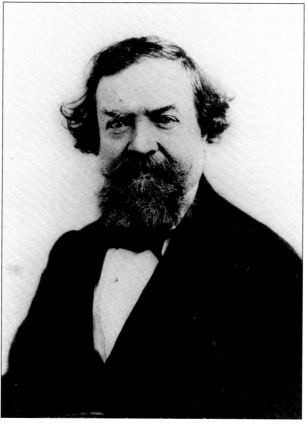

Fig. 1–2. Constantino Brumidi, 1859. *This photograph, taken by Montgomery Meigs, captures Brumidi's lively personality.*

From Charles E. Fairman, *Art and Artists of the Capitol*, 1927.

No one who enters the United States Capitol can fail to remark on the astonishing murals that enliven many interior spaces. The eye of every visitor who enters the vast Rotunda in the center of the Capitol is drawn to Brumidi's *Apotheosis of Washington,* the central scene painted on the curved canopy under the dome. It is crowded with men and women, gods and goddesses, some of whom seem to be rising to the heavens above. Encircling the base of the dome is a procession of figures that appear to be carved out of stone, but on closer scrutiny are seen to be painted. Visitors to the Senate Reception Room see ceilings and walls elaborately embellished with symbolic figures and gilded plaster filigree. The first-floor Senate corridors are teeming with trellises of leaves inhabited by an immense variety of creatures, providing a lively framework for historical scenes and figures (fig. 1–1). Other richly decorated rooms can sometimes be glimpsed by visitors and are enjoyed by those who use them for official business. The murals in these spaces are all the work of the Italian-born

Fig. 1–1. View of the Brumidi Corridors. *Visitors walking through the corridors are surrounded by lively patterns and colors. The marble bust of Constantino Brumidi by Jimilu Mason was placed in the Patent Corridor to honor the artist in 1968.*

painter Constantino Brumidi, who proudly signed one fresco, "C. Brumidi Artist Citizen of the U.S."

Brumidi left evidence of his genius and his skilled hand in playful cherubs, graceful classical figures, and stern historical portraits, painted with rich color and texture so that they seem to come alive and to project from the wall. Even more impressive to the modern eye is the way Brumidi made each symbol and story part of an architectural whole. These murals are surprising to visitors used to the much plainer treatment of modern architecture, but they would also have amazed most Americans in the mid-nineteenth century who had not traveled to Europe.

When Constantino Brumidi left Italy for the United States in 1852, he was nearly fifty years old, a mature artist bringing with him a wealth of skills, traditions, and imagery. While drawing heavily on his past artistic experience, he enthusiastically incorporated the history and symbols of his newly adopted country. His originality lay in integrating American themes into his classical repertoire. Brumidi's unique fusion of the classical tradition with patriotic feeling for his new country was summed up in an obituary: "The artist worked in a spirit of decoration which was a compromise between history and mythology. . . . He tried to make his work American."[1]

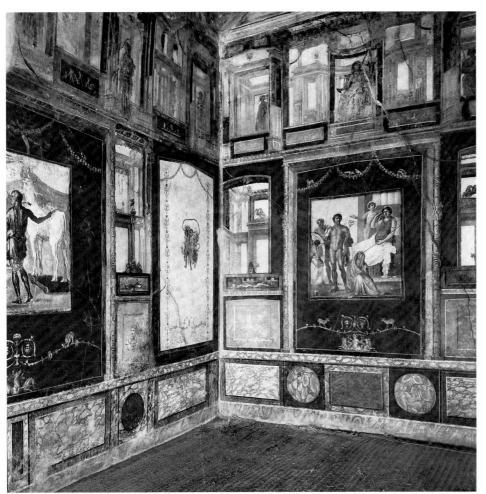

Fig. 1–3. The Ixion Room,
House of the Vetii, Pompeii, Italy.
Directly inspired by Pompeian murals such as these, Brumidi designed similar illusionistic architectural framework, panels with cherubs on a black background, and floating figures for room S–127.

Photo: Alinari/Art Resource, NY.

Fig. 1–4. Murals that inspired
Brumidi in the Baths of
Titus/Golden House of Nero.
Similar trellis-like framework, floating classical figures, and illusionistic architectural motifs can be seen in the ceiling of S–127 and the Brumidi Corridors.

From Antonio de Romanis, *Le Antiche Camere Esquilline, dette Comunemente Delle Terme de Tito,* Rome, 1822.

We know Brumidi the artist primarily from what he painted on the walls of the United States Capitol, which benefited immensely from his sophisticated training, well-developed talents, and enthusiasm for his new homeland. We can glean only glimpses of Brumidi the man through surviving documents and photographs. One photograph taken in the 1850s best captures his personality, showing eyes that look at once humorous and thoughtful, and untamed hair and beard that give him a rakish, bohemian air (fig. 1–2). He was only 5 feet 5 inches tall and had gray-blue eyes, brown hair, and a dark complexion.[2]

Brumidi was well prepared for his work at the Capitol by his study and experience in Rome, where he had been considered one of the leading artists.[3] Through living in the midst of classical ruins and richly decorated palaces and churches, his training at the Accademia di San Luca, and his experience executing murals, he had become a master of the classical tradition rooted in ancient Rome. Brumidi believed that "the solid construction of this National Building, required a superior style of decoration in real fresco, like the palaces of Augustus and Nero, the Baths of Titus and Livia at Rome, and the admired relics of the painting at Herculaneum and Pompei [*sic*]."[4] The style, techniques, and motifs Brumidi brought from Italy were well suited to the classical architectural forms of the Capitol extensions and dome.

Classical wall painting, which originated in Greece, reached a high degree of refinement and sophistication during the Roman republic and early empire, from the second century B.C. through the first century A.D. The Romans excelled in creating illusionistic effects of figures, objects, landscapes, and architectural views, making them look three-dimensional through light and shade and through the use of perspective to create a sense of space. Roman murals enlivened and visually opened up the interior spaces of windowless Roman houses. The best-preserved Roman wall paintings were found in the cities of Pompeii and Herculaneum, which had been buried during the eruption of Vesuvius in A.D. 79 (fig. 1–3). Since excavation of the towns began in the eighteenth century, Brumidi would have been familiar with the numerous published images of the murals and could easily have visited the sites; he credits them among his most important inspirations.

Brumidi was also inspired by the decorations in what he knew as the Baths of Titus (fig. 1–4). Today this structure is primarily identified as the Domus Aurea, or

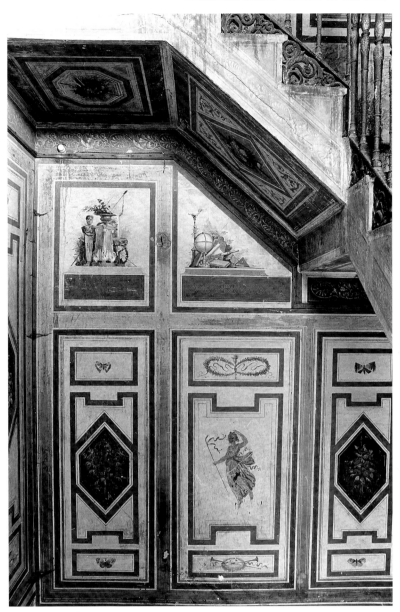

Fig. 1–5. Murals under the staircase in the theater of the Villa Torlonia. *Many classical motifs from Brumidi's projects in Rome reappeared at the Capitol.*
Photo: Courtesy Alberta Campitelli, Comune di Roma.

Golden House, the first-century palace of the Emperor Nero, which was built on the ruins of the Baths of Titus and later in the first century used as the foundation for the Baths of Trajan. The ruins of this complex are on the Esquiline Hill in Rome, not far from where Brumidi lived. The murals in the Golden House were discovered in the sixteenth century by the painter Raphael, who called the classical designs he found there "grotesques" because the arched chambers filled with rubble looked like caves or grottoes. The ruins were more extensively excavated and documented in publications in the nineteenth century, and their designs were adopted by many artists, including Brumidi (fig. 1–5).

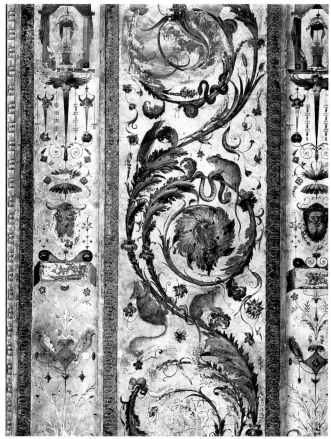

Fig. 1–6. Raphael, Detail of the decoration of a pilaster.
Brumidi emulated Raphael's design of scrolls of leaves with birds and animals such as these squirrels and other rodents. Loggia, Vatican Palace, Vatican State.
Photo: Alinari/Art Resource, NY.

A third important inspiration for Brumidi, especially for the Brumidi Corridors, was Raphael's classical decoration in the Vatican (fig. 1–6), which had been inspired by the Golden House of Nero. Similar classical designs of vases, vines, birds, animals, and mythological creatures were used repeatedly by mural artists in palaces and in the Vatican corridors through the sixteenth and seventeenth centuries. Brumidi knew Raphael's work in the Vatican well and designed similar classical grotesques for the Capitol (fig. 1–7).

Although often called the Michelangelo of the Capitol, Brumidi most accurately should be called the Raphael of the Capitol, since it was Raphael who was his greatest inspiration.[5] Raphael's work was the epitome of the High Renaissance and of the classical mode (fig. 1–8). Even personally, Brumidi was much more similar to the even-tempered, well-liked, and productive Raphael than to the temperamental and tempestuous Michelangelo. Brumidi's admiration for Raphael shows clearly in his art in Rome (fig. 1–9) and in the Capitol (fig. 1–10). It is also evident in the fact that he gave his Italian son Giuseppe the middle name Raffaello.

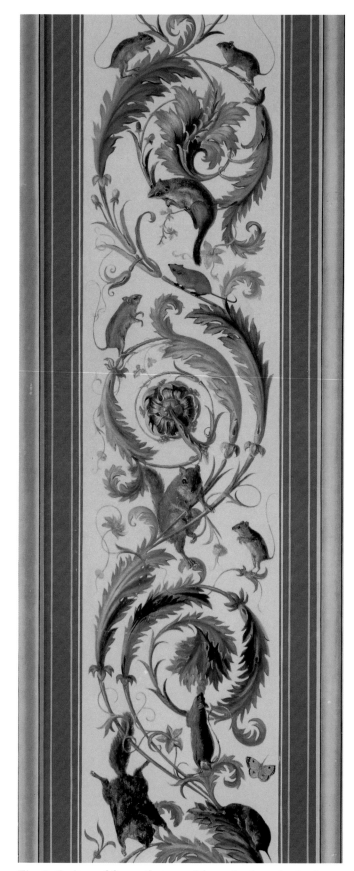

Fig. 1–7. One of four pilasters with squirrels and mice in the Brumidi Corridors. *Brumidi's designs were directly inspired by Raphael's loggia, although the species shown were all American.* Across from S–118.

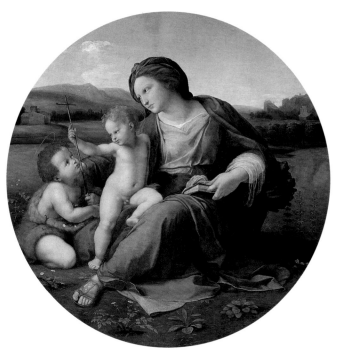

Fig. 1–8. Raphael, *Alba Madonna. Brumidi was inspired by Raphael's gracefully composed Madonnas.* National Gallery of Art, Andrew W. Mellon Collection.

Photo: National Gallery of Art.

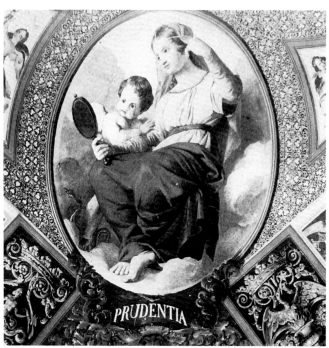

Fig. 1–9. Ceiling of the Throne Room in the Palazzo Torlonia, Rome. *Brumidi's Raphaelesque figure of Prudence is very similar to those he later painted in the Capitol.*

Photo: Courtesy Marco Fabio Apolloni.

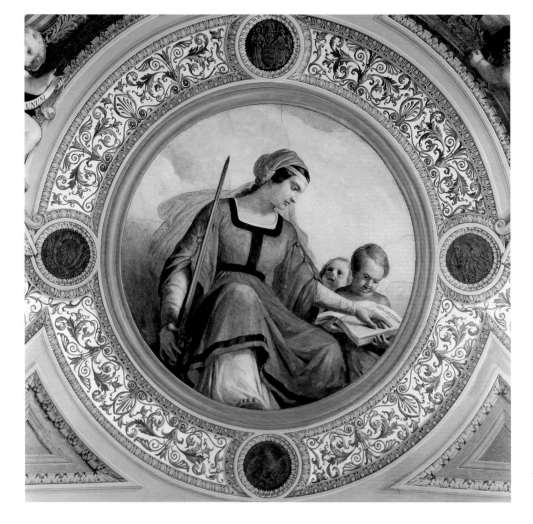

Fig. 1–10. *Legislation. This frescoed tondo in the President's Room shows the influence of Raphael.* S–216.

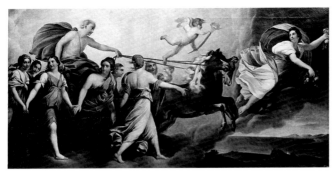

Fig. 1–11. *The Aurora. Brumidi's copy of the seventeenth-century ceiling fresco by Guido Reni shows his love and mastery of the classical tradition.* Hood Museum of Art, Dartmouth College, Hanover, N.H.; Gift of Moses Titcomb, Class of 1879H.

Photo: Hood Museum of Art.

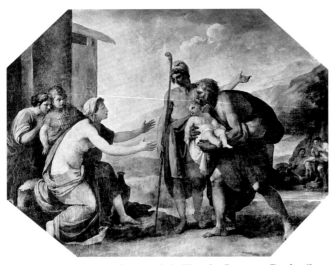

Fig. 1–12. Vincenzo Camuccini, *Hecuba Recovers Paris. Camuccini, teacher at the Accademia di San Luca, taught Brumidi neoclassical style and themes.* Galleria Borghese, Rome, Italy.

Photo: Alinari/Art Resource, NY.

Raphael's work was a major source of inspiration for the classically oriented Baroque artists of the seventeenth century, among them Annibale Carracci, Guercino, and Guido Reni, whose work Brumidi copied (fig. 1–11). [6] Raphael's style was revered again in the nineteenth century by academic neoclassicists such as the French artist Jean Auguste Dominique Ingres, who was director of the French Academy in Rome, and by Brumidi's teacher Vincenzo Camuccini (fig. 1–12). Brumidi, who had learned Camuccini's lessons well (fig. 1–13), may also have been somewhat affected by the purist movement, the Italian version of the German Nazarenes, which looked to early Raphael and the artists who preceded him for a pure and idealized style in order to express emotion.[7] Overall, however, his style is closest to that of the seventeenth-century classical painters and to the other Roman academics and followers of Raphael, such as Francesco Podesti, who also painted at the Villa Torlonia.

Along with a mastery of classical style and composition, of color and light and shade, and of painting techniques, Brumidi brought from Italy a repertoire of visual images and symbols upon which he drew for the rest of his life. His academic training would have included years of drawing classical sculpture in the extensive collections in Rome, giving him a mental storehouse of poses and gestures. He was intimately familiar with the classical motifs of gods and goddesses, cupids, mythological creatures, leafy scrolls, and illusionistic architecture seen in Roman wall paintings and sculpture, which were reborn on the walls of Renaissance and Baroque palaces, and this inspiration is clear in many rooms in the Capitol. He understood the allegorical symbols codified by Cesara Ripa in

Fig. 1–13. *The Judgment of Paris. Brumidi's signed and dated mural in Rome clearly shows Camuccini's influence.* Theater, Villa Torlonia, Rome.

Photo: Courtesy of Alberta Campitelli, Comune di Roma.

Fig. 1–14. **Engraving owned by Brumidi of a seventeenth-century ceiling at Versailles.** *The pencil grid helped Brumidi enlarge the allegorical figure seated on a cloud, which is similar to many he painted in the Capitol.* Estate of Anna Strieby Fogle.

his 1593 *Iconologia*. Brumidi's undoubtedly excellent visual memory was reinforced by sketchbooks and engravings he carried with him from Rome. Among these were an album/sketchbook now at the Library of Congress (see fig. 3–14) and engravings of elaborate ceilings at Versailles (fig. 1–14).

For his work in Washington, Brumidi supplemented these European prototypes by copying painted or engraved portraits of American heroes or historical scenes. He filled his studio with sculpture, painting, and sketches to keep his inspiration fresh.[8] The ability to incorporate references to earlier works of art was highly valued in the nineteenth century, when originality was not considered as important as skill and knowledge of tradition. Yet only on rare occasions did Brumidi copy an entire composition; rather, he inventively adapted and reworked settings, gestures, and motifs for his American subjects.

Brumidi was known not only as a fine craftsman, but also as a person of intellect and "a man of cultivated tastes and wide reading, especially fond of the classical poets, and thoroughly conversant with works of historical art. He was fond of Shakespeare, and Dante, and the old Italian poets were his familiar friends. To praise them would always rouse his enthusiasm and interest."[9] Senator Justin Morrill recalled Brumidi reading the works of eighteenth-century historian Edward Gibbon and of his contemporary George Bancroft, author of a ten-volume history of the United States.[10]

Brumidi's education and his continuing love of classical literature and symbolism, combined with an interest in American history, enabled him to carry out the complex iconographical programs for the Capitol. Even when supervising engineer Montgomery C. Meigs or others suggested general subjects, it was up to Brumidi to compose the scenes and fill in the symbols and details. From the time of his first work in the Capitol, he consulted books in the Library of Congress such as Carlo Botta's *History of the War of the Independence of the United States*, of which the first of many editions was published in Italian in 1809, and James Herring's *National Portrait Gallery of Distinguished Americans*, republished in 1854. He also carried out his own research for the scenes in the frieze.[11]

Brumidi evidently had a quick mind and an ear for languages. In addition to his native Italian, he probably learned some Greek from his father.[12] He could also speak and write in French, the language he used when first in Washington. Only months after his arrival at the Capitol, he was writing letters in English, although they contained grammatical and spelling errors, and even at the end of his life his English was still described as "broken."[13]

Brumidi was a passionate and compassionate man as well as a dedicated painter. He was a convivial person, not an artistic recluse, with a "cordial and charming manner

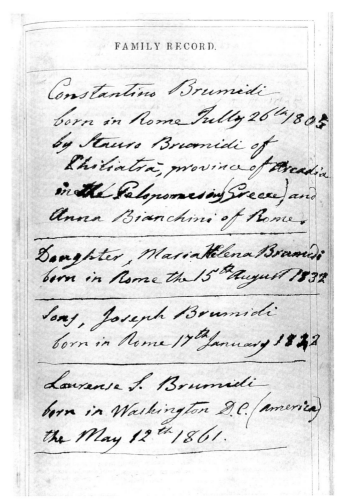

Fig. 1–15. Page in Brumidi's Bible. *Brumidi wrote anglicized versions of his children's names in the Bible given him on arriving in the United States.* Architect of the Capitol.

for his friends."[14] He seems to have had a good sense of humor and to have enjoyed music; he had a piano with him in 1863, and one was seen in his last studio.[15] Brumidi maintained a loyal team of assistants (see Appendix B). He had close ties with other Italian artists working at the Capitol, such as bronze worker Frederick Casali, his "friend and companion."[16] The Italian sculptor Guido Butti praised him to Meigs.[17] Brumidi's son Laurence remembered that his father "gave freely to his countrymen in distress, medical, financial aid, following them often to the grave his great good heart paid for."[18] While generous to others, Brumidi was not always good at managing his money, for he ended his life in poverty.

Brumidi clearly enjoyed female companionship. His eye for nubile female beauty, seen in his paintings, is also evident from the fact that two of his three brides were teenagers. Brumidi's first wife, Maria Covaluzzi, however, was an older widow, whom he married in 1832, only six weeks before their daughter was born. Maria Elena was the first of his three children (fig. 1–15). Brumidi stayed

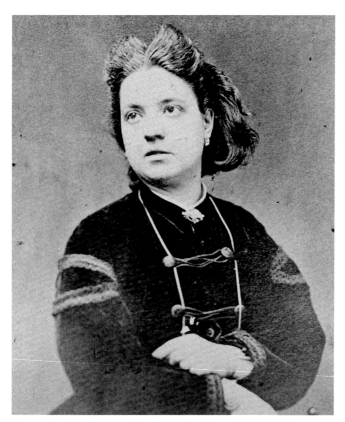

Fig. 1–16. Elena Brumidi, c.1870s. *This photograph of Brumidi's Italian daughter was taken in Rome.* Lola Germon Brumidi Family Album. United States Senate Collection.

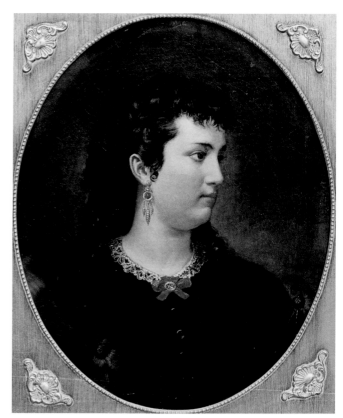

Fig. 1–17. *Lola Germon Brumidi*, c. 1860. *Brumidi painted this charming portrait of his American wife during their early days together.* Private Collection of William R. and Audrey O. Greever.

in contact with Elena, who was twenty when he left Italy in 1852 (fig. 1–16). They corresponded every month; he regularly sent her money, and she visited him in Washington in 1871.[19] Brumidi married sixteen-year-old Anna Rovelli in 1838, a few months after his first wife's death. She apparently stayed in Italy with their ten-year-old son, Giuseppe, who had been born in 1842.[20]

A woman recorded on the cursory list of passengers as "Mary Brumidi, age 30," traveled with Brumidi from Mexico in 1854. Meigs described unflatteringly a woman who accompanied the artist: "I suppose his wife . . . a dirty, slatternly person."[21] It is possible that this woman is identical with the Roman-born Clara Scarselli Brumidi, whom Brumidi buried in Congressional Cemetery at age 36 in June 1859.[22] By that time, Brumidi had already met Lola Germon, who became his American wife.

The beautiful, dark-haired Lola Virginia Germon (1843–1918) (fig.1–17) was the key woman in Brumidi's life in the United States. At the time they met, around 1858, she was only sixteen years old and living in Georgetown. Her father, Vincent, had died in 1855. His ancestors had come from the island of Martinique, and his family had an interest in the arts. Some of Lola's cousins worked in the theater, and others owned an art gallery and photography studio, Germon's Temple of Art, in

Philadelphia.[23] She and Brumidi were living together in 1860; their son Laurence was born in May 1861 (fig. 1–18). Socially, Lola was known as Mrs. Brumidi, and her name appears as Lola V. Brumidi, "the wife of Constantine Brumidi," on legal documents, although no marriage record has been found.[24]

A month after arriving in Washington, Brumidi had "taken a house on Delaware Avenue, within one square of the Capitol, for his work."[25] He thus started out living in an area now part of the Capitol grounds, across from the Russell Senate Office Building. In subse-

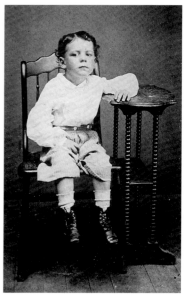

Fig. 1–18. Laurence S. Brumidi as a child, c. 1865. *Brumidi's American son would follow in his father's footsteps as a painter.* Lola Germon Brumidi Family Album. United States Senate Collection.

Fig. 1–19. *Crucifixion* in Cathedral of Saints Peter and Paul, Philadelphia, 1864. *Brumidi's impressive frescoed altarpiece was destroyed when the cathedral was enlarged.*
Photo: Robert S. Halvey.

quent years, the painter would continue to reside within easy walking distance of the Capitol. He lived at 63 Indiana Avenue in 1858, at 485 D Street [N.W.] in 1860, and at 128 2nd Street West [N.W.] from 1862 to 1870, in a house owned by Lola. She also owned the last two houses in which he lived, at 911 and 921 G Street, N.W., now the site of the Martin Luther King Memorial Library.[26]

Although fitting the bohemian-artist stereotype in many ways, the Italian expatriate was at the same time well connected in the Catholic church. His commissions included altarpieces and murals in important churches and cathedrals in Mexico City, New York, Baltimore, Washington, and Philadelphia (fig. 1–19 and Appendix C).

Brumidi clearly earned the respect of people he encountered in his adopted country, of those in important positions at the Capitol as well as of the men who worked with him, for his artistic talent and skill and for his personal integrity. Although Montgomery C. Meigs, the engineer in charge, and Thomas U. Walter, the architect of the Capitol extensions and dome, came to be enemies during the construction of the Capitol, both liked and valued Brumidi (see chapter 4). Their arguments over how and to what degree the Capitol should be decorated stemmed from their power struggle, not from differences over the quality of Brumidi's work, which they both esteemed. Meigs believed that "Brumidi is for our work better than any painter we have."[27] His high regard for Brumidi's character as well as his artistic talent is revealed in a heartfelt letter of recommendation written after he was transferred from the Capitol: "As a historical painter on a certain class of subjects he has no equal in the country. . . . I do not mean to claim for Mr. Brumidi the genius of Raphael, but he is a modest gentleman, a true and instructed and skillful artist, and I have as yet seen no one who could compare with him as a director of the decoration of the interior of the Capitol."[28] Walter also thought highly of Brumidi; he wrote, "I believe him to be the best living artist, in fresco, particularly in figures. . . . He is one of the most amiable, and excellent & unostentatious of men."[29]

Brumidi wisely stayed out of the dispute between Meigs and Walter. Furthermore, there is no evidence that Brumidi was directly involved in American politics during the time he worked at the Capitol, which spanned the administrations of six presidents, from Franklin Pierce through Rutherford B. Hayes. However, at times his ability to work at the Capitol was affected by politics, as when it was halted by lack of funds, when it was attacked in heated congressional debates, and when the superintendence of construction at the Capitol changed.

Brumidi may have avoided the political arena because of his earlier traumatic experience of being imprisoned after the 1849 uprising in Rome (see chapter 2), although later he romanticized his role as a revolutionary by saying he was arrested because he had refused to fire on civilians.[30] In fact, he had only reluctantly become involved in the revolution. Having joined the civil guard because it was expected of him as a shopkeeper, he tried unsuccessfully to resign as captain; he also refused to join extremely liberal groups or even to allow political discussions in his coffee shop.[31] Yet the value he placed on his personal freedom and his opportunities to use his talents, as well as his allegiance to the United States, was genuine. He was proud of being an American citizen and of being chosen to decorate the Capitol. He is reported to have declared: "My one ambition and my daily prayer is that I may live long enough to make beautiful the Capitol of the one country on earth in which there is liberty."[32]

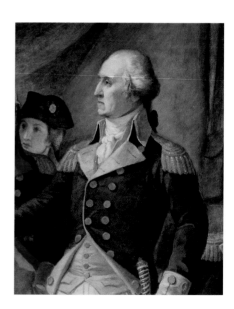

Fig. 1–20. George Washington's portrait in details from Brumidi's murals. *The first president is found, from the upper left, in S–128, H–144, S–216, S–213, the Rotunda canopy, and H–117.*

Brumidi expressed his patriotism and pride in his new homeland through the iconographical program depicting American history and values that he carried out under Meigs's direction. He included a proliferation of patriotic symbols such as striped shields, eagles, and the liberty cap throughout the mural decoration. This emphasis on the nation's history, achievements, and symbols must have seemed particularly urgent at a time when the union was threatened by dissolution as tensions escalated between the North and South. His central motifs, President George Washington and American progress through technological advances, can be found in most of the murals he designed for the Capitol.

The image of George Washington appears in the first room Brumidi painted for the House Committee on Agriculture (H–144) and in the very center of the Capitol in the canopy over the Rotunda. Washington is central to the iconography of his fresco for the House chamber (now in H–117), the President's Room (S–216), the room designed for the Senate Committee on Military Affairs (S–128), and the Senate Reception Room (S–213) (fig. 1–20). The first president has been closely associated with the Capitol from its conception, and the center of the building was conceived as a mausoleum for him. Although his remains were never moved to Washington, the place intended for him two floors below the Rotunda has con-

Fig. 1–21. Images of new technology and inventions in Brumidi's murals. *From left to right: S–211, the Rotunda canopy,* John Fitch, *Brumidi Corridor ceiling, S–213, and H–144.*

tinually attracted visitors. Brumidi would have known a number of portraits of Washington already placed in the Capitol, including John Trumbull's historical scenes in the Rotunda, Antonio Capellano's bust over the central door, John Vanderlyn's full-length portrait, and Rembrandt Peale's "porthole" portrait. By the time Brumidi arrived in Washington, the monumental seated sculpture of Washington, commissioned for the Rotunda from Horatio Greenough in 1832 and installed in 1841, had been moved to the Capitol grounds. A plaster cast of Jean Antoine Houdon's standing portrait of Washington was on display, and the unfinished Washington Monument was also a constant reminder of the first president's impor-

tance. By the mid-nineteenth century, Americans were focusing on the American Revolution as the heroic age of this country, and Washington was even considered superior to Roman heroes.[33] The appropriateness of honoring Washington in the fresco decoration of the Capitol must have seemed obvious to people of the time, and Meigs's decision to do so never provoked debate or criticism.

Brumidi's art in the Capitol also reflects Meigs's keen interest in new technology. The supervising engineer was deeply curious about scientific inventions. At the time he was commissioning work from Brumidi, he was also designing structures and ventilating systems for the Capitol and building a system to supply water to the city of Wash-

11

ington. He participated, along with Titian R. Peale, head of the Patent Office, and Joseph Henry, secretary of the Smithsonian Institution, in a scientific club, called the Saturday Club, which met in members' houses once a month.[34] He kept up-to-date through these meetings and his reading and observation, on which he commented in his journals.

Even before arriving at the Capitol, Brumidi shared Meigs's nineteenth-century pride in technology, as shown in his painting *Progress*, which includes a locomotive and steamship (see fig. 5–4). In the Capitol, he highlighted new inventions, beginning with his first room (H–144), where he depicted the McCormick reaper. In the canopy over the Rotunda, he included the reaper, steam engines, an ironclad ship, electrical generators, and the first transatlantic cable, which was being laid as he painted the fresco. American inventions are also featured in the Brumidi Corridors and numerous murals throughout the building (fig. 1–21).

The success of Brumidi's work in the Capitol results in part from the artist's ability to integrate the modern with the classical. This gift of imagination was supported by a foundation of talent and thorough academic training; its translation into reality was aided by a temperament that allowed him to work effectively with others to carry out his designs. And, as the following chapters show, Brumidi's abilities were marshalled and given direction by his unceasing enthusiasm for celebrating not only the history but also the ideals of his adopted country.

Notes to Chapter 1

1. "Death of a Great Artist," *Washington Post*, February 20, 1880.

2. Notes taken by Mildred Thompson, great grandniece of Lola Brumidi, from passport application, USSC/MTP.

3. Guiseppe Checchetelli. *Una giornata di osservazione nel Palazze e nella Villa de S.E. il Principe D. Alessandro Torlonia* (Rome: Tipografia de Crispino Puccinelli, 1842).

4. CB to Justin Morrill, November 30, 1874, AOC/CO. The document in the AOC Curator's Office, in the artist's own hand, is presumably a copy that Brumidi sent to Edward Clark.

5. Regina Soria, *American Artists of Italian Heritage, 1776-1945: A Biographical Dictionary* (London and Toronto: Associated University Press, 1993), p. 40.

6. Brumidi copied seventeenth-century altarpieces by Guercino Annibale Carracci for churches in Rome. A.V. Jervis, "Costantino Brumidi," *La Pittura in Italia: L'Ottocento* (Milan: Electa, 1991). Brumidi gave his copy of Guido Reni's *Aurora* to Moses Titcomb, and later he had his son Laurence copy the same painting for Justin Morrill.

7. The manifesto of the purist movement, "Del purismo nelle arti," was published by Brumidi's cousin Antonio Bianchini in Rome in 1843; see Norma Broude, *The Macchiaioli* (New Haven: Yale University Press, 1987), chapter 1 for background.

8. "Constantino Brumidi," *Daily (Washington) Critic*, undated news-

paper clipping marked 1880, AOC/CO.

9. "Death of a Great Artist."

10. *Congressional Record*, 46th Cong., 2d sess., February 24, 1880, p. 1076.

11. MCM to Representative Tyson, May 1, 1856, AOC/LB. CB consulted with the wife of General Winfield Scott while preparing the *American Army Entering the City of Mexico* for the frieze. CB to EC, March 22, 1879, AOC/CO.

12. Greek diplomat Alexander Rhizos Rangavis visited the Capitol on May 31, 1867, and mentioned meeting the "Greek Bromidis" in his journal, see P. B. Peclaris, "Constantinos Brumidis: The Greek Painter who Decorated the U.S. Capitol," *Hellenic Review* 4 (April 1963), p. 19. He was introduced by Mr. Kimon of the State Department, see Harry Lagoudakis to Mildred Thompson, October 30, 1953, AOC/CO.

13. MCMJ, December 28, 1854 (A–358); CB proposal in French for the decoration of the Senate Reception Room, c. 1855, AOC/CO; CB to MCM, May 26, 1856, written in English, AOC/CO; *Congressional Record*, 46th Cong., 2d sess., February 24, 1880, p. 1076.

14. "Death of a Great Artist."

15. TUW to Amanda Walter, May 8, 1863 TUW/PA (AAA reel 4141). "Constantino Brumidi," *Daily Critic*, c. 1880.

16. MCMJ, April 9, 1855 (A–519); The List of All Passengers, taken on board the steamship *Onzaba*, at the port of Vera Cruz, bound for New Orleans, December 12, 1854. NARA/RG 36, Passenger Lists and Indexes, New Orleans, courtesy of Kent Ahrens. Casali appears to have been the young Italian who translated for Brumidi and Meigs at their first meeting. He served as head of the Capitol bronze foundry from 1855 until his death in July 1857. MCMJ, April 9, 1855 (A–520), with mentions of Casali through July 13, 1857 (B–606).

17. MCMJ, July 26, 1855 (A–629).

18. Laurence Brumidi, "History of the Frieze in the Rotunda of the U.S. Capitol, Washington, D.C.," [1915], p. 10, AOC/CO.

19. *Congressional Record*, 46th Cong., 2d sess., February 24, 1880, p. 1076. Elena Brumidi to EC, July 14, 1879, AOC/CO. Elena's picture taken in Rome in 1876, in Lola Germon Brumidi family album, USSC/MTP.

20. Giuseppe died in 1916. His daughter Maria, Brumidi's granddaughter, was referred to as a lunatic and was living in a welfare house in Rome in 1925. She claimed to be the artist's only heir after the death of Laurence, Probate Court no. 27803, Supreme Court of District of Columbia, October 16, 1925.

21. The List of All Passengers, December 12, 1854. MCMJ, January 30, 1855 (A–410). Because the dates of these documents are only six weeks apart, the assumption is made that this is the same woman.

22. "Death," *National Intelligencer*, June 8, 1859, p. 1.

23. Lola's cousin Effie Germon made her stage debut at Wallach's theater in 1868. The Temple of Art, at 914 Arch Street, was the predecessor of the McClees Gallery, Senate Curator's interview with Mildred Thompson, USSC/MTP.

24. TUW refers to "Mrs. Brumidi" in a letter dated March 30, 1863 TUW/PA (AAA reel 4141). "Indenture," dated November 21, 1864, names "Lola V. Brumidi, the wife of Constantino Brumidi" as second party in a real estate transaction, USSC/MTP.

25. MCMJ, January 30, 1855 (A–410). Brumidi lived on Delaware Avenue between B and C Streets in a brick rear kitchen with two rooms on the second floor owned by Mr. Brent, a lawyer, who lived at 306 Delaware Avenue. CB to MCM, May 26, 1856 AOC/CO and *Washington Directory*, 1858.

26. Brumidi was listed only sporadically in *Boyd's Washington and Georgetown Directory*. He is shown at 63 Indiana Avenue in 1858 and at 485 D Street North in 1860. His longest-term address was 128 2nd Street West, where he resided from 1862 to at least 1870. Lola V. Brumidi purchased this property, lot 16, square 571, on November 21, 1864. In 1870, they took out a loan on this property and Lola was listed at A Street near 4th SE (326 A Street, SE), perhaps signaling a separation. In 1878, he lived with his son Laurence in a brick house at 911 G Street, N.W. He spent his last months at 921 G Street, N.W., a house purchased by Lola V. Walsh in 1879. Record of purchase, Young & Middleton, March 22, 1879, USSC/MTP; "Constantino Brumidi," *Daily Critic*, c. 1880, and CB will dated June 27, 1879, Records of the Government of the District of Columbia, Department of Public Health.

27. MCMJ, March 26, 1855 (A–502).

28. MCM to Caleb B. Smith, Secretary of the Interior, June 5, 1862, NARA/RG 48, series 291, box 4.

29. TUW to John Boulton, February 5, 1863, TUW/PA (AAA reel 4141).

30. Charles Fairman, *Art and Artists of the Capitol of the United States* (Washington, D.C.: Government Printing Office, 1927), p. 160.

31. CB, Statement of Innocence, February 22, 1851, ASR/SC.

32. Smith D. Fry, *Thrilling Story of the Wonderful Capitol Building and Its Marvelous Decorations* (n.p., 1911), p. 41.

33. Edwin A Miles, "The Young American Nation and the Classical World," *Journal of the History of Ideas* 35 (April–June, 1974), pp. 269–270.

34. Albert C. Peale, "Titian R. Peale," *Philosophical Society of Washington Bulletin*, 14 (1905), p. 317.

The Italian Years

PELLEGRINO NAZZARO

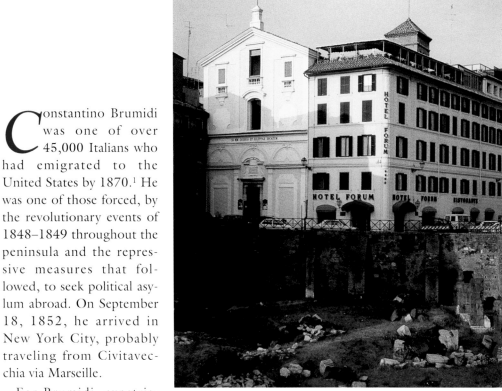

Fig. 2–2. Corner where Brumidi lived. *The Brumidi family coffee shop in Rome was on the site of the present Hotel Forum, next door to the church where Brumidi was baptized and married, and overlooking the Forum of Augustus.*
Photo: Wolanin.

Constantino Brumidi was one of over 45,000 Italians who had emigrated to the United States by 1870.[1] He was one of those forced, by the revolutionary events of 1848–1849 throughout the peninsula and the repressive measures that followed, to seek political asylum abroad. On September 18, 1852, he arrived in New York City, probably traveling from Civitavecchia via Marseille.

For Brumidi, expatriation ended a promising artistic career in Rome, the Eternal City of aspiring artists and intellectuals (fig. 2–1). Political events played an important role in his decision to leave Rome for the United States and would deeply influence his personal life and artistic career.

Constantino Brumidi was born in Rome on July 26, 1805, of a Greek father and an Italian mother. His father, Stauro (or Croce in Italian), was born in Greece in 1752 and settled in Rome in 1781. His mother, Anna Maria Bianchini, was born in Rome. On March 14, 1798, Stauro and Anna Maria had been married in the Church of SS. Quirico and Giulitta. Their son was baptized "Costantino Domenico" in the same church, which was adjacent to the large coffee shop on the Via Tor de' Conti that the family owned and operated (fig. 2–2).[2]

At the age of thirteen, having already begun his study of art, Brumidi was accepted at the most prestigious art school in Rome, the Accademia di San Luca, founded in the fifteenth century as a college and association of painters.[3] At the academy Brumidi studied painting under Vincenzo Camuccini, an artist esteemed by popes and by other artists and intellectuals. He also worked under Filippo Agricola, who was acclaimed for his interest and expertise in historical and religious subjects. Brumidi's teachers in sculpture were Antonio Canova, the nineteenth century's most refined neoclassical sculptor, and the Danish Bertel Thorwaldsen, Canova's most faithful disciple and master of the classical revival in Italy. Brumidi was registered as a professional painter.[4]

Fig. 2–1. The culmination of Brumidi's career in Rome. *The ceiling murals in the Church of the Madonna dell'Archetto, so well integrated with the neoclassical architecture, show Brumidi well prepared for his later work at the Capitol.*
Photo: Vasari Studio Fotografico. Courtesy of Henry Hope Reed.

On June 30, 1832, at the age of twenty-seven, Brumidi married Maria Covaluzzi, a widow eight years his senior. They had a daughter, Maria Elena Assunta Fortunata. Tragedy struck early in their marriage. In a span of ten months, between August 1837 and June 1838, Brumidi's wife and mother both died. He remarried on October 17, 1838. His new bride, Anna Rovelli, was sixteen; he was thirty-three. Their son, Giuseppe Antonio Raffaello, was born on January 19, 1842.[5] When he left Rome in 1852, Constantino Brumidi left behind his wife Anna and two children, then twenty and ten years old.

Brumidi and the Vatican

Brumidi's first known opportunity to work in the Vatican came in 1840, when he was thirty-five. Under the supervision of Vincenzo Camuccini and Filippo Agricola, a group of talented young artists, including Brumidi, was commissioned to restore the frescoes in the Third Loggia of the Vatican Palace, decorated in the second half of the sixteenth century during the pontificates of Pius IV and Gregory XIII by Girolamo Nanni, Giorgio Bellunese, and Girolamo Amalteo. Although the Third Loggia (called

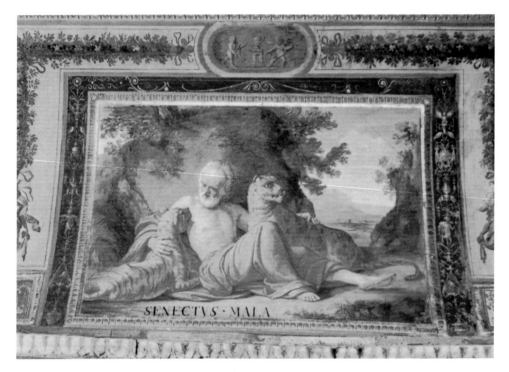

Fig. 2–3. *Senectus Mala. Brumidi left his mark in the Vatican Palace in this fresco, created as part of a restoration project.* Third Loggia, Vatican Palace.

Photo: Courtesy of Dr. Pellegrino Nazzaro.

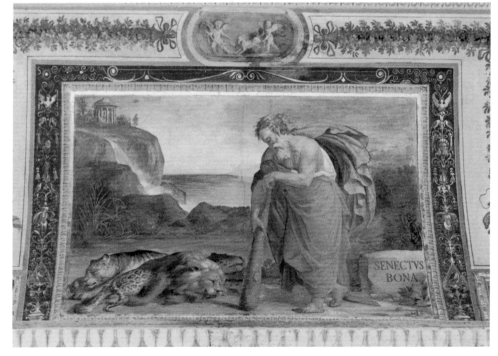

Fig. 2–4 *Senectus Bona. Brumidi's panels contrast wicked and virtuous old age, with the beasts representing vices.* Third Loggia, Vatican Palace.

Photo: Courtesy of Dr. Pellegrino Nazzaro.

the Loggia della Cosmografia) did not have the artistic merit of Raphael's Loggia, it was richly decorated. The walls were covered with frescoes reproducing maps; the vaults, with depictions of religious and allegorical subjects. Over the years the vaults and walls had deteriorated from neglect, and by the 1830s they required immediate restoration to preserve the paintings from total disintegration. The restoration of the loggia was carried out during the pontificate of Gregory XVI (1831–1846), who was interested in the preservation and development of the arts.

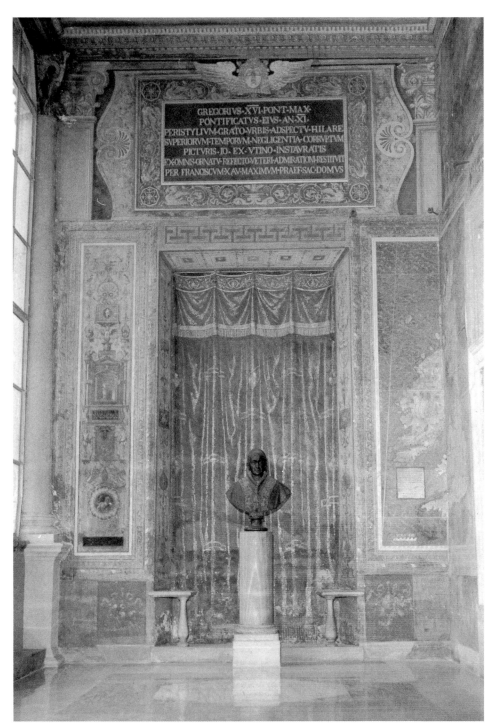

Camuccini and Agricola assigned to Brumidi and to Domenico Tojetti the restoration of the eleventh bay of the vault. The work consisted of redoing the three major frescoes in the vault. The painting in the first panel, entitled *Senectus Mala*, represented wicked old age, symbolized by an old man surrounded by wild felines, allegories of the human vices of incontinence, malice, and bestiality (fig. 2–3). The second lunette, entitled *Senectus Bona*, represented good old age as an old man surrounded by dead beasts, signifying the triumph of honesty and integrity over the vices (fig. 2–4). In the central panel the artists added a fresco that depicted the coat of arms of Pope Gregory XVI, consisting of a ring adorned with diamonds with three intertwined feathers that encircled the Latin word *semper* (always).

Brumidi and Tojetti were also assigned the task of decorating the end wall of the loggia, which was dedicated to Gregory XVI to memorialize his interest in the restoration. The two artists painted a richly ornate trompe-l'oeil drapery with golden brocade (fig. 2–5).

The restoration, completed in March 1842, received high praise from artists, critics, and experts. The total cost of the project was over 10,000 gold scudi, of which Brumidi was paid 200 scudi.[6]

Fig. 2–5. Wall of the Third Loggia. *Brumidi and Tojetti frescoed the end wall with a dedication and illusionistic curtains to set off the bronze bust of Gregory XVI.* Vatican Palace.

Photo: Courtesy of Dr. Pellegrino Nazzaro.

Brumidi and the Palazzo Torlonia

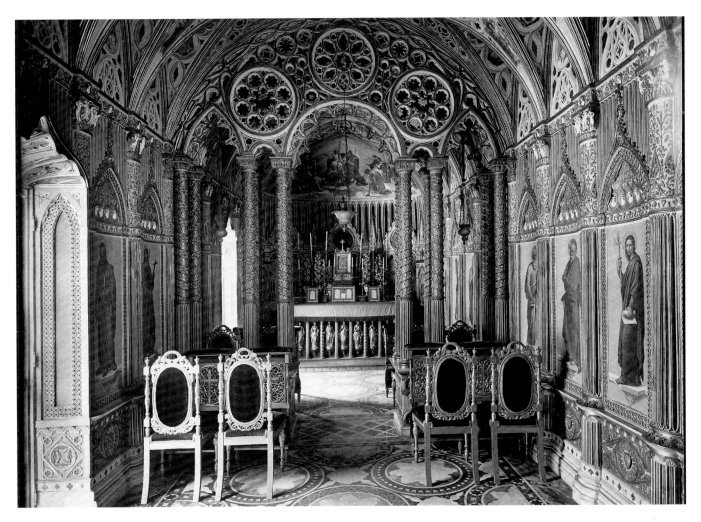

Fig. 2–6. Torlonia coat of arms in the Palazzo Torlonia, Rome. *Brumidi painted Alessandro Torlonia's family coat of arms combined with that of his wife, a member of the prominent Colonna family, to symbolize their 1840 marriage. The surrounding cherubs are cousins to those Brumidi painted in the Capitol.* Destroyed.

Photo: Courtesy of Marco Fabio Apolloni.

The Palazzo Torlonia, located on the Piazza Venezia in one of the most prestigious sections of Rome, near the present monument to Victor Emmanuel II, was built by the architect Carlo Fontana in 1650 and purchased at the end of 1700 by Giovanni Raimondo Torlonia, Duke of Bracciano, a banker who had newly acquired his title. The palace was described by historians and art critics as one of the most beautiful buildings of eighteenth-century Rome. Its Baroque architecture symbolized Roman wealth and aristocracy. In 1856, August J. C. Hare, an American art critic, described it as follows: "Giovanni Torlonia, the Roman banker who purchased the title and estate of the Duke of Bracciano, fitted up the Palazzo Nuovo di Torlonia with all the magnificence that wealth commands: a marble gallery with polished floor, modern statues,

Fig. 2–7. Chapel in the Palazzo Torlonia, Rome. *Brumidi's frescoes glorifying the Torlonia family in the elaborate Gothic-style chapel in the Palazzo Torlonia are known only from this photograph.* Destroyed.

Photo: Alinari/Art Resource, NY.

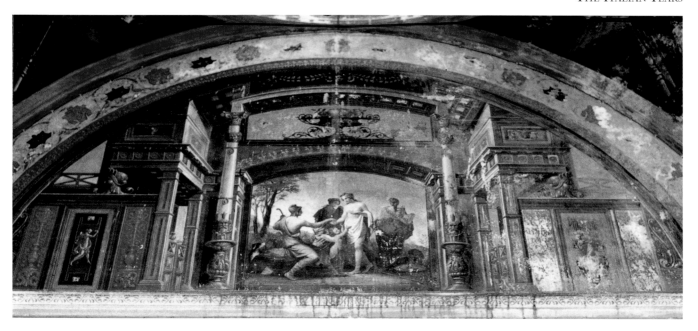

Fig. 2–8. Murals in the theater of the Villa Torlonia. *The scene showing the* Judgment of Paris *by Brumidi was surrounded by illusionistic architecture.*
Photo: Courtesy Alberta Campitelli, Comune di Roma.

painted ceilings and gilded furniture. All outshines the faded splendor of the halls of the Old Roman Nobility."[7] Torlonia's son, Alessandro, who became a prince and the richest man in Rome, continued the decoration of the palace (fig. 2–6). Unfortunately, it was demolished in 1900–1901.[8]

In the Palazzo Torlonia, Brumidi executed the first major frescoes and murals of his artistic career. Recently uncovered evidence shows that he first worked there in 1836, decorating the vaults of the second-floor throne room with allegorical figures that symbolized the triumph of the Emperor Constantine.[9] From 1840 to 1842, under the supervision of the architect and painter Giovan Battista Caretti, Brumidi painted decorations in several rooms, including the neo-Gothic family chapel on the third floor.

Although it is no longer possible to view Brumidi's work in the chapel, published sources and an archival photograph give an idea of its nature and extent[10] (fig. 2–7). The chapel's Gothic architectural style presented difficulties that Brumidi overcame by adorning the main altar with a painting depicting the spiritual triumph of the Torlonia family. The altarpiece showed the Holy Trinity with Prince Alessandro Torlonia being presented by his guardian angel to the throne of God, flanked by the family name saints, John and Anne on the right and Martin and Charles on the left. The walls were decorated with frescoes of full-length figures of Apostles and other holy personages. One contemporary critic went beyond a trib-

ute to the skill and competence of the artist to underscore the recognition that Brumidi was far ahead of his peers in the art of painting and the technique of fresco: "The colors and the harmony of the entire decoration are such that Brumidi's name will be accepted from now on among the greatest artists of all times."[11] The decorative work carried out in the palace by Caretti, Brumidi, and other artists covered 4,793.35 *palmi* (some 2,790 square feet) overall, and the total cost of the project amounted to 11,373 scudi and 45 baiocchi. An 1844 appraisal in miscellaneous records of the Biblioteca Sarti in Rome containing a detailed description of the entire surface frescoed by Brumidi estimated that his work covered some 900 square feet. The document makes no mention of the payment Brumidi received for his work.[12]

There is reason to believe that Brumidi's success in executing this grand project reinforced his confidence in his ability to handle frescoes of large proportions. It may have been because of this experience that the artist later undertook the extraordinary *Apotheosis of Washington* in the United States Capitol, certain of his final success.

Recent research by Alberta Campitelli and Barbara Steindl has led them to attribute to Brumidi most of the decorations in the theater of the Villa Torlonia, on the Via Nomentana in Rome, constructed beginning in 1841, where there are lunettes signed and dated by the artist in 1844 and 1845 (fig. 2–8). Campitelli and Steindl also provide substantive evidence that in 1837 Brumidi was commissioned to create the marble bas-reliefs, including a *Pietà*, *The Expulsion of Adam and Eve from Paradise*, *The Holy Family at Nazareth*, *The Adoration of the Shepherds*, and the *Crucifixion* on the altar, in the Weld-Clifford Chapel in the crypt of San Marcello al Corso.[13]

19

Brumidi's Portraits of Popes

In 1847 Brumidi painted a full-length seated portrait of Pope Pius IX, commissioned by Cardinal Gabriele Ferretti as a personal gift to the pope (fig. 2–9). The painting is an oil on canvas of large dimensions and beautifully executed. The work is a composition in rich reds in which the ornate papal garments do not obscure the sense of a human figure beneath. The artist received other commissions for portraits of Pius IX from Italian and foreign prelates. It is probable that Monsignor John Hughes, Archbishop of New York, commissioned one for the Archdiocese of New York. Hughes spent several months in Rome in 1850–1851 and invited the artist to New York to execute frescoes for Catholic churches there.[14]

During this period, Brumidi painted a series of historical portraits of popes, including Felix IV, Stephan I, Sixtus I (fig. 2–10), Vitalian, Paul I, Leo VI, Sabinian, Sixtus V, John IX, and John XVI. The paintings, oil on canvas in a round format, were used as studies for the mosaic frieze of the Basilica of St. Paul Outside the Walls, decorated by Vincenzo Camuccini, Brumidi's teacher at the Accademia di San Luca. Camuccini considered Brumidi the best artist of religious subjects in Rome at that time.[15] Interestingly, this commission was completed after the republican revolution of 1849, but before Brumidi was arrested for his role in it in 1851.

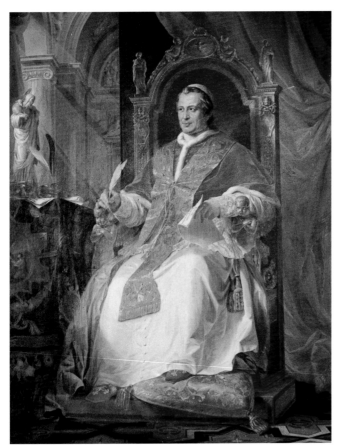

Fig. 2–9. *Pope Pius IX.* *Brumidi's portrait of the pope, painted the year after he was elected, shows the artist's mastery of Baroque light, color, and texture.* Vatican Museums.

Photo: Courtesy of Dr. Pellegrino Nazzaro.

Brumidi and the Church of the Archetto

Brumidi was selected for another important church commission after the revolution was quelled in 1850. The Church of the Madonna dell' Archetto, located at 41 Via S. Marcello, was built in 1850–1851 by the architect Virginio Vespignani, one of Rome's most celebrated artists (fig. 2–11). The church was commissioned by the Count Alessandro and Countess Caterina Papazzurri Savorelli to house a painting depicting the Virgin Mary as the Madonna dell'Archetto, commissioned in 1690 by their ancestress and executed by Domenico Muratori of Bologna.[16] By 1850 the painting, also known as the *Mater Misericordiae*, was believed to possess miraculous powers and had become the most popular and adored effigy of the Virgin Mary in Rome. Brumidi was chosen to decorate the dome and ceiling of the new church. He completed the work, his last in Rome, by January 1851.

Brumidi's frescoes for the Church of the Archetto combined symmetry and pictorial effects in one of his finest works in Rome. He adorned the center of the dome with a depiction of the Immaculate Conception with the Madonna surrounded by angels (fig. 2–12). Cherubs in

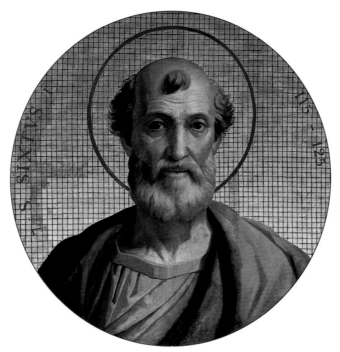

Fig. 2–10. *Pope Sixtus I.* *One of fifteen round portraits of early popes that Brumidi painted in oil as models for mosaics.* Vatican Museums.

Photo: Vasari Studio Fotografico. Courtesy of Henry Hope Reed.

20

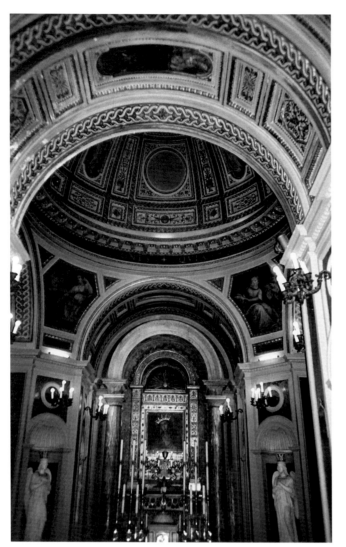

Fig. 2–11. **The Church of the Madonna dell'Archetto.** *Brumidi decorated the church reputed to be the smallest in Rome.* Photo: Wolanin

Fig. 2–12. ***Madonna of the Immaculate Conception.*** *The figure in the center of the dome anticipates symbolic figures Brumidi would later paint in the Capitol.* Church of the Madonna dell'Archetto.

Photo: Vasari Studio Fotografico. Courtesy of Henry Hope Reed.

Fig. 2–13. ***Strength*** **in one of the pendentives of the dome.** *Brumidi would continue the tradition of painting allegorical virtues in the Capitol.* Church of the Madonna dell'Archetto.

Photo: Vasari Studio Fotografico. Courtesy of Henry Hope Reed.

the coffers complete the composition. In this fresco he achieved an ensemble of motif and rich color in harmony with the spiritual quality of the sacred images. The cupola's pendentives were frescoed with four female allegorical figures symbolizing the four theological virtues: Wisdom, Prudence, Innocence, and Strength (fig. 2–13).

Following the dedication on May 31, 1851, the newspaper *Il Giornale di Roma* published a detailed description of the interior decoration of the Church of the Archetto. Brumidi's work was described as endowed with extraordinary talent and a "sure hand which blends light and symmetry in a unity and variety that charm the spectator and attract his attention and imagination." "Costantino Brumidi," the account continued, "has reached pictorial effects second only to the great masters of the High Renaissance."[17] Ironically, while the Roman press was praising Brumidi for his artistic talent, he was in prison.

The Republican Revolution

Soon after Giovanni Mastai-Ferretti was elevated as Pope Pius IX in 1846, he began to grant constitutional rights to the people of Rome and the Papal States. Tariffs were reduced, monopolies were restricted, the judicial system was reorganized, censorship of the press was abolished, and commercial treaties were made with other nations. The City of Rome was granted a municipal government and local councils were set up. An amnesty was granted for all political crimes, and hundreds of political prisoners were released. The pope set up a council to advise him and expand the participation of laymen in administering the city.[18] He authorized the formation of a civic guard, of which Brumidi became a captain. The pope was praised worldwide, including in the United States. He set an example for other states which granted constitutions and a greater recognition of individual rights and stirred up the desire for power in the hands of the people.

In the second half of 1848, the situation in Rome deteriorated. The pope refused to support war against Austria or to appoint the prime minister the Roman republicans supported. On November 15, 1848, the day of his inauguration, the papal appointee, Pellegrino Rossi, was assassinated, and mobs gathered outside of the Vatican. The pope and several cardinals fled to Gaeta.

The liberals and radicals appointed a Supreme Committee of the State and called for a Roman Constituent Assembly, elected by the people, to draft a constitution. On February 9, 1849, the Constituent Assembly abolished the temporal power of the pope in Rome and proclaimed the Roman Republic. The triumvirate elected to govern was open to meeting with and listening to the people. The entire population of Rome developed a sense of deep affection for and confidence in the republic. The republican experiment was short lived. The city faced the intervention of the Catholic countries: Austria, France, and the Kingdom of the Two Sicilies. The pope condemned the republic, and Louis Napoleon sent French troops to Rome in April 1849. Despite the resistance of the people, the troops took over the city, and Pius IX returned to power on April 12, 1850.

Brumidi's Imprisonment and Trial

The return of the pope was followed by repressive measures, of which the champion was Cardinal Giacomo Antonelli. On February 4, 1851, Brumidi was one of a group of revolutionary leaders arrested and imprisoned on charges of committing grand larceny, aggravated assault, and kidnapping against churches, convents, and monasteries of the city of Rome during the period of republican rule.[19]

Brumidi's indictment resulted from his actions as captain of the civic guard, when he had seized the convent of Santa Francesa Romana to house Piedmontese troops who had joined the Romans in the defense of the republic. Brumidi was charged with ordering the occupation of the monastaries and convents of Santa Croce in Gerusalemme, Santa Francesca Romana, and La Scala Santa. Monks and nuns were forced to leave, and the buildings were ransacked and confiscated. Brumidi was accused of taking several pieces of furniture, paintings, silverware, and a box containing 1,000 scudi collected by the monks. Finally, the indictment stated that the "ultimate goal of the revolutionaries was the destruction of the Catholic Church and institutions in the City of Rome." Brumidi had, in fact, taken furniture for safekeeping and placed it in his studio and, as ordered by his superior, had paintings moved to the Lateran Palace, to protect them in case of bombardment by the French.[20]

The trial was postponed several times because of the illness of Brumidi's defense lawyer. While in jail, he petitioned the pope, Secretary of State Giacomo Antonelli, and the president of the Tribune of the Sagra Consulta, the body of advisors to the pope. He reiterated that he was innocent of any wrongdoing and that his arrest and imprisonment were politically motivated. He requested his immediate release to emigrate to the United States, where he planned to continue his artistic career.[21] His petitions were unanswered. When the trial finally took place in December 1851, Brumidi's lawyer provided evidence that the order to occupy the convents was not aimed at the confiscation of church property or intended to abet or perpetrate crime but was given solely to protect works of art of incalculable value, which otherwise might have been stolen or destroyed by French soldiers. A number of affidavits supported the argument of the defense, including several from monks who vouched for his good intentions as well as the official order to Brumidi to move paintings to the Lateran Museum. Despite all of this evidence, Brumidi was found guilty on all counts on January 2, 1852, and sentenced to 18 years in prison.[22]

On January 31, 1852, following a second round of petitions signed by the monks of the three convents, Pope Pius IX reduced Brumidi's sentence by two-thirds. Finally, in a public audience of March 20, the pope granted Brumidi full and unconditional pardon, ordering his immediate release.[23] Less than six months later, Brumidi left Rome for the United States.

Notes to Chapter 2

1. Egisto Rossi, *Gli Stati Uniti e la Concorrenza Americana* (Florence, 1884), pp. 73–75.

2. Records of baptism, July 26, 1805, and of marriage, March 14, 1798, Parish of SS. Quirico and Giulitta, Tabularium Vicariatus Urbis, Achivio Storico del Vicariato di Roma.

3. Giovanni Bellini et al., *Dizionario enciclopedico moderno*, 4 (Milan: Edizioni Labor, 1956), p. 419.

4. Giuseppe Argentieri, *La pittura Italiana dell'Ottocento* (Milan: Mondadori, 1965), pp. 12–15; Aaron-Albertucci, "Filippo Agricola," *Dizionario biografico degli Italiani*, 1 (Rome: Istituto della Enciclopedia Italiana, 1960), pp. 501–502; Calvart-Canefri, "Antonio Camuccini," ibid., 17 (1970), pp. 627–630; Canella-Capello, "Antonio Canova," ibid., 18 (1975), pp. 197–222.

5. The Brumidi-Covaluzzi marriage in records of marriage, June 30, 1832, vol. 4, Parish of SS. Quirico and Giulitta (1825–1838); the birth of Brumidi's daughter, Maria Elena Assunta Fortunata, in records of baptism, August 16, 1832, vol. 13, Parish of SS. Quirico and Giulitta (1828–1847); the Brumidi-Rovelli marriage in records of marriage, October 17, 1838, vol. 2, Parish of Santa Maria ai Monti (1835–1841); the birth of Brumidi's son, Giuseppe Antonio Raffaelle, in records of baptism, January 23, 1842, vol. 13, Parish of SS. Quirico and Giulitta (1828–1847), Tabularium Vicariatus Urbis, Archivio Storico del Vicariato di Roma.

6. Gaetano Moroni, *Dizionario di erudizione storico-ecclesiastica da S. Pietro sino ai nostri giorni*, 50 (Venice: Tipografia Emiliana, 1851), pp. 276–278; *Nuova descrizione del Vaticano ossia del Palazzo Apostolico di San Pietro data in luce da Giorgio Pietro Chattard*, 2 (Rome: Stampe Del Mainardi, 1856), pp. 335–344; William Mitchell Gillespie, *Rome: As Seen By A New-Yorker in 1843-4* (New York and London: Wiley and Putnam, 1845); Filippo Agricola, *Relazione dei restauri eseguiti nelle terze loggie del pontificio palazzo Vaticano, sopra quelle dipinte dalla scuola di Raffaello* (Rome: Tipografia di Crispino Puccinelli, 1842), pp. 7–32.

7. August J. C. Hare, *Walks In Rome*, 2 vols. (Philadelphia: David McKay Publisher, 1865), pp. 75–78.

8. The Italian government ordered the demolition of the Palazzo Torlonia to provide a setting with an appropriate stagelike effect ("una ribalta di adeguato effetto scenografico") for the Vittoriano, the monument to King Victor Emmanuel II. *Le "Generali" a Roma tra cronaca e storia* (published by the Assicurazioni Generali, n.d.). After the demolition all works of art, including Brumidi's frescoes, were stored in a building in Via Margutta under the supervision of Pietro Ciccotti Principe, a well-known Neapolitan artist, and his collaborator Francesco Tancredi, a Neapolitan art dealer. It is possible that part of the collection is still preserved in Via Margutta; however, much of it may have been sold to Italian and foreign art dealers. Soon after the transfer to Via Margutta, an illustrated catalog was compiled by Tancredi. The catalog, in Italian and French, was mailed throughout Europe. On May 19–20 and 21–23, 1901, auctions took place in Rome. "Paintings, statues, floors and frescoes were mostly acquired by Russian nobles and art dealers, who transferred them to their villas and palaces in Russia," according to Jorgen Birkedal Hartmann, *La vicenda di una dimora principesca romana* (Rome: Edizioni Palombi, 1967).

9. Alberta Campitelli and Barbara Steindl, "Costantino Brumidi da Roma a Washington. Vicende e opere di un artista romano," *Ricerche di Storia dell'arte* 46 (1992), p. 53.

10. Brumidi's work was described at the time in Giuseppe Checchetelli, *Una giornata di osservazione nel Palazzo e nella Villa di S. E. il Principe D. Alessandro Torlonia* (Rome: Tipografia di Crispino Puccinelli, 1842), and Romano, *Dizionario*, 51, pp. 8–9.

11. Checchetelli, *Giornata*, pp. 57–58.

12. "Perizia del Cav. Filippo Agricola e di Giuseppe Marini per rilievi al merito e valore decorativi eseguiti dal Sig. Caretti per ordine di S. E. il Principe Don Alessandro Torlonia nel Palazzo di Piazza Venezia," in *Miscellanea Varia* 3-30 L.5 (Rome, May 25, 1844), p. 70, Biblioteca Sarti, Piazza dell'Accademia di San Luca, Rome.

13. Campitelli and Steindl, "Costantino Brumidi," pp. 49-50. They have also found documentation of another sculptural commission in England for a Count Maxwell and of another neo-Gothic chapel built for Marino Torlonia in the park of his Villa of the Porta Pia, later demolished. See also the volume of essays, "Villa Torlonia: L'ultima impresa del mecenatismo romano," *Richerche di Storia dell'arte* 28-29, 1986.

14. CB to Benvenuti Fiscale, February 22, 1851, n. 1876; CB to Monsignor Matteucci, president of the Tribunale Supremo della Sagra Consulta, March 8, 1851, n. 7166; CB to Cardinal Giacomo Antonelli, secretary of state, October 19, 1851, n. 13021; all in ASR/SC. CB to Pope Pius IX, June 4, 1851, n. 9155, Tribunale Supremo della Sagra Consulta in Segreteria dei Memoriali, Segreteria di Stato, Anno 1851, ASR/SC. Copies of documents relating to Brumidi's Italian years and trial are on file in the AOC Curator's Office, courtesy of Henry Hope Reed.

15. Brumidi made the studies c. 1848–1850. The papal portraits, now in the Vatican Museum, were executed as mosaics: Sixtus I by Chibel Guglielmo in 1850–1851, Felix IV (Saint) by Gioacchino De Angelis in 1852, Sabinian by Cesare Castellini in 1852–1853, Stephan I (Saint) by De Muzio Felice in 1852–1853, Vitalian (Saint) by Gherardo Volponi in 1857, Paul I (Saint) by Ettore Vannutelli in 1858, John IX by Alessandro Agricola in 1862, Nicholas III by Spiridione Malusardi in 1862, Leo VI by Spiridione Malusardi in 1862, and John XVI by Gioacchino De Angelis in 1864. Records also show that he painted Urban V (mosaic by Ettore Vannutelli in 1867), Luke III (Gaetano Pennacchini in 1869), Gregory XIII (Costanzo Maldura in 1869), John XXI (Costanzo Maldura in 1871), and Callistus III (Felice Muzio in 1872). Archivio della Reverenda Fabbrica di San Pietro, III, P.S., 20, vol. 6, pp. 28, 29, 30, 115, 150, 188, 274, and 29, vol. 2, pp. 661–664.

16. Domenico Muratori received the commission from Countess Alessandra Mellini Muti Papazzurri Savorelli. The Church of the Archetto was declared a national monument by the Italian government in 1970.

17. Lamberto De Camillis, *La Madonna dell'Archetto, Storia del piu' piccolo santuario Mariano di Roma* (Rome: Edizione Soc. Promotrice di Buone Opere, 1951), pp. 28–34.

18. A. C. Gambol, *Case e stato in Italia negli ultimi cento anni* (Turin, 1963) pp. 42–60.

19. Record of Brumidi's admission into the Carceri Nuove di Roma, February 4, 1851, ASR/SC.

20. "Furti violenti a danno del Ven. Monastero di S. Croce in Gerusalemme," Title I, pp. 4–19 and "Furto violento a danno del Monastero di Santa Francesca Romana," Title IV, pp. 45–67, ASR/SC.

21. CB to Pope Pius IX, February 22, 1851; CB to Mons. Matteuci, March 8, 1851 and December 22, 1851; CB to Card. Antonelli, October 19, 1851, ASR/SC.

22. CB to Tribunale Supremo della Sagra Consulta, Memoria con Sommario, June 15, 1851; Originale della Sentenze, January 2, 1852, ASR/SC.

23. Ministero di Grazia e Giustizia, Rome, January 31, 1852, Prot. n. 4815, and March 20, 1852, Prot. n. 5030, ASR/SC.

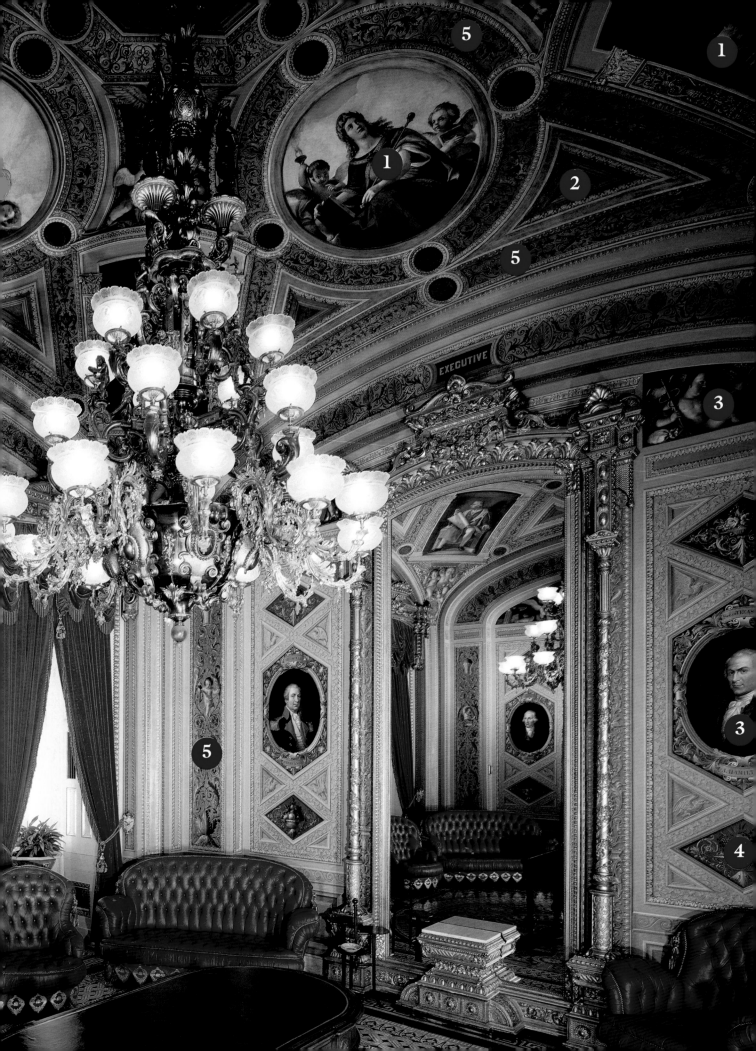

CHAPTER 3
Brumidi's Painting Techniques

Constantino Brumidi used a number of specialized painting techniques and sophisticated artistic skills to express his artistic vision in the Capitol (fig. 3–1). Knowledge of the variety of Brumidi's painting media and procedures has greatly increased from observations made during the course of recent conservation treatments that removed layers of varnish and overpaint and through scientific analysis of materials. However, research and analysis are ongoing.[1]

Brumidi was trained in a variety of disciplines at the Accademia di San Luca; his son described him as "artist, sculptor, architect."[2] Brumidi himself described to a reporter his thorough academic training: "'In Europe one studies as one does not study in America,' with an eloquent Italian shrug that disposed of American art-training. 'I studied fourteen years. I worked at Rome. In the great schools a boy begins young; he has great works to copy. He works all day and every day. It is the right way.'"[3] As a student he would have had courses in geometry, history, and mythology. He copied drawings, drew and modeled copies of classical sculpture, and copied paintings by others. Working from a live model was highly desirable, and Brumidi once signed a petition to the academy requesting one. Knowledge of how to render forms with light and shade, command of the human figure, and understanding of how to compose groups of figures were essential. Brumidi developed a high level of skill in these areas and won awards in student competitions for copying antique sculpture and paintings by others.[4]

The Technique of True Fresco

In order to paint in the classical tradition, Brumidi had to master a variety of painting media, particularly the difficult medium of true fresco, called *buon fresco* in Italian. The Capitol is the major building in the United States decorated in true fresco. Although in nineteenth-century America the word "fresco" was sometimes loosely used to mean wall painting in general, Brumidi believed that he created "the first specimen of real fresco introduced in America," and he was the only artist working in the United States in the 1850s and 1860s known to be capable of executing a true fresco painting.

Brumidi described the technique as follows:

> Fresco derives its name from fresh mortar, and is the immdiate [*sic*] and rapid application of mineral colors, diluted in water, to the fresh mortar just put upon the wall, thereby the colors are absorbed by the mortar during its freshness, and repeating this process in sections day by day, till the entire picture will be compleated [*sic*].
>
> This superior metod [*sic*] is much admired in the celebrated works of the old masters, and is proper for historical subjects, or Classical ornamentations, like the Loggie of Raffael at the Vatican.[5]

Fresco, used for murals in ancient Rome, became prominent again in the Renaissance and reached a height

Fig. 3–1. The President's Room. *In the Capitol, Brumidi employed the full range of painting techniques he had learned in Rome to create rich and impressive settings for important legislative functions. Here the mural techniques include (1) true fresco, (2) tempera, (3) oil, (4) lime wash fresco, and (5) gold leaf. S–216.*

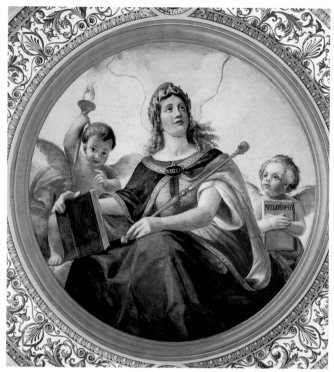

Fig. 3–2. An unusually prominent *giornata*. *Because Brumidi cut out and replaced the section of mortar containing the head of Executive Authority, the join was unusually prominent, especially before conservation.* S–216.

Fig. 3–3. *Giornate* in *Executive Authority*. *The sections of mortar applied each day usually followed outlines of the forms and varied in size according to the amount of detail to be painted.* S–216.

of perfection with Raphael and Michelangelo in the early sixteenth century. The Baroque painters of the seventeenth century applied pigment more thickly, using more vigorous, textured brushwork on rougher mortar, and it was this version of fresco that was revived in early nineteenth-century Rome and taught to Brumidi. (A century later, in the 1930s, fresco was again revived and used for a number of murals in the United States.)

True fresco entails the application of pigments dispersed in water to fresh, damp mortar (often referred to as plaster) composed of lime (calcium hydroxide) and sand. The wall is first prepared with a rough coat of mortar (*arriccio*). The pigment is applied to the second finish coat (*intonaco*), which is applied in sections over the *arriccio* by a mason. Each section of *intonaco* is called a *giornata*, the Italian word for day's work, because the painting on each section of *intonaco* has to be completed in a single day, before the mortar has set—that is, while it is still fresh, or *fresco* in Italian. The joins between the *giornate* are normally discernible only in raking light or on close-up inspection of the surface (fig. 3–2). The mason needs to mix the ingredients consistently and be careful not to splash on the sections already painted.

The very considerable technical difficulties of executing true fresco become evident when one considers that a fresco painter like Brumidi is really constructing a complex but precise monumental work of art like a puzzle, piece by piece, *giornata* by *giornata* (fig. 3–3). This painted puzzle must be so accurately planned and executed that the parts will blend together and that it will be possible to create forms that appear to be components of their architectural environment.

As the mortar sets, or cures, it is transformed from calcium hydroxide to calcium carbonate by combining with carbon dioxide in the air, becoming rock hard in the process.[6] The pigments are incorporated into the crystalline structure of the calcium carbonate, resulting in a mural painting that is essentially as durable as the wall itself. The fresco painter sometimes mixes the pigments with a fine lime paste to create a paint with a thicker consistency, called "impasto," that is raised from the surface of the wall, and often uses a rougher surface, with larger grains of sand. Reflective flecks of mica in the sand can be seen on close inspection of many of the Capitol frescoes. This baroque technique is often seen in Brumidi's frescoes. In his frescoes, he often modeled or shaded forms with hatched lines, to create a sculptural effect while retaining a sense of transparency in his colors (fig. 3–4).

Because the surface of the mortar is wet when the paint is applied, in the best fresco technique the brush strokes are not reworked, as is done in oil painting, because the surface of the mortar would become muddy. Instead,

26

Fig. 3–8. Details showing types of guidelines made in the wet mortar.

a. **Incisione,** *outlines incised with a sharp instrument around Columbus's compass;*

b. **Puntini,** *an outline of small holes made with a spiked wheel in the knee of* Legislature; *and*

c. **Spolvero,** *a dotted outline made by dusting powdered charcoal through pinpricks in the cartoon around the head of a cherub.* S–216.

Photo: Cunningham-Adams.

a. Incisione

b. Puntini

c. Spolvero

of heavy paper, to the exact scale of execution. These 1:1 scale drawings are known as cartoons. For large compositions, Brumidi made half-scale cartoons and then enlarged the figures to full size in what he called "working drawings."[8] Unfortunately, none of his cartoons is known to have survived, although the image of one was preserved in a photograph (fig. 3–7).

The appropriate cartoon is tacked in place over the damp *giornata*. The outlines of the composition are transferred to the *giornata* by incising the cartoon with a stylus to leave indented guide-lines (*incisione*), by perforating the outlines of the cartoon with a spiked wheel to leave a line of points (*puntini*), and/or by pouncing through the line of perforations with a colored powder to leave a colored dotted line (*spolvero*). These three types of transfer lines are all visible with close-up inspection in Brumidi's murals in the Capitol (fig. 3–8). When the outline is transferred, the artist begins the actual painting of the composition, using the preparatory painting as his guide. Brumidi would normally paint half a life-sized figure in a day, using brushes appropriate for the level of detail (fig. 3–9).

After the fresco dries, the artist may decide to apply some final details in colors that would react with the lime, using traditional water-borne tempera paints, oil paints, or gold leaf, applied on oil or glue adhesives ("sizes"). These are executed *a secco*, on a dry (*secco* in Italian) surface. Unlike true fresco, *a secco* details generally are fragile and poorly bonded to the mortar, and they are thus easily damaged by water or abrasion. The extent, if any, of Brumidi's application of *a secco* details to his frescoes is not yet clear.

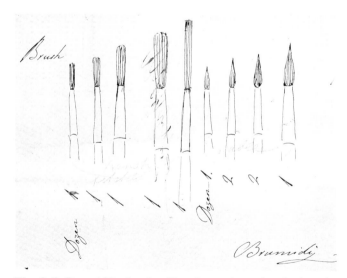

Fig. 3–9. **Brumidi's sketch of brushes to be ordered.** *A variety of types and sizes of brushes, including French fitches and the tapered sable brushes specified here, were needed for the range of painting mediums used for the Capitol murals.* Architect of the Capitol.

Other Mural Painting Mediums Used in the Capitol

A technique recently discovered to be part of Brumidi's repertoire is lime wash fresco, *fresco in scialbatura*, which is used to cover large surfaces of simple decoration. The extensive and repetitive decorative trompe l'oeil panels on the lower walls of the Brumidi Corridors and the President's Room (S–216) were executed in this technique (fig. 3–10). Assistants could quickly apply pigments mixed with water to a fresh lime wash brushed over a dampened *intonaco* to create the fields, borders, and basic forms. In this method, the *giornata* joins are not noticeable. In the Brumidi Corridors, the details of the birds, flowers, etc., were enhanced with more intense colors.[9] Microscopic analysis shows that the wall is covered with several layers of smooth, colored plaster. This technique is more durable than tempera and can be painted efficiently by teams of painters.

Brumidi had extensive experience in Italy decorating walls and ceilings with tempera (often called "distemper" in the nineteenth century). The decoration of the theater at the Villa Torlonia in Rome, thought to have been directed by Brumidi, is executed primarily in tempera.[10] Many of the ceilings and borders in the Capitol were painted in tempera by assistants from Brumidi's designs, with spaces left for Brumidi's true fresco figures and scenes.

Tempera is pigment mixed with a water-soluble binder or emulsion, such as the egg used in the Renaissance. In the Capitol, the binding medium was glue, explaining the large quantities of white glue listed on supply orders.[11] Tempera can be applied to dry plaster without the time constraints of true fresco, giving painters the leisure to work out details. It has a soft, matte surface. The velvety texture of the tempera is close to the appearance of fresco, so the difference in medium is indistinguishable at ordinary viewing distance (fig. 3–11). Unfortunately, tempera remains water soluble, so that it is sensitive to changes in humidity and can be inadvertently removed if someone tries to clean it with water.

Oil paint is composed of pigment mixed with linseed oil as a binder. It is commonly used for paintings on canvas, as Brumidi did for portraits and altarpieces, but it can also be applied to plaster, as he did for some of the murals in the Capitol (fig. 3–12). It is more durable than tempera, since it cannot be removed with water. The oil produces deeper, richer colors and a surface gloss. Since fresco was not transportable, Brumidi could have carried some rolled-up oil paintings, such as his *Martyrs in a Landscape* (fig. 3–13), to America, as proof of his painting skill.[12]

In many rooms in the Capitol, Brumidi orchestrated the use of multiple techniques to create the effect he desired. In most cases, he was so successful that the viewer is not aware of variations in painting medium.

Fig. 3–10. Detail showing lime-wash fresco. *The still lifes and illusionistic carved stone borders in the President's Room exemplify the delicate details and rich colors possible with this technique.* S–216.

Fig. 3–11. Merging of fresco and tempera. *In this detail from the ceiling, Brumidi painted toes in tempera on the cherub's frescoed foot, a difference not perceptible from the floor.* S–216.

Photo: Cunningham-Adams.

Fig. 3–4. **Detail of fresco.** *On close inspection, one can see the rough mortar, Brumidi's strokes of thick pigment, and his use of parallel hatched or crosshatched lines for shadows in this cherub's face.* S–216.

Photo: Cunningham-Adams.

each brush stroke must be decisive and complete in order that the painting maintain its freshness, clarity, and luminosity. In addition, the brushwork must be bold and expressive in order to project vitality and three dimensionality from the great distance at which frescoes are normally viewed. At very close range, therefore, many well-executed frescoes have a choppy, sketchy appearance that translates into dynamic vitality from a distance.[7]

In addition to the need to work rapidly, the fresco painter faces other constraints. First, the fresco palette is limited to those few pigments that can withstand the corrosive high alkalinity of the lime mortar. These include the earth pigments, such as indian red, earth green, various ochers, siennas, and umbers, as well as some artificial colors, such as smalt, cobalt, or ultramarine blue. Second, major mistakes cannot be corrected by covering over with new paint. Thus, a flawed *giornata* must be chipped off the wall and a new one inserted by applying a new section of mortar, which is then painted correctly. Finally, the artist has to be able to judge how much the colors will lighten as they dry. All these difficulties of execution are rewarded by the result, a durable monumental painting of great luminosity and subtle color.

Before beginning a monumental fresco, a painter like Brumidi must analyze and sketch the architectural space and sources of light. For example, Brumidi often created figures that appear to be lighted from the windows in the room. Next he developed and sketched the overall composition of the murals for a room, showing how the frescoes fit into the architectural and decorative elements (fig. 3–5). He then conceptualized the overall composition and coloring of each individual fresco on a preparatory painting, usually a precisely executed small-scale color

Fig. 3–5. Design for the Ladies Waiting Room. *Brumidi worked out details for murals and decorations in pencil sketches such as this one. The scenes he proposed in 1856, but never executed, featured heroines of the American Revolution such as Betsy Ross and Molly Pitcher. This sketch includes a design for an ornate mirror frame.*

Fig. 3–6. Preparatory oil sketch for Senate Military Affairs Committee room. *Brumidi's small paintings included all of the essential elements for his frescoed lunettes.* Estate of Edna W. Macomb.

Photo: Diplomatic Reception Rooms, U.S. Department of State.

Fig. 3–7. Detail of cartoon for maiden with pearls. *This photograph is the only known image of one of Brumidi's full-size cartoons for the Capitol. The outlines were transferred to the wall by* spolvero, *dots made by dusting powdered charcoal through pinpricks.* Architect of the Capitol.

sketch in oil or watercolor, which would usually be submitted for approval. A number of his sketches for Capitol murals are known (fig. 3–6). The preparatory painting was then divided into sections. Brumidi had to know how to enlarge the preparatory painting to fit the exact dimensions of the wall, while simultaneously dividing the overall composition into sections for systematic transfer to, and execution on, the individual *giornate.* The composition of each section was enlarged as a drawing on pieces

Fig. 3–12. Cherub in lunette painted in oil on plaster. *The rich color, soft modeling, and fine detail are characteristic of the oil medium.* S–216.

Photo: Cunningham-Adams.

Fig. 3–13. *Martyrs in a Landscape. This oil-on-canvas painting, which Brumidi is said to have brought with him from Italy, apparently depicts Early Christian martyrs.* Architect of the Capitol.

Architectural Painting

In addition to his well-developed skill in working in various media, Brumidi was gifted in the use of rich color and in understanding how to depict forms in light and shade (fig. 3–14). The technique of creating the effects of light and shade and perspective to convince the viewer that he is looking at actual sculpture, paintings with carved frames, or figures floating on clouds, is called "trompe l'oeil," French for "fool the eye." His skill in creating trompe l'oeil effects was undoubtedly enhanced by his study of sculpture at the Accademia di San Luca. Brumidi's only known sculptures are the four marble lunettes in low relief, two angels, and the crucifixion over the altar in the Weld-Clifford Chapel in the crypt of the Church of San Marcello al Corso in Rome (fig. 3–15). It is not known if Brumidi was responsible only for the design, or if he modeled or carved the sculpture as well.[13]

Fig. 3–14. Sketch from Brumidi's album. *This classical figure with leaves instead of legs, perhaps copied from a relief in Rome, uses light and dark to give a three-dimensional effect.* Library of Congress.

Photo: Library of Congress.

31

Fig. 3–15. *Pietà*, one of four marble relief lunettes by Brumidi for a subterranean chapel. *The figures are gracefully balanced within the semicircular shape, a skill Brumidi would use later in the lunettes in the Capitol.* Weld-Clifford Chapel, Church of San Marcello al Corso, Rome.

Photo: Vasari Studio Fotografico. Courtesy of Henry Hope Reed.

Fig. 3–16. *Project for the Broadway Rail Road, 1862. This pencil drawing is the only one that has survived of this project, and it hints that Brumidi may have been involved in urban planning.* Athenaeum of Philadelphia.

Photo: Athenaeum of Philadelphia.

In the Capitol, he merely sketched a preliminary design for the Brumidi Staircases.

Although there is no evidence that Brumidi ever carried out architectural work, his understanding of the dynamics of architectural space is evident in his designs for the Capitol. This mastery was grounded in his work in Rome, which included the decoration of rooms in the Palazzo Torlonia (see chapter 2). His one known Italian architectural project is a proposal made in 1846 for a grandiose new avenue from the Quirinale to the Vatican, which included the construction of a monumental bridge and a triumphal arch in honor of Pius IX.[14] The only evidence of Brumidi's interest in urban planning in the United States is a proposal, dated May 1862, for an elevated railroad on Broadway in New York City, which was found among the papers of the Architect of the Capitol Extensions and Dome, Thomas U. Walter (fig. 3–16). Brumidi's knowledge of sculpture and architecture enhanced his ability to visualize three-dimensional forms in space and paint them convincingly on flat surfaces within a harmonious whole, thus fooling our eyes into believing we are seeing sculpture and moldings projecting from flat walls (fig. 3–17). His arrival in the United States in 1852 was at a fortunate moment for his career. Only a year earlier, work had begun on the enlargment of the United States Capitol.

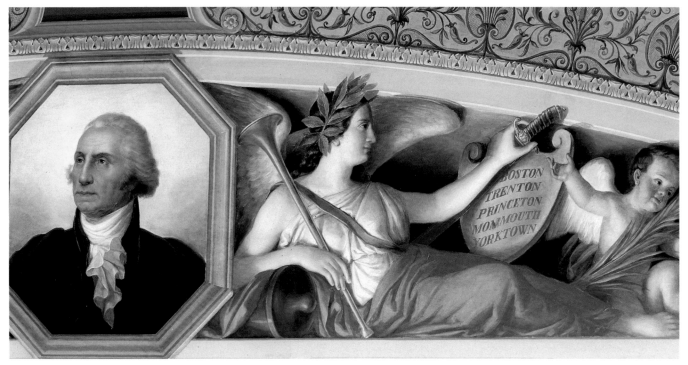

Fig. 3–17. Example of trompe l'oeil. *Through his understanding of light and shade, Brumidi created the illusion of carved molding, a framed oil painting, and figures and objects on a ledge. In actuality only the gilded molding over the curved door is three dimensional.* S–216.

The building's neoclassical architecture provided a most appropriate context for the classically based style of painting Brumidi had learned in Rome, and its masonry construction created natural fields for a fresco painter.

Notes to Chapter 3

1. The section "The Technique of True Fresco" was largely written by Constance S. Silver. She, Christiana Cunningham-Adams, Bernard Rabin, and Catherine S. Myers have each separately conducted scientific analysis along with their conservation of Brumidi's murals in the Capitol. The most comprehensive publication on mural techniques is Paolo Mora, Laura Mora, and Paul Philippot, *Conservation of Wall Paintings* (London: Butterworths, 1984).

2. Laurence Brumidi, "History of the Frieze in the Rotunda of the U.S. Capitol, Washington, D.C.," c. 1915, p.3, AOC/CO.

3. "Brumidi's Life Work," *Washington Post*, April 11, 1879, p.1.

4. Records of 1821, 1822, and 1823 prizes and 1823 student petition, Accademia di San Luca, Archivio.

5. CB, "Relative to his Employment at the Capitol," November 30, 1874, AOC/CO.

6. To create lime, limestone $(CaCO_3)$ is dissociated by heat in kilns. Carbon dioxide is released, producing quicklime $(CaCO_3 \rightarrow CaO + CO_2)$. When water (H_2O) is added to the powdered quicklime, a paste of slaked lime, calcium hydroxide $(Ca(OH)_2)$ is formed. The *intonaco* is made of slaked lime mixed with sand in a ratio of 1:3. During drying,

the calcium hydroxide reacts with carbon dioxide to re-form calcium carbonate $(Ca(OH)_2 + CO_2 = CaCO_3 + H_2O)$.

7. Christy Cunningham-Adams, "Conservation Treatment Report: U.S. Capitol, President's Room Ceiling," 1995, p. 18, AOC/CO.

8. MCMJ, April 18, 1855 (A–527); "Brumidi's Life Work," p. 1.

9. Christy Cunningham-Adams, "Brumidi Corridors Restoration Plan," January 4, 1994, AOC/CO, and Mora et al., "Conservation of Wall Paintings," p. 11.

10. Conversation with Alberta Campitelli, Curator of the Villas of Rome, August 16, 1994, and her article on the restoration, "Il programma di restauro di Villa Torlonia: primi interventi," in "Villa Torlonia," *Ricerche di Storia dell'arte*, n. 28–29 (1986), pp. 182–223.

11. Supply orders for Brumidi, 1856–1863, AOC/EXT.

12. The painting was donated by Zeake Johnson, former Sergeant-at-Arms of the House of Representatives, in memory of his wife Theodosia McK. Johnson. She purchased the painting from Mrs. Elaine Hale Blair of Washington, D.C., in 1959. Mrs. Blair's father had purchased this painting and an *Adoration of the Madonna and Child* from Brumidi, who had brought them with him from Italy, according to memos to the file written in 1959 and 1960, AOC/CO.

13. Alberta Campitelli and Barbara Steindl, "Costantino Brumidi da Roma a Washington. Vicende e opere di un artista romano," *Ricerche di Storia dell'arte: Pittori fra Rivoluzione e Restaurazione*, n. 46 (1992), pp. 49–59, and Maria Sofia Lilli, *Aspetti dell'arte neoclassica: Sculture nelle Chiese romane 1780–1846* (Rome: Istituto Nazionale di Studi Romani, 1991).

14. Campitelli and Steindl, "Constantino Brumidi," pp. 50–54.

PRESENT STATE OF THE CAPITOL AT WASHINGTON.—SEE PAGE 18.

CHAPTER 4
The Capitol Extensions and New Dome

WILLIAM C. ALLEN

*I*n the 1850s, the enlargement of the United States Capitol employed scores of artists in addition to thousands of construction workers. Of all the artists to work on the Capitol extensions, Constantino Brumidi was the most famous and controversial. The new large, vaulted wings built at the ends of the old Capitol provided ample surfaces for fresco painting and other forms of elaborate decoration. The new cast-iron dome, authorized in 1855, provided Brumidi with additional opportunities to display his art. Indeed, his presence may have influenced a significant revision to its interior design.

When Brumidi arrived at the Capitol at the end of 1854, he found a building not yet thirty years old flanked by construction sites where hundreds of men worked on scaffolds that partially obscured the rising walls (fig. 4–1). The grounds were dotted with sheds where stone was cut and carved, fenced yards where mountains of marble and millions of bricks were stored, stables where the work horses were kept, and shops where belching steam en-

Fig. 4–2. Franciso Pausas, *Thomas Ustick Walter,* 1925. *Based on a period photograph, this portrait shows Walter at the beginning of his fourteen-year term as Architect of the Capitol Extension.* Architect of the Capitol.

gines helped turn blocks of stone into column shafts. Construction on the additions to the Capitol, already under way for three and a half years, had been administered by two different cabinet departments and had always been the center of controversy. From the beginning of the project in 1850, bickering among rival architects and engineers, libels traced to disappointed contractors, scrutiny by the partisan press, and political grandstanding shrouded the project in a pervasive cloud of acrimony. After he started work, it would not take Brumidi long to be caught up in the quarrelsome atmosphere that seemed to prevail on Capitol Hill.

Expanding the Capitol was meant to solve two problems: space shortages and bad acoustics. The old Capitol, finished in 1826, was designed when there were only fifteen states in the Union. After the 1850 admission of California as the thirty-first state, the Capitol was very nearly out of space. The growth of the legislature, with its committees and its large library, strained the building's facilities and made an addition inevitable. Even more serious than cramped quarters was the dreadful acoustics in the Hall of the House of Representatives. In that otherwise impressive room, the voice of a member speaking from the floor reflected off the smooth, curving ceiling to become inaudible to some and a reverberating babble to others. One member remarked that it was impossible to be a gen-

Fig. 4–1. *Present State of the Capitol at Washington,* 1853 (detail). *The building completed by Charles Bulfinch was shown in* the Illustrated News *with the new extension under construction, shortly after Constantino Brumidi arrived in the United States.* U.S. House of Representatives, Conable Collection.

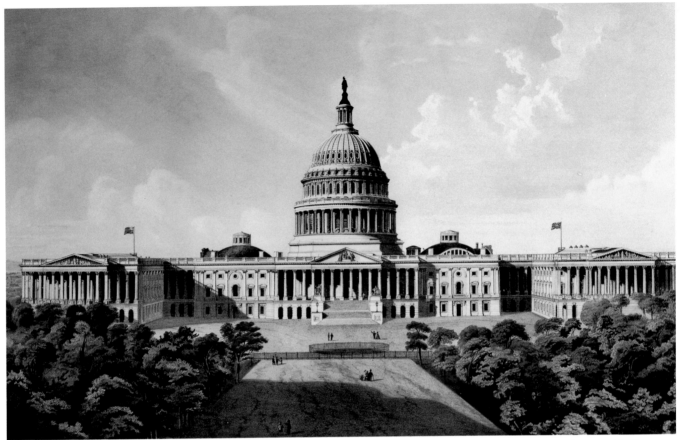

Fig. 4–3. Charles Hart, *U.S. Capitol Washington. D.C.,* c. 1866. *Although differing in detail and materials, the two wings that were added to the Capitol were designed to harmonize with the existing structure. The great cast-iron dome, completed in 1866, unified the composition.* U.S. House of Representatives, Conable Collection.

tleman in that confusing, "unmannerly Hall."[1] Some thought that millions of dollars could be saved each year if only members could understand debates and know what they were voting for. A number of proposed solutions were tried, but nothing worked. The only remaining possibility was to build an entirely new hall, one designed with attention to the principles of acoustics.

The project to enlarge the Capitol was initiated on September 30, 1850, when Congress appropriated $100,000 to start construction and directed President Millard Fillmore to select the manner by which the building would be enlarged and to appoint an architect to design and build the addition. More than a dozen architects submitted designs; in June 1851 the president appointed the Philadelphia architect who had gained a national reputation for his Greek Revival-style Girard College for Orphans, Thomas U. Walter (fig. 4–2).

Walter's design featured wings attached to the old Capitol by narrow corridors. Each three-story wing was 142 feet wide and 240 feet long; the corridors were 45 feet in length (fig. 4–3). The wings were built of brick on gneiss and granite foundations and were faced with a beautiful white marble quarried in western Massachusetts. One hundred Corinthian columns, with fluted, monolithic shafts, were used for the ten exterior porticoes and colonnades. Windows were framed by elaborate fron-

tispieces with carved consoles supporting pediments. A full entablature and balustrade partially masked the low-pitched roofs, which were carried on iron trusses. A large new legislative chamber was located in each wing, and over one hundred additional rooms were provided for committees and offices.

The basic style of the Capitol—a neoclassical design in the Roman Corinthian order, with columns, pilasters, and entablature—was established in Dr. William Thornton's original 1793 design. Walter was obliged to follow much of Thornton's composition, varying only such small things as the profile of the balusters and window details. By the 1850s, Roman architecture had long passed out of favor, superseded by a modern rage for ancient Greece. Both were distinct phases of neoclassicism, a late eighteenth-century revival of artistic order that characterized the art and architecture of Hellenic Greece and Imperial Rome.

On July 4, 1851, President Fillmore laid the cornerstone of the Capitol extension in a ceremony highlighted by Secretary of State Daniel Webster's two-hour oration.

Work on the extensions stopped in December 1851 due to the cold weather and resumed in mid-April 1852, the day after another appropriation passed Congress. To resolve problems with slow delivery of granite, and the attendant need to dismiss idle stonecutters (who retaliated with an angry petition to the Secretary of Interior), the government contracted with the firm of Provost and Winter for all future stonecutting and carving (fig. 4–4). This seemingly simple arrangement was to have a surprising consequence, however: an alliance of disappointed stone contractors and workmen, including Commissioner of Public Buildings William Easby, decided to get even by accusing Walter of accepting bad stone and bad workmanship, paying inflated prices, receiving favors from contractors, selling public property for private gain, and so on. Although at first only a minor annoyance to Walter, these charges set off a chain of events that eventually put the architect under the authority of an ambitious military engineer who became Brumidi's principal government patron.

A congressional committee was formed under Senator Sam Houston of Texas in August 1852 to investigate "abuse, bribery or fraud . . . in obtaining or granting [government] contracts."[3] The committee heard testimony from three dozen witnesses; the most damaging led to the forced resignation of the general superintendent, Samuel Strong, who was said to extort money from workmen and to have a pecuniary interest in brick contracts. Walter rebutted the charges against him in a 123-page handwritten defense. While admitting that a few "dishonest, unprincipled, and indolent men" had committed fraud, he also expressed his hope that they would be prosecuted fully. He was confident that the frauds were limited and were "inconsiderable" compared to the size and cost of the project. Point by point, supported by his balanced accounts and meticulously kept records, Walter exposed Easby's accusations as rumor, hearsay, and lies.

Houston's committee ordered its 216-page report printed on March 22, 1853, two and a half weeks after the close of the Fillmore administration. It laid out the charges, testimony, and rebuttal but presented neither recommendations nor conclusions. The new administration of

Fig. 4–4. Capitol extension under construction. *Carved marble awaiting installation is shown in the foreground of this view of the south wing.* Montgomery C. Meigs Photo Album. Architect of the Capitol.

In a few weeks Walter moved his family from Philadelphia to Washington, appointed a New York builder, Samuel Strong, as general superintendent, and placed advertisements for building materials in newspapers from Boston to Richmond. Soon he had contracts for stone, river sand, cement, and lime and began to build the foundations to a depth of 40 feet on the west and 15 feet on the east, uniformly 8 feet 9 inches thick. Walter and a "commission of scientific gentlemen"[2] tested a dozen types of American marble for strength, durability, and resistance to moisture; the contract—the most important and lucrative for the project—was awarded to John Rice and James Baird of Philadelphia for marble from their quarry near Lee, Massachusetts.

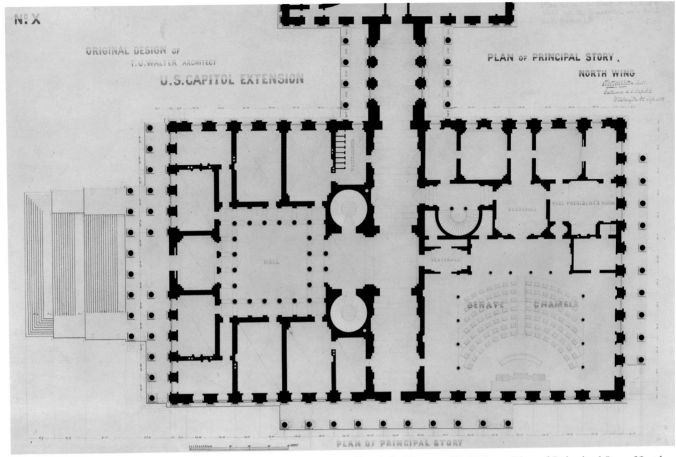

Fig. 4–5. Thomas U. Walter, *Plan of Principal Story North Wing, 1851. This plan placed the Senate Chamber in the north-west corner of the wing.* Architect of the Capitol.

Franklin Pierce included a new Secretary of War, Jefferson Davis, who had been the driving force in the Senate Committee on Public Buildings behind the effort to enlarge the Capitol. Davis wanted to control the work, and the unflattering publicity that Walter had suffered during the recent investigation made it easy to convince the president that the Capitol extension project would be better handled by the Army Corps of Engineers. The corps was, after all, the government's construction contractor—although admittedly more accustomed to forts than capitols. The transfer was ordered on March 23, 1853. For Walter the change was a bittersweet pill to swallow. He was not dismissed, but neither did he receive a vote of confidence. However, with an army engineer detailed to the works, he would be freed from thousands of annoying administrative details. He could now concentrate on working out architectural details, a labor more suited to his taste and temperament.

To take control of the Capitol project, Davis appointed Montgomery C. Meigs, a thirty-six-year-old captain of engineers trained at West Point. Meigs was fully empowered to suggest changes to the design; in Walter's office, he enthusiastically examined the elevations and floor plans and

soon ordered alterations. On the exterior, he decided only that the two eastern porticoes should have pediments to accommodate sculptural groups. He directed radical alterations to the floor plans, however. The original plan placed the legislative chambers in the western half of each wing, affording legislators fresh air and the garden view of the Mall away from the dust and noise of the east plaza. But Meigs saw one problem: members and senators going to and from their chambers were obliged to pass through large public corridors that would undoubtedly be clogged with annoying petitioners, lobbyists, and visitors. Meigs suggested relocating the chambers to the middle of each wing and surrounding them with corridors and lobbies, some of which could be made strictly private (figs. 4–5 and 4–6). Without windows, the chambers would be lit by skylights and ventilated by steam-powered fans. Doors could be placed on all four sides of the chambers, greatly improving access and circulation. From all accounts Walter liked Meigs's idea, cheerfully worked out the new plans, and redesigned the foundations to accommodate them. By July 5, 1853, President Pierce had approved the revised plans and elevations.

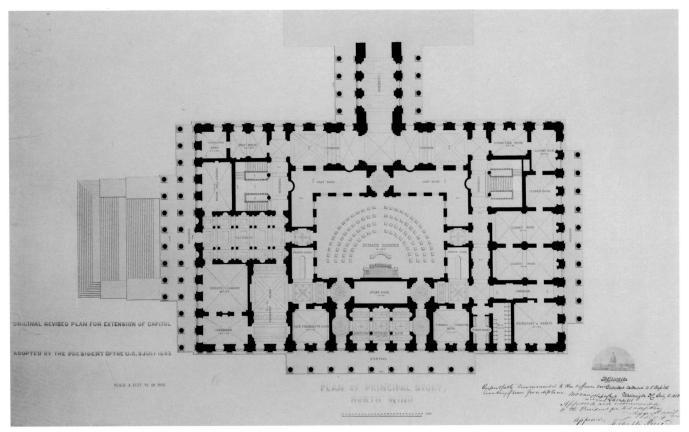

ORIGINAL REVISED PLAN FOR EXTENSION OF CAPITOL

ADOPTED BY THE PRESIDENT OF THE U.S. 5 JULY 1853

SCALE 5 FEET TO AN INCH

PLAN OF PRINCIPAL STORY,
NORTH WING

Fig. 4–6. Thomas U. Walter, *Original Revised Plan for Extension of Capitol,* 1853. *Meigs directed that the Senate Chamber be moved to the center of the wing; he made similar revisions regarding the House Chamber in the south wing. Secretary of War Jefferson Davis and President Franklin Pierce approved the changes.* Architect of the Capitol.

At the beginning of their association Meigs and Walter worked well together, each seemingly satisfied with his role in the enormous undertaking. Walter was happy to be free of administrative burdens and devoted his time to architectural studies for the Capitol extension and to other assignments thrust upon him by the government. For his part, Meigs thrived on the importance of his position, derived genuine satisfaction from knowing that his payrolls provided the livelihood for so many men and their families, and relished his scientific studies in acoustics, heating, and ventilation. He could not count on his paltry salary as an army captain to bring him fortune, but he counted on his command at the Capitol to bring him fame. Happily, Meigs preferred fame over fortune anyway. One of his favorite ways of helping history to remember his name was having it carved or cast in a variety of ways in many different locations. At the Washington Aqueduct, which Meigs began a year before taking over the Capitol project, his name was cast into all the pipes that brought water to Washington from the upper Potomac. An iron staircase he designed used the giant letters MCMEIGS as the riser for each step. At the

Capitol, Meigs's name was cast into all the iron beams that formed the roof trusses. Copper plates bearing his name were routinely embedded in the mortar between marble blocks in the walls. Walter considered his colleague's appetite for fame a great weakness, and once wondered why Captain Meigs forgot to "order old Vulcan to stamp his name on the thunderbolts."[4]

One aspect of his work at the Capitol was particularly gratifying to Captain Meigs: it was his chance to become America's foremost patron of the arts. With its views of economy, the Fillmore administration had expected the interiors of the Capitol extensions to be finished in a plain manner. Except for the chambers and public lobbies, brick floors and whitewashed walls would suffice. Ornamentation was expected to be spare. But the Pierce administration thought that opulent decorations were more fitting for the greatest building of the age. Grand interiors unlike anything seen on this side of the Atlantic were a challenge that perfectly suited Meigs's ambition. With Jefferson Davis's encouragement and backing, Meigs intended the extensions to be finished in the most elaborate fashion possible. Like a latter-day Medici, he doled out

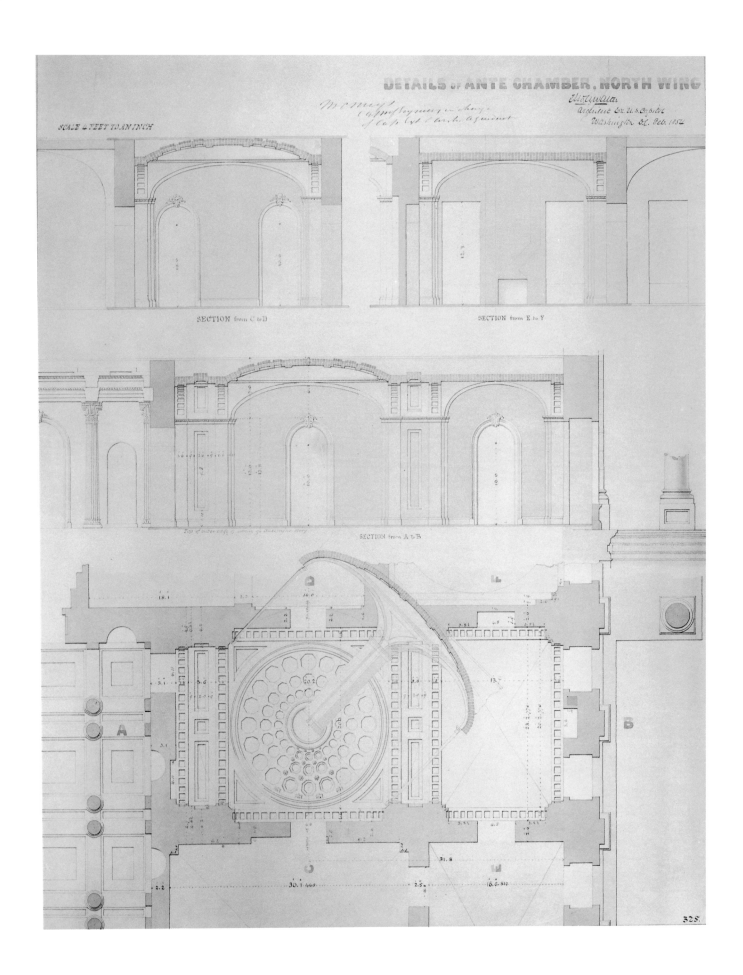

SCALE 4 FEET TO AN INCH

SECTION from C to D

SECTION from E to Y

SECTION from A to B

40

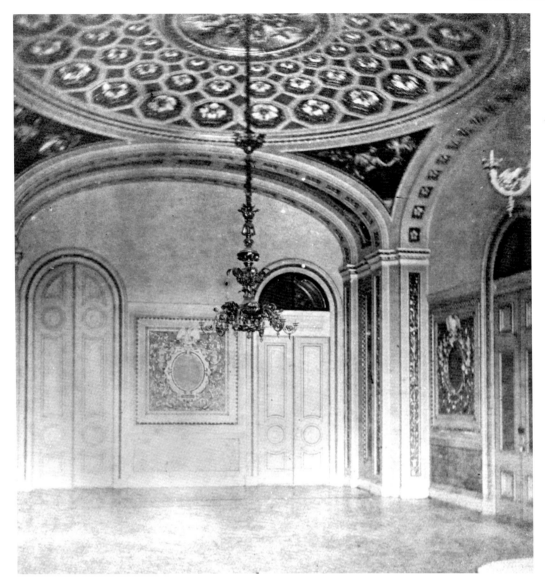

Fig. 4–8. Stereoscope of Senate Reception Room, c. 1860. *The room is shown here shortly after its construction. Only a few of Brumidi's frescoes have been finished, but the plaster ornamentation by Ernest Thomas and the imitation-marble wainscot have been completed.*

Photo: American Stereoscopic Company, New York.

vast sums for paintings and sculpture that would, he hoped, enrich the nation's Capitol to compare favorably with the great buildings of Europe. If they were to have large entrances, why not commission bronze doors to rival Lorenzo Ghiberti's famous Baptistery doors in Florence? If the walls needed painting, why not employ artists to do the job in a high style? Most public buildings in America, he said, "starve in simple whitewash."[5] Artists flocked to the Capitol, hoping to profit from Meigs's ambition and largess.

Fig. 4–7. Thomas U. Walter, *Details of Ante Chamber, North Wing,* **1854.** *Known today as the Senate Reception Room, the "Ante Chamber" was constructed with a remarkable variety of interdependent vaults and arches. Paneled and coffered elliptical arches framed a low dome on pendentives that adjoined a groin vault.* Architect of the Capitol.

Constantino Brumidi's appearance at the end of 1854, when the extensions were far enough along for decorations, was a case of perfect timing. The interior architecture presented a variety of spaces built in various ways, offering abundant opportunities for enrichment. The legislative chambers would be the most grand, with glass and iron ceilings, niches for sculpture, and large panels for paintings, in addition to sumptuous architectural detail. Lobbies, corridors, and committee rooms were built with brick vaults, the most durable and fireproof means of construction. Vaults could be groin or barrel, and low coffered domes carried on pendentives were also built for the sake of variety (fig. 4–7). Piers that helped support the vaults were treated like columns, with elaborate cast plaster capitals with egg-and-dart and other decorations (fig. 4–8). Window and door trim was cast iron, with a profusion of classical and rococo ornament. Colorful and long-wearing encaustic Minton tile from England was used as flooring except in the carpeted cham-

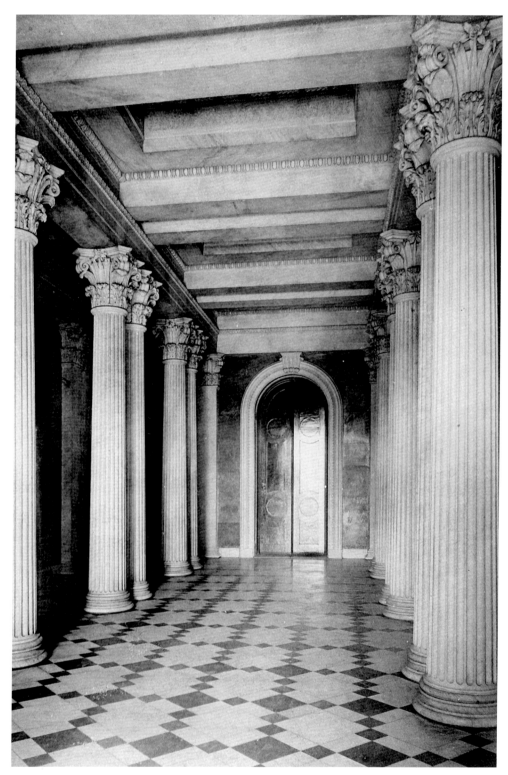

Fig. 4–9. Senate Corridor, Principal Story, c. 1902. *For the main passage into the Senate Chamber, Walter designed a heroic double colonnade of paired Corinthian columns supporting a richly carved marble ceiling with stained-glass panels. Walter incorporated tobacco, corn, and magnolia leaves in the capitals.*

From Glenn Brown, *History of the United States Capitol,* 1902.

bers and in the marble-floored entrance lobbies on the principal floor (fig. 4–9). These lobbies were further elaborated by Corinthian columns that Walter designed incorporating native American plants: corn, magnolia, and tobacco. In each wing two public staircases were designed with screens of marble columns with cast bronze Corinthian capitals. For the sake of variety, one of these grand staircases in the north extension was made wholly of white marble imported from Italy (fig. 4–10). These staircases provided skylit landings that were reserved for heroic history paintings twenty feet high and thirty feet long. Four private staircases were designed with sculptured bronze railings. Even the gas chandeliers made in Philadelphia were beautiful and useful sculptural decorations (figs. 4–11 and 4–12). Grandeur, variety, and permanence were Meigs's goals for the Capitol's interiors

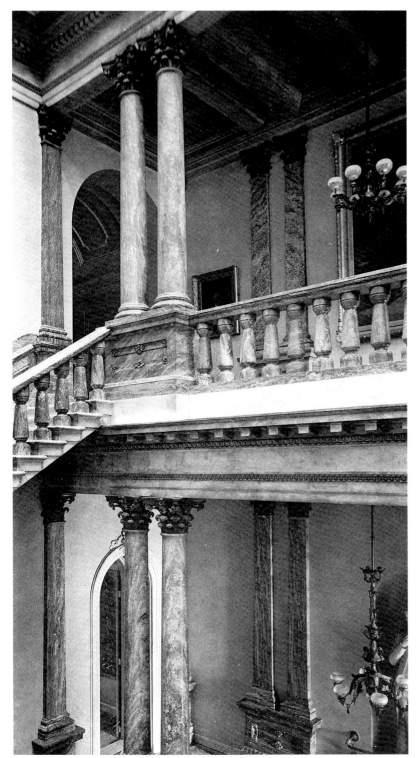

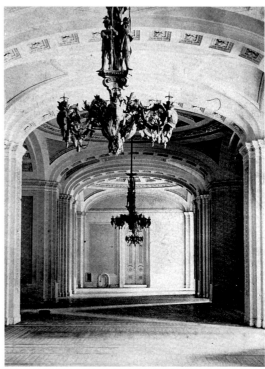

Fig. 4–11. South corridor, principal floor, Senate wing, c. 1860. *These spacious corridors illustrate the complexity, variety, and beauty of vaulted construction.* Denys Peter Meyers Collection.

Fig. 4–10. East grand stair, House wing, c. 1902. *Each wing was provided with two monumental public stairs designed with Corinthian columns and pilasters with bronze capitals, massive handrails and balusters, steps carved from individual blocks of marble, and niches for sculpture.*
From Glenn Brown, *History of the United States Capitol*, 1902.

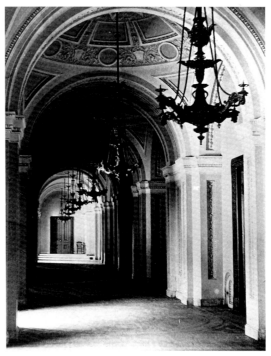

Fig. 4–12. North corridor, principal floor, House wing, c. 1860. *The bronze gas-burning chandeliers were made in Philadelphia by the firm of Cornelius and Baker.* Denys Peter Meyers Collection.

43

Fig. 4–13. Thomas U. Walter, *Section Thro' Corridor. South Wing* with *Plan of Ceiling*, 1855. *Running the full width of the House wing on the first floor is the so-called Hall of Columns. Twenty-eight columns made of Lee, Massachusetts, marble were designed by Walter with thistle and tobacco along with the conventional acanthus in an American variation of the Corinthian order.* Architect of the Capitol.

(figs. 4–13 and 4–14). Walter shared these goals but would later disagree with some of the methods employed to achieve them.

In his unprecedented fine-arts patronage Meigs sought only Jefferson Davis's approval. He never felt obligated to confer with Walter, who, he thought, had credit enough as architect. Meigs was determined to leave his mark on the design of the Capitol and considered the decorations a perfect way to do so. The conflict that ensued with Walter was both unavoidable and bitter. It simmered just below the surface until Jefferson Davis left office when President James Buchanan's administration began in March 1857. Davis returned to the Senate and John B. Floyd of Virginia took over the War Department. With the change of administration, Walter tried to reassert his rights as architect to control all aspects of design, including decora-

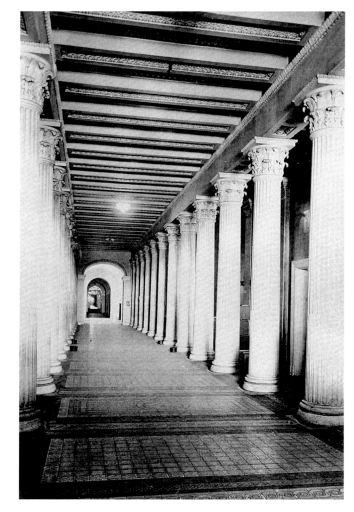

Fig. 4–14. Hall of Columns, c. 1902. *Walter made extensive use of cast iron in the Capitol extensions. The ceiling of the Hall of Columns was made of nearly a quarter of a million pounds of iron cast in Baltimore by Hayward, Bartlett & Co.*
From Glenn Brown, *History of the United States Capitol,* 1902.

tions. As Meigs and Walter battled over responsibilities, prerogatives, and authority, many of those working on the extensions were caught in the middle. But most remained loyal to Meigs, who held the purse strings. Brumidi often aroused Walter's ire, but it was Meigs's high-handedness that was the real root of the problem.

One early example of the conflict between art and architecture was the case of the frescoes Brumidi designed in 1856 for the Ladies Waiting Room (part of the third floor Senate Press Gallery (S–313A). Walter designed the domed ceiling with coffers enriched with architectural decorations. When he discovered the coffers altered to provide space for paintings he bitterly confided to his diary:

> Found that Brumidi has had all the octagonal lacunaes pealed [sic] off the arch over the ladies retiring room, north wing, weakening the arch and rendering it dangerous; for the purpose of putting fresco pictures in it instead of architectural decorating. . . . such things ought at least to be the subject of consultation with the archt.[6]

Walter's opinion of Brumidi's work reflected his own lack of influence on the designs and color palette. He liked the idea of decorated walls, and wrote privately: "My desire is, if we have pictures here at all, to have them in real fresco that they may form part of the wall."[7] He praised (again privately) Brumidi's decoration of the House Committee on Agriculture room, calling it "our best room."[8] By contrast, his public remarks on Brumidi's work fell just short of wholesale condemnation. In late 1857 he wrote officially to the Secretary of War to recommend

> that the very ornate and inappropriate decorations of the walls and ceilings of the committee rooms be dispensed with,—these rooms being intended for the transaction of the business of the committee can be seen by a very few, unless they should be kept open for exhibition, which of course, cannot be contemplated, as it would interfere with an important branch of legislation.
>
> . . . Some of these rooms are so extravagantly decorated with crude and disharmonious colors that it is painful to remain in them, and when they are overshadowed by the projecting arcades of the porticoes yet to be built, they will be dark and gloomy.
>
> . . . I object to the dark, and heavy, and excessively ornate painting that has been commenced in the entries and passages of the north wing, and I respectfully recommend that it be stopped immediately, and that all the passages and entries be finished, in light and harmonious tints with a very sparing application

of foliated ornament and gold leaf, and the introduction of a few frescoes where the lights are favorable.[9]

Meigs availed himself of Brumidi's skill in areas other than fresco painting. He put the artist in charge of decorating the vast ceiling of the new Hall of the House. Measuring 139 feet long and 93 feet wide, it was made of cast iron supported from above by iron trusses. It was divided into 117 panels, nearly a third of which contained colored glass that gave "the effect of Mosaics set in silver."[10] Papier-mâché moldings and ornaments, selected for richness and light weight, were fastened to the ironwork. After Brumidi had finished painting a section of the ceiling, its complex and opulent style surprised and delighted Meigs:

> He has used much more gilding than I intended, and the effect is most magnificent. I am not quite sure that it is not too gorgeous, but I begin to think that nothing so rich in effect has ever been seen this side of the Atlantic. He has used, as I directed, strong, positive colors—blue and red and yellow—but has bronzed and gilded the molding to the highest degree.[11]

Not everyone agreed with Meigs's assessment of the new Hall of the House. In the Senate, Jacob Collamer of Vermont took exception to the color scheme and expressed his hope that the new, unfinished Senate Chamber would be spared a similar treatment.[12] Rising to defend the polychromatic color scheme of the Hall, Senator Jefferson Davis claimed no special expertise in the matter but expressed his faith in Brumidi's skill and talent, asserting that

> . . . there is not an artist who would attempt to ornament a building by painting with one color. His skill is shown in the harmony of the colors, blending them so that no one rests on the eye and commands its single attention. I would be surprised at the American Congress if it were to wipe out these great efforts of art and introduce as a substitute the crude notion of single color.[13]

Walter despised the color scheme of the House Chamber but could hardly blame Brumidi, whom he considered a tool of Meigs's ambition. In referring to the newly occupied hall, Walter wrote:

> The Capt. has taken upon himself to have all the painting and gilding done under his special direction, without any consultation with me and I must say that it is the most vulgar room I was ever in, I hope Congress will order it repainted and allow your old friend to have some say as to how it shall be done—it is susceptible of being made as handsome and dignified a looking room as any in the world. Now it

is the very worst I ever saw—and so says everybody.[14]

In another piece of correspondence, Walter took a more philosophical stance on the House Chamber and other decorating projects: "The only thing in which my taste has been disturbed is the gaudy coloring and gilding and daubing of my works but I console myself that all this may be cured by the paint brush."[15]

Meigs's handling of the decorations eventually stirred a backlash in Congress and prompted a petition signed by 127 American artists that called for the creation of an art commission (see chapter 7). By the time the commission issued its report, however, Meigs had been relieved of his command at the Capitol. His friend and patron, Senator Jefferson Davis, had not been able to stem the tide against him in Congress and the War Department. On November 1, 1859, Captain William B. Franklin of the Corps of Topographical Engineers was given charge of the Capitol extensions. Walter was delighted with the change in command.

With Meigs's departure, Walter's relationship with Brumidi warmed considerably. Walter commissioned Brumidi to paint and decorate his own house in the Germantown section of Philadelphia. On February 2, 1863, Walter sent Brumidi original drawings showing the rooms of the house to enable him to determine the "character of ornamentation."[16] He offered no words of advice, no direction, or anything else for Brumidi to interpret: "I leave the whole matter to you; your taste is never at fault."[17] Later that year Brumidi sent a copy of his painting *The Five Senses* as a present for Walter's wife, Amanda. In a letter to her, Walter gave detailed instructions on how the painting should be unpacked and where it should hang. He called it "the best picture I ever saw"[18] and urged his wife to gather the children around the package while it was being opened so that they might enjoy "the full effect."[19]

Perhaps the highest compliment Walter paid Brumidi was when he altered his design for the Capitol's new cast-iron dome to include a massive painting as the climax of its interior decoration. Authorized in 1855, the new

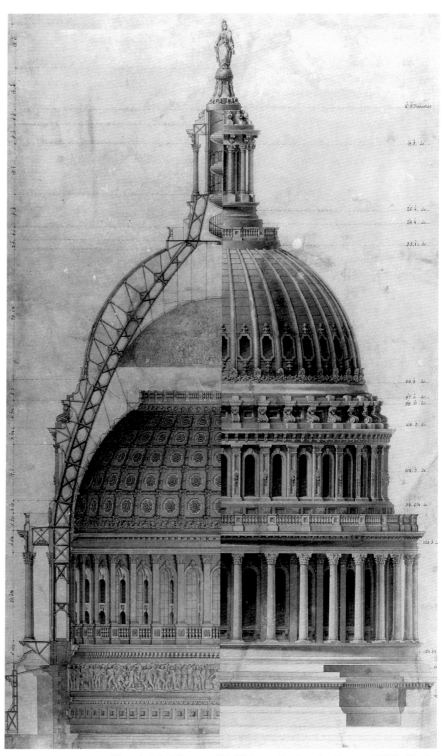

Fig. 4–15. Thomas U. Walter, *Design for Dome of U.S. Capitol*, 1859. *This combined elevation and section of the double dome illustrates the position of the canopy over the eye of the inner dome and of the frieze at its base.* Athenaeum of Philadelphia.

Photo: Athenaeum of Philadelphia.

dome was added on top of the old sandstone walls of the Rotunda constructed in the 1820s. Walter's first design for the new dome called for a vast enlargement of the Ro-

tunda from its original height of 96 feet to 200 feet, but did not include any painted decorations.

In 1859, during the height of Walter's conflict with Captain Meigs, a period in which the architect never spoke to or transmitted drawings to the engineer, the design of the dome underwent a significant revision to its exterior proportions. While he worked out these changes Walter took the opportunity to revise the interior design as well. The revised interior scheme introduced a separate inner dome with an oculus through which a monumental painting would be seen (fig. 4–15). (The scheme was derived from the Panthéon in Paris, which Walter had studied during his European tour in 1838.) Covering 4,664 square feet, the painting would be carried on a canopy suspended over the oculus, with sufficient space between to allow natural light, reflected by huge mirrors, to illuminate it. There was never a question that Walter had Brumidi in mind when he included a grand painting in the revised design. It is also likely that Brumidi's fitness for the task prompted the revisions. The subject of the painting was an apotheosis of George Washington, and, according to Walter, there would be "no picture in the world that will at all compare with this in magnitude, and in difficulty of execution."[20] It offered Brumidi the unprecedented opportunity to give the Capitol and the American people a magnificent finale to the magnificent new dome. With this commission, even Meigs would have agreed that Walter, ironically, became Brumidi's most important patron.

In the spring of 1865, while Brumidi was working on the canopy painting, events led Walter to resign as architect of the Capitol extensions and new dome. Walter's office had been returned to the Department of Interior in 1862, and since that time he had been free to administer the works unencumbered by military rule. On May 23, 1865, however, his office was suddenly placed under the authority of the Commissioner of Public Buildings. This was the last straw: he quit three days later. Walter was sure the administration would find him irreplaceable and would restore the status quo. But on August 30, 1865, his former pupil and assistant, Edward Clark, was appointed by President Andrew Johnson to fill Walter's place at the Capitol. Clark, who held the office until his death in 1902, completed the few remaining parts of the Capitol extension and became an important figure in Brumidi's later career.

In his retirement, Walter was asked by the editor of *The American Architect* to write a biographical sketch of Brumidi and his works. Unfortunately, the architect's leisurely life was shattered by the Panic of 1873, and he was obliged to take on jobs that kept him busy day and night. To prepare his article he wanted to go to Washington to interview the artist but did not make the journey before Brumidi died in 1880. He sent the magazine Brumidi's obituary from the *Philadelphia Evening Telegraph*, saying that he could not undertake a biography: "I really have not time to devote to the subject as it would require a good deal of thought and some correspondence with Washington to do justice to the subject."[21] Tired and penniless, Walter died in 1887 without writing his eulogy to Brumidi. However, the Capitol extensions and the great dome still stand in testimony to the skill, hard work, and taste of their designers, builders, and decorators—chief among them, Walter, Meigs, and Brumidi.

Notes to Chapter 4

1. *Congressional Globe*, July 24, 1850.

2. Senate Executive Document no. 52, 32d Cong., 1st sess. March 29, 1852, p. 2.

3. Senate Rep. Com. No. 1, Special Sess. 33d Cong.: Senate Documents Special Session, 1853. This is the Houston Committee Report on which this discussion has been based. Six years after Senator Houston issued the report he asked Thomas U. Walter to design a retirement house for his family in Texas. Walter drew plans and elevations, but the house was never built.

4. TUW to Amanda Walter, May 22, 1858 TUW/PA (AAA, reel 4138).

5. *National Intelligencer* (Washington), December 7, 1857.

6. TUW Diary, May 4, 1857, TUW/PA (AAA, reel 4133).

7. TUW to G. W. Lawson, December, 1857, TUW/PA (AAA, Reel 4138).

8. TUW to John Boulton, February 5, 1863, TUW/PA (AAA, Reel 4141).

9. TUW to John B. Floyd, December 21, 1857, TUW/PA (AAA, Reel 4138).

10. Edwin T. Freedley, *Philadelphia and Its Manufactures* (Philadelphia: Edward Young, 1858), p. 278.

11. MCMJ, November 13, 1856 (B–340).

12. *Documentary History of the Construction and Development of the United States Capitol Building and Grounds* (Washington: Government Printing Office, 1904), p. 677.

13. Ibid., p. 678.

14. TUW to Richard Stanton, December 8, 1857, TUW/PA (AAA, Reel 4138).

15. TUW to J. F. Bryant, December 14, 1857, TUW/PA (AAA, Reel 4138).

16. TUW to CB, February 2, 1863, TUW/PA (AAA, Reel 4141).

17. Ibid.

18. TUW to Olivia Walter, August 20, 1863, TUW/PA (AAA, Reel 4141).

19. TUW to Amanda Walter, August 29, 1863, TUW/PA (AAA, Reel 4141).

20. TUW to CB, December 24, 1862, AOC/LB.

21. TUW to W. P. P. Longfellow, March 4, 1880, TUW/PA (AAA, reel 4143).

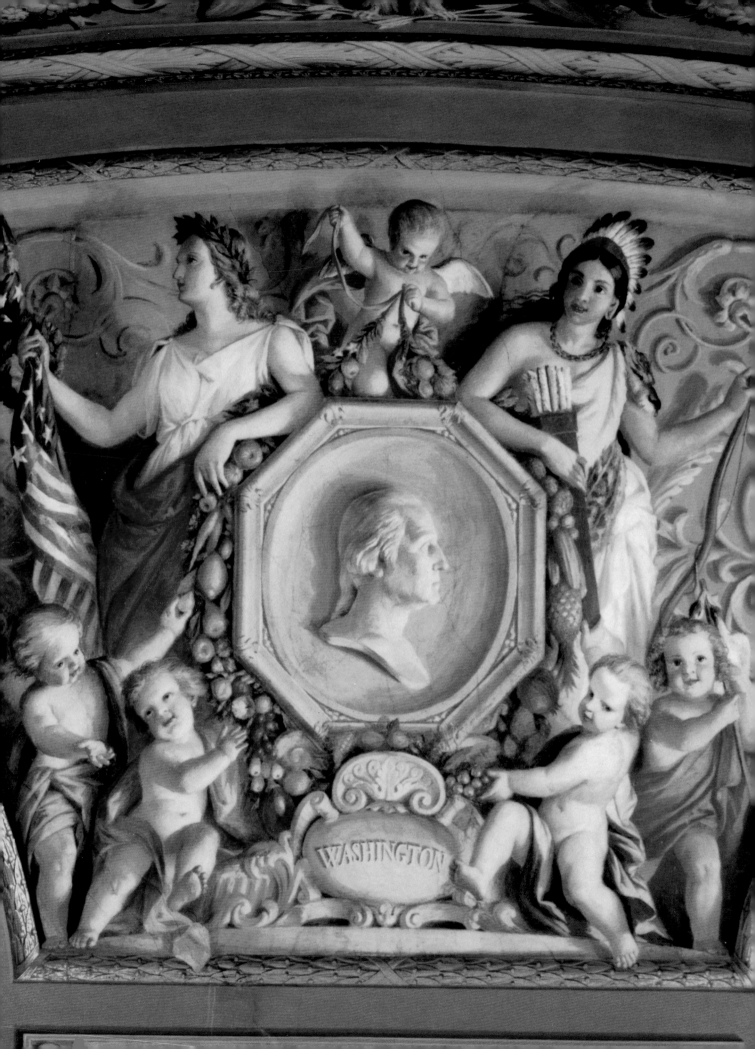

CHAPTER 5

Getting Established in the New World

Fig. 5–2. Inside cover of Brumidi's Bible. *The artist recorded the date of his arrival in the United States.* Architect of the Capitol.

Constantino Brumidi arrived in New York only a few months after his release from prison in Rome, ready to begin a new career in the United States. He later said he emigrated as much for artistic opportunities as because of his political exile, "desiring a broader field and more profitable market for his work."[1] He had promises of church commissions through American clergymen he knew in Rome, and he probably heard about the construction at the Capitol from expatriate American artists such as Thomas Crawford, who served with him in the civic guard. In the two years between his arrival in the New World in the fall of 1852 and his coming to Washington, D.C., in late 1854, he obtained commissions in New York, Massachusetts, and Mexico City. The turning point in his career was his introduction to Captain Montgomery C. Meigs, who superintended the construction of the United States Capitol extensions and gave him the

opportunity to paint the first frescoed room in the Capitol (fig. 5–1).

As recorded in the Bible given to him by the American Bible Society upon his arrival (fig. 5–2), Constantino Brumidi landed in New York on September 18, 1852, coincidentally the fifty-ninth anniversary of the laying of the cornerstone of the Capitol by George Washington. His commitment to his new country was clear, for, at the end of November, he filed a statement of intent to become a United States citizen.[2]

During the next two years, Brumidi earned his living chiefly by painting portraits and decorating private houses in the northeastern United States. He immediately made connections with prominent families. His earliest known American portrait, dated 1852, is of Boston merchant Emery Bemis.[3] The next year, he signed and dated a finely detailed portrait of Eveline Fessenden Freeman (fig. 5–3), daughter of the U.S. marshal for Massachusetts, who in 1860 would marry Thomas U. Walter's assistant Edward Clark. Brumidi's portraits are lifelike, well composed, and skillfully painted in a style that shows his neoclassical training and his skill at convincingly depicting varied textures of skin and fabric.

For the Bennitt family of New York he painted portraits and, in 1853, three allegorical images, *Progress, Freedom,*

Fig. 5–1. Fresco with profile relief portrait of George Washington in Brumidi's first room in the Capitol. *The Italian artist was hired as the artist of the Capitol after proving his ability to work in true fresco, to paint the illusion of three-dimensional forms, and to create American subjects and symbols.* H–144.

49

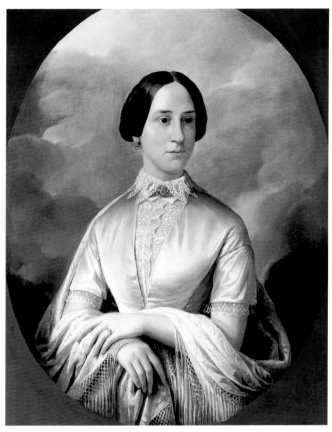

Fig. 5–3. *Eveline Fessenden Freeman. Miss Freeman, depicted by Brumidi in finely rendered lace and satin, later married Edward Clark, future Architect of the Capitol.* Architect of the Capitol.

Fig. 5–4. *Progress. Painted for a private home, Progress rides on a dolphin and wears a headdress with feathers and a star, suggestive of America. The cherubs hold symbols of commerce and liberty, while the steam ship* Baltic *and a locomotive appear in the distance, all motifs Brumidi later painted in the Capitol.* Architect of the Capitol, donated through the United States Capitol Historical Society by Howard and Sara Pratt.

and *Plenty,* for their house in South Hampton, Long Island; these are his earliest documented domestic murals (fig. 5–4).[4] Brumidi continued to paint for domestic settings throughout his career, although few examples are securely documented or intact.

In 1854, before coming to Washington, Brumidi traveled to Mexico City; he was there by May and left in December.[5] There he executed his first church commission in the New World, a Holy Trinity, a large altarpiece or mural, for the cathedral in Mexico City. This work was mentioned in numerous nineteenth-century articles about Brumidi, but its present location is unknown. The commission was an outgrowth of the strong ties between the art academies in Rome and Mexico City. The best Mexican artists went to study at the Accademia di San Luca in Rome, and some of Brumidi's former colleagues at the Villa Torlonia taught or exhibited at the Academia Nacional de San Carlos de México.[6] While in Mexico City, Brumidi sketched Aztec idols and the large calendar stone then displayed at the cathedral; he later incorporated these objects in the scene "Cortez and Montezuma at the Aztec Temple" for the frieze in the Capitol.[7]

Five paintings by Brumidi were exhibited at the Mexican academy in January 1855, among them a portrait and large canvases of the Assumption of the Virgin and the Immaculate Conception. In December 1856, he exhibited a nine-foot-high Holy Trinity, possibly the altarpiece itself, as well as a smaller version, probably an oil study for it.[8] These paintings must have been submitted for the exhibition by friends, for there is no evidence that Brumidi returned to Mexico after he left for the United States on December 12, 1854.[9]

The Holy Trinity for the cathedral in Mexico City was only the first of numerous major church commissions Brumidi undertook in the New World. He painted murals and altarpieces in Washington, Baltimore, Philadelphia, New York, and Havana after he began working at the Capitol. American clergymen whom Brumidi had met in Rome were instrumental in his being selected for work in new churches being built in the United States. One supporter was John Norris, who studied for the priesthood in Rome from 1848 to 1851, and with whom Brumidi, before his arrest, had hoped to travel to America. Brumidi painted Norris's portrait and those of Norris's mother, sister, and brother-in-law, Andrew J. Joyce, with whom Brumidi stayed when he first came to Washington.[10] Brumidi may also have been helped by his acquaintance with the first American archbishop, John Hughes of New York, who

Fig. 5–5. *St. Charles Borromeo Giving Holy Communion to St. Aloysius Gonzaga. Brumidi's altarpiece, inspired by a seventeenth-century painting of the subject, includes a self portrait, in the center distance, and the features of the designer of the church, Father Benedict Sestini, in the priest at the far right, while Mrs. Stephen Douglas is thought to be the model for St. Aloysius's mother.* St. Aloysius Church, Washington, D.C. Photo: Page Conservation, Inc.

was in Rome in 1851. Hughes collected art and preached at many of the churches where Brumidi painted.[11] Brumidi's closest and longest personal connection was with the Reverend Benedict Sestini, S.J., who came from Rome to Georgetown University. He became a lifelong friend of the artist and was instrumental in securing at least two of Brumidi's church commissions. He recommended Brumidi to the Church of St. Ignatius in Baltimore. He also designed the Church of St. Aloysius in Washington, D.C., for which Brumidi painted the altarpiece, in which he included Sestini's portrait (fig. 5–5). Father Sestini was the

priest called to Brumidi's deathbed.[12] It is clear that Brumidi's connections with the Roman Catholic Church were important throughout his life.

Brumidi's earliest known church commission in the United States was for St. Stephen's Church in New York. This commission was initiated before he left Italy, and he mentioned it when he was introduced to Montgomery Meigs at the Capitol in late 1854. Brumidi postponed work for the church to paint his trial piece at the Capitol, but by 1855, he had created the design for *Martyrdom of St. Stephen.* The immigrant artist had thus

Fig. 5–6. Montgomery C. Meigs, c. 1861. *In his role as supervising engineer, Meigs oversaw the art program carried out by Brumidi.* Lola Germon Brumidi Family Album, United States Senate Collection.

within a few years established himself as the artist of the most important ecclesiastical and political monuments then being constructed.

On December 28, 1854, only two weeks after leaving Mexico, Brumidi was in Washington, D.C., and had arranged an introduction to Captain Montgomery C. Meigs (1816–1892), the engineer in charge of decorating as well as constructing the Capitol extensions for the War Department (fig. 5–6). The intermediary, according to Meigs's journal, was an "old gentleman," sculptor Horatio Stone, who served with Meigs on the vestry of St. John's Episcopal Church in Lafayette Square. Stone was

about the same age as Brumidi, whom Meigs similarly described as "a lively old man." Stone had established himself as a sculptor in Washington and in 1856 would be commissioned to create a marble sculpture of John Hancock for the Capitol. (Ironically, he later formed the Washington Art Association, which attacked Brumidi's work in the Capitol.[13])

Brumidi's arrival in Washington enabled Meigs to realize his grand plans for decorating the extensions with murals in addition to sculpture. Meigs felt a strong sense of mission about his role in decorating the Capitol: "Although an engineer and 'nothing more' I have some feeling for art, some little acquaintance with its principals [*sic*] and its precepts and a very strong desire to use the opportunities & the influence which my position, as directing head of this great work, gives me for the advancement of art in this country."[14] Even before Brumidi's appearance, Meigs had already envisioned fresco painting like that of Raphael and Michelangelo on a grand scale for the interior of the Capitol. The engineer had great confidence in his own artistic judgment and taste, as is shown in comments in his journals. He had a deep and long-standing personal interest in art and had studied art at West Point with Seth Eastman and possibly with painters Charles Leslie and Robert Weir, who taught drawing there during his student years.[15] His own landscape drawings and watercolors are more than competent (fig. 5–7). He was always interested in increasing his knowledge about art. Meigs also consulted experts in the field of art, such as collector Gouverneur Kemble, who solicited advice for him from painter John Chapman, and he corresponded about the art program with the German-born painter Emanuel Leutze.[16] At every opportunity he visited galleries and artists' studios and studied art books. He was familiar with the murals of Pompeii through books. In 1854, he went to the Astor Library in New York to see a set of books of Raphael's works in the Vatican reproduced in color, and he was especially impressed with the loggias. Meigs commented: "I have never seen color engraving of these works before. They are very beautiful, rich and harmonious in color, simple and beautiful in design. I wish I could see the rooms themselves. This book will give us ideas in decorating our lobbies."[17] Thus, when Brumidi, who had worked in these very Vatican loggias, appeared in Washington, he must have seemed like the answer to Meigs's prayers.

Not surprisingly, Meigs determined that the content of the decoration for the Capitol should be American history, an idea he expressed in a letter to sculptor Thomas

Fig. 5–7. Montgomery C. Meigs, *From a Sketch, Washington City by Capt Eastman.* *This drawing shows Meigs's skill and documents his reconnection with his drawing instructor Seth Eastman.* Department of Political History, National Museum of American History, Smithsonian Institution, Washington, D.C.

Photo: Smithsonian Institution.

Crawford: "In our history of the struggle between the civilized man and the savage, between the cultivated and the wild nature are certainly to be found themes worthy of the artist and capable of appealing to the feeling of all classes."[18] Meigs was not convinced, however, that any American painters were capable of carrying out his vision, which was of more concern to him than the nationality of the artists. His biographer Russell Weigley commented:

> Meigs was trying in his own way to make the art of the Capitol a distinctively American art; but he conceived of the American quality of art as a characteristic of the work of art, not necessarily of the birthplace of the artist. The proposition that the art of the United States Capitol ought to be American art commanded widespread agreement from the American public, government, and press. What constituted an American art was not so clear. To Meigs, the main

test seemed to be that the subject matter be American, if not the spirit and manner.[19]

Unfortunately, Meigs's ideas about the iconographical program were undoubtedly conveyed to Brumidi in person and were not recorded, even in Meigs's personal journal. Meigs's recently transcribed private journal does, however, give us a vivid description of his first meeting with Brumidi on December 28, 1854, and the painting of Brumidi's first fresco (see Appendix A). The engineer failed to catch the Italian painter's name, but remembered him as "a lively old man with a very red nose, either from Mexican suns or French brandies." Their discussion was conducted in "bad French," the language they had in common.[20] Despite their difficulty in communicating, Brumidi made a positive first impression on Meigs.

Meigs was impressed with Brumidi's credentials, which included his training at the academy in Rome and his experience in fresco in the splendid house of the banker Torlonia, and with his confidence in his skill. Brumidi told him of pending religious and secular commissions, one for a church, undoubtedly St. Stephen's in New York, and another for a hotel. When told he would need to start a sample piece soon, so that the members of Con-

gress could see it, Brumidi "laughed and said that the church would be there always, Congress would pass, and he would paint this first."[21] Meigs immediately thought of a lunette in his temporary office in the new House extension as a good location for a trial piece. Meigs later summarized this meeting:

> . . . in a fortunate moment an Italian artist applied to me for employment as a painter of fresco. He asked the use of a wall on which he might paint an example of his skill, saying that he could not carry fresco paintings with him, had executed none in the U. States to which he could refer me, but if I gave him the opportunity he would paint one at his own expense. I hesitated but at length told him that the room in which I then sat, which had only a rough coat of brown plaster, might be assigned to the Committee on Agriculture, and he might paint in the lunette of the wall a subject relating to agriculture, provided the sketch he should submit seemed to me worthy. [22]

Although tempered with caution in this account, Meigs's optimism about this recent immigrant's ability to carry out a grand decorative plan would prove to be fully justified.

Meigs chose the theme of Cincinnatus called from the plow to be dictator of Rome, "a favorite subject with all educated Americans, who associate with that name the Father of our Country," for what Brumidi called "the first specimen of real fresco introduced in America."[23] The subject was appropriate because of the planned use of the room by the House Committee on Agriculture and its connection with George Washington. Lucius Quinctius Cincinnatus was a Roman hero of the fifth century B.C., a farmer, soldier, and statesman. George Washington was often compared with Cincinnatus and was, in fact, the first president of the Society of the Cincinnati, which was formed by officers of the Continental Army. The choice of this subject must have delighted Brumidi, for he had already painted a lunette of the same subject in Rome.[24]

Before beginning the fresco, Brumidi prepared an oil sketch of the scene (fig 5–8). In his journal, Meigs commented positively on the sketch: "It is good and shows skill in drawing and composition and coloring, much greater than I expected."[25] Once the sketch was approved, Brumidi created a full-size cartoon, with which Meigs was less satisfied, feeling the artist had drawn the figures carelessly and out of proportion (perhaps not understanding the use of foreshortening): "I pointed out some defects, which he did not seem to be quite pleased at my doing. I told him that he would have many critics, as the American painters would all look with jealousy at him and at his works and that they would find all the fault they could."[26]

Meigs's journal entries describing the painting of the room (Appendix A) give us remarkable step-by-step details of Brumidi's working procedures and progress; we even learn that Meigs caught cold from the dampness created by the wet mortar.[27] The master mason, Alexander B. McFarlan, applied the mortar for Brumidi. Meigs recorded that the artist began to paint in fresco on January 24, 1855. Brumidi worked cautiously, completing only half of a figure in a day, and sometimes having to cut out and redo sections with which he was not satisfied. Meigs noted that Brumidi put the finishing

Fig. 5–8. Sketch for *Calling of Cincinnatus from the Plow*. *Brumidi prepared this oil sketch of his first fresco for the Capitol for Meigs's approval.* Estate of Edna W. Macomb.

Photo: Diplomatic Reception Rooms, U.S. Department of State.

Fig. 5–9. House Appropriations Committee room. *Brumidi proved his ability to design murals, his skill in executing fresco, and his artistic talent in the first room he painted in the Capitol. H–144.*

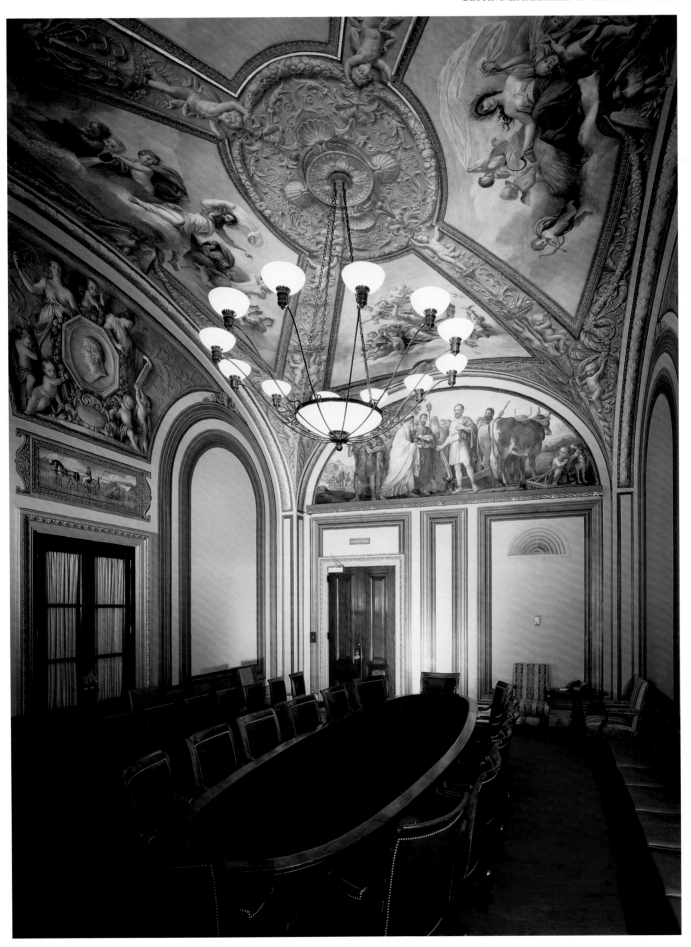

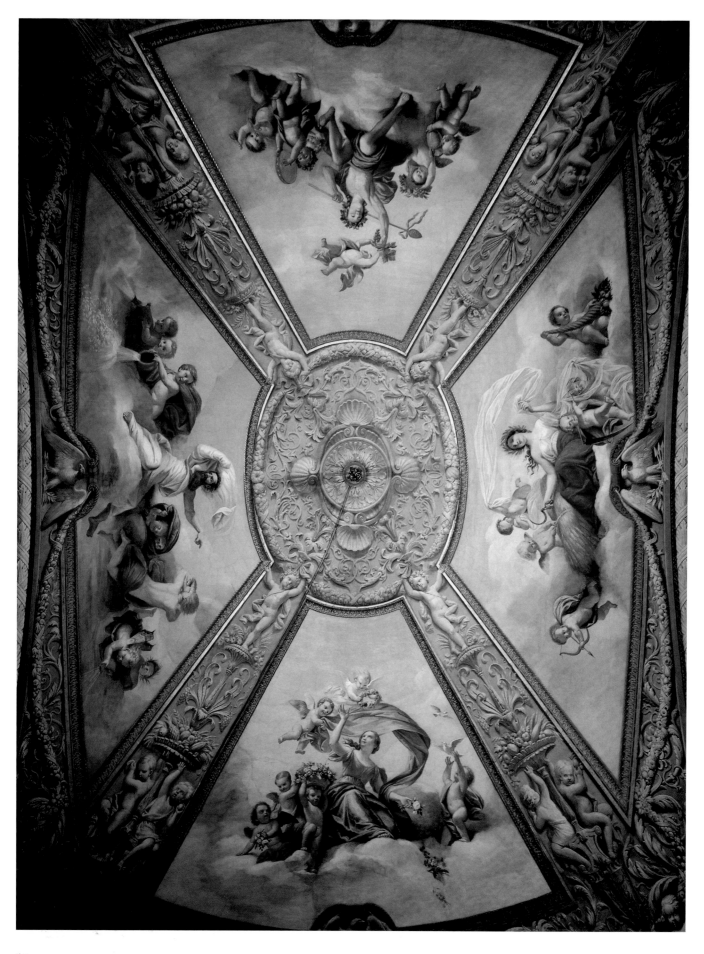

touches on the fresco on March 17, 1855, after four weeks of work, at which point he signed and dated the lunette at the lower right.[28] Meigs was pleased with reactions to the fresco: "The experiment was successful. No better picture yet adorns the walls of the Capitol, and I was relieved from much anxiety by finding that our Legislators visited and admired the picture and were much interested in its progress and in the process then first seen in this country of the noble art of fresco painting, and that even strict economists and men from the western wilderness expressed their satisfaction and encouraged me to go on."[29]

In addition to members of Congress, other government officials and art connoisseurs viewed the Italian artist's progress. Among the important people Meigs brought to see Brumidi's accomplishments were President Franklin Pierce, Secretary of War Jefferson Davis, Senator Stephen Douglas, financier and art collector William Corcoran, and painter Daniel Huntington. Congressman Richard Stanton, Chairman of the House Committee on Public Buildings and Grounds, expressed great admiration for Brumidi's work.[30] On March 20, Davis authorized Meigs to pay Brumidi, who had been working at his own expense, $8 per day retroactively, thus officially approving the work and allowing him to proceed with the decoration of the rest of the room.[31] Captain Meigs wrote in his official report to the secretary of war: "One of the rooms of the basement [first floor] of the south wing is now being painted in fresco. This will enable Congress to see a specimen of this the highest style of architectural decoration. It is the most appropriate and beautiful mode of finishing the building. . . ."[32]

Once he had won the approval to go ahead, Brumidi painted more quickly, assisted by painter Louis Franze and laborer Michel Long. Meigs gave his full support, including the use of a separate "painting room" for preparation of cartoons and assistance in researching Revolutionary uniforms.[33] By the end of March 1855, Brumidi had made the sketch of *The Four Seasons* for the ceiling. In early June, after two months of working the cartoons, the artist was ready for the scaffold to be erected.[34] After almost a year of working on the ceilings and walls, in early April 1856, Brumidi completed the decoration of the room and the key was turned over to the Speaker of the House. Meigs judged: "I think that whatever committee takes possession of it will have a hard time with the public who throng to see it." He reported the total cost

of decorating the room as $3,700, of which Brumidi earned $2,632 for 329 days of work.[35]

The beautifully decorated room attracted great congressional interest, and several committees were allowed to meet there. In May 1856, for example, it was used by the Committee on Public Buildings and Grounds, which was chaired by Brumidi's admirer Congressman Stanton, "when permitted to do so by the crowd of persons attracted there from day to day."[36] In July, Meigs noted that "the fresco painting . . . is evidently popular with the Members. Of committees, no less than 4 committees have met in this room."[37] The public also continued to show great interest in the frescoed room. By 1857, it had become such a tourist attraction that during recesses of Congress it was necessary to have a person on duty all day just to admit visitors.[38] Even in the 1880s, it was visited by thousands of people a year.[39] The Agriculture Committee occupied the space intended for it until 1922, when the room was assigned to a subcommittee of the Committee on Appropriations. Recently, H–144 has been converted to a hearing room by the Appropriations Committee.

Brumidi's first room in the Capitol (fig. 5–9) is one of the most beautiful he ever executed. It is particularly pleasing because he was able to complete his entire scheme without interruption. Brumidi demonstrated his understanding of the Renaissance tradition and created aesthetic and thematic harmony and balance. His trompe l'oeil illusionistic effects are completely convincing. The room seems to be filled with live figures, carved sculpture, and gilded frames that look three-dimensional but are actually flat.

On the ceiling, Brumidi depicted figures representing the Four Seasons floating on clouds above stone arches (fig. 5–10). On the east is Spring, represented by the youthful Flora, Roman goddess of flowers, who drops blossoms into the room below; she is framed by billowing pink drapery and surrounded by cherubs, one of whom is crowning her with a wreath. On the south is Summer, represented by Ceres, goddess of agriculture, who is shown with a sheaf of wheat and a sickle, flanked by cupids with a scythe and cornucopia. Representing Autumn on the west is Bacchus, the god of wine, who carries his traditional thyrsus (a pinecone-tipped staff) and accepts a bunch of grapes while being transported by a cloud in a procession led by cherubs with ancient cymbals and a tambourine. Finally, Boreas, the bearded god of the north wind, commands the cherubs to create Winter's wind and snow.[40] Between the framed vaults are illusionistic carved stone reliefs of garlands, cherubs, and eagles. In the Renaissance tradition, Brumidi painted the forms as if illuminated by the light from the actual windows in the room.

Fig. 5–10. *The Four Seasons. Figures personifying spring, summer, autumn, and winter appear to float on clouds above the arches in the ceiling.* H–144.

Fig. 5–11. *Calling of Cincinnatus from the Plow. The fifth-century B.C. Roman hero at the center of the east lunette, standing by his oxen-drawn plow, receives a helmet and sword from a white-robed priest.* H–144.

In the east lunette (fig. 5–11), Cincinnatus, in the weight-shifted (*contrapposto*) stance of classical sculpture, is being approached by a priest. Two of the Roman soldiers hold fasces, the symbol of authority of the Roman government, which had been adopted as the mace of the House of Representatives. In the distance at the left is an idealized view of Rome, while at the right a curly-haired boy, for which Meigs's son Monty posed, and a dog observe the event.[41] The rake held by the boy is inscribed "1855 C. Brumidi." The composition is beautifully balanced, and the palette of reds and violet with touches of blue played against the earthy browns and greens creates a subtle harmony.

Across from Cincinnatus, in the west lunette, Brumidi painted a parallel story, *Calling of Putnam from the Plow to the Revolution* (fig. 5–12). In 1775, the American Revolutionary hero Israel Putnam rushed to command the defense of Breed's Hill in Charlestown, Massachusetts (later called the Battle of Bunker Hill). Brumidi's composition was based on a lithograph (fig. 5–13). Published about 1845, the print made an intentional comparison with Cincinnatus.[42]

On the south wall, Brumidi created a small framed illusionistic painting showing the traditional method of harvesting grain with a sickle, under a trompe l'oeil relief profile portrait of George Washington, which is flanked by allegorical figures representing America (see fig. 5–1). On the opposite wall (see fig. 7–7),

Thomas Jefferson's relief portrait is over a scene showing the modern mechanical McCormick reaper, as suggested by Meigs, who arranged for Brumidi to examine the machinery.[43]

Finally, the lower part of the room was painted in fresco with the illusion of arched carved moldings on the stone-colored walls.[44] These walls were later covered with oil-based paint, but the original configuration of the moldings was preserved.

Over the years Brumidi's first frescoes for the Capitol were obscured by disfiguring grime and overpaint on the lunettes; a long crack in the mortar on the north wall also gave the room high priority for conservation. Soot from the fireplace under the west lunette darkened the scene of Putnam. After a small fire, restoration in 1921 included scrubbing the lunettes with abrasive caustic and heavily repainting them in oil. The repaint on the lunettes later darkened further, and the scenes were repainted again in 1930. Fortunately, the ceiling and agricultural scenes were left basically untouched.[45]

Conservation treatment carried out in 1987 and 1988 included cleaning the surfaces of grime, repairing the crack, and reattaching flaking paint on the gilded trompe l'oeil frames (fig. 5–14). The most difficult task was the removal of the heavy overpaint from the frescoes. A study of the lower walls revealed that the stone-like colors had been changed, but that the general pattern of the moldings is original. The flat areas were repainted to match the original color as closely as possible to help restore the overall color harmony of the room, whose beauty can now be more fully appreciated.

Fig. 5–12. *Calling of Putnam from the Plow to the Revolution*. *Brumidi painted the American Revolution hero across the room from Cincinnatus, with horses instead of oxen, and with a drummer mounted on a rearing horse pointing him toward the battle in the distance. H–144.*

Fig. 5–13. Artist unknown. ***General Putnam Leaving his Plow for the Defence of his Country*.** *Brumidi took the major elements for his lunette from this lithograph. He changed the relative proportions and positions of the figures and simplified the landscape to create a more harmonious composition.* Yale University Art Gallery. The Mabel Garvan Collection.

Photo: Yale University Art Gallery.

Fig. 5–14. *Calling of Putnam* during conservation. *Disfiguring grime and overpaint have been partially removed. H–144.*

Photo: Bernard Rabin.

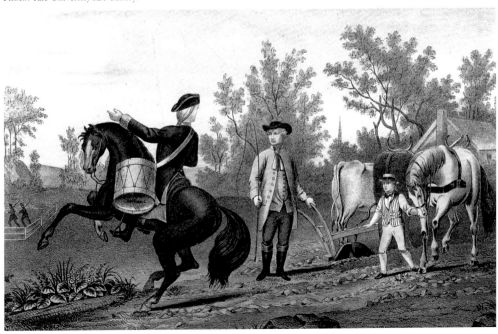

Notes to Chapter 5

1. "Constantino Brumidi," *Daily Critic*, c. 1880. Request of CB to Cardinal Secretary of State Giacomo Antonelli to go to New York, October 19, 1851, ASR/SC.

2. Brumidi's "Intention to become a Citizen of the United States," NARA/RG21.

3. The companion portrait of his wife, Susan Pickering Bemis, is undated. Correspondence in the NMAA curatorial files shows that the donors believed that Mr. Bemis's portrait was done from life while Mrs. Bemis's portrait was done "from memory and photographs," Madelon Chandler Benton to William Truettner, curator, NMAA, March 11, 1976.

4. *Progress* is signed and dated 1853. The canvases of *Progress* and *Plenty* have the stamp of a New York preparator.

5. John Black, U.S. Consul to Mexico, certified on the back of Brumidi's document of intent to become a citizen that it was presented to him in Mexico City on May 5, 1854, NARA/RG 21.

6. The Academia Nacional de San Carlos de México was chartered in 1785. During a reorganization in 1843, the directorship had been offered to Brumidi's colleagues Francisco Coghetti and Francisco Podesti. Among the Italians listed in the exhibition catalogs for the academy are F. Podesti in 1853 and 1855, F. Coghetti in 1854, and M. Capalti in 1856. Manuel Romera de Terreros, ed., *Catalogos de las Exposiciones de la Antigua Academia de San Carlos de Mexico, 1850–1898* (Mexico: Imprenta Universitaria, 1963), pp. 134, 186, 161, and 246.

7. "Brumidi's Life Work." *Washington Post*, April 11, 1879. The twelve-foot-diameter stone is now in the National Museum of Anthropology in Mexico City.

8. Manuel Romera de Terreros, editor, *Catalogos*, 186, 187, 189, 192, 248, 249. In the exhibition opening January 1855, Brumidi exhibited in the section of works sent from outside the academy a full-length Immaculate Conception, 59 by 40 inches (no. 22); a half-length Virgin in an oval, copied after Isabey, which was for sale (no. 24); a Virgin with Christ Child and Saint John, 29 by 23 inches (no. 47); an Assumption of the Virgin, 100 by 72 inches (no. 73); and a portrait of Señorita Doña Elena Basadre, 39 by 31 inches (no. 161). In December 1856 he exhibited a Holy Trinity, 34 by 25 inches (no. 70), and a larger version, 111 by 79 inches (no. 93).

9. List of All Passengers, taken on board the steamship *Onzaba*, at the port of Vera Cruz, bound for New Orleans, December 12, 1854, NARA/RG 36, Passenger Lists and Indexes, New Orleans, courtesy of Kent Ahrens.

10. Charles Fairman noted that Brumidi painted portraits of the Norris family and the Joyce family in Washington, *Congressional Record*, 71st Cong., 2d sess., January 29, 1930, p. 3. No evidence supports Fairman's statement that Norris (1825–1869) came with Brumidi from the Vatican to New York and Washington, since Norris left Rome in late 1851 and was sent to Wisconsin, see Norris's obituary "In Memoriam," *National Intelligencer*, January 15, 1869. The portraits are now in the collections of Mr. and Mrs. George Gardner Herrick and others (see Appendix C). According to Washington city directories of 1850 and 1853, Andrew J. Joyce, blacksmith, is listed at addresses near 14th and Pennsylvania Avenue.

11. CB petition to leave for the U.S. to paint churches, June 4, 1851, ASR/SC. John R. G. Hassard, *Life of John Hughes (1797–1864): First Archbishop of New York* (New York: Arno Press), 1969, p. 496.

12. Father Benedict Sestini, S.J., (1816–1890) was born in Florence, entered the Society of Jesus in Rome in 1836, and was ordained there in 1845, so that he and Brumidi may well have been acquainted in Italy. Father Sestini taught mathematics and astronomy at Georgetown Col-

lege until 1869, when he moved to the Scholasticate at Woodstock. In 1870, Brumidi gave his friend a painting of the Holy Family in Egypt, now at St. Aloysius, for the chapel at Woodstock, Maryland. "Fr. Benedict Sestini," *Woodstock Letters*, vol. 20, 1890, pp. 259–263, courtesy of Father George Anderson, S.J. CB to B. Sestini (in Italian), Nov. 11, 1855, Georgetown University Archives.

13. MCMJ, January 30, 1855 (A–410). Meigs mentions Mr. Stone or Dr. Stone over a dozen times in his journal; these are plausibly all references to Horatio Stone (1808–1875). Another Washington artist with the same last name, William James Stone (1798–1865), an engraver who had studied under Hiram Powers in Italy in 1847, and who might have met Brumidi then, is a possible but less likely candidate.

14. MCM to J. Durand, editor of *The Crayon*, October 11, 1856, AOC/LB.

15. MCMJ, September 23, 1856 (B–297). The suggestion that Meigs also studied drawing with Robert W. Weir appears in Russell F. Weigley, "Captain Meigs and the Artists of the Capitol: Federal Patronage of Art in the 1850's," *Records of the Columbia Historical Society of Washington, D.C. 1969–1970* (Washington, D.C.: Columbia Historical Society, 1971), p. 293.

16. On February 28, 1854, the painter John Chapman wrote to Gouverneur Kemble from Rome, who forwarded his letter to Meigs. Chapman discussed fresco painting, emphasizing the importance of the artist's ability to create a cartoon and downplaying the need for experience in the fresco technique. Meigs copied Chapman's letter in shorthand and sent the original on, as instructed, to Senator Pearce, AOC/CO. Emanuel Leutze to MCM, February 14, 1854, AOC/CO.

17. MCMJ, August 28, 1854 (A–225).

18. MCM to Thomas Crawford, August 18, 1853, AOC/LB.

19. Weigley, "Captain Meigs," pp. 293–95.

20. MCMJ, December 28, 1854 (A–358).

21. Ibid.

22. MCM to J. Durand, October 11, 1856, AOC/LB.

23. Ibid.; CB to Justin Morrill (copy given to EC), November 30, 1874, AOC/CO.

24. Drawing for lunette, private collection, Rome. Courtesy of Alberta Campitelli.

25. MCMJ, January 24, 1855 (A–400). The oil sketch included a design for the facing lunette which was not used. It showed classical allegorical figures, including one dressed as an Indian to represent America, similar to the one he painted on the south wall.

26. MCMJ, February 12, 1855 (A–426).

27. MCMJ, February 25, 1855 (A–457).

28. March 17, 1855, Pocket Diary, MCM Papers, LC.

29. MCM to J. Durand, October 11, 1856, AOC/LB.

30. MCMJ, February 21 (A–443), March 17 (A–493), March 20 (A–497), May 19 (A–556), May 29 A–564), April 2 (A–513), 1855. Other members noted by Meigs who viewed the work were [Lewis D.] Campbell of Ohio and [E. Wilder] Farley of Maine.

31. MCMJ, March 20, 1855 (A–497).

32. *Annual Report of Capt. M.C. Meigs, in charge of the Capitol Extension*, October 14, 1855, 34–1, House Ex. Doc. No. 1, pt. 2, pp. 113 and 115.

33. MCMJ, April 7, 1855 (A–517). MCM to [George] Washington P[arke] Custis, January 19, 1856, AOC/LB.

34. Brumidi had finished the sketch for the four seasons by March 30, 1855. He worked on the cartoons in April, and on April 28, the govern-

ment paid Antonio DeVoto to model for him for five days. By June 6 the cartoons were completed and the scaffold was being erected, MCMJ, March 30, 1855 (A–508); AOC/Capitol Complex: Vouchers, 1855; MCMJ, June 6, 1855 (A–576).

35. MCMJ, April 11, 1856 (B–159); MCM to Carstens, April 12, 1856, AOC/CO; and "Statement of Cost of finishing Agricultural Committee Room," undated, AOC/LB. Louis Franze received $624.00 and Michel Long received $300.00. Painting materials cost $130.50. The total cost of the work, including payment to Brumidi, was $3,686.50.

36. May 26, 1856, *Congressional Globe*, 34th Cong., 1st. sess., Appendix, p. 619.

37. MCMJ, July 25, 1856 (B–238).

38. MCM to General William Cullom, Clerk of the House of Representatives, March 23, 1857, AOC/LB.

39. J. L. Graves to Jefferson Davis, September 5, 1885, Alabama Department of Archives and History.

40. The significance of the traditional directional orientation of the seasons was pointed out by Francis V. O'Connor (see chapter 10).

41. MCMJ, March 14, 1855 (A–486) and March 15, 1855 (A–489). Meigs's wife Louisa had suggested that Brumidi use their son Monty to pose for the boy in the corner, who has a very different appearance in the oil sketch.

42. Laura K. Mills, *American Allegorical Prints: Constructing an Identity*. New Haven: Yale University Art Gallery, 1996, pp. 6–7. Sculptor Henry Kirke Brown visited Brumidi at work and may have been influ-

enced by the figure of Putnam for the farmer in his design for the House pediment, according to Thomas P. Somma, *The Apotheosis of Democracy, 1908–1916* (Newark: University of Delaware Press, 1995), p. 28.

43. MCM to a Mr. Engle at the Agricultural warehouse, February 5, 1856: "Be good enough to show Mr Brumidi one of the McCormick reaping machines. I wish him to introduce a sketch of one in the decoration of the Room of the Com^ce on agriculture," AOC/LB.

44. Although Walter later remembered the walls being painted in "distemper," TUW to Boulton, February 5, 1863, TUW/PA (AAA reel 4141), the technical study and paint analysis performed by Constance Silver and Frank Matero in 1988 revealed that the walls were done entirely in fresco and that the designs presently seen follow the original patterns. The original moldings were left untouched behind the mantel mirror and were revealed when the mirror was removed for conservation. In 1874 Emmerich Carstens was paid $200 "For painting in Panel the walls of Agricultural Committee Room, House of Representatives," AOC/Annual Repairs U.S. Capitol, 1866–1898, C to F, book 2. This work may have been a touch-up to the original. The walls were painted over in oil after a fire in 1920, "Blaze in Capitol Does Damage to Committee Room," *Evening Star*, December 18, 1920, part I.

45. Charles Moberly restored the room after a wastebasket caught fire. "Blaze in Capitol Does Damage to Committee Room," *Evening Star*, December 18, 1920; Will P. Kennedy, "Moberly Restoring Brumidi Decorations at the Capitol," *Evening Star*, August 14, 1921. The second layer of overpaint on the Putnam lunette appears to be by George Matthews and to date from c. 1930.

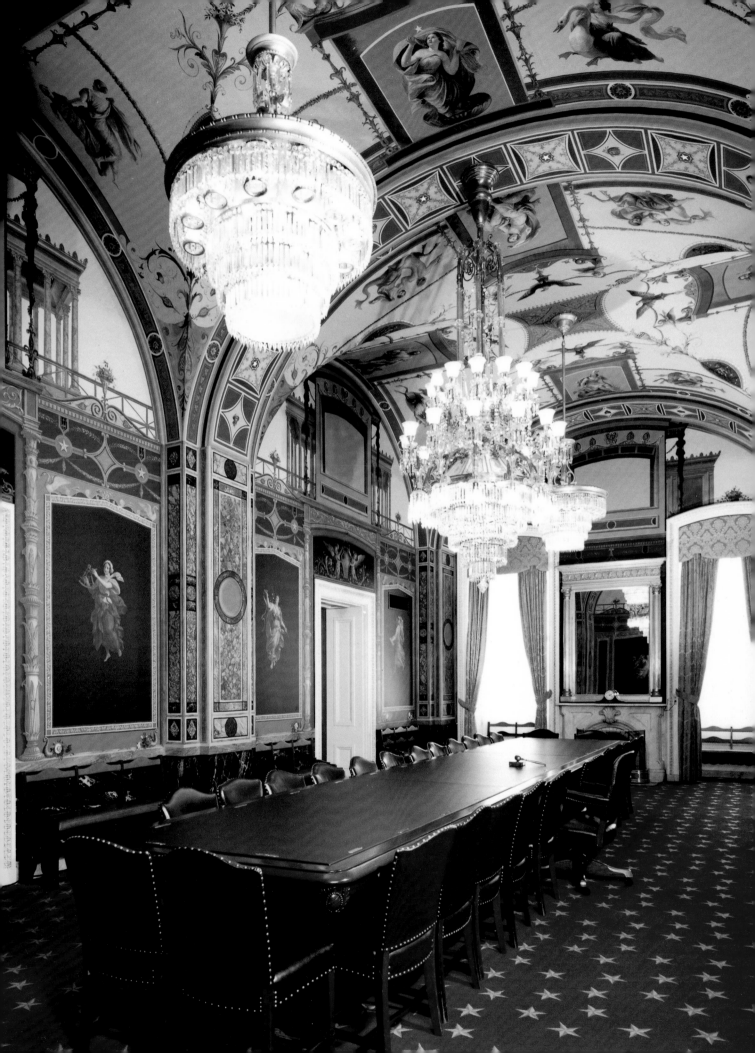

CHAPTER 6
Decorating the Capitol in the Pompeian Style

With his successful completion of the frescoes for the Agriculture Committee room, Constantino Brumidi's career spanning twenty-five years as the artist of the Capitol was launched (figs. 6–1 and 6–2). Having hired Brumidi and numerous skilled craftsmen in 1856, Meigs began to move ahead with the decoration of the new rooms. Walter included "frescoing 89 rooms" at $1,000 each in his estimate of the cost to finish the extensions; he used the word "frescoing" loosely to include any decorative painting on plaster, as was common in the nineteenth century. Meigs immediately set Brumidi to work "making designs & cartoons for ceilings & walls." In the spring of 1856, Brumidi was making designs for the Senate Reception Room (S–213), the ceiling of the Hall of the House, the Senate Committee on Naval Affairs room (S–127), and the Senate corridors. By November, Meigs

Fig. 6–2. Constantino Brumidi, c. 1860. *Brumidi's congenial personality as well as his expertise and talent enabled him to effectively oversee painters of diverse backgrounds.* Lola Germon Brumidi Family Album. United States Senate Collection.

could report on the progress of the decoration of seven rooms. That year alone, 19 orders were placed for painting supplies.[1]

Contrary to the popular impression, Brumidi did not single-handedly decorate the Capitol. In the years the extensions were being completed, they were a beehive of activity, with several artists and many decorative painters simultaneously at work along with plain painters and plasterers and specialists in decorative plaster, gilding, and scagliola, an imitation marble. However, Brumidi was indisputably the major artist decorating the Capitol. He executed all of the true frescoes himself, while supervising teams of painters who carried out the more decorative elements of his designs. In some cases, his designs were even carried out under someone else's supervision. Although Captain Meigs had Brumidi design most of the highly decorated rooms, he asked other artists to contribute to some of his rooms and also had others design and supervise room decoration. He was under pressure to complete the extensions and could not assign all the decoration to Brumidi.[2]

Because of Meigs's regard for his qualifications, Brumidi had the highest rank of any of the artists working in the Capitol. His status was reflected in his relatively high pay, which in 1855 was at the same rate as a member of

Fig. 6–1. Senate Appropriations Committee hearing room. *The ornately decorated room, originally painted for the Senate Committee on Naval Affairs, is the most fully Pompeian in style in the Capitol.* S–127.

Congress. In July 1857, his pay was raised from $8 to $10 per day, retroactive to April.[3] This rate was less only than Walter's salary of $375 per month (approximately $15 a day, based on the six-day work week that averaged 26 days a month). It was much higher than Meigs's $150 per month, the equivalent of less than $6 a day. Emmerich Carstens, who was in charge of all the decorative painters, earned only $5 a day, half as much as Brumidi. Another fine artist, Johannes Oertel, was paid $6 a day, while James Leslie, considered an independent artist, received only $4. The most highly skilled assistant painters, such as Alberto Peruchi and Joseph Rakemann, earned $3, while apprentices and laborers were paid as little as $1 a day.

As "the chief conductor of the work," Brumidi was insistent on his right to have independent control over his own work and crew, asserting "I have always considered that I had the entire management (i.e., in an artistic sense) of those who were place [*sic*] under my immediate superintendence in executing my work. . . ." He himself created the overall design and painted the most ambitious parts himself, especially the historical scenes, large figures, and portraits. He explained that the panels containing figures "require carefull [*sic*] studio, and drawings and cartoons from models, before [I] paint it in the walls, and I cannot employ any other artist to help me, but I must do everything by my hand. . . ."[4]

Brumidi, who had experience in working with teams of painters and decorators in Italy, was able to use effectively the skills of artists of different abilities and nationalities to create a harmonious whole. As mural artists still do today, he assigned assistants to make the best use of their individual skills. Several painters might work on any one section, and the master artist made sure that the style was consistent throughout, making it impossible to distinguish individual contributions.

Brumidi developed a loyal team of assistants, whom he evidently treated with respect. Meigs wrote that he had "never [in Brumidi] seen the petty jealousy which inferior artists exhibit. I have always found him ready to praise where praise was due. . . . He has suffered from the cliques and jealousies which have beset the works of the Capitol, as they do, I presume every great national work, but has himself behaved with modesty and propriety, and

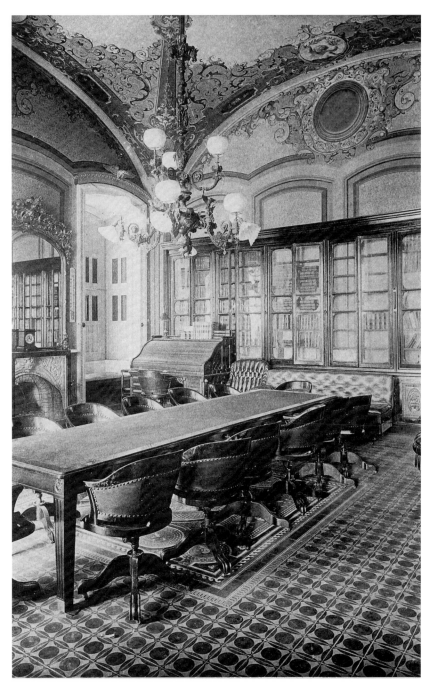

Fig. 6–3. Photograph of room designed by Emmerich Carstens in 1856. *Carstens's decorative murals for the Judiciary Committee of the Senate (S–126) were painted over in the twentieth century.*

From Glenn Brown, *History of the United States Capitol*, 1902.

attended laboriously to his duties."[5] Among Brumidi's closest assistants were Alberto Peruchi and Ludwig Odense, who worked frequently with him at the Capitol and whom he also hired for outside projects, such as the decoration of Walter's house.[6] Peruchi seems to have been his main assistant, since he was giving orders for Brumidi in 1858. He was an expert in "arabesques" and

Fig. 6–4. Trophy of military equipment, detail of wall panel. *In the Brumidi Corridors, the beautifully detailed trophies representing various areas of human endeavor are attributed to English artist James Leslie.* Near S–125.

prepared designs for individual figures in the Senate corridor.[7] Other Italian assistants were Peter Schio, who died in 1858, and Joseph Uberti.[8] Urban Geier helped prepare cartoons and colors, and Michel Long worked under Brumidi as a laborer. Brumidi also worked with Henry Walther and Joseph Rakemann, emigrants from Germany who specialized in painting fruits and flowers.

Alongside Brumidi and his assistants, German-born Emmerich Carstens, called "master painter" and later "foreman of decorative painters," played a major role in the decoration of the Capitol. He was in charge of ordering painting supplies and of decorative painting, which included solid-colored plain walls, trompe l'oeil molding, repetitive designs, and small figures, but not historical or allegorical scenes. Meigs had recruited Carstens in 1854, trying to persuade him to move from New York shortly before Brumidi appeared on the scene. He finally succeeded in hiring him in January 1856. He directed Carstens to paint rooms in tempera rather than having Brumidi decorate them all in fresco not to save money but because of lack of time. Although dismissed in 1859, Carstens was reappointed "foreman of ornamental painting" in 1861. He continued to work at the Capitol until 1898, long after Brumidi's death.[9]

At times, disputes arose between Carstens and Brumidi over lines of authority, such as when Carstens fired one of Brumidi's assistants, but in general they worked together amicably for many years.[10] In some cases Carstens executed Brumidi's designs, as perhaps in the case of the tempera ceiling of the Senate north entry, for which he was paid for "frescoing" (see fig. 6–20). He himself also designed decorations for rooms in the Capitol, including the Committee on Foreign Relations (S–118) and the Senate Committee on the Judiciary (S–126) (fig. 6–3). Meigs commented on this room, comparing Carstens to Brumidi and showing sensitivity to the difference between fine art and decorative painting:

> It is very beautiful, though not so high a style of art as the fresco in room number 17 of Agriculture [H–144]. The coloring is gay and cheerful, with striking contrasts but very harmonious. The effect is very beautiful, and at first sight it pleases as much as the higher art in the other room. But it does not wear so well. The mind finds nothing to study in it. A few scrolls and bunches of fruit and flowers are the whole; and after a few minutes, the novelty wears off, though the impression of beauty and harmony remains.[11]

In the 1850s the highly skilled English painter James Leslie worked independently alongside Brumidi and Carstens and earned Meigs's esteem and appreciation. Leslie first offered designs for the Capitol in 1856; Meigs eventually agreed to hire him at a daily rate. Meigs noted in his journal that he would "have the benefit of the skill and taste which Leslie seems to have, though he is not a Brumidi." Leslie painted the trophy panels in the Senate Committee on Military Affairs room (S–128) (see fig. 8–19) and sections of the first-floor Senate corridors (fig. 6–4). He was entirely responsible for the design and exe-

Fig. 6–5. Corner of room painted by James Leslie. *The room for the Committee on Territories was intricately designed and skillfully painted by Leslie in 1856 with Indian implements, wild birds and other animals, and seals of the areas soon to become states. The tulip stenciling and seal of the House of Representatives are later additions.* H–128.

cution of the elaborate decorations for the House Committee on Territories (H–128) (fig. 6–5), and he applied to be foreman when Carstens was fired in 1859. His skillful contributions to the decoration of the Capitol ended with his sudden death from typhoid fever in 1860.[12]

In managing the decoration of the Capitol, Meigs also hired other artists, such as George West and Johannes Oertel, with whose work he was less pleased. He also attempted to bring in others, such as illustrator F. O. C. Darley, to contribute designs.[13]

We know relatively little about the surprisingly large number of other painters listed on the payrolls. The scant information available about individuals who decorated the Capitol comes primarily from letters complaining about pay or disputing hiring decisions. The payroll documents give no indication of specific areas where a painter worked. The names on the rolls are primarily Italian, German, and English. The painters were hired for varying amounts of time, some for as little as a few weeks, while others worked continuously for many years. Between 1856 and 1861, the names of approximately 75 decorative and fresco painters were listed on the payroll (see Appendix B). In 1857 alone there were 81 painters of all types, including plain wall painters, at work. In 1858, a newspaper claimed that "a crowd of sixty or seventy foreign painters, chiefly Italians and Frenchmen" was working under Brumidi. In actuality, that year Brumidi supervised 15 painters and 3 laborers in 5 rooms, while Carstens kept 15 painters and 2 laborers working in 3 rooms. In May 1858, 22 decorative painters petitioned

to be reinstated after having been let go. By November of the same year, 29 decorative and fresco painters were on the rolls.[14] Added to these numbers were the utilitarian painters and plasterers and the decorative plasterers, gilders, and experts in scagliola, who worked alongside the decorative and fresco painters to create the total room decorations.

The few problems that did arise between Brumidi and the other painters working in the Capitol seem to have been created by ambiguous or duplicate orders given by Meigs, perhaps by oversight, in haste to get the work finished, or in order to have a variety of designs from which to choose, as in the conflict with Johannes Oertel over S–211 (see chapters 7 and 8). In 1856 Louis Franze, originally recruited by Brumidi, became resentful after Meigs reduced his pay. Another painter caught by conflicting orders was Otto Lahayne, who was told by Robert Briggs, the mechanical engineer, to take charge of painting materials, while Brumidi had given this duty to Peruchi.[15] Significantly, there is no evidence that Brumidi was ever the direct cause of conflict with others at any time during his career at the Capitol.

Brumidi was considered the major artist at the Capitol because of his knowledge of true fresco, his expertise in drawing the figure, and his thorough and first-hand knowledge of the classical tradition. Brumidi's antique sources can be seen most clearly in the present Senate Committee on Appropriations room (S–127), originally created for the Senate Committee on Naval Affairs, and in the first-floor Senate corridors, today called the Brumidi Corridors.

S–127

The room designed for the Committee on Naval Affairs, now the Senate Appropriations Committee hearing room, shows Brumidi's virtuosity in designing murals in the Pompeian style (see fig. 6–1). This richly decorated room was created for a committee crucial to the defense of the nation following naval reforms led by its chairman Stephen H. Mallory.

In May 1856, when Captain Meigs began planning this room, he was pleased with Brumidi's just-completed first room (H–144); however, he was still interested in finding other artists to help decorate the Capitol. For the Committee on Naval Affairs, he thought of asking James Hamilton, an Irish-born marine painter in Philadelphia, to paint naval battles from the War of 1812. He solicited designs from Henry Sharp and James Leslie and considered making Brumidi responsible only for the figures, apparently to save money. In late August, however, he rejected Sharp and Leslie's $4,000 estimate as much too costly, shortly after having approved Brumidi's overall de-

sign.[16] During the two years the room was being painted, Meigs learned that he could rely on Brumidi for both quality and dependability.

For the committee room, the right-hand design in Brumidi's beautiful watercolor sketch, signed by Meigs on August 20, 1856, was adopted for the decorative framework (fig. 6–6). Along with a naval battle featuring the *General Armstrong*, the sketch includes the scene *Colum-*

bus and the Indian Maiden, which Brumidi did not use for this room but many years later painted over the door to S-132 (see fig. 6–29). By the fall of 1856, the room was being painted, "the ceiling in distemper and fresco, the walls in oil."[17] In addition to designing the overall decorative scheme, Brumidi executed the important figures, including the eight gods and goddesses frescoed on the ceiling and the floating maidens painted in oil on the walls.

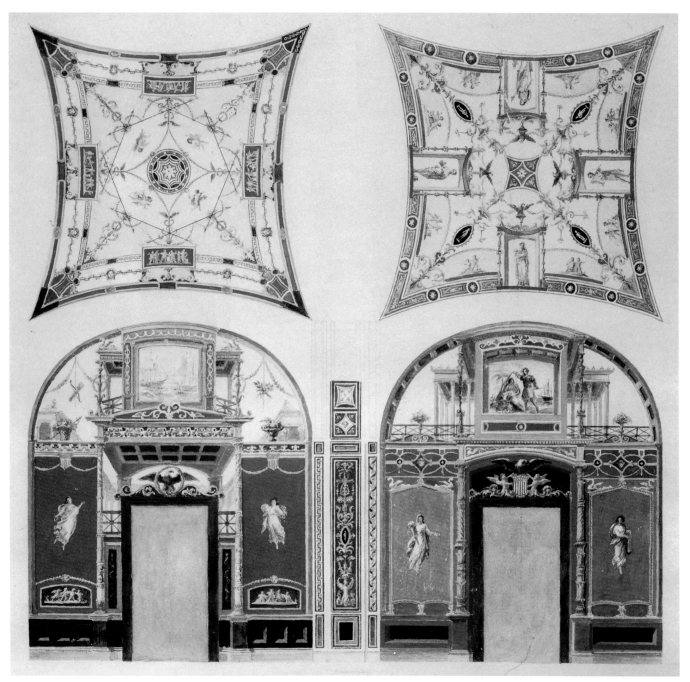

Fig. 6–6. Brumidi's sketch for Naval Affairs Committee room, 1856. *This beautifully detailed watercolor showing an overall design for ceilings and walls is the only known sketch of this type by the artist. It shows different designs and color schemes in the two sections of the room.* Architect of the Capitol.

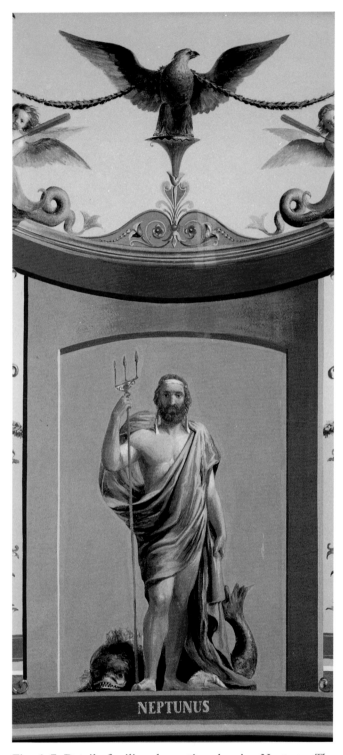

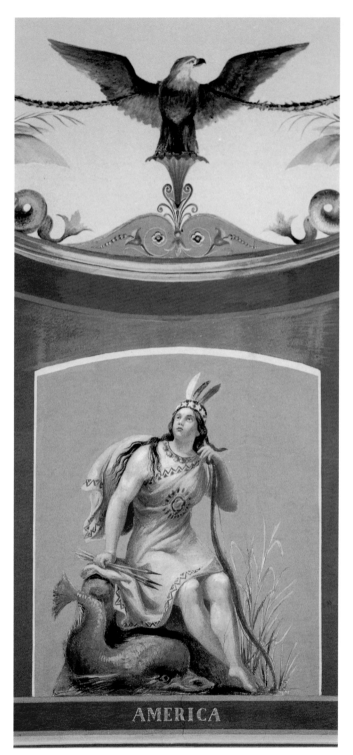

Fig. 6–7. Detail of ceiling decoration showing Neptune. *The god of the sea, holding his trident, presides over the other sea gods and goddesses and sea nymphs in the ceiling.* S–127.

Fig. 6–8. Detail of ceiling with America. *Brumidi included the figure of an Indian woman dressed in deerskin and holding a bow and arrows as one of the American symbols in the committee room.* S–127.

Still seeking to recruit other artists, Meigs asked George R. West, known for his scenes of China, to paint in the upper wall panels the naval battles suggested in Brumidi's sketch. Meigs thought that West would work as Brumidi's pupil, but found that West had a high opin-

ion of himself, thought he deserved greater pay, and was insulted by Meigs's offer to keep him on as a decorative painter. By the end of 1856, Meigs was so displeased with him that the artist offered to erase his six naval scenes. These included the War of 1812 battles between

Fig. 6–9. Detail of cherubs over doorway. *Brumidi's winged cherubs with leaves instead of legs are directly inspired by Pompeian murals, while the striped shield adds an American note. S–127.*

the *Constitution* and the *Guerrière* and between the *General Armstrong* and the British and, possibly, the 1855 launch of the frigate *Minnesota*.[18] West's scenes were obliterated; it is possible that traces of them still exist under later paint layers.

The six architectural perspectives now visible in the lunettes were painted by Camillo Bisco, one of the Italian painters who worked directly under Brumidi. However, because he was fired in 1858, only the central portion of one lunette was ever completed. Also left blank were the circles on the lower walls, for which portraits of naval heroes were designed by Brumidi after Johannes Oertel failed to produce them.[19]

In 1858, shortly after the room was occupied by the committee, an explanatory note about its classical sources, most likely based on what Brumidi had told Meigs, was posted in the room:

> The decorative paintings of this room are a specimen of the manner in which the ancient Greeks and Romans ornamented their splendid buildings, some of which are still extant in the precious monuments of Pompeii and the baths of Titus. America, with the sea divinities, are painted on the ceiling in real fresco. These mythological figures are delineated agreeably to the poetical descriptions we have received of them, and they are Neptune, the god of the seas,

Amphitrite, his wife, Aeolus keeping the winds chained to the rocks, Venus, the daughter of the Sea, Oceanus with crampfish claws on his head, Thetis, his wife, and Nereus, the father of the Nereids, drawn by Glacus, and the Tritons by marine horses or swans, or else mounted on sea monsters.[20]

Meigs was very proud of Brumidi's achievement. After comparing it to plates in books on Pompeii and Gruner's *Ornamental Art* in the Library of Congress, he concluded that "the decoration of the Capitol will compare favorably with the best of the examples that are given. The Pompeian rooms are better than the examples from Pompeii. . . . "[21]

All the designs in the room are adaptations of types of wall painting that can be found in Pompeii or in what Brumidi knew as the Baths of Titus (see fig. 1–4). The ornamental trelliswork painted on the ceiling vaults frames classical figures related to the theme of the sea. Into this profusion of antique imagery, including Neptune (fig. 6–7), Brumidi introduced a few American symbols, an allegorical figure representing America (fig. 6–8) and faces of pioneers and Native Americans on one of the ceiling arches. In the lunettes under the arches, Bisco's illusionistic architectural frames hold depictions of classical porticoes painted in convincing perspective. Over the doorways are cherubs with striped shields, painted on a black background suggesting night, similar to ones found in Pompeii (fig. 6–9).

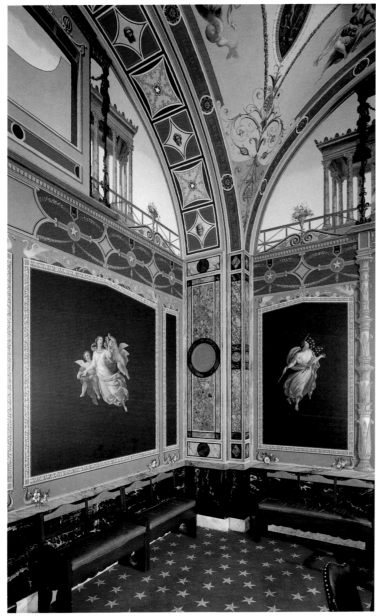

Fig. 6–10. Southeast corner with floating maidens. *One of the maidens directly inspired by a Pompeian figure carries an American flag. S–127.*

Fig. 6–11. Cartoon for maiden with pearls. *Brumidi transferred this drawing directly to the wall.*

Fig. 6–12. Baccante in a fresco from Pompeii. *Brumidi adapted the pose of this figure for his maiden carrying the flag.* Museo Archeologico Nazionale, Naples, Italy.

Photo: Alinari/Art Resource, NY.

Lower on the walls, illusionistic columns frame nine panels with floating female figures by Brumidi (fig. 6–10). The maidens, dressed in flowing classical robes, hold nautical and marine objects, including an anchor, chart, compass and telescope, sextant, fish, and pearls (fig. 6–11). They are modeled after Pompeian maenads, or followers of Bacchus (fig. 6–12). As seen in Brumidi's color sketch (see fig. 6–6), early descriptions, and recent test cleaning patches, these figures originally floated on a light blue background; with discoloration and yellowed varnish, the fields turned to dark green, which is the color they were repainted.[22] The pilasters and lower walls are decorated with scagliola. The Pompeian style of the room made it a

lightning rod for attacks on the decoration of the Capitol. One writer disparagingly compared it to a valentine shop and argued that classical motifs were obsolete:

It is scarcely possible to imagine anything more absurd, or in more outrageous taste. Yet it is entirely

Fig. 6–13. Room S–127 as it appeared c. 1900. *By the turn of the century, Brumidi's murals were partially obscured by bookcases and other furniture. Note the original bronze chandeliers decorated with anchors.*

From Glenn Brown, *History of the United States Capitol,* 1902.

in keeping with the general style of decoration of the Capitol, which is a servile, tasteless reproduction of the Pompeian style, with its worn-out, *fade* [insipid], wearisome gods, goddesses, nymphs, and monsters. . . . [23]

In contrast, today the room is considered one of the treasures of the Capitol, with its wealth of detail and symbolism showing Brumidi's mastery of the Pompeian idiom.

The room suffered some changes during its history. The Naval Affairs Committee met in the room until 1897, briefly followed by the Committee on Printing. From 1899 the room was used by the Committee on the Philippines until 1912, when it was assigned to the Senate Committee on Appropriations, which still occupies it today. By

the turn of the century, cabinets hid parts of the walls (fig. 6–13). Although Brumidi's basic designs remain largely intact, many areas in the room have been repainted. Charles Moberly touched up the room in 1919, and decorative painters worked there in 1955. In 1978, during the restoration of the room, the plain fields were repainted and damaged areas redone. This restoration was carried out by in-house painters before the professional mural conservation program at the Capitol was begun.[24]

S–210

Another room decorated in a variation of the Pompeian style is S–210, known since 1964 as the John F.

71

Fig. 6–14. Another example of the Pompeian style. *This room, designed to be the Stationery Room for senators, has a framework of classical designs; the blank areas were intended for Brumidi's frescoes.* S–210.

Kennedy Room, because he used the room while president-elect (fig. 6–14). Now used by Senate officers, it was created as the Stationery Room for the Senate and was used for many years by the Official Reporters of Debates. The decorative framework painted in 1856 includes trompe l'oeil moldings and classical motifs painted in tempera on the ceiling and lunettes; it may have been designed by Brumidi but was probably carried out by Emmerich Carstens. The palette of cream, greens, and reddish browns is similar to that in the ceiling he painted in the north entry. The numerous plain fields were intended for frescoes, for which Brumidi gave an estimate in late 1859, but which he never executed.[25]

Fig. 6–15. View from west to east of the north Brumidi Corridor. *The decoration of the Capitol corridors was inspired by Raphael's loggia in the Vatican, which was in turn based on Roman murals.* First floor, Senate wing.

Fig. 6–16. Raphael's Loggia in the Vatican. *Decorative details that inspired Brumidi's designs for the Brumidi Corridors are more visible in this nineteenth-century photograph than they are today.*

From Heinrich Strack, *Baudenkmaeler Roms des XV-XIX Jahrhunderts*, Berlin, 1891.

The Brumidi Corridors

The most extensive and most accessible space in the Capitol decorated in the Pompeian style is the network of corridors on the first floor of the Senate wing, in recent years called the Brumidi Corridors (fig. 6–15). The Italian artist, who played a major role in the overall design for the walls and ceilings and in painting the most important elements, was assisted by many others in creating the ornate mural decoration. Brumidi himself painted the historical portraits along the walls and the frescoed lunettes with historical and allegorical figures and scenes. In his design for the corridors, Brumidi integrated American motifs into a classical framework.

The design of the corridors reflects the classical Roman style as it had been recreated in the corridors of the Vatican, where the walls and ceilings are divided by trompe l'oeil architectural moldings and filled with classical flora, fauna, and mythological figures. Raphael's second-floor loggia in the Vatican was a direct source of inspiration (fig. 6–16). Brumidi's work is more richly colored and ornate than Raphael's, giving it the Victorian flavor characteristic of his time, which is further enhanced by the colorful Minton tile floors.

Remarkably, before he had met Brumidi, Captain Meigs had already envisioned having the corridors decorated like Raphael's Vatican loggias, which he had seen in colored engravings. Meigs was therefore enthusiastic about Brumidi's elaborate decorative scheme and put it into effect, even though architect Walter found it "excessively ornate," preferring walls painted in "light and harmonious tints" with "a few frescoes where the lights are favorable."[26]

As an early guidebook justly estimated, "It would require a volume to describe the corridors accurately. . . ."[27] It would take many hours if not days of careful looking to appreciate all of the details. The Italian artist incorporated American flowers, fruits, birds, small mammals, insects, reptiles, inventions, and historical portraits, along

73

The Brumidi Corridors

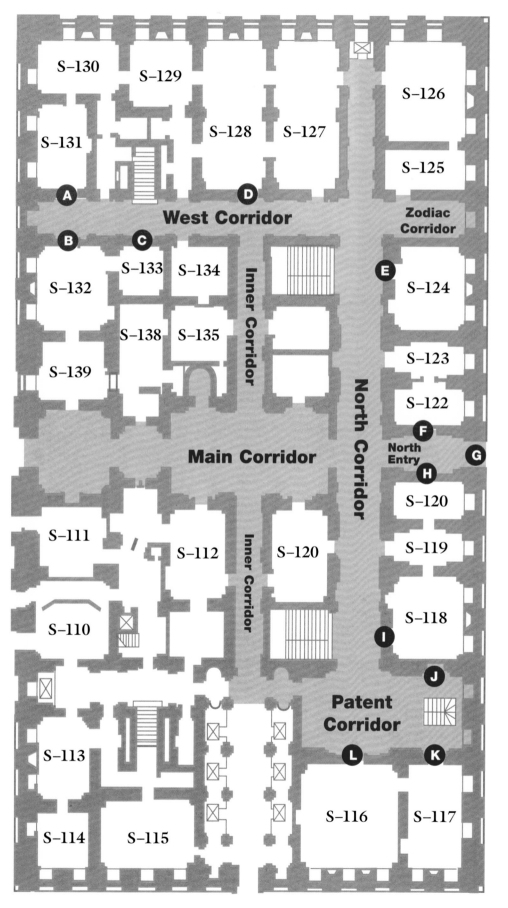

S–130

S–129

S–131

S–128 S–127

(A) Authority Consults the
Written Law

(B) Columbus and the
Indian Maiden

(C) Bartholomé de
Las Casas

(D) Bellona, Roman
Goddess of War

(E) Cession of Louisiana

(F) Chancellor James Kent

(G) Chancellor Robert
R. Livingston (bust)

(H) Justice Joseph Story

(I) Signing of the First
Treaty of Peace with
Great Britain

(J) John Fitch

(K) Benjamin Franklin

(L) Robert Fulton

Frescoed lunettes by
Brumidi:

S–126

S–125

Zodiac
Corridor

West Corridor

(A) **(D)**

(B) **(C)**

S–133 S–134

S–132

S–138 S–135

S–139

Inner
Corridor

(E) S–124

S–123

S–122

(F)

North
Entry

(G)

North Corridor

Main Corridor

(H)

S–120

S–119

S–118

(I)

S–111

S–112 S–120

Inner
Corridor

S–110

(J)

S–113

Patent
Corridor

(L) **(K)**

S–116 S–117

S–114 S–115

Fig. 6–17. Floor plan of the
first-floor Senate wing
showing the Brumidi
Corridors. *The names of the
individual corridors and locations
of the frescoed lunettes are
indicated to correspond with the
descriptions in the text.*

with classical figures and motifs, within the trellises of rinceaux, scrolling vines growing out of urns, acanthus leaves, and the like, set in panels framed with illusionistic molding.

It is important, however, to appreciate the overall concept of the corridors before succumbing to delight in the details. Brumidi and Meigs created a space that lets visitors know immediately that they are in a place of great importance, and that the Senate is an institution with roots in the classical world.

The decoration on the walls originally gave the illusion of three-dimensional moldings and recessed panels, thus enriching the flat walls upon which they were painted. This relief effect has been to a large degree hidden by several campaigns of repainting the solid background fields and the constant touch-up needed in the heavily trafficked area (see chapter 15 for a more detailed description of this process). The plain border areas have gradually changed from a sandstone-colored light tan to a murky green. In the central panels cleaning tests have revealed the original colors of red, white, and blue described in early guidebooks.[28] Each time the wall was repainted, details were changed through heavy-handed retouching. Varnish applied to protect the murals has significantly yellowed and added a sheen to the walls, which flattens out the trompe l'oeil effects and makes the decorations look like wallpaper to the untrained eye. In addition to all of the other changes, the electric lighting creates a markedly different effect from that of the old gas fixtures. For all of these reasons, it is difficult to grasp fully the overall design and original visual impact of the corridors.

The corridors are complex on several different levels. Architecturally, they are laid out in a network, with the longest, the north corridor, running east and west parallel to the north end of the wing (fig. 6–17). This corridor is bisected by the north entry, which connects to the main corridor, actually a series of halls leading toward the center of the building. The perpendicular Zodiac Corridor and western corridor are also highly decorated. On the east lies the open hall called the Patent Corridor. A narrower inner corridor which runs east and west is much plainer in design.

Brumidi created in these corridors a complex scheme, like a symphony with themes and variations, that demonstrates his great ability to visualize space in architectural terms. Brumidi used the projecting pilasters, which transmit the weight of the vaulted ceilings, to establish the fields of design. The walls are subdivided by vertical panels framed by illusionistic molding on the pilasters and rectangular panels between them. The panels simulate designs that in antiquity would have been carved in three dimensions. Each panel is symmetrically designed. The panels are also interrelated symmetrically in three-dimensional terms, mirroring each other across the corridor; for

example, the pilasters with parrots face each other. In addition, the basic divisions continue vertically up the walls and around the ceiling vaults. There is a larger symmetry as well: basic design patterns alternate symmetrically, starting from the north entry; for example, the pilasters near the staircases at both ends of the northern corridor are decorated with mice and squirrels.

Beyond these principles of order, no two panels are identical. Complexity of design is compounded by variations in style, which stem from the piecemeal decoration of the corridors by many artists over a long period of time. The decorative painting of the corridors began in late 1857, and it was at its greatest intensity throughout 1858 and most of 1859. During this period, the spaces planned for pictures were left blank because of restrictions set by Congress as it contemplated giving authority to an art commission (see chapter 7). Brumidi added the signs of the zodiac and the medallion portraits in the 1860s, and he painted the frescoed lunettes between 1873 and 1878, twenty years after the start of the project. Because of lack of time and funds, Brumidi was never able to fill many areas intended for paintings, which remain blank today.

In order to carry out the elaborate decoration Meigs envisioned, Brumidi supervised teams of decorative painters of many nationalities, who at at times had to work by candlelight.[29] Among his assistants for the corridors were two Italians, Camillo Bisco and Albert Peruchi, and many painters of German descent, including Joseph Rakemann, Ludwig Odense, Frederick Roeth, Anthony Dempf, Peter Baumgras, F. Schneck, and Otto Lahayne. The Englishman James Leslie is documented to have worked on ceilings and walls in the corridors. He is thought to be responsible for the beautifully painted trophies (see fig. 6–4), since they are similar to the trophy panels in the Senate Committee on Appropriations room that are known to be by him (see fig. 8–19).[30]

Adding to the stylistic diversity of the corridors, some of the blank areas in the north corridor have been filled by more recent artists. The walls of the north entry, noticeably different in style from the rest, probably date from the turn of the century. Around 1930, an unknown artist portrayed the Wright brothers' airplane and Charles Lindbergh's *Spirit of St. Louis*, and a scene showing the *U.S.S. Constitution* was added by George Matthews. In 1975, Allyn Cox painted *The First Landing on the Moon, 1969*. The most recent addition to the corridor is the scene depicting the ill-fated crew of the space shuttle *Challenger* by Charles Schmidt, painted in 1987.

The corridors are technically as well as stylistically complex. Brumidi painted all but one of the lunettes in true fresco, while the most recent additions to the corridor were painted in oil on canvas and then applied to the

Fig. 6–18. Details from the Brumidi Corridors. *The decorative painting in the corridors includes birds, flowers, fruits, classical figures, and landscapes; other animals, statues, and historical portraits can also be found.*

wall. The walls were originally painted in an unusual medium, called *fresco in sciabaltura*, which allowed the artists time to paint the surfaces and details in multiple passes. Because the walls were later touched up in oil paint and varnished many times, they today have the shiny appearance of oil paint. The ceilings were decorated in water-based tempera, but many areas were later overpainted in oil; the only section of entirely original ceiling is that in the north entry (see fig. 6–20).[31] The corridors

are rich in subject matter as well as in design and technique. At least a hundred distinct species of birds are depicted in the corridors; although they are mostly North American, South American examples appear as well (fig. 6–18). The painters worked from stuffed birds and animals borrowed from the Smithsonian Institution. However, many of their ornithologically correct details have been obscured by later overpainting.[32] In addition to the birds, there are many distinct species of mammals, insects,

reptiles, fruits, vegetables, and flowers painted with great naturalism. The natural subjects alternate with classical figures and historical portraits and scenes.

Beginning with the elevator near S–126 and S–127, at the west end of the north corridor are distinctive large plain panels with delicately painted trophies of weapons, musical and nautical instruments, and agricultural implements and products at their centers; all are attributed to James Leslie (see fig. 6–4).[33] On the pilasters can be seen

brilliantly colored parrots and other birds, such as owls, woodpeckers, and herons. Among the flora are morning glories, cornstalks, and fruit baskets. Classical figures such as Mercury and Poseidon and allegorical figures of the Constitution, Union, and Freedom add a more serious touch, as do the illusionistic relief portrait medallions by Brumidi.

The ceilings are punctuated with vases of flowers and ovals showing sky and clouds, most likely painted around

Fig. 6–19. North entry. *This area includes frescoes of prominent early jurists by Brumidi.*

1900. The vault at the crossing of the north and west corridors has oval medallions with types of plows.

On the walls of the Zodiac Corridor, at the end of the west corridor, are more trophy panels attributed to Leslie. In the ceiling at the end of the western corridor are oval landscapes and the signs of the zodiac painted by Brumidi in 1860 on fields of blue.[34] Modern inventions, such as new types of plows, are highlighted in the nearby ceiling, with the airplanes obviously twentieth-century additions.

The west corridor begins with a landscape lunette of Day and ends with one of Night near S–131 and 132.[35] This corridor contains four frescoed lunettes by Brumidi. Along the walls of the west corridor, Brumidi's monochrome profile medallion portraits of famous early Americans include signers of the Declaration of Independence and other members of the Continental Congress, such as John Hancock, Robert Livingston, John Jay, and Robert Morris.[36] Eagles decorate the tops of the panels, where hummingbirds and parrots are among the birds featured. The most distinctive motifs on the walls in this area are the miniature altars, one of which includes a tiny representation of the marble seated statue of George Washington that was then on the Capitol grounds. The delicate

architectural frameworks, similar to those inside the Senate Committee on Appropriations room, may also have been painted by Camillo Bisco.

Moving back to the north corridor, and turning past the staircase, the panels contain birds, such as quail; reptiles; small mammals, including chipmunks, squirrels, mice, and an ermine; and many varieties of flowers and fruits, as well as classical dancing cherubs and canephores. The monochrome medallion portraits show leaders of the Revolutionary War such as Jonathan Trumbull, Horatio Gates, and Israel Putnam.

The north entry was one of the last areas to be finished; Carstens painted the decorative ceiling with classical patterns in 1875 and Brumidi added the frescoed portraits in 1878 (fig. 6–19). Untouched by overpainting, the original tempera colors are here darker and earthier and the surface is more velvety and matte than those of the repainted ceilings in other areas (fig. 6–20). Brumidi

Fig. 6–20. North entry ceiling painted by Emmerich Carstens, 1875. *This ceiling, one of the few areas in the corridor never painted over, shows the original soft colors of the tempera decorations.*

Fig. 6–21. One of the Members' private staircases. *The bronze railings are composed of cherubs, eagles, deer, birds in nests, squirrels, and snakes, entwined in leafy rinceaux, echoing the designs in the pilasters.* Across from S–118.

contributed the illusionistic paintings of Supreme Court Justice Joseph Story and New York Chancellor James Kent and an illusionistic marble bust of New York Chancellor Robert R. Livingston.[37] These murals highlight the role of the judicial branch, possibly in recognition of the Supreme Court, which then met in the Capitol.

On the walls of the north entry are profile portraits identified as Andrew Jackson, Henry Clay, Daniel Webster, and [John Quincy] Adams, now partially obscured by the doors. The decorative trellises with birds and medallions of wild animals, which appear inferior in quality, probably date to the turn of the century. Across from the entry is a small lunette showing the U.S.S *Constitution*, painted by George B. Matthews, after a 1924 lithograph which was sold to finance the preservation of the ship.[38]

At either side of the north corridor are the senators' private stairs, called the Brumidi Staircases, which echo the wall decoration (fig. 6–21). From Brumidi's design (fig. 6–22), they were sculpted by Edmond Baudin, using live children and animals as models, and cast in Philadelphia by Archer, Warner, Miskey & Co. in 1858 and 1859. Cleaning and conservation in 1988 brought back their original architectural bronze patina.

Brumidi's frescoed lunettes above the doors of committee rooms reflect the functions of the committees that met there at the time the frescoes were planned. The Committee on Patents occupied the room on the east end of the north corridor, now S–116. For the Patent Corridor, Brumidi created frescoed lunettes paying tribute to three important American inventors: John Fitch working on his steamboat model (1876), Benjamin Franklin (completion

Fig. 6–22. Design for the Members' private staircases, c. 1857. *Brumidi established a general design for the railings in this drawing.* Architect of the Capitol.

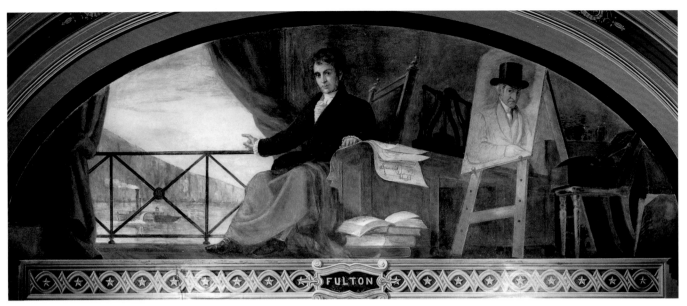

Fig. 6–23. *Robert Fulton*, c. 1873. *Brumidi showed the inventor seated in his studio, looking out at the palisades of the Hudson River and his steamboat; a portrait of Benjamin West, with whom he studied painting, is on his easel.* Over the door to S–116.

Fig. 6–24. *Signing of the First Treaty of Peace with Great Britain*. *This lunette, one of the most seriously damaged, has been conserved. The faces of John Adams, Benjamin Franklin, John Jay, and Henry Laurens have been reconstructed from the famous eighteenth-century portraits that Brumidi copied.* Over the door to S–118.

Fig. 6–25. *Cession of Louisiana*. *The Marquis Barbé-Marbois, the representative of the French government, is depicted standing and showing a map to Robert Livingston, who coordinated the negotiations, and James Monroe, the minister to France.* Over the door to S–124.

date undocumented), and Robert Fulton (1873). The wide lunette showing Fulton (fig. 6–23) is a focal point visible the length of the north corridor. Emblems of various fields of knowledge, such as science, agriculture, navigation, and the arts, are depicted in the ceiling among garlands of fruit, while roses, fruit, and birds are included in the wall decorations.[39]

At the east end of the north corridor, over S–118, then the Senate Committee on Foreign Relations room, is the *Signing of the First Treaty of Peace with Great Britain*, fin-

ished in 1874 (fig. 6–24). The scene of the 1782 event was based on an unfinished sketch by Benjamin West, with a figure representing the British representative Richard Oswald added.[40] In 1875, at the west end of this corridor, over S–124, then the Senate Committee on Territories, Brumidi painted the *Cession of Louisiana*, depicting the 1803 negotiations that led to the Louisiana Purchase (fig. 6–25).[41] This lunette is one of the best preserved and shows Brumidi's ability to suggest the textures of various materials, using fresco almost like oil paint.

81

Fig. 6–26. Bellona. *The Roman goddess of war stood guard over the door to the room of the Military Affairs Committee.* Over the door to S–128.

Above the Senate Committee on Appropriations room, S–128, originally the room of the Committee on Military Affairs, is *Bellona, Roman Goddess of War* (fig. 6–26), whose date of execution is unrecorded. The figure, visible down the long inner corridor that she faces, stands with a sunset sky behind her and stacked rifles and cannons to either side.[42]

At the end of the corridor is *Authority Consults the Written Law*, painted about 1875. The subject is related to the Senate Committee on the Revision of Laws, which met in S–131 (fig. 6–27). The scene is composed in the manner of a Venetian Renaissance altarpiece, with Authority like a madonna before a niche with flanking saints.

Justice, standing next to her, holds scales and a silver and ebony mace, modeled after the one in the House of Representatives. The bearded, elderly male figure holding the book of law represents Judgment or Lycurgus, author of the Spartan constitution.[43] The figure of Authority was once repainted in oil, in a pose much different from the original (fig. 6–28). All of the lunettes have now been cleaned and conserved, so that Brumidi's original designs can be fully appreciated.[44]

Columbus and the Indian Maiden and *Bartholomé de Las Casas* were painted in the lunettes over the doors to the Senate Committee on Indian Affairs room, now S–132 and S–133. In the lunette over S–132, Columbus stands near the center (fig. 6–29). The composition painted by Brumidi about 1875 seems to be based on classical groups, such as Truth unveiled by Time, and may reflect Brumidi's knowledge of Italian monuments to Columbus as well as Luigi Persico's *Discovery*, then on the east front of the Capitol.[45] Brumidi portrayed the seated woman with a classical profile and dressed her in a Native American necklace with a transparent sari-like veil tied over her shoulder and a white veil or shawl bordered in blue over her head. She is surrounded with a variety of cacti to create a sense of exotic locale. The rosy sky may signify the dawn of a new age. The fresco was completed by early 1876, when a newspaper humorously commented about the pair: "She is dressed in a gaily-colored robe, and altogether is as interesting looking a female aborigine as one would care to see. The expression on the face of Columbus, notwithstanding this, is one of entire indifference. Not even a ghost of a smile lights up his grim countenance. . . . [which] suggests the idea that Mrs. Columbus was watching her liege lord from the vessel near by."[46]

In the 1920s, the lunette, after being scraped to prepare the surface, was almost entirely overpainted with oil pigments by George B. Matthews, leaving an awkward-looking scene (fig. 6–30). Fortunately, Brumidi's fresco was discovered basically intact during the conservation treatment.

Fig. 6–27. *Authority Consults the Written Law. Enthroned Authority, robed in red, holds a sword and wears her attribute, a wreath of the three-pointed hastate leaf.* Over the door to S–131.

Fig 6–28. *Authority Consults the Written Law* as it appeared before conservation. *The top half of the central figure was drastically changed from Brumidi's design.*

Fig. 6–29. *Columbus and the Indian Maiden. With his rowboat and ship visible in the distance, Columbus lifts the veil of an Indian maiden, symbolizing the discovery of America.* Over the door to S–132.

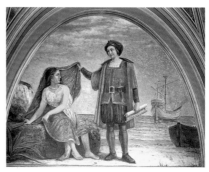

Fig. 6–30. *Columbus and the Indian Maiden* as it appeared before conservation. *Brumidi's fresco had been repainted with a spotty blue sky dotted with seagulls, a beach with sea shells instead of the spiky plants, and different colors and patterns for the clothing.*

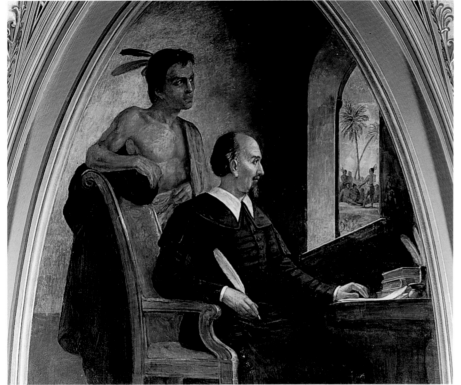

Fig. 6–32. *Bartholomé de Las Casas* **before conservation.** *Before it was cleaned of overpaint, the painting showed Las Casas holding a large piece of paper with the names of the men who painted over Brumidi's composition in 1928.*

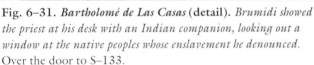

Fig. 6–31. *Bartholomé de Las Casas* (detail). *Brumidi showed the priest at his desk with an Indian companion, looking out a window at the native peoples whose enslavement he denounced.* Over the door to S–133.

Next to Columbus Brumidi painted Bartholomé de Las Casas, called "the apostle of the Indians" or "apostle of the Indies," a sixteenth-century Spanish missionary to Columbus's settlement Hispaniola (fig. 6–31). Las Casas was author of *The History of the Indies*, which only had recently been published at the time Brumidi painted him in 1876. For an unknown reason, Brumidi painted this lunette in oil directly on the plaster rather than in true fresco. Because of its deeper colors, the scene carries well as one descends the stairs opposite. This mural was also heavily overpainted in 1928 (fig. 6–32).[47]

Moving toward the center of the Capitol, the east-west inner corridor is decorated with eight oval medallions of landscapes on plain walls. In the bisecting narrower middle corridor are eight medallions of wild animal groups alternating with repeated red, white, and blue shields. During the recent conservation of these medallions it was discovered that Charles Ayer Whipple, who restored these areas around 1919, deliberately painted his own scenes over the originals, which have now been uncovered and conserved.

The main corridor opens into a square space between S–111 and S–139 which contains lunettes with monochromatic trophies of battered armor and weapons, attributed to James Leslie. The original tempera ceiling gives the effect of carved stone coffers with eagles and

wreaths (fig. 6–33); it is similar to areas Brumidi may have painted in the theater of the Villa Torlonia in Rome.

The story of repairs and restorations to the corridors is almost as complicated as that of their creation over time. Brumidi was requested to make repairs to the decorations of the north wing as early as 1861, and attention may well have been needed in the corridors.[48] The first major campaign of scrubbing the walls and repainting the plain backgrounds, which had "scaled," was carried out "in light colors" by William H. Duckstein in 1896 and 1897.[49] He may have painted the walls of the north entry at this time. A major campaign of retouching and sometimes complete repainting was gradually carried out by Charles Ayer Whipple from 1918 into the 1920s, and restoration continued in the corridors until 1935 (fig. 6–34).[50] In the 1920s, Whipple and George B. Matthews proudly signed and dated some of the repainted lunettes, after changing costumes and colors and adding their own details. Beginning in 1952 and continuing on and off for a decade, the walls were retouched and ceilings repainted under Francis Cumberland, Joseph Giacolone, and others.[51] Leaks created problems in a number of areas, including the Zodiac Corridor, which was "redesigned and painted" by Cliff Young in 1980.[52] In addition, minor repairs and retouchings have been constantly carried out as part of the routine maintenance of the building. Since

Fig. 6–33. Area with trophy lunettes and ceiling with illusionistic coffers. *The original tempera decoration of the ceiling remains mostly untouched.* Near S–111 and S–139.

1985, the focus has been on systematically restoring the corridors as much as possible to their original appearance.

With all of the attention paid to the first-floor Senate corridors, it is puzzling to learn that the matching House corridors received no similar decoration. A number of possible explanations for this imbalance suggest themselves. One factor was Thomas U. Walter's opposition, reinforced by criticism in the press, to classically inspired decoration in the Capitol. Another was the difference between the collective aesthetic sensibilities of the two houses of Congress: at this time, senators were not directly elected by the people, and the Senate was, therefore, a more elitist body than the House of Representatives and less prone to "populist" taste. Other, more pragmatic, reasons were budgetary and time constraints. However, the major reason for the overall imbalance in the number of rooms decorated was that the House wing was completed earlier than the Senate wing. When the appropriation bill was being debated in 1858 a representative pointed out that it was obvious that the money would go toward decorating the Senate side, since the interior decoration of the House rooms was "in such a state of forwardness that to stop them would be a waste of public money. In the other end of the Capitol, these are barely begun"[53] In any case, the first-floor corridors on the House side of the Capitol were left bare until a mural program was begun by the United States Capitol Historical Society in the 1970s.

Fig. 6–34. Charles Ayer Whipple repainting the Brumidi Corridors. *Whipple was one of several so-called restorers who painted over Brumidi's murals.*
From unidentified clipping, 1920, Architect of the Capitol.

Notes to Chapter 6

1. TUW to MCM, August 8, 1856, TUW/PA (AAA, reel 4137). Voucher no. 124, June 26, 1856, in Meigs's handwriting, signed by both Meigs and Brumidi, AOC/CO. *Annual Report of Capt. M. C. Meigs, in charge of the Capitol Extension,* 34th Cong., 3d sess., November 1856, Senate Ex. Doc. No. 5, v. 2, p. 217. Supply Orders, 1856 AOC/EXT.

2. MCMJ, August 4, 1856 (B–245).

3. CB to Senator Justin Morrill, November 30, 1874, AOC/CO. MCM to Mr. Denham, Disbursing Agent, April 3, 1857, AOC/LB.

4. CB to MCM, December 10, 1858, AOC/CO. CB to EC, July 20, 1866, NARA/RG 48, series 290, box 2.

5. MCM to Caleb B. Smith, June 5, 1862, NARA/RG 48, series 291, box 4.

6. TUW to CB, April 6, 1863, TUW/PA (AAA, Reel 4141).

7. Otto Lahayne to MCM, October 24, 1859, AOC/CO.

8. Uberti was a witness when Brumidi filed his naturalization papers. November 12, 1857, NARA/RG 21.

9. MCMJ, November 18, 1854 (A–311) and August 4, 1856 (B–245). MCM letter of recommendation for Carstens, March 18, 1859, AOC/LB. Carstens's Oath of Office, March 9, 1861, AOC/EXT.

10. E. Carstens to MCM, December 6, 1858, AOC/EXT.

11. MCMJ, May 15, 1856 (B–207).

12. MCM to James Leslie, December 9, 1858; MCMJ, August 28, 1856 (B–277); James Leslie to MCM, December 7, 1858; MCM to James Leslie, August 28, 1856; James Leslie to MCM, March 18, 1859; William J. Belshaw to "My Dear Friends," October 21, 1860. Correspondence in AOC/CO and AOC/LB.

13. MCM to F.C. Darley, September 18, 1856, AOC/LB; MCMJ, December 11, 1856 (B–362).

14. MCMJ, April 18, 1857 (B–525). "The Decoration of the Capitol," *New York Tribune,* May 17, 1858. E. Carstens to MCM, February 6, 1858, AOC/CO. Petition to MCM, May 7, 1858, and Roll of Persons employed in the Extension of the U.S. Capitol, November 18, 1858, AOC/EXT.

15. MCM to Louis Franze, December 18, 1856, AOC/LB, and Franze to MCM, December 18 and 29, 1858, AOC/CO. Lahayn to Briggs, March 26, 1859, AOC/CO.

16. MCMJ May 17, 1856 (B–211). May 15, 1856, Pocket Diary, MCM Papers, LC. The Sharp and Leslie proposal was received August 27, 1856, AOC/CO; see also: MCMJ, August 27, 1856 (B–275) and August 28, 1856 (B-276).

17. Brumidi may have included ideas for both the Naval and Military Affairs rooms in the sketch. Francis V. O'Connor, "Constantino Brumidi as Decorator and History Painter: An Iconographic Interpretation of Two Rooms," paper delivered at United States Capitol Historical Society Symposium, March 16, 1990. Samuel Chester Reid, captain of the *General Armstrong,* wrote to his son of the same name on January 12, 1856, about Brumidi's picture of the battle, Samuel Chester Reid Papers, LC. *Annual Report of Captain Meigs,* November, 1856, p. 220.

18. MCMJ, September 10, 1856 (B–288); October 31, 1856 (B–332); George R. West to MCM, December 10, 1856, AOC/CO; MCM to West, Dec. 12, 1856, AOC/LB. Ben Perley Poore remembered that "after he [West] had completed two he refused to submit to the military rule of Meigs, and stopped work." *Perley's Reminiscences,* vol. 1 (Philadelphia: Hubbard Brothers, Publishers, 1886), p. 495. For the subjects of the naval battles, see: MCMJ, October 6, 1856 (B–312), October 30, 1856 (B–331), and November 3, 1856 (B–334), and letter

from Samuel Chester Reid to his son, January 12, 1857, Samuel Chester Reid Papers, LC.

19. Camillo Bisco to MCM (in French), February 10, 1858, AOC/CO. CB to MCM, April 26, 1855, AOC/CO.

20. "The Decoration of the Capitol." The article may have misprinted "crampfish" for "crayfish."

21. MCMJ June 22, 1858 (C–352).

22. The blue background appears in Brumidi's sketch and also in early guidebook descriptions, such as DeB. Randolph Keim, *Keim's Capitol Interior and Diagrams* (Washington, D.C.: n.p., 1875), p. 52. The backgrounds appear light in plate 237 of Glenn Brown, *History of the United States Capitol,* Volume II (Washington, D.C.: Government Printing Office, 1903). Even as late as 1950 Murdock described them as "dark blue," Myrtle Cheney Murdock, *Constantino Brumidi: Michelangelo of the United States Capitol* (Washington, D.C.: Monumental Press, Inc.), p. 32.

23. "The Decoration of the Capitol."

24. This project won a 1984 Preservation Award from the Washington Chapter of the American Institute of Architects.

25. TUW to WBF, November 29, 1859, and TUW for the art commission, February 2, 1860, AOC/LB. On the first list, Brumidi's estimate of $1000 for frescoes in the Stationery Room was crossed out and changed to $500.

26. TUW to John B. Floyd, Secretary of War, December 21, 1857, AOC/LB.

27. Dr. John B. Ellis, *The Sights and Secrets of the National Capital* (Chicago: Jones, Junkin & Co., 1869), p. 82.

28. Study prepared for the Architect of the Capitol by Cunningham-Adams Fine Arts Painting Conservation, January 4, 1994, AOC/CO.

29. "The Senate Wing," Washington *Union,* June 9, 1858.

30. James Leslie to MCM, December 7, 1858, AOC/CO. Leslie reported that he began to paint pilasters in May, and was ordered to work on the ceiling in July, for a total of 4 months' work on the corridors.

31. On December 7, 1875, Carstens was paid $250.00 for this work, AOC/CO. This is the only section of the ceiling in the corridors that is specifically documented.

32. DeB. Randolph Keim, *Keim's Illustrated Hand-Book: Washington and Its Environs* (Washington, D.C.: n.p., 1874), p. 101. The Smithsonian collection of birds began in 1850 with a donation of 3600 birds by Spencer F. Baird; he also donated his extensive collection of animals, which was supplemented by those gathered on government and other expeditions. George Adams of Cunningham-Adams Fine Arts Painting Conservation, "Preliminary Identification and Comments on the Birds of the Brumidi Corridors, Senate Wing, U.S. Capitol," 1993, AOC/CO.

33. When elevators were installed, the pilasters at the end of the corridor were damaged and repainted, and murals on the end wall were destroyed or covered over. Frescoed lunettes in the vestibule of the eastern entrance have also disappeared.

34. W.B. Franklin wrote to Brumidi on September 8, 1860, suggesting the proper order of the zodiac signs, AOC/LB.

35. *Keim's Illustrated Handbook,* 1874, p. 101.

36. A request that Brumidi correct the spelling of Thomson's name establishes that some if not all of the portrait medallions were in place by 1865, TUW to CB, February 21, 1865, AOC/LB. All of them were completed by the time Keim described them in 1874.

37. Edward Clark ordered a Brady photograph of Story for Brumidi, per a voucher of July 5, 1877, AOC/CO. The portrait of Kent was

based on an engraving after a painting by Alonzo Chappel published in *National Portrait Gallery of Eminent Americans,* vol. 2 (New York: Johnson, Fry & Company, 1862), p. 39. Brumidi was paid $500 for painting the portraits on August 24, 1878, AOC/CO.

38. Information regarding the lithograph provided by George W. Adams.

39. The subjects of Franklin and Fitch were directed by Edward Clark, according to *The Evening Star* (Washington), February 25, 1876, p. 1. An oil sketch of Franklin is at the Corcoran Gallery of Art (Washington, D.C.), one of Fitch at the Western Reserve Historical Society (Cleveland, Ohio). There is also a portrait of Samuel F. B. Morse at the Corcoran, which may have been intended for the Fitch lunette. A small oil sketch of the scene with Fulton was published, but its present location is unknown; Fulton's likeness was said to be based upon a portrait painted by Fulton himself, according to *Keim's Illustrated Handbook,* 1874, p. 101. Before its restoration, the Fitch lunette was signed "Whipple 1926."

40. The Architect's report of November 1, 1874, stated that the lunette was done "from a sketch by Benjamin West," AOC/CO. West's 1783–1784 sketch was left unfinished. West's original study is in the collection of The Henry Francis du Pont Winterthur Museum. A copy of it, now in the Diplomatic Reception Rooms, U.S. Department of State, was owned by Lewis Cass, American Minister to France and later Secretary of State in Washington, and it could have been this version that Brumidi saw and copied. Senator Charles Sumner of Massachusetts left a copy of West's picture for Brumidi, according to *Keim's Capitol Interior and Diagrams,* p. 55. Brumidi changed the positions and identities of some of the figures. George B. Matthews signed his overpainting in two places, AOC/CO.

41. Brumidi painted the fresco in the summer of 1875, according to the *Evening Transcript* (Boston), April 23, 1875, p. 6, which first reported the title as the "Cession of Louisiana." The fresco, called *The Negotiation for the Acquisition of Louisiana* was completed by November 1, 1875, AOC/AR. Brumidi's 10 ½ x 21 ½ inch sketch for the lunette was published in an ad in *Antiques Magazine,* November 1980, but attributed only to "American School."

42. *Bellona* was completed earlier in 1875, AOC/AR. .

43. The identification as Lycurgus was given in "Art and Artists," *Evening Transcript* (Boston), February 29, 1876, p. 6. However, the writer described the central figure as Justice. The figures have the symbolic attributes described by Cesare Ripa, *Iconologia,* first published in

1593, and Gravelot and Cochin, *Iconologie par Figures,* 1791. The fresco is not specifically documented but was executed in 1875 or early 1876, since it was described as "recently finished" in the article.

44. The lunettes were conserved over a number of years: *John Fitch,* by Bernard Rabin, 1985; *The Signing of the First Treaty of Peace with Great Britain* and *Benjamin Franklin,* by Constance Silver, 1989; *Robert Fulton,* by Christy Cunningham-Adams, 1991; *Authority Consults the Written Law,* by Catherine S. Myers, 1991; *Columbus and the Indian Maiden,* by Constance Silver, 1991; the portraits of Chancellors Kent and Livingston and Justice Story, by Christy Cunningham-Adams in 1992; *Bartholomé de Las Casas* and *Bellona, the Roman Goddess of War,* by Catherine Myers, 1993; and *The Cession of Louisiana,* by Christy Cunningham-Adams, 1993.

45. Columbus was shown with an Indian maiden representing America in a monument by Lorenzo Bartolini in Milan and a similar one by Vincenzo Vela in Lima, which was published through an engraving (Constance Silver, "The Conservation Treatment of the Fresco *Columbus and the Indian Maiden,*" 1991, p. 2).

46. "Art and Artists." The author says that Brumidi copied his Columbus from a portrait and the ship from a drawing made by the explorer.

47. "New Pictures at the Capitol," *Evening Star* (Washington), February 23, 1876, p. 1, and "Art and Artists." The now-removed inscription read "Moberly/Matthews/Held/Weishautt/1928," AOC/CO.

48. CB to MCM, June 3, 1861, AOC/CO.

49. 1897 AOC/AR, p. 5, AOC/CO. "Painting the Capitol," *Evening Star* (Washington), October 8, 1897, p. 12.

50. C.A. Whipple to Elliott Woods, September 23 and September 25, 1918, AOC/CO. "Artist is Restoring Capitol's Great Paintings," *Sunday Star* (Washington), April 13, 1919, p. 1. See: AOC, Annual Reports of the Architect of the Capitol for 1919, 1920, 1921, 1922, 1923, 1924, 1926, 1929, and 1935. "Capitol Gets Redecorated," *Evening Star* (Washington), September 9, 1933.

51. *National Geographic,* vol. 102 (August 1952), p. 179. *Washington Post-Times Herald,* September 30, 1957. *Washington Post,* January 10, 1962.

52. Cliff Young to Florian Thayn, October 28, 1980, AOC/CO. Architect George M. White remembers that Cliff Young only made minor changes. Flaking paint was reattached in 1994.

53. *Congressional Globe,* June 7, 1858, p. 2760. Testimony of Rep. Dan Sickles.

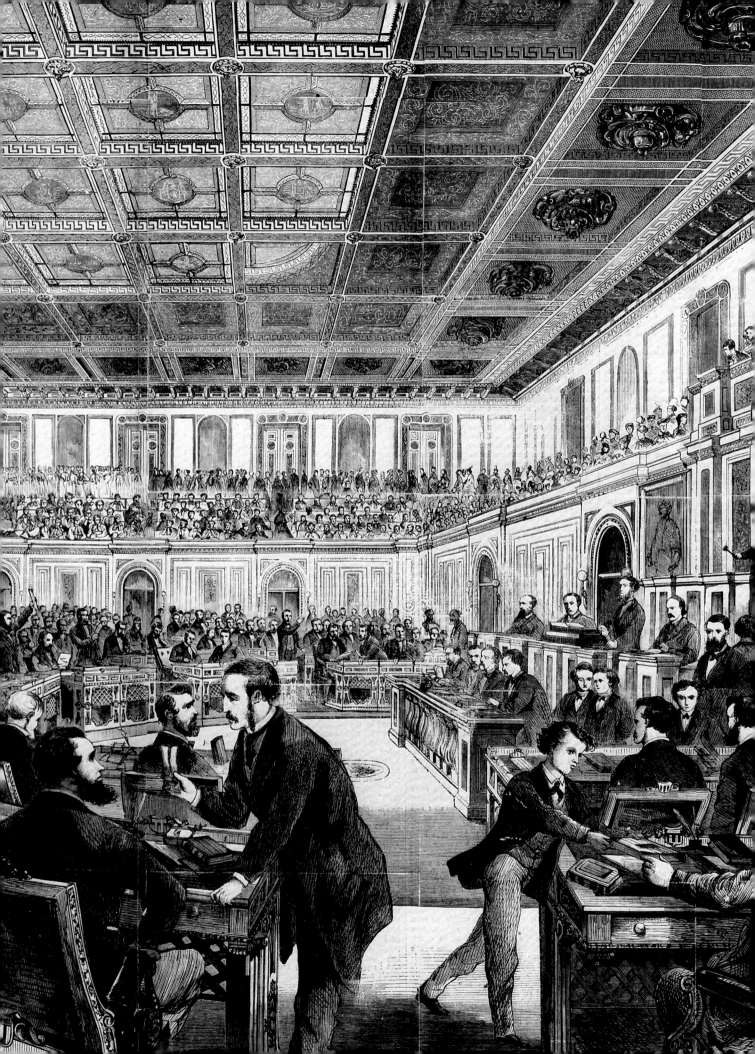

CHAPTER 7
Art and Politics

Fig. 7–2. Photograph of the Hall of the House showing Brumidi's *Cornwallis* fresco in situ, 1868. *The fresco at the far right remained on view here for almost a century.*
From a stereoscopic slide published by Bell & Bro.

By the end of 1857, when Brumidi had designed or begun painting murals in many areas of the Capitol, tensions over the decoration were escalating. As detailed in chapter 4, Architect Walter took issue with the way Supervising Engineer Meigs was having the new extensions decorated, once even commenting on "the hideousness of his ornamentation."[1] One of the few mural projects on which Walter and Meigs agreed was having Brumidi paint historical scenes in the new Hall of the House of Representatives. However, the single fresco Brumidi painted there proved to be a lightening rod for criticism. The struggle between Walter and Meigs for control over the construction of the Capitol was part of a broader climate of political upheaval, in which a new party, popularly called the Know-Nothings, gained brief ascendancy, stirred up criticism against foreigners, and lent support to the idea of a commission of artists in charge of selecting art for the Capitol.

Fig. 7–1. Theodore R. Davis, *Interior of the House of Representatives at Washington—The House in Session*, 1868 (detail). *This print shows the patterns on the cast-iron and stained-glass ceiling, but Brumidi's rich color scheme can be appreciated only through written descriptions.*
From *Harper's Weekly*, March 14, 1868.

The Hall of the House

Brumidi was responsible for designing various aspects of the decoration of the new spaces for the House of Representatives. He sketched bronze stair railings; cherub light sconces and classical patterns for the pilasters in the Speaker's Room (now the Members' Retiring Room, H–213); and possibly the decoration on the cast-iron ceiling of the lobby, now covered by later patterns. He may also have created designs for the House Post Office, now part of the Speaker's Office (H–209), with borders and pilasters filled with flowers, fruits, birds, and shields. The semicircular blank spaces on the ceiling may have been intended for frescoes.

For the new meeting place for the House, Brumidi was responsible for the colors of the red seat cushions and the color scheme for Carstens's designs, which Meigs described as "positive" and "strong." For the cast-iron ceiling beams supporting stained-glass panels with seals of the states, Brumidi selected primary colors—red, blue, and yellow—enhanced with areas of gold and bronze (fig. 7–1).[2] Meigs at first was unsure of the effect: "Brumidi is painting a portion of the ceiling of the House of Representatives in bright colors as a trial. I fear he will make it too gay for the use of the building. However, he knows much more of the laws of color than I do. . . ."[3] When Brumidi finished the sample, Meigs found the effect "magnificent. I am not quite sure that it is not too gor-

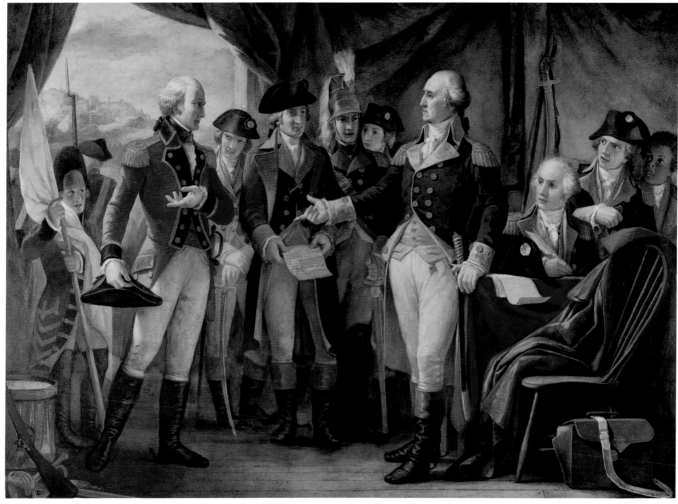

Fig. 7–3. *Cornwallis Sues for Cessation of Hostilities under the Flag of Truce, 1857. Brumidi showed General Washington surrounded by his staff and gesturing toward the British emissary sent by Lord Cornwallis, who is accompanied by a drummer boy holding the white flag of truce.* H–117.

geous, but I begin to think that nothing so rich in effect has ever been seen this side of the Atlantic," and he directed Brumidi to oversee the painting of the rest of the ceiling in the same way.[4]

Meigs's fears about the reception of the bold decorations were well founded. *Harper's Weekly* reported: "Some critics have caviled at the profuse and gaudy decorations of the new Hall The general effect, says one of the Washington correspondents, is dazzling and meretricious; one is reminded of a fashionable saloon in a gay capital, rather than the place of meeting of national legislators." However, the decoration received some praise as well: "The new Hall is certainly a complete success, and reflects the highest credit on those who designed it . . . it is a beautiful specimen of the art of interior decoration"[5]

To complete the decoration of the room, Meigs envisioned paintings of Revolutionary scenes in the panels on the lower walls. As of October 1, 1857, when the Hall was being readied for the representatives, the plastered walls were not dry enough to be painted in any medium other than fresco. Therefore Meigs directed Brumidi to

prepare a design for a fresco that could be finished quickly. Walter agreed with Meigs that the chamber should be embellished with fresco, because it would be more durable than oil on canvas, and he intended to have Brumidi fill all of the panels.[6]

By the end of October, Brumidi had selected as his subject General Washington receiving an emissary from Lord Cornwallis at the end of the Revolutionary War and was developing his sketch, with the aid of a profile portrait of George Washington that Meigs borrowed for him. By mid-December, Brumidi's scene in the southwest corner of the room was finished and attracting comment (fig. 7–2).[7]

In *Cornwallis Sues for Cessation of Hostilities under the Flag of Truce* (fig. 7–3), Brumidi depicted an event that took place in Yorktown on October 17, 1781. An aide to the British commander brought to Washington a letter requesting a twenty-four hour cessation of hostilities to

Fig. 7–4. Detail of the corner of *Cornwallis*. *Brumidi's inscription "C. Brumidi Artist Citizen of the U.S." is unique to this fresco. H–117.*

consider the terms of surrender. Washington, aware that the British fleet could arrive at any time, granted only a two-hour cease fire. His decision led to the surrender of Cornwallis two days later and to the end of the Revolutionary War.

On the strap of the dispatch case Brumidi proudly signed "C. Brumidi Artist Citizen of the U.S." (fig. 7–4). Just a few weeks earlier, on November 12, he had filed his final naturalization papers.[8] The unique inscription was undoubtedly a response to criticism of him as a foreigner. However, despite his legal citizenship, negative comments about the fresco fueled the controversy over the assignment to an Italian of so much work at the national Capitol.

The fresco was also attacked for its artistic quality. On December 14, an anonymous letter signed "Officious" was sent to Meigs, charging that "the wall painting—The Surrender of Cornwallis—is universally condemned. The subject is considered inappropriate & the execution execrable, in view of all which I suggest to you to have the painting wiped out." Meigs defended himself in a note written at the bottom of the letter: "One of many indications. The picture is as good as could be painted in 6 weeks[;] it shows to them what the effect of pictures in the panels will be which is all I believed[;] it cost little & I have not the least objection to a better painting being by Congress put over it but it is the best that could be done in the time & no more time was at my disposal."[9]

Two days later, on December 16, 1857, the House of Representatives met in its new chamber for the first time. Brumidi was never allowed to paint any other historical scenes in the chamber, and the panels were left filled with illusionistic molding. Later, in the 1870s, Congress

purchased landscapes by Albert Bierstadt to fill two of the spaces.

In 1950, the fresco was covered over during the remodeling of the Hall of the House. It was cut out of the wall and moved to the new Members' Dining Room (H–117) in 1961. Not surprisingly, the fresco sustained considerable damage, which was repaired by muralist Allyn Cox. It was professionally cleaned and restored in 1989.[10]

Know-Nothings and Critics

The reception of Brumidi's work was affected by national political turmoil as well as by the power struggle between Meigs and Walter. In the vacuum caused by the disintegration of the Whigs, the nativist American or Know-Nothing Party surged into prominence in the 1854 elections. Rooted in a small secret society popularly known as the Know-Nothings, because members replied only "I know nothing" when queried about their meetings, the American Party had a million members for a brief period near the beginning of the 34th Congress. The Know-Nothing movement peaked in 1855, when 51 members of the House identified themselves as American Party and 100 were listed as Opposition, compared with 83 Democrats. In 1856, former president Millard Fillmore ran as the presidential candidate for the American Party, which was in control of the local government in a number of cities, including the District of Columbia. Many local and east coast newspapers espoused its viewpoint.

The goal of the anti-immigrant, anti-Catholic American Party was to elect native-born Protestants, in reaction to the influx of poor Irish, who flooded the cities seeking work after the potato famine, and of "Forty-Eighters," political refugees from Italy and Germany, among whom Brumidi could be counted. The party proposed extending the waiting period for citizenship from five to twenty-one years. The party's sudden growth was augmented by fear of the growing political power and militancy of the Catholic Church and by the mistaken but widely held beliefs that the Know-Nothing Party opposed slavery and supported temperance.[11]

Tensions surrounding the Know-Nothing party affected Meigs, as construction superintendent responsible for hiring and contracting, despite his efforts to stay clear of politics. Although not personally sympathetic to the Know-Nothings, in 1855 he resisted pressure to fire the party's members among his crews, even though President Pierce "begged [him] not to appoint any of these miserable Know-Nothings. . . ." Later, the Know-Nothing vote became crucial to the appropriation for constructing the Capitol, and Meigs believed that Know-Nothings were behind the effort to remove from him control of the

art in the extensions.[12] It was a Know-Nothing, Representative Humphrey Marshall of Kentucky, who introduced a bill to create a commission to select art for the Capitol.[13] Thus, the criticism voiced during congressional debates of Meigs for hiring foreign-born artists and of Brumidi's art for not being American was clearly connected to the nativist and anti-immigrant stance of the Know-Nothing movement. Meigs commented that the New York *Express* "abuses me in the Know-Nothing interest" after an article appeared supporting the accusations about few American artists being hired at the Capitol, listing seventy-four names and claiming that only twelve could "be pleaded as Americans," and criticizing Meigs for his "adverse, pro-foreign will and favoritism."[14]

Overlapping the party politics was the indignation of many American artists who had not been hired to create art for the new extensions. Some had petitioned Congress for commissions even before construction started, and others had applied but been rejected. Now they saw foreign-born artists busy at work.[15] One of the most influential of the disgruntled artists was Henry Kirke Brown of New York (fig. 7–5), whose proposal for a pediment sculpture had been rejected by Meigs.[16] He was a leader of the American artists who petitioned the Congress. His congressman, one-term Democrat George Taylor of New York, led attacks against Meigs. The artist George West, whose work for the Naval Affairs Committee (S–127) had been found unsatisfactory, complained to Meigs that he felt it was his misfortune that he was not foreign-born.[17]

Another angry artist who stirred up feeling against Meigs was Johannes Oertel, an independent artist Meigs recruited in 1857 on the recommendation of John Durand, the son of painter Asher B. Durand and editor of the New York art magazine *The Crayon*. Meigs directed him to paint designs for the state seals for the stained glass ceiling of the House of Representatives, after having first asked him to make designs for the Senate Library (S–211). A year later, Oertel returned to that room to find Brumidi executing his own designs there. He complained to Meigs that there was "scarcely a single room of importance left which is not at present occupied or anticipated by Mr. Brumidi." Even though, in a Solomon-like move, Meigs offered to let him paint half of the library, Oertel resigned. Although Oertel himself was German born, his indignant letter to Meigs was used by the engineer's enemies to stir up resentment against him and Brumidi.[18]

Oertel's sponsor, *Crayon* editor John Durand, was also a leader in the push for an art commission, and he had urged in 1856 that American artists be employed in creating designs for the Capitol, even though he conceded that Americans were not trained in fresco painting.[19] In reply, Meigs defended his strong record in hiring American artists to create architectural sculpture for the Capi-

tol and pointed out his lack of authority to commission free-standing sculpture or framed pictures. He described to Durand the positive response to Brumidi's first work at the Capitol in the Agriculture Committee room. While expressing his interest in hiring American painters who would be willing to work at reasonable rates, he stressed the difficulty of finding an American with expertise in fresco or even in mural painting. He praised Brumidi: "The artist is engaged at a salary and his task and industry have been of great service to the building. I wish I could find an American his equal in modesty, in knowledge of art, in fertility and in speed. . . ." He firmly believed that "Brumidi is for our work better than any painter we have." [20]

The Washington Art Association, instrumental in making an art commission for the Capitol a reality, was founded in late 1856 under the presidency of the sculptor Horatio Stone, primarily to organize large national art exhibitions. Meigs perhaps shortsightedly declined an invitation to help organize the group because of limited

Fig. 7–5. Henry Kirke Brown, one of three artists appointed to the Art Commission formed in 1860. *The sculptor was one of Meigs's strongest critics.* Brady-Handy Collection, Library of Congress.

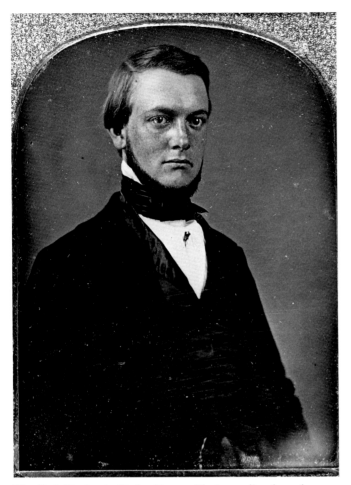

Fig. 7–6. Benjamin Perley Poore. *The journalist, shown here around 1850, verbally attacked the decoration of the Capitol in his articles published in a number of newspapers.* Library of Congress.

time.[21] The association eventually included among its members many of his enemies, such as Johannes Oertel, Peter Baumgrass, and George West, who had come into conflict with him and Brumidi at the Capitol. Speakers at the group's meetings included Thomas U. Walter and Representatives George Taylor and Horace Maynard of Tennessee, a member of the American Party, who criticized Brumidi's art and who worked closely with Horatio Stone. In February 1858, the day after Taylor had introduced a bill to create an art commission and to remove Meigs's authority over art for the Capitol, Stone gave an address and circulated a letter complaining that the decoration of the Capitol was in charge of an engineer instead of artists.[22] Stone's organization evolved into the National Art Association, which at its March 1858 convention prepared a "Memorial to Congress" petitioning for the formation of an art commission whose members would be "the channels for the distribution of all appropriations to be made by Congress for art purposes." Among the better known of the 127 signers were painters

Rembrandt Peale, Albert Bierstadt, George Inness, William Rinehart, and Thomas Sully.[23]

In May, the petition was accepted by the House and referred to a select committee of five, which included Humphrey Marshall and George Taylor, appointed on June 1, 1858.[24] Discussions of the decoration of the Capitol were most heated during the debates that month over funds for completing the Capitol in the appropriation bill for 1859, which was finally passed on June 12, 1858. Tensions were high because the previous appropriation for the Capitol had expired on April 30, and workers had been discharged.

The debate over the merit of the decorations of the Capitol took place in the press as well as on the floors of Congress. One of the most outspoken and eloquent critics of Brumidi's art was Benjamin Perley Poore (fig. 7–6). His Washington column for the Boston *Union*, a publication sympathetic to the Know-Nothings, and articles published and quoted in many other papers, including the *New York Tribune*, did much to articulate and foment criticism of Brumidi and other foreign artists. He published Oertel's letter against Meigs and called Brumidi "a dauber of speckled men and red horses in true oyster-saloon style," and he urged Congress to take the decoration away from "Meigs, Brumidi & Co."[25] He was probably the author of a series of stories on the decoration of the Capitol published in the *New York Tribune*, which were sharply critical of Meigs's direction:

> The best artists of the country, with scarcely an exception, have offered their services and asked to be employed upon the Capitol. Without an exception their applications have been rejected, and the work of decoration is going rapidly forward under the direction of an Italian whose reputation is little better than that of a skillful scene painter, and who employs under him a crowd of sixty or seventy foreign painters, chiefly Italians and Frenchmen.[26]

Meigs wrote in his own defense:

> The point that is made of neglect in employing American artists is unfounded and unjust. He [Meigs] has a national pride, and is gratified when he can assist native talent, and is not likely to overlook it when the public interest will be benefitted. It matters not where an artist is born: that is beyond his control.[27]

Between 1857 and 1860, in addition to the general concerns that foreigners rather than American artists were receiving commissions and that an engineer was making decisions about art, every aspect of Brumidi's decoration was criticized by members of Congress or the press. First, many people were uncomfortable with the ornate style of Brumidi's art, describing it as "flashy,

snobbish," "gingerbread and tinsel," and "inappropriate to a Republic," unlike the plainness and simplicity of the decoration of the old Hall of the House: "One sighs for something more in keeping with the gravity of the interests to be adjusted in that room, and the sober air which ought to pervade the debates of an American Congress." Benjamin Perley Poore ridiculed the decoration of the Senate Corridors:

> On passing through the corridors, and viewing the various committee-rooms in the north wing, on the one hand may be seen a group of imported artists, adorning the walls and ceilings with groups of figures, animate and inanimate—duopedal, quadrupedal, and multipedal—representing objects in heaven and on earth, and some which have no existence beyond the fertile brain of the delineator—in all the colors of the rainbow, and many others which are not in the rainbow—with flowers and fruit which could only have grown in Utopia—ornamented with scrolls, volutes, and circumvolutes; modillions and all other imaginable forms which can be made by the combination of straight lines, curved lines, and crooked lines, and covering every visible inch of surface, with the most lavish profusion, apparently with the idea that, as nature abhors a vacuum, so does the intelligent eye abhor a plain surface.

Representative Taylor complained: "We have expended already thousands of dollars on this contemptible decoration, which is disgraceful to the age and to the taste of the country . . . it is absolutely disgraceful." [28]

In addition to its ornateness, Brumidi's work was strongly criticized for not being sufficiently American. Another article, probably also by Poore, drew attention to the "foreign element" in *The Calling of Putnam from the Plow*: "The whole tone of the latter picture is Italian, not American. The landscape, the grouping, the attitudes and the expression, are of the Roman Campagna and not of Connecticut, as they should be. The foreign artist has done his best, with the aid of native pictures and engravings, to make the thing American, but he has succeeded no better than a Chinese artist succeeds in copying a Western painting. He copies with the most minute fidelity, but his work has still an inevitable strangeness of tone and feeling." [29] Even less charitable was an article in *The Crayon* ridiculing the ceiling of H–144, the Agriculture Committee room, as "loaded with a senseless tangle of finery, which entirely destroys the repose and dignity of the apartment. The eye and mind rest nowhere, but are harassed by images of flying, tumbling, and reclining Cupids, involved in a wilderness of garlands, in which, of course, there is no special reference to the American Flora." Despite singling out for praise the two small pic-

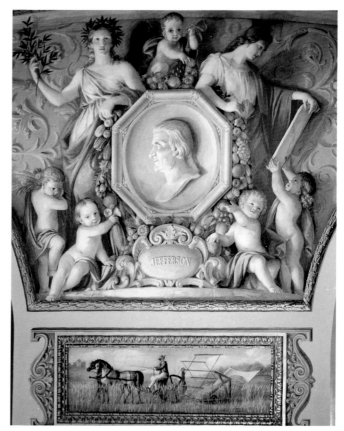

Fig. 7–7. South lunette in Agriculture Committee Room.
Critics approved of the scene of reaping wheat as American, but criticized the mythological figures as foreign. H–144.

tures showing methods of reaping (fig. 7–7), the writer otherwise decried the "bitter stupidity which overlooks this teeming life of a continent for Cupids and garlands." [30] Members said they wanted to see more of the national history and character, and some made specific suggestions, such as depictions of a variety of ships in the Senate Naval Affairs Committee room, or current agricultural methods in the House Agriculture Committee Room. Though far from averse to such subject matter, Meigs noted that he was constrained to carry out the decoration of the Capitol with an eye to practicality: "The idea of making everything in the Capitol express an American idea, that all must be of the highest order of art, is fine enough, but to accomplish it, where are the artists to do the work? In the meantime shall we not wish to use such appropriate decorations as will make the building beautiful and pleasant to the eye? This I have done, and tried not to leave the other undone." [31]

Brumidi's scenes in the Agriculture Committee room were also the subjects of comments during a heated debate over the agricultural appropriation on the floor of the House, and they were even used to bring up the question of slavery. Congressman Owen Lovejoy, chair-

man of the Committee on Agriculture and an abolitionist Republican from Illinois, suggested that not only maize and the western plow but also the contrast between free labor and slave labor should be depicted in the Agriculture Committee room.[32]

In addition to its subject matter, some critics attacked the quality of Brumidi's work, calling it mediocre and the artist himself incompetent, a creator of "tawdry and gaudy ornaments, vile in taste, poor in design and offensive in color."[33]

Beyond this range of criticism of Brumidi's art, some members saw art in general as an extravagance, superfluous to the construction of the wings: "All this ornamentation is surplusage; it can be better done afterward than now." [34]

As is often true, critics found it easier to lampoon Brumidi's work than to make a serious, informed assessment of its artistic quality. However, although in the minority, positive and supportive comments about his work did appear in print. In 1856, the *Crayon* was enthusiastic about the decoration of the Naval Affairs Committee room (S–127), reporting "its ceiling and walls are being most tastefully and fittingly frescoed and painted. Neptune, Amphitrite, the Tritons, and all the gods and goddesses of the deep find spirited representations somewhere on the walls of this unique room." The *New York Tribune* pointed out in regard to the House chamber: "Much of the unfavorable criticism on the decoration of the hall comes from the friends of inferior artists who could not get employed upon the work, and is the mere outpouring of envy and malice. Some of it, however, is from sheer ignorance." Later, in response to a strong attack published in the *Tribune* on May 17, 1858, Guglielmo Gajani, an Italian sculptor who had known and admired Brumidi in Rome, wrote a forceful letter to the editor in support of his compatriot's art. He first explained the skill needed to paint in fresco, and concluded: "I would challenge any man of sound judgment to enter the room of the Agriculture Committee without being struck by the good choice of the subject and the excellent execution."[35]

Senator Jefferson Davis wholeheartedly supported Meigs's decorative program, recalling the approval with which the Congress received Brumidi's work in the Agriculture Committee room (H–144): "It was not given by any vote, but it came to me in every other form that they wanted the building finished in the very highest order of modern art. One expression I recollect most distinctly was very general, that Brother Jonathan was entitled to as good a house as any prince or potentate on the face of the earth, and they wanted the best materials and best style of workmanship and highest order of art introduced into the Capitol of the United States."[36] Davis offered an amendment to protect the sculpture already begun, using language drafted by Meigs.

The Art Commission

Following the long and heated debates, funds for continuing the construction of the Capitol in 1859 were authorized by the 35th Congress on June 12, 1858, with a significant new condition imposed:

> Provided, that none of this appropriation shall be expended in embellishing any part of the Capitol Extension with sculpture or paintings, unless the designs for the same shall have undergone the examination of a committee of distinguished artists, not to exceed three in number, to be selected by the President, and that the designs which said committee shall accept shall also receive the subsequent approbation of the Joint Committee on the Library of Congress; but this provision shall not be so construed as to apply to the execution of designs heretofore made and accepted from Crawford and Rogers.[37]

Fortunately for Brumidi, decorative mural painting continued on the basis that it was part of the construction. The art commission authorized by the bill was not appointed for almost a year, until after the report of the House select committee of five was submitted on March 3, 1859. The select committee pointed out that the work had been carried out under a foreigner by foreigners and claimed to find "nothing in the design and execution of the ornamental work of the Capitol, thus far, which represents our own country, or the genius and taste of her artists." It disparagingly concluded, borrowing words from Walter's report, that a "plain coat or two of whitewash" would be preferable as a temporary finish to the "'tawdry and exuberant ornament with which many of the rooms are being crowded.'" Also on March 3, the appropriations bill for 1860 was passed, restating the proviso authorizing the art commission but in addition allowing "the completion of the painting of rooms in the north wing already painted."[38] Meigs took credit for influencing the wording of the final version of the bill to protect the art already begun.[39]

As authorized by the appropriations bills, on May 15, 1859, President Buchanan appointed to the United States Art Commission three artists recommended by the National Art Association: sculptor Henry Kirke Brown, portrait painter James R. Lambdin, and landscape painter John F. Kensett.[40] A month later, Meigs gave the members of the commission a tour of the work in progress. On November 1, 1859, however, he was replaced by Captain William B. Franklin, and much of the planned decorative work for the Capitol was stopped. Thomas U. Walter prepared a cost estimate for completing work in the extensions, "made in consultation with Mr. Brumidi,"

which he submitted to Captain Franklin; he also gave his estimates to the Art Commission.[41]

The United States Art Commission submitted its report on February 22, 1860, probably not coincidentally George Washington's birthday. The report echoed many of the criticisms heard in the halls of Congress and published by the press. It was pointedly critical of the art of "an effete and decayed race which in no way represents us" on the walls of the Capitol. Brumidi's qualifications were indirectly questioned in the statement: "It is not enough that the artist select an American subject for his work. He must also be imbued with a high sense of the nature of the institutions of the country, and should have a certain assimilation with its habits and manners." His classical sources were pointedly attacked:

> We are shown in the Capitol a room in the style of the "Loggia of Raphael;" another in that of Pompeii; a third after the manner of the Baths of Titus; and even in the rooms where American subjects have been attempted, they are so foreign in treatment, so overlaid and subordinated by symbols and impertinent ornaments, that we hardly recognize them.

They praised with reservations the decoration of the Senate corridors (fig. 7–8):

> Our chief delight in this survey is in a few nicely painted animals and American birds and plants, in some of the lower halls; and even here one familiar with foreign art sees constantly intermingled and misapplied symbols of a past mythology, but wanting in the exquisite execution and symbols of the originals.

The report also criticized the "display of gaudy, inharmonious color," which they judged "unsuited to the hall of deliberation, where calm though and impassion reason are supposed to preside." They recommended that the corridors be painted in flat colors.[42]

The art commission recommended expenditures totaling $166,900 to complete the decoration of the Capitol. Discussion of the report led to a heated debate on June 5, 1860, over taste in art in the House.[43] Criticized for the weakly stated recommendations contained in the report as well as for the high cost estimate, the commission, rather than being given the authority to select art it requested, was abolished on June 20, 1860. It had lost political support by this time: neither George Taylor nor Humphrey Marshall had been reelected to Congress; the Know-Nothing party had dissipated, and its antislavery members were being absorbed by the new Republican Party.

While the art commission prepared its report, even though Meigs had been replaced by Franklin and Carstens had been fired in 1859, Brumidi continued to work on murals already begun. Although he worked

Fig. 7–8. Detail from the Brumidi Corridors. *One of the few things in the Capitol that the Art Commission praised in its report was "a few nicely painted animals and American birds and plants, in some of the lower halls. . . ."*

without compensation from January to June 1860, he was finally paid retroactively in July, after the commission was abolished. Neither the brief-lived art commission nor the change in command derailed the decorative program Meigs had established, and Brumidi would continue to carry it out over the following two decades.

Notes to Chapter 7

1. TUW to Amanda Walter, August 10, 1858, TUW/PA (AAA reel 4138).

2. *Annual Report of Capt. M.C. Meigs, in charge of the Capitol Extension*, 34th Cong., 3d sess., November, 1856, Sen. Ex. Doc. No. 5, v.2, p. 217. Brumidi's designs were executed by Emmerich Carstens and his crews. Some parts of the decoration were also designed by Carstens himself. MCM, Letter of recommendation for Emmerich Carstens, March 18, 1859, AOC/LB.

3. MCMJ, October 21, 1856 (B–325).

4. MCMJ, November 13, 1856 (B–340).

5. "The Capitol Extension and New House of Congress," *Harper's Weekly*, February 6, 1858, p. 90. "The Latest News," *New York Tribune*, December 14, 1857, p. 4.

6. TUW to Rev. G.W. Samson, TUW/PA (AAA, reel 4138); MCM to CB, October 1, 1857, AOC/LB; "Local Intelligence: Capitol Extensions," *Evening Star*, September 17, 1857.

7. Meigs requested the loan of the portrait in a letter to Mr. James P. McKane, October 29, 1857, AOC/LB. Brumidi's working sketch was preserved by Lola Germon and was owned in 1950 by Mrs. Ashmun Brown, grandniece of Lola Germon. Myrtle Cheney Murdock, *Constantino Brumidi: Michelangelo of the United States Capitol* (Washington, D.C.: Monumental Press, 1950), p. 92. Brumidi was paid for 25 days of fresco work in November on December 4, 1857, Murdock, *Brumidi*, p. 108.

8. Naturalization papers, November 12, 1857, NARA/RG 21.

9. "Officious" to MCM, December 14, 1857, AOC/CO. The letter was misquoted in Murdock, *Brumidi*, 1950, p. 16; Meigs's comments were also slightly misquoted in Charles Fairman, *Art and Artists of the Capitol of the United States* (Washington, D.C.: Government Printing Office, 1927), p. 177.

10. The removal was described by Henri G. Courtais, "A Blind Approach to the Removal of Fresco," *Studies in Conservation*, 8 (February 1963). Also see the treatment reports by Allyn Cox, 1961, and Bernard Rabin, 1989, AOC/CO.

11. Charles Fairman first suggested the relevance of the Know-Nothings in a note, AOC/CO. The Know-Nothing fear that Catholics owed their first allegiance to the pope was heightened because the growing American Catholic Church, led by Archbishop John Hughes of New York, was demanding government support for parochial schools and actively seeking converts, while at the same time influencing the outcome of elections. See Tyler Anbinder, *Nativism and Slavery: The Northern Know Nothings and the Politics of the 1850s* (New York: Oxford University Press, 1992).

12. MCMJ, May 19, 1855 (A–557). For example, in 1855 a group called the Union Association objected to Meigs's hiring of a man fired at the Navy Yard for being a Know-Nothing, and resolved "that the retention in important positions of other <u>champions</u> of the Know-Nothing party by Capt Meigs is an outrage upon popular sentiment, unjust to the friends of the present administration, and ought to be corrected by Executive interposition." Resolution of Meeting of the Union Association of the City of Washington, September 11, 1855, AOC/LB. Meigs received letters accusing half a dozen men of being Know-Nothings, including foreman of the blacksmith shop Samuel Champion, who was accused of being a member of a "secret midnight order." July 13, 1855, AOC/LB and MCMJ, July 9, 1855 (A–606). MCMJ, February 3, 1858 (C–78).

13. *Congressional Globe*, 35th Cong., 1st sess., p. 638

14. MCMJ, May 7, 1858 (C–212); "Americus" (probably Benjamin Perley Poore); "American Artists at the New Capitol," *New York Express,* May 1, 1858. The list itself is an important document of the men decorating the Capitol and their rate of pay.

15. Lillian B. Miller, *Patrons and Patriotism* (Chicago: University of Chicago Press, 1966), p. 68.

16. MCMJ, December 15, 1856 (B–364) and May 25, 1858 (C–254).

17. George R. West to MCM, December 15, 1856, AOC/CO.

18. MCMJ, January 2, 1857 (B–386); Oertel to CB, April 23, 1858; Oertel to MCM, April 17, April 22, and April 27, 1858; Johannes A. Aertel [*sic*], "A Letter to Captain Meigs," April 27, 1858, published in *The States*; MCM to Oertel, April 23, 1858; CB to MCM April 26, 1858, AOC/CO. MCM to CB, June 21, 1858, AOC/LB.

19. "Sketchings—The Capitol Extension," *The Crayon*, October, 1856, p. 311; see also "The Leader," *The Crayon*, July 1855, p. 26.

20. MCM to J. Durand, October 11, 1856, AOC/CO; MCMJ, March 26, 1855 (A–502).

21. MCMJ Nov. 3, 1856 (B–334 and B–335).

22. Josephine Cobb, "The Washington Art Association: An Exhibition Record, 1856–1860," *Records of the Columbia Historical Society of Washington, D.C., 1963–1965* (Washington, D.C.: Columbia Historical Society, 1966), p. 130.

23. Select Committee, *American Artists*, 35th Cong., 2d sess., March 3, 1859, H. Rept. 198, Appendix A.

24. The other members were Laurence M. Keitt of South Carolina, Edward Joy Morris of Pennsylvania, and George H. Pendleton of Ohio, *Congressional Globe*, 35th Cong., 1st sess., May 31, 1858.

25. Perley [Benjamin Perley Poore] , "The Old Capitol," letter to the editor of the *Boston Journal* dated November 25, 1857, MCMJ, December 2, 1857 (B–768). Poore's articles appeared in *The States*, *New York Express*, and *New York Tribune*. He was at the same time Clerk of the Senate Printing Committee and editor of the Congressional Directory.

26. "The Decoration of the Capitol," *New York Tribune*, May 17, 1858.

27. *National Intelligencer* (Washington), May 24, 1858.

28. Perley, "The Old Capitol"; "The Capitol Extension and New House of Congress," *Harper's Weekly*, February 6, 1858; "The Capitol Extension," *The Union*, June 11, 1858; *Congressional Globe*, 35th Cong., 1st sess., p. 2759.

29. "The Decoration of the Capitol."

30. "Sketchings: Art on the Capitol, Washington," *The Crayon*, October 1858, p. 296.

31. MCMJ, August 4, 1859 (C–903).

32. *Congressional Globe*, 35th Cong., 1st sess., May 19, 1858, pp. 2243–2244.

33. *New York Express*, April 24, 1858, and June 16, 1860; "The Decoration of the Capitol."

34. *Congressional Globe*, 35th Cong., 1st sess., May 28, 1858, p. 2464.

35. "The Decoration of the Capitol"; "The Decorations of the Capitol," *New York Tribune*, May 31, 1858.

36. "The Ceiling of the New House of Representatives," *The Crayon*, December, 1856, p. 377; *New York Tribune*, December 15, 1857; "The Decorations of the Capitol"; *Congressional Globe*, May 28, 1858, 35th Cong., 1st sess., p. 2462.

37. *Statutes at Large of the United States of America, 1789–1873* (Washington: 1850–1873) vol. 11, p. 323.

38. Select Committee, *American Artists*, 35th Cong., 2d sess., March 3, 1859, H. Report 198; *Statutes at Large*, vol. 11, p. 428.

39. MCM to Henry Dexter, March 18, 1859, AOC/CO.

40. James Buchanan, letter of appointment, May 18, 1859, AOC/CO. For the history of the art commission, see: Miller, *Patrons and Patriotism*, chapters 6 and 7.

41. MCMJ, June 24, 1859 (C–827). TUW estimate, November 26, 1859, TUW/PA (AAA reel 4146); TUW to WBF, November 29, 1859, AOC/LB; TUW "Notes for Art Commission," February 2, 1860, AOC/LB.

42. *Report of United States Art Commission*, Ex. Doc. No. 43, House of Representatives, 35th Cong., 1st sess.

43. *Congressional Globe*, 36th Cong., 1st sess., pp. 3043–5.

CHAPTER 8
"Gems of the Capitol"

Fig. 8–2. *Design for Ceiling of Senate Library.* *Brumidi worked out the details for the ceiling room, now S–211, in his 1857 pencil sketch. However, before the fresco was completed, the room had changed function, and "Print" and "Philosophy" were not used.* Library of Congress, Prints and Photographs Division. Photo: Library of Congress.

Despite the atmosphere of political controversy and disruptions, the years between 1857 and 1860 were among Brumidi's most productive, in terms of both design and execution. He painted frescoes in several important rooms and completed the decoration of the President's Room, which has always been considered "one of the gems of the Capitol."[1] During this period he and Meigs laid out the plan for all of the Capitol murals. By 1859, Brumidi had designed virtually all of the murals he would paint at the Capitol through the end of his life.

Under the direction of Thomas U. Walter and W. B. Franklin, work moved forward as funds were available. Brumidi continued to work in a number of rooms at once. The execution of the designs proceeded with stops and starts, at some points because of lack of money for supplies. Sometimes there were long intervals between campaigns. Given the many interruptions in carrying out these projects, it is surprising how great a sense of unity Brumidi was able to create.

A long-standing misconception to be dispelled about Brumidi's working methods is that he deliberately left blank areas so that future events could be depicted. On the

contrary, as has been seen in the case of the Naval Affairs Committee room (S–127) and as will be seen in this chapter, Brumidi made designs for these areas; they were left unexecuted only because of financial and time constraints. The artist struggled for decades to convince those in charge to allow him to finish his planned decorations.

Brumidi's role in decorating the Senate Chamber was limited, for Walter stopped the gilding that he had started there. The senators preferred a meeting chamber much more sober in design than that of the House, but they apparently appreciated Brumidi's elaborate designs for other rooms in their new wing (figs. 8–1 and 8–2). Walter's November 1859 cost estimate, "made in consultation with Mr. Brumidi," and his February 1860 notes for the United States Art Commission listing all expenditures on "works of art and art decoration," are valuable documentation of the murals in progress at the time.[2] They show that Brumidi was working on an impressive number of projects, including making a design for bronze stair railings, advising on furniture colors for the Senate Chamber, and designing a never-realized sculptural clock for the Senate Chamber (fig. 8–3). He was designing or executing frescoes in the Stationery Room (S–210) (see fig. 6–14), the Senate Post Office (S–211), the President's Room (S–216), the committee room for Military Affairs (S–128), and the Senate Reception Room (S–213). He was also involved in never-executed designs for the Post

Fig. 8–1. Room intended for the Senate Library. *On the ceiling, Brumidi depicted fields of knowledge set in an illusionistic frame, with life-like groups of figures on pedestals in the corners.* S–211.

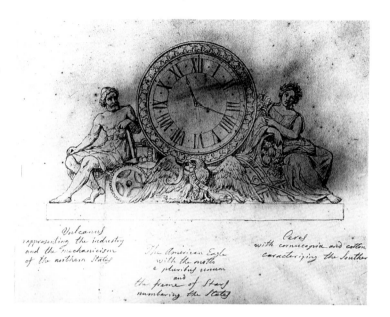

Fig. 8–3. *Proposal for a clock for the Senate Chamber,* c. 1859. *Brumidi's unrealized design included bronze figures of Vulcan, representing, in the artist's words, "the industry and the mechanism of the northern States," and Ceres, "with cornucopia and cotton flowers caracterizing [sic] the Southern States."* Montgomery C. Meigs Photo Album, Architect of the Capitol.

Office Committee room (S–117), the Indian Affairs Committee room (S–132), and the Ladies Waiting Room, now part of the third-floor Senate Press Gallery (S–313A). In 1859, the work remaining for the Senate first-floor corridors was so extensive that an estimate of $20,000 was given to finish them, including the frescoes.

S–211

For the decoration of the room intended for the Senate Library, now the Lyndon B. Johnson Room, Captain Meigs envisioned "groups of history, legislation, etc.," commenting in 1857, "I hope to make this a beautiful room."[3] Brumidi completed the rich and harmonious decorative scheme representing fields of knowledge only after ten years and several interruptions (see fig. 8–1).

Brumidi submitted a design for the ceiling to Meigs on February 16, 1857, which depicted *Print* and *Philosophy* along with the *Geography* and *History* that he later executed (see fig. 8–2). He later painted detailed oil sketches for the lunettes. He decided to create semicircular fields imitating framed paintings, with groups of figures in the corners that appear to support the weight of the ceiling.[4] Meigs asked Johannes Oertel to prepare designs for the room, but judged his figures too large for the space, and diverted him to another assignment. Oertel was later dismayed to find that Brumidi had begun his own frescoes. By the spring of 1858, Brumidi had finished the lunette *Geography* and one corner group, and Camillo Bisco, one of his Italian assistants, had painted the decorative borders.[5] By the time the Senate moved into the new extension in 1859 the room had become the Senate Post Office, containing a glass-and-walnut post office with a box for each senator.[6]

In 1862, Brumidi submitted estimates for completing the still unfinished room, but no action was taken. In 1866, at the urging of the chairman of the Committee on Public Buildings and Grounds, Architect of the Capitol Edward Clark asked the artist to submit new estimates. Clark thought that Brumidi's figure of $2,000 per ceiling panel was "unreasonably high," and the artist agreed to perform the work at his earlier rate of $1,500. He also agreed to paint the remaining three-quarters of the ceil-

ing for a total of $4,989 under protest, claiming that his proposed fees were very reasonable in comparison with the $20,000 paid in 1862 to Emanuel Leutze for his mural *Westward the Course of Empire Takes Its Way* in the House stairway. With the help of Alberto Peruchi and Urban Geier in preparing cartoons and mixing colors, Brumidi finally completed the ceiling in 1867.[7]

The center of the ceiling contains a trompe l'oeil medallion of acanthus leaves with striped shields in the corners. Borders of morning glories on dark red fields encircle the four lunettes. In the corners are groups of three figures, the central one a canephore, a figure holding a basket of flowers on its head (fig. 8–4). Visually, they function as caryatids, figures used as columns supporting architectural weight. Although Brumidi once described them as the "months of the year," significant differences among the individual figures are not apparent, with the exception of the group of three males wearing wreaths of laurel, flowers, and wheat.[8] The male group was undoubtedly the one painted in 1858; the style is more delicate, the musculature more detailed, and the modeling of light and dark more subtle than in the figures in the other corners. The three female groups vary in their poses. With their arms intertwined, gazing out to the viewer, they recall the classical Three Graces. Overall, they express abundance and growth. Eagles rest at the feet of each group, flanking the elaborately decorated pedestal on which the figures stand.

The four ceiling lunettes contain scenes focusing on female allegorical figures. Each is composed within the lunette like an easel painting; the figures do not project illusionistically into the viewer's space.

Geography, sitting on clouds, leans over as if to look out over the world (fig. 8–5). She wears a richly brocaded

Fig. 8–4. Corner figure groups. *The group of three male figures undoubtedly dates from 1858 because it is next to the first lunette Brumidi completed and is painted in more detail than the female groups in the other corners. S–211.*

Fig. 8–5. Geography. *The central figure points to a globe with a pair of dividers. One of her winged assistants spreads out a map of the New World, while the other holds a protractor and a miniature locomotive. S–211.*

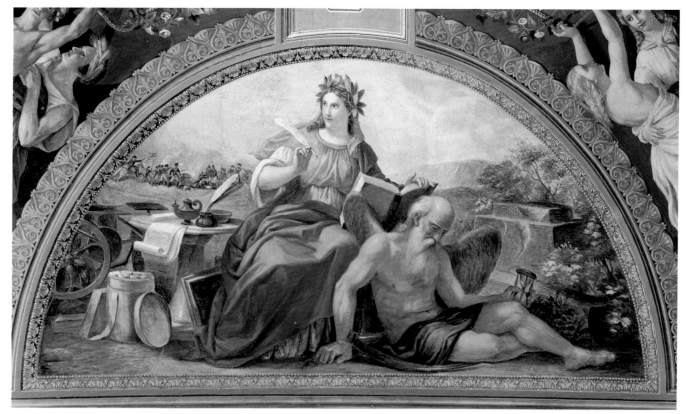

Fig. 8–6. History. *The figure representing History, crowned with the laurel wreath of fame, records the story of the Revolutionary War battle raging in the distance. Her book is propped against Father Time. S–211.*

skirt and a headdress with a strap around her forehead and under her chin. A similar figure appears in an engraving that belonged to Brumidi of a ceiling at Versailles (see fig. 1–14). *History* is depicted with an oil lamp, inkpot and quills, and documents on a pedestal table; a framed picture, a cylindrical box with scrolls, and a printing press are on the ground beside her (fig. 8–6). By her knees sits Father Time, an old man with wings who holds an hour glass; next to him is his sickle. The chipped empty stone pedestal behind him also suggests the passage of time, as well as the transitory nature of fame.

The fresco *Telegraph* may relate to the function of the room as the Senate Post Office (fig. 8–7). It closely follows Brumidi's oil sketch, *Telegraph [America Welcoming Europe: The Completion of the Laying of the Transatlantic Cable]* (fig. 8–8).[9] Europa, at the left, sits astride a bull (the form in which Jupiter, the king of the gods, disguised himself). She shakes hands with America, who sits at the edge of the sea, while a cherub holds the telegraph cable laid between England and America in 1866. America wears a phrygian, or liberty, cap wreathed with the oak leaves of strength, and chest armor for protection. She holds the caduceus, the symbol of Mercury, god of commerce, and leans on an anchor. Next to her are an

eagle bearing an olive branch of peace, a flag, ramrods, and a cannon, on which lies a cornucopia of fruit. The objects amassed around the symbol of the New World on the shore give her greater weight and importance in the composition than the figure of Europa in the water.

In the scene entitled *Physics* (fig. 8–9), Brumidi shows how the science has been applied to creating new modes of transportation. Physics is seated, resting one elbow on a pedestal, examining a chart; to her right stands a boy in a sailor suit. Next to her is a plane table, an instrument on a tripod used for plotting survey lines. Behind the group are a paddle-wheel steamboat and steam locomotive crossing a bridge, as seen in Brumidi's 1853 painting *Progress* (see fig. 5–4). A blacksmith, whose muscular back is turned to the viewer, holds a hammer; beside him are an anvil and iron locomotive wheels he has made.

The wall lunettes are decorated with shields and rinceaux. The lower wall panels, defined by illusionistic moldings, were originally decorated with a damask pattern of shields and trompe l'oeil marble relief. The lower walls are finished with scagliola.

The room served as the Senate Post Office until 1869, when it became the meeting place for the District of Columbia Committee. In 1958 it was assigned to Majority

102

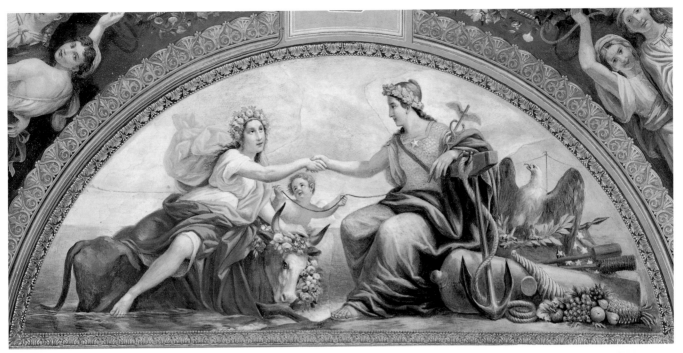

Fig. 8–7. *Telegraph. Figures symbolizing Europe and America shake hands, representing the bringing together of the continents by telegraphic communication after the laying of the transatlantic cable.* S–211.

Fig. 8–8. Sketch for *Telegraph,* c. 1862. *Brumidi followed this oil sketch when he painted the fresco* Telegraph, *changing only minor details.* United States Senate Collection. Photo: Senate Curator.

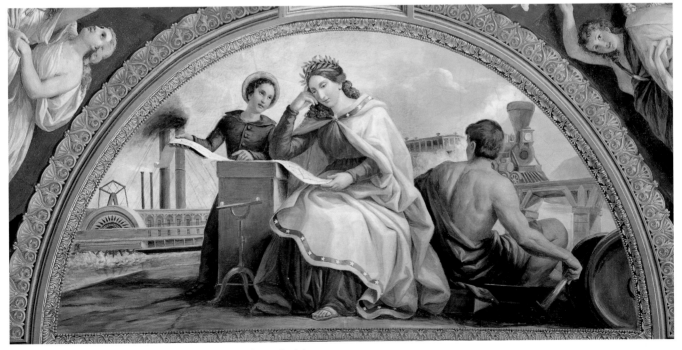

Fig. 8–9. *Physics. Wearing a wreath and a cape trimmed with stars, Physics studies a long scroll, at which a boy dressed as a sailor points. One of Vulcan's blacksmiths sits on the right; a steamship and steam locomotive appear prominently in the background.* S–211.

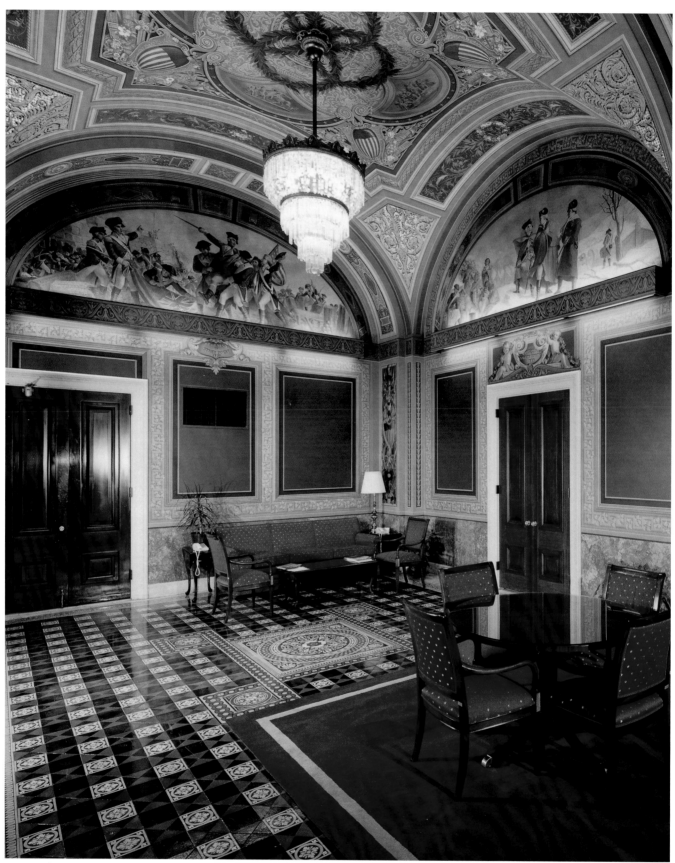

Fig. 8–10. Room designed for the Senate Military Affairs
Committee. *The theme of the decoration is the American
Revolution. Brumidi contributed the overall design and the
frescoes, and James Leslie painted the trophy panels.* S–128.

Leader and later Vice President Lyndon B. Johnson, after whom it was named in 1964. In recent years, the room has been used for Senate meetings such as party caucuses and conferences.

Repairs to the decoration were made in 1900 and 1901. In 1947, the frescoes may have been cleaned and coated with "mastic, a type of varnish."[10] The wall panels have been painted over in solid color. Some features, such as the gilded mirror and valances, were renovated in 1988. The murals have not yet received conservation treatment because they are in relatively good condition.

S–128

The room originally designed for the Senate Committee on Military Affairs and Militia was decorated over a span of fifteen years (fig. 8–10). In 1856, Meigs was advised by the illustrator Felix O. C. Darley: "The best subjects for the room of the Committee on Military Affairs would be scenes from the Revolution when Washington or his principal generals could be introduced, such as the Storming of Stony Point, the Battle of Trenton, &c." Although Darley expressed willingness to prepare designs in ink, he said that Meigs needed a fresco painter to execute them.[11] There is no evidence that Darley actually sent sketches to Meigs. In late 1857, Emmerich Carstens wrote to Meigs that "the work to be done on the walls of the Military Committee room can only be done by Mr. Brumidi himself and by Mr. Leslie who is at work now on the pannels [sic] to paint the arms. . . ."[12] Leslie finished the trophies by the end of 1857.[13] Brumidi apparently began working after Leslie had completed his part. Early in the next year, before Brumidi started his frescoes, Camillo Bisco painted the perspective frames around the lunettes.[14]

Brumidi first prepared small oil sketches for the frescoed lunettes (fig. 8–11). In 1858, he frescoed two scenes, *Battle of Lexington* and *Death of General Wooster, 1777*, but because the committee, then under the chairmanship of Jefferson Davis, wanted to use the room, he was not able to complete the other three. He had prepared oil sketches for four additional scenes, of which only *Storming of Stony Point, 1779* was executed later. In the frescoes he executed, he closely followed the oil sketches, making only slight compositional adjustments. The three scenes that were not executed are entitled on the oil sketches "General Mercer's death by bayonet stroke," "Death of General Montgomery," and "The Americans at Sagg [sic] Harbour, burned twelve brigs and sloops and [illegible] with him many prisoners."

In 1871, Senator Henry Wilson, who had been chairman of the committee during the Civil War, requested that the decoration of the room be completed while Brumidi was still alive. He wrote to Edward Clark, "It has occurred to me that it is quite desirable to employ the same artist. . . . Mr. Brumidi is getting old."[15] Wilson was consulted about the subjects for the last three lunettes, and two new subjects were executed: *The Boston Massacre, 1770* and *Washington at Valley Forge, 1778*; oil sketches for these have not been located. Brumidi, then in New York, heard that there would be a congressional recess and expressed eagerness to get to work. In October 1871 he was paid $1,000 for each lunette plus $100 for each of three groups of children over the doorways.[16] Other small paintings on the ceiling were added later.

As completed, the room is ornately decorated with scenes and details related to the Revolutionary War. The ceiling contains shields; emblems of war and peace, such as wreaths of victory, weapons, and fasces; and small grisaille illusionistic sculptural groups with historic scenes depicting subjects such as the "Death of General Montgomery" (fig. 8–12), the "Boston Tea Party," and the "Surrender of Cornwallis." Several of the compositions were derived from unused lunette designs or from scenes sketched for the frieze, including "Colonel Johnson and Tecumseh." Gold leaf applied under intricate rinceaux and diamond patterns in the pendentives creates a rich, mosaic-like effect.

Brumidi's five frescoed lunettes are the focal points of the room. His compositions work effectively in the lunette shape, with the main figures at the center, balanced by landscapes or groups of figures in the corners. On the south wall, over the door into S–129, is one of the lunettes painted in 1858, *The Battle of Lexington* (fig. 8–13). Brumidi created a sense of the tumult and noise of the battle by effective use of diagonal lines and swirling smoke, closely following his oil sketch (see fig. 8–11).

To the left of the door is *Washington at Valley Forge, 1778* (fig. 8–14). This scene, one of those Brumidi painted in 1871, is the most quietly dramatic; only the blowing capes and scarf appear to be in motion. Brumidi's technique of using thick paint, or *impasto*, is very visible in the snow.

The west wall is filled with ornate gilded valances and the mirror over the marble mantel. The mirror frame, specially made for this room in 1859, contains images of military equipment such as drums and muskets.[17]

Over the north wall is *The Boston Massacre, 1770* (fig. 8–15). Brumidi based the scene on Paul Revere's famous engraving of the event in which British soldiers fired on a mob of citizens in front of the Old State House (fig.

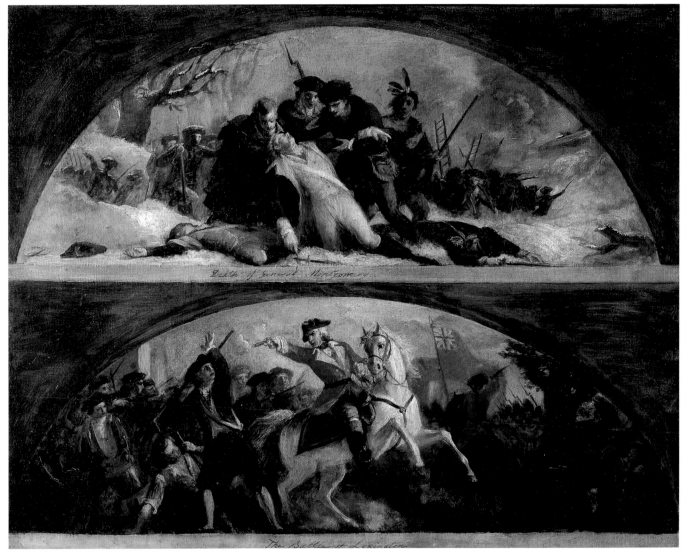

Fig. 8–11. Oil sketches for *Death of General Montgomery* and *The Battle of Lexington*. *Brumidi created these compositions for lunettes in the Military Affairs Committee room. Only the lower scene was executed in fresco.* Collection of Edna W. Macomb.
Photo: Diplomatic Reception Rooms, U.S. Department of State.

8–16). He changed the composition, however, and depicted an earlier point in the event to emphasize the heroism of Crispus Attucks, an escaped slave, by making him the central figure. This may be because Brumidi painted this lunette during the Reconstruction period. As in Renaissance altarpieces, the curved pediment over the doorway of the Old State House suggests a halo over the martyr's head. At the left, closely based on Revere's print, are two of the other victims. Brumidi also included men throwing snowballs, representing the Boston boys who taunted the British soldiers. Brumidi's symmetrical composition is more static and stiff than those he had designed earlier for the room.

Death of General Wooster, 1777 (fig. 8–17) is inscribed on the oil sketch, "General Wooster at Ridgefield mortally wounded is carried out of the field." Brumidi composed the dying general, whose shoulder and arm are bare, like the body of Christ in a Renaissance Pietà. In this scene, Brumidi created a dramatic contrast between foreground and background spaces and a sense of a quiet, reverent moment in the midst of the battle.

Finally, over the door to the corridor is *Storming of Stony Point, 1779* (fig. 8–18). Brumidi inscribed his sketch "Storming at Stonypoint, General Wayne wounded in the head carried to the fort." The battle at which "Mad Anthony" Wayne was wounded revived the spirits of the

Fig. 8–12. "Death of General Montgomery." *One of eight small scenes painted on the ceiling to look like stone reliefs, this one is based on Brumidi's unused oil sketch for a lunette. S–128.*

Fig. 8–13. *The Battle of Lexington. At the center of the composition is a British officer on a rearing white horse, firing on the Minutemen to the left; this event on April 19, 1775, marked the beginning of the War of American Independence. S–128.*

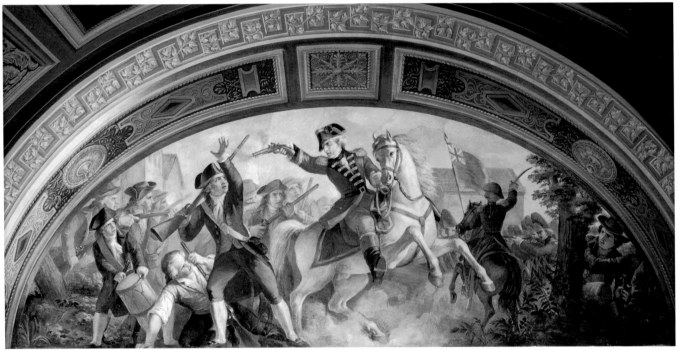

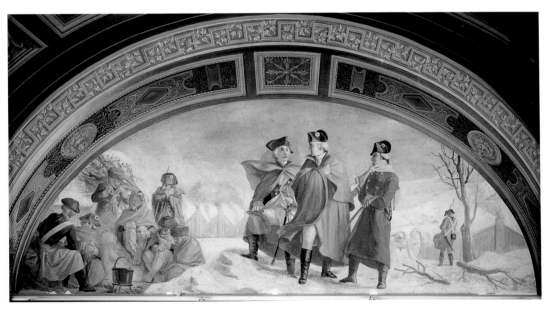

Fig. 8–14. *Washington at Valley Forge, 1778. General Washington is shown with his officers standing on a snowy incline, while his troops huddle around a fire at the left. The bare branches emphasize the sense of cold and suffering. S–128.*

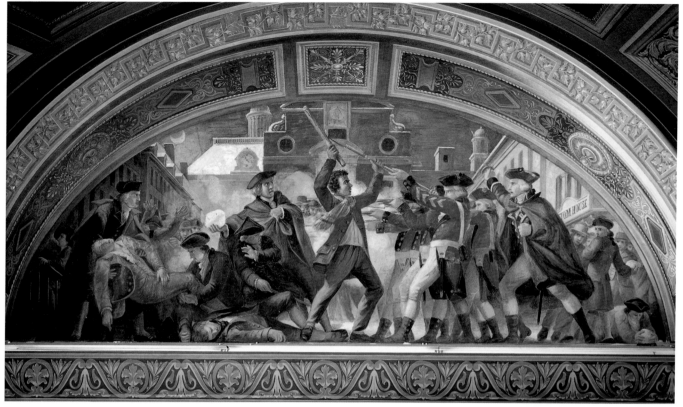

Fig. 8–15. *The Boston Massacre, 1770.* Brumidi depicted Crispus Attucks in the moment just before he was fatally shot by the British Captain Thomas Preston. Attucks is shown raising his only weapon, a piece of firewood, and grasping the barrel of a soldier's musket. S–128.

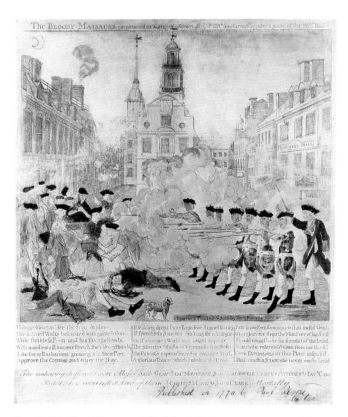

Fig. 8–16. Paul Revere, *The Bloody Massacre perpetrated in King Street Boston on March 5th 1770, by a party of the 29th Reg[.]* Brumidi used many engravings in creating images for the Capitol. As in this case, he often rearranged the compositions. Library of Congress.

Continental Army and prevented the British from dividing New England from the rest of the colonies. The composition is tripartite, with the fort on the left, and the British and American flags used to add color and drama.

Under four of the lunettes are illusionistic plaques holding the title of the scene, flanked by cherubs with garlands of flowers. Plain panels, probably originally blue but now dark green, framed with leafy designs fill the walls.

On the pilasters are six intricately detailed trophies of arms painted by James Leslie, with specific military implements of various historical periods, shields of the United States, and military medals. Each trophy contains different objects, among them George Washington's sword in the panel on the north central pilaster (fig. 8–19).

This room did not receive the negative criticism that its neighbor, the Naval Affairs Committee room (S–127), did, since its themes are so clearly American. In his eulogy for Brumidi, Senator Daniel Voorhees praised the decorations, asking the rhetorical question: "Who ever passed through the room of the Committee on Military Affairs without feeling that the very genius of heroism had left there its immortal aspirations?"[18]

108

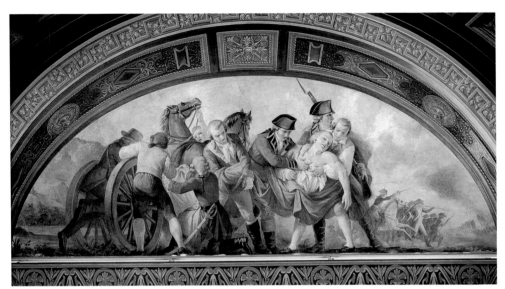

Fig. 8–17. *Death of General Wooster, 1777. This event followed the burning of the unprotected town of Danbury, Connecticut, by British troops. The American leader of the Continental Army, General David Wooster, was mortally wounded during the counterattack.* S–128.

Fig. 8–19. Trophy panel by James Leslie. *This is one of six different illusionistic groupings of weapons and accoutrements of war painted by the English artist in convincing detail.* S–128.

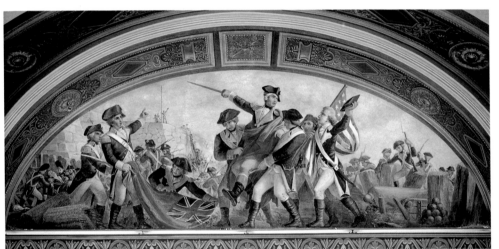

Fig. 8–18. *Storming of Stony Point, 1779. General "Mad Anthony" Wayne had made a daring midnight raid on the British garrison overlooking the Hudson River and captured enemy ammunition and supplies. He is shown with his head bandaged, being carried victoriously by his soldiers.* S–128.

The room was used by the Military Affairs Committee until it was assigned to the Appropriations Committee in 1911. Recorded alterations to the decoration of the room include a cleaning and touching up by Charles Moberly in 1919, the channeling for air-conditioning ducts and addition of bookcases around 1936, and the dividing of the room in half with a wooden partition in the 1940s. In 1979 the room was returned to more of its original appearance by the removal of the partition and bookshelves, the camouflaging of the ducts, Cliff Young's cleaning and repair of the lunettes, and the retouching of the ceiling. The murals await more extensive professional cleaning and conservation.

109

Fig. 8–20. North end of the Senate Reception Room. *This end of the room, dominated by the allegorical figures in the vaults, has been cleaned of the dark coatings and overpaint that obscured Brumidi's delicate color scheme. S–213.*

Fig. 8–21. Sketch for Senate Reception Room. *Brumidi eventually painted three of the vaults as he planned in this oil sketch, changing only the figure of Peace.* Estate of Edna W. Macomb.
Photo: Diplomatic Reception Rooms, U.S. Department of State.

S–213

The Senate Reception Room is one of the rooms decorated by Brumidi that still serves its original purpose, that is, as a place where senators meet constituents; this was an especially useful function in the decades before senators had offices (fig. 8–20). The room was first called "the antechamber of the Senate," the "Receiving Room of the Senate," and later in the nineteenth century, the "Ladies Reception Room." The history of this room is unusual because of the way the iconographical program for the wall lunettes changed over time (although only one was ever completed), while the subjects of the allegorical figures, including the Virtues in the ceiling, were modified only slightly.

Brumidi began preparing designs for this room even before the House Committee on Agriculture room was finished. In December 1855, Meigs reported: "Brumidi brought me a design sketch in pencil for the decoration of the Senate anteroom. It is beautiful. He is full of innovation, and this, if worked up with skill, will make a beautiful room."[19] Brumidi wrote a detailed outline of his pro-

gram for the room in French in late 1855 or early 1856. He described the subjects of the allegorical figures as well as five complex historical scenes, including the first meeting of Congress and the proclamation of independence to the American people.[20] By the end of July 1856, he had prepared oil sketches for three of the five historical scenes. Meigs also had him design an impressive mantel with a bronze figure.[21] Little of this first comprehensive plan, approved by Secretary of War Jefferson Davis, was executed.[22] However, early in 1857 Ernest Thomas, foreman of ornamental plasterers, began the elaborate decorative plaster work, which was covered with burnished gilding by François Hugot; it was less than half done by the end of the year.[23] In 1858, Brumidi painted the frescoes in the four pendentives and the center of the dome and designed those for the groin vaults in the north part of the room.[24]

In the 1860s, attention was again focused on the room. In 1862, Brumidi gave estimates to architect Thomas U. Walter for completing the decoration with five panels of

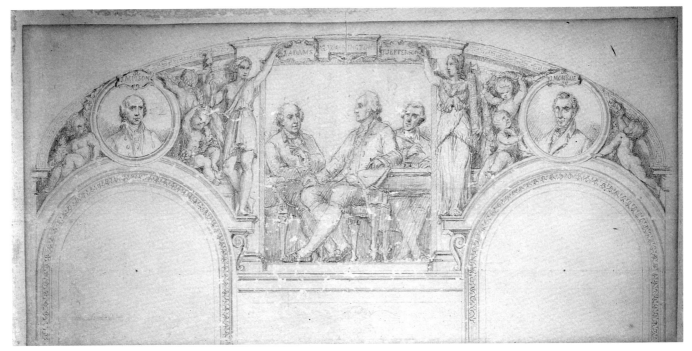

Fig. 8–22. *Washington, Adams, Jefferson. This pencil sketch documents Brumidi's intention to include portraits of all the early presidents in the Senate Reception Room. When this plan was dropped, Adams was replaced by Hamilton and the figures were rearranged.* Arthur J. Phelan Collection.

historical scenes; four groin vaults with figures of War, Peace, Freedom, and Plenty, for which he had made oil sketches (fig. 8–21); and five portraits of illustrious men; however, no action was taken. In 1866 Senator B. Gratz Brown, chairman of the Committee on Public Buildings and Grounds, wrote to the secretary of the interior, who had been given responsibility for the construction, to point out that the completion of rooms had been covered in the 1859 appropriation, and recommending that the reception room be finished; Brumidi then submitted new estimates. Not until 1869 did Brumidi paint the allegorical images in the four triangular fields of the north groin-vaulted ceiling.[25]

Finally, in June 1870, Brumidi created new designs for the lunettes, with figures rendered in chiaroscuro, using darks and lights, in imitation of sculpture and portraits in color. Two extant pencil sketches for the lunettes, apparently dating from this time, show that Brumidi had changed the configuration and the subjects. Instead of multifigured scenes of historical events, he planned to incorporate portraits of the first sixteen presidents. One sketch shows Washington, Adams, and Jefferson seated together, flanked by rondels with portraits of Madison and Monroe (fig. 8–22). The other includes a seated John Quincy Adams, a rondel of Jackson, and a seated Van Buren (fig. 8–23). The portraits are framed by red curtains and illusionistic sculpture of maidens and cherubs. Brumidi

sent the designs to Clark for the inspection of Senator Charles Sumner, chairman of the powerful Foreign Relations Committee. In November 1870, Brumidi was paid for painting the chiaroscuro figures in the lunette of the south wall; he painted these in oil on dry plaster rather than in true fresco. A second lunette on the south end was finished by July, and the remaining three "panels with figures and medallions" were completed by November 1871. Clark reported that year: "The lunettes of the walls of the reception room of the Senate are being decorated in such a manner as to leave spaces for portraits. It is proposed to fill these with the portraits of men most conspicuous in our legislative history, and to have them painted by our most skillful artists, so as to have in the Capitol a specimen of the styles of the principal painters."[26]

In August 1872, the subject of the scene on the south wall was changed. Clark wrote to Brumidi that the committee had authorized him to have the murals painted and had ordered Brumidi to substitute Alexander Hamilton for Adams; "Then the picture would represent Washington and his two principal Cabinet Officers—Jefferson and Hamilton—whom he most consulted." Brumidi prepared an oil sketch of this changed composition, and followed it closely when he executed it on the wall that year.[27] As late as 1876, Brumidi petitioned to be allowed to fill the remaining spaces, but to no avail, and the blank spaces remain today.

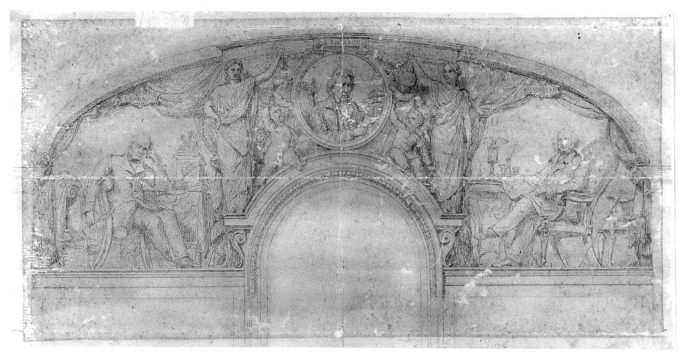

Fig. 8–23. *Adams, Jackson, Vanburn,*
c. 1870. *The sketch, with Van Buren's
name misspelled, shows that the sixth,
seventh, and eighth presidents were to
have appeared over the door leading
to the Senate Chamber.* Architect of
the Capitol.

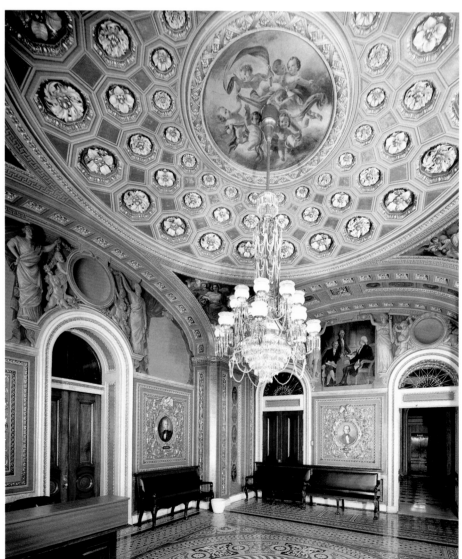

Fig. 8–24. South end of the Senate
Reception Room. *The domed ceiling is
decorated with gilded coffers and rosettes,
with flying cherubs at the center. This
photograph, taken before restoration was
begun, shows the brownish coating that
covered the murals.* S–213.

The ceiling nearest the entrance from the corridor is a dome filled with elaborate rosettes set in gilded coffers, which are graduated in size to enhance the three-dimensional illusion (fig. 8–24). In the central rondel, which originally held a gas chandelier, seven cherubs dance in the air as if seen from below, trailing draperies of red, blue, and gold. Brumidi in French called these nude babies *genies* or geniuses, spirits symbolizing various ideas through the objects they hold. In Italian, he might have called them *putti*, or little boys.

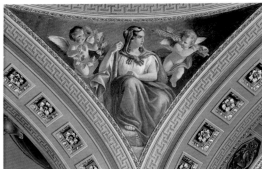

Fig. 8–25. *Strength*, after and before restoration. *The attributes of the Virtues are reinforced by objects held by the cherubs. Here, for example, the oak leaves represent strength and the fasces is a symbol of authority. S–213.*

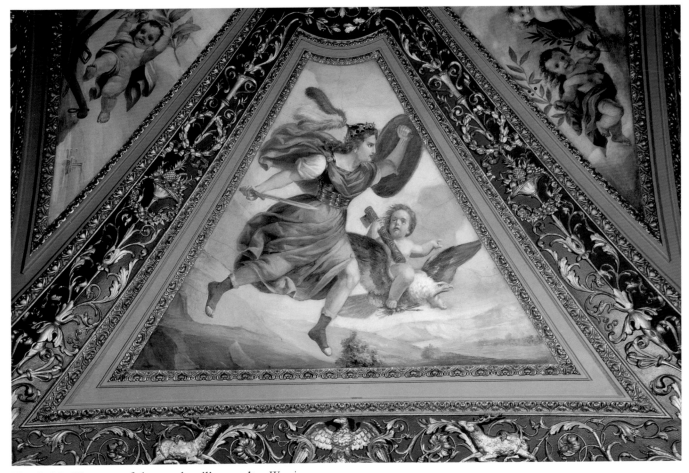

Fig. 8–26. *War*, one of the north ceiling vaults. *War is portrayed by Minerva, goddess of wisdom and battle, flying across a landscape, brandishing a shield and sword, accompanied by a cherub riding on an eagle and holding the fasces. S–213.*

In the pendentives of the dome Brumidi depicted the four cardinal virtues. Strength (or Fortitude) wears the lion's skin and holds the club of Hercules (fig. 8–25). Prudence gazes into a mirror, while cherubs hold a snake, her other attribute, and a clay jar. Justice (or Jurisprudence) holds a tablet; she is being crowned with a laurel wreath by one winged cupid, while another holds out the scales of justice. Temperance touches a bridle, her signature attribute, and holds a palm frond; a winged cherub pours water from a pitcher into a jug of wine.[28]

In the groin vault of the ceiling at the north end of the room are four frescoes by Brumidi, conceived as easel paintings bordered with gilded frames applied to the ceiling. War (fig. 8–26) wears a helmet encircled with stars and sprouting white and blue feathers, possibly a reflection of the headdress on Thomas Crawford's Statue of Freedom. The figure nearest the window is Liberty in a red cap and robe; she holds the fasces and a scroll with the Constitution, supported by a cherub. Another cherub flies in from the left with olive branches of peace, and a third, to the right, holds the shield of the United States and one end of a banner inscribed "E Pluribus Unum;" the other end is held by the beak of an eagle. Underneath Liberty's foot are the crown and scepter of royal power. Peace holds an olive branch in her right hand and instruments of art and architecture in her left hand: a triangle, compass, and paintbrushes. A cherub holds a lyre and trumpet on the left, and to the right another prepares to cast a shield of war down atop a discarded helmet and broken sword. Plenty holds a cornucopia and touches a plow, which is grouped with other agricultural implements. To the left are a locomotive and a cherub holding a caduceus, the symbol of Mercury and of Commerce. The cherub to the right flies in with blossoming branches. Many of the symbols depicted here can also be seen in the canopy in the Rotunda and in other rooms, such as the President's Room.

The pilasters and archways near the entrance and at the center of the room hold illusionistic relief panels of classical and Native American heads, cherubs holding various symbolic implements, and birds (fig. 8–27).

In the four large lunettes over the doorways on the side walls, Brumidi created the illusion of classical maidens and cherubs sculpted in marble flanking a central rondel. The maidens pull back red curtains, but the portraits they were designed to frame were, unfortunately, never executed. In the south wall, however, Brumidi was allowed to paint a scene showing President Washington with his Secretary of

Fig. 8–27. Wall panel after restoration. *The panels painted in tempera appear to be made of carved stone, inset with medallions of alternating colors. Each cherub is a different infant god, here Mars, Neptune, and Mercury.* S–213.

115

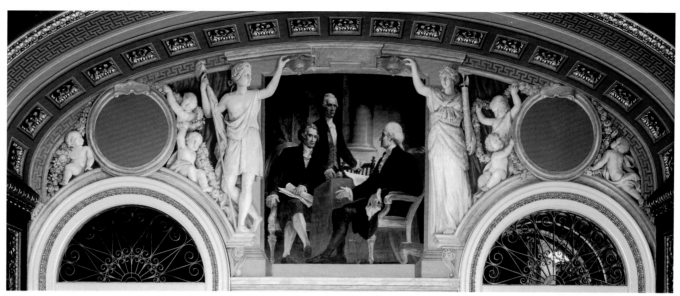

Fig. 8–28. Lunette on south wall. *Brumidi's depiction of President Washington with Thomas Jefferson and Alexander Hamilton is the only historical scene he completed in the Senate Reception Room.* S-213.

State Thomas Jefferson and Secretary of the Treasury Alexander Hamilton (fig. 8–28). Washington is shown seated, in profile, across from Jefferson, while Hamilton stands behind, one hand on a stack of bills, the other resting on the turned chair back. The north wall is dominated by a lavishly carved marble mantel and magnificent gilded mirror and cornices, dating from the 1880s, which obscure a head of Liberty and red curtains, probably painted later.

The Senate Reception Room is one of the most heavily and ornately decorated of the rooms in the Capitol. The elaborate gilded plaster relief decorations include stags with projecting antlers and eagles in addition to leaves and fruit; these attract almost as much attention as the murals. The lower walls are covered with scagliola to simulate marble.

The room was damaged in an explosion in 1915, after which the murals were retouched by Charles Moberly. In 1930, George Matthews signed and dated his "restoration" of the frescoes, and the plaster work was regilded.

That year, curator Charles Fairman proposed subjects for the vacant spaces, but nothing was carried out until legislation was passed in 1955 to authorize five portraits of senators. These portraits, added in 1959, include Henry Clay by Allyn Cox, Daniel Webster by Adrian Lamb, Robert M. LaFollette by Chester La Follette, Robert A. Taft by Deane Keller, and John C. Calhoun by Arthur Conrad. The portraits fulfill Brumidi's original plan for including "illustrious men" in these spaces.

Until conservation began on the north section of the room in late 1994, the murals appeared relatively dark because the walls and ceiling were coated with a brown-

ish-yellow varnish as well as layers of grime and nicotine. Conservators have removed extensive overpaint as well as layers of coating. Unexpected soft mauves and greens were uncovered in the borders and panels, which harmonize with the colors in the cleaned frescoes. The work was divided into phases over two years to accommodate the schedule of the Senate.

S–216

The President's Room is among the most completely decorated and best-preserved rooms in the building (fig. 8–29). It also, at times, fulfills its original function as a place for the president during his visits to the Capitol. Presidents, probably beginning with James Buchanan, and certainly with Abraham Lincoln, signed legislation here at the end of sessions of Congress, just before their terms ended on March 4, a date changed by the Twentieth Amendment.[29] The room has been used much less frequently by presidents in the twentieth century, although most have signed special bills here, and the room is now used primarily by senators for press conferences and meetings.

It is not certain when the decision was made to have a room for the president in the new extension. A signed but undated Brumidi drawing for a ceiling similar to the one in this room, labeled "Ceiling of the Vice President's Room," was approved by Meigs (fig. 8–30), and it is possible that the function of the room was changed afterwards. The groin-vaulted ceiling on Walter's floor plan

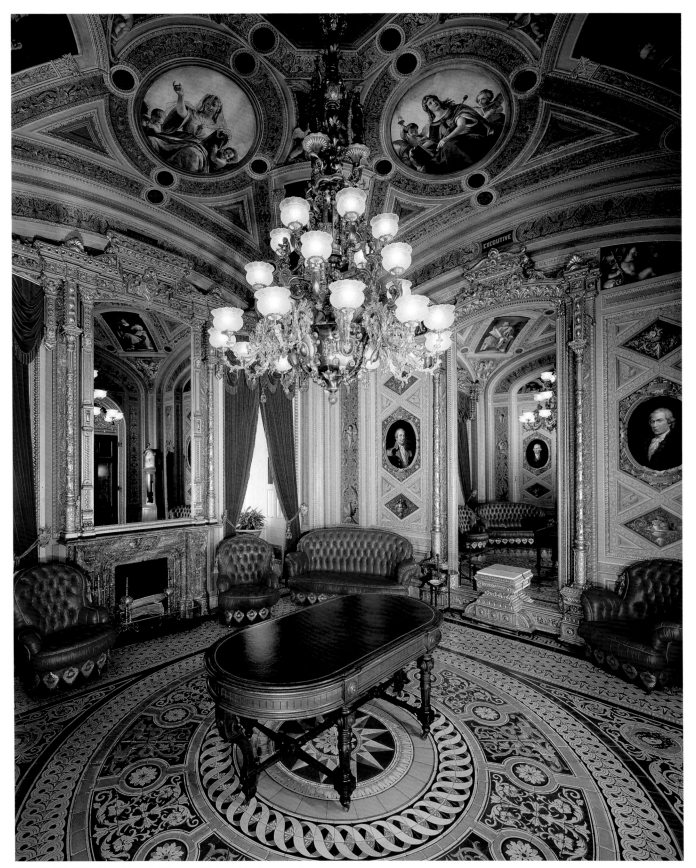

Fig. 8–29. The President's Room. *This richly decorated room, which Brumidi covered from floor to ceiling with murals celebrating the men and ideals fundamental to the country, is shown after its recent restoration.* S–216.

Fig. 8–30. Drawing adapted for the President's Room ceiling. *Known only from this photograph, the drawing includes the same overall plan and the same corner figures that Brumidi painted in S–216. Here the female figures in the tondos are labeled Eloquence, Cosmology, Philosophy, and Religion, and stars appear instead of the state seals.*

Fig. 8–31. Raphael, Ceiling of the Stanza della Segnatura in the Vatican Palace. *Brumidi would have been familiar with this ceiling in Rome, and Meigs could have known it from color reproductions such as this one.*
From Lewis Gruner's *Specimens of Ornamental Art,* 1850.

was probably changed to accommodate Brumidi's design, which was closely modeled on that of one of Raphael's rooms in the Vatican (fig. 8–31).[30] Brumidi and his assistants decorated this room in 1859 and early 1860; "C. Brumidi 1860" appears on the spine of a book next to a cherub on the west wall.

For this unique room, Brumidi developed a scheme even more elaborate than the one he devised for the House Committee on Agriculture. The ceiling contains several levels of illusionistic space: projecting moldings, thirty-six trompe l'oeil copper relief medallions with the seals of the states and territories, gilded borders decorated with arabesques, and the actively engaged, lifelike cherubs. Every detail is carefully thought out; for example, the seals of the states and territories are arranged chronologically, with those of the first states of the Union at the center and those of the territories at the outer edges. The corner frescoes contain figures seated in niches, while the four frescoed tondos hold seated female figures shown against the sky as if looking down into the room, two with their toes pushing out past the frame toward the viewer. The walls below are completely covered with framed portraits, still lifes, and more cherubs and arabesques. The whole room conveys a sense of exuberance and energy and Brumidi's pride in his new country.

Brumidi expertly combined multiple painting media to achieve the effect he desired. The tondos, corner figures, and cherubs and eagles on the ceiling are in true fresco, surrounded by architectural moldings and medallions in tempera (fig. 8–32). The lunettes and portraits are in oil on plaster, while the lower walls are primarily *fresco in scialbatura.* The delicately painted motifs on the gilded borders and panels also appear to be in that medium. However, the viewer is aware only of the harmony of the whole.

The four framed circular tondos on the ceiling hold Madonna-like allegorical figures representing the foundations of the government. Executive [Authority] holding a scepter, rules with the aid of "Wisdom" inscribed on her brooch, books entitled *US Law* and *Philosophy,* and the torch of Knowledge. Religion (fig. 8–33), on the north, seems to greet all who enter the room, while the other figures look down at their work or up to heaven for inspiration. Legislation, soberly dressed in warm brown Renaissance-style robes, holds an upraised sword and reads the Constitution. Liberty (fig. 8–34), looking upward, wears a red liberty cap and robe and is surrounded by thirteen stars in the sky. Pairs of cherubs in front of striped shields of the United States and eagles alternate with the tondos. The cherubs hold objects related to the

Fig. 8–32. Ceiling of the President's Room. *The complex design contains figures in various illusionistic architectural compartments, while the four circles seem to be open to the sky.* S–216.

Fig. 8–33. Religion. *Her face covered by a transparent veil, the figure symbolizing religion wears a cross and brocaded lace robe and holds a Bible.* S–216.

Fig. 8–34. *Liberty.* *The figure symbolizing liberty wears a sword and is pulling the axe out of the fasces.* S–216.

Fig. 8–35. *Christopher Columbus.* *The explorer examines a globe and chart on a pedestal, at the base of which are an octant, mercury barometer, and magnetic compass.* S–216.

Fig. 8–36. Cherub with eagle. *Beneath the portrait of Franklin is one of the most beautifully painted figures in the room, a cherub pulling the arrow of war out of an eagle's beak. Note the seal for the territory of Utah.* S-216.

adjacent scenes; for example, the figures next to Liberty hold the fasces and a scroll inscribed "E Pluribus Unum." Because they overlap the frames, the cherubs appear to project toward us in three dimensions.

In the corners, as if seated in curved niches, with feet or knees projecting toward the viewer, are four historical figures representing fundamental aspects of the development of the nation: Amerigo Vespucci, with maps and spyglass, for Exploration; Christopher Columbus, with nautical instruments, for Discovery (fig. 8–35); Benjamin Franklin, reading a sheet inscribed *Buon Uomo Ricardo* ("Poor Richard" in Italian), referring to his almanac, and surrounded by books, newspapers, and a printing press, for History; and Pilgrim leader William Brewster holding a Bible for Religion. Early guidebooks note that Brumidi based his depictions on known portraits.[31]

Filling the pendentives under each portrait are varying numbers of squirming cherubs (fig. 8–36); the three in the northeast corner replace Brumidi's, which were damaged by leaks.[32]

On the south wall is a lunette with a portrait of George Washington (fig. 8–37), modeled on the Rembrandt Peale porthole portrait then hanging in the Vice President's Room.[33] On the walls below, members of Washington's first cabinet are depicted in oval frames: Secretary of State Thomas Jefferson, Secretary of Treasury Alexander Hamilton, Secretary of War Henry Knox, Attorney General Edmund Randolph, and Samuel Osgood, the first postmaster general.[34] The walls around and below them are embellished with trellis-like arabesques with cherubs and classical heads over gold backgrounds, illusionistic moldings, and still lifes of fruit.

Overall, the President's Room today presents much of its original appearance. The elaborate bronze chandelier, cast by Cornelius and Baker, is the only one made for the extensions remaining in the Capitol. It holds figures of Native Americans, pioneers, and different ethnic types.[35] The Minton floor tiles are in nearly original condition and the Tennessee marble mantel is the one designed by Walter. The Turkish sofa and chairs were purchased in 1875 and were re-covered in gold-embossed red leather by the Senate Commission on Art during its 1991–1992 refurbishment of drapery and furnishings.[36]

However, some changes have been made to the room over the years. Brumidi himself made estimates for repairs as early as 1862; painting, probably of door frames, was carried out in 1868. Elaborate mirror frames, consoles, and valances were installed about 1883 to replace simpler frames designed for the room in 1860; they cover the illusionistic painted frames created by Brumidi. Brumidi's three cherubs with an American flag, which originally flew around the chandelier, were destroyed when the plaster around the fixture fell to the floor in

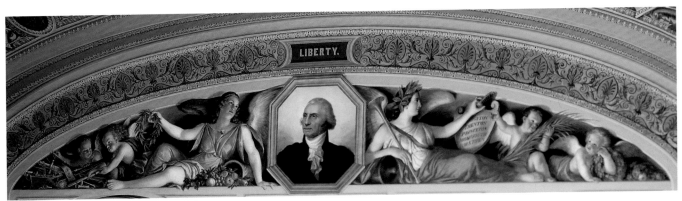

Fig. 8–37. Portrait of Washington on south wall. *The portrait of Washington is flanked by figures representing Peace and Victory (whose shield is inscribed with the names of Revolutionary War battle victories). S–216.*

Fig. 8–38. Newly conserved west wall. *Cleaned of overpaint and yellowed varnish, the jewel-like tones of the portraits of Randolph and Osgood and of the decorative elements enliven the room. Brumidi's signature appears near the cherub at the upper right. S–216.*

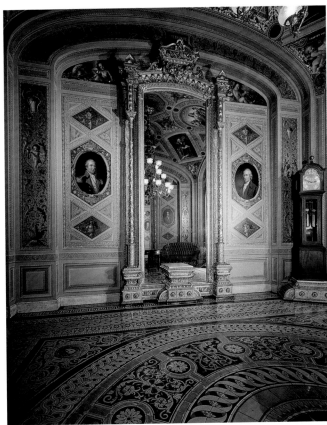

1921.[37] The decorative borders and moldings on the walls and ceiling have been overpainted, with some modification of the original design. These borders and lower walls were painted in *fresco in scialbatura* in the color of stone, from which yellowed varnish has now been removed.[38] Annual reports note that the room was retouched in 1912 and 1916, and that restorations were performed in 1918 by Charles Moberly. In 1928, Brumidi's decoration was threatened with destruction or removal when plans for the enlargement of the Senate Chamber were being discussed. In 1931, after the enlargement project was dropped, the corner cherubs were replaced and the room was given an extensive cleaning and restoration, with "colors freshened" and the gold leaf replaced and reburnished.[39] The ceiling murals were professionally conserved in 1994, when extensive overpaint was removed from Brumidi's frescoes, restoring his vibrant colors and the illusion of figures able to move in space. The walls were given conservation treatment the next year (figs. 8–38 and 8–39).[40]

Fig. 8–39. Conservator Christiana Cunningham-Adams at work. *The removal of discolored varnish has made a dramatic difference in the overall appearance of the President's Room. S–216.*

Notes to Chapter 8

1 Dr. John B. Ellis, *The Sights and Secrets of the National Capital* (Chicago: Jones, Junkin & Co., 1869), p. 89.

2. TUW cost estimate to complete the extensions, November 26, 1859, TUW/PA (AAA reel 4146). TUW, "Notes for the Art Commission," February 2, 1860, AOC/LB.

3. MCMJ, February 21, 1857 (B–464).

4. Feb. 16, 1857, Pocket Diary, MCM Papers, LC. Photograph of pencil sketch for ceiling signed by Brumidi and Meigs, LC (Prints and Photographs Division). In addition to the sketch for Telegraph, ones for History, Physics, and three groups of Graces were owned by Mrs. Ashmun Brown, according to Myrtle Cheney Murdock, *Constantino Brumidi: Michelangelo of the United States Capitol* (Washington, D.C.: Monumental Press, 1950), p. 79.

5. On February 10, 1858, Bisco wrote to Meigs that he had completed "la presque totalité de la peinture de la voûte dans la Chambre dit Book Room [nearly all of the painting of the vault in the chamber called the Book Room]", AOC/CO. MCMJ, February 26, 1857 (B–473) and May 24, 1858 (C–193). Oertel to MCM, April 17, 1858, AOC/CO.

6. *Annual Report of Captain Meigs*, 36th Cong., 1st sess., October 27, 1859, Sen. Exec. Doc. 2, vol.2, p. 561. John B. Ellis, *The Sights and Secrets of the National Capital* (Chicago: Jones, Junkin & Co., 1869), p. 87.

7. CB to TUW, October 10, 1862; Chairman B. Gratz Brown to Secretary of the Interior James Harlan, July 17, 1866; EC to CB, July 19, 1866; CB to EC, July 20, 1866; EC to Harlan, July 21, 1866; Harlan to EC, August 8, 1866; EC to CB, August 9, 1866; CB to EC, August 12, 1866; EC to Harlan, August 13, 1866; Harlan authorized the work the same day. On August 14, 1866, Clark asked Brumidi to begin work; Brumidi replied to him the next day. NARA/RG 48, Series 290 and 291; AOC/CO.

8. Brumidi sent Walter an estimate for painting in the Post Office Room "Three groups of figures representing the months of the year in the corners" CB to TUW, October 10, 1862, TUW/PA (AAA roll 4149). The oil sketch for the three groups of female figures was reproduced in Murdock, *Brumidi*, p. 79.

9. The oil sketch was published in "Brumidi Paintings Found in Washington After a Search of Forty Years," *Washington Star*, November 2, 1919.

10. 1900, AOC/AR, p. 4. "Soap-and-Brush Brigade Cleans Up the Capitol," *Times-Herald*, August 26, 1947.

11. Copy of letter from F.O.C. Darley sent by J. Durand to MCM, October 30, 1856, AOC/CO.

12. E. Carstens to MCM, November 6, 1857, AOC/CO.

13. J. Leslie to MCM, December 7, 1858, AOC/CO.

14. C. Bisco to MCM, February 10, 1858, AOC/CO.

15. Henry Wilson to EC, March 8, 1871, AOC/CO.

16. Voucher, October 19, 1871, AOC/CO.

17. A medallion with the head of Liberty, flanked by flags, weapons, and fasces, was visible in the area now covered by the top of the mirror frame. DeB Randolph Keim, *Keim's Capitol Interior and Diagrams* (Washington, D.C.: n.p., 1875), p. 54.

18. *Congressional Record*, 46th Cong., 2d sess., February 24, 1880, p. 1075.

19. MCMJ, December 17, 1855 (A–772.)

20. The other proposed historical subjects were the election of Washington as commander of the American army, the first formal audience given by the Congress to a representative of France, and the peace treaty between the United States and Britain. CB, undated proposal for the Senate Reception Room, written in French, c. 1855, AOC/CO.

21. MCMJ, January 15, 1856 (B–21.)

22. Meigs recorded the subjects as "Washington thanking Congress for the election as Commander-in-Chief, the signature of the Treaty of Paris, the representation of the French Ambassador, Gerard, in Congress" MCMJ, July 28, 1856 (B–240). Brumidi may have used the scene of the Treaty of Paris later in the first-floor Senate corridor.

23. Thomas was appointed superintendent of ornamental plasterers, Aug. 28, 1856, MCM Pocket Diary, MCM Papers, LC. The drawings may be by Thomas; the gilding was done by a Frenchman, Hugot, "peintre doreux," Hugot to MCM, March 20, 1859, AOC/CO, MCM to Ernest Thomas, Jan. 21, 1857, and TUW to John Floyd, Dec. 21, 1857, AOC/LB.

24. Only the four spandrels and the center of the dome were finished in early 1859. "The New Senate Hall," *New York Times*, January 5, 1859, p. 1.

25. B. Gratz Brown to James Harlan, secretary of the interior, July 17, 1866, NARA/RG 48, series 291, box 2. CB to EC, July 20, 1866, and EC to James Harlan, July 21, 1866, NARA/RG 48, series 290, box 2. *Report of the Architect of the Capitol Extension*, Nov. 1, 1869, p. 3, and Voucher, November 22, 1869, AOC/CO.

26. CB to EC, June 9, 1870, AOC/CO. 1870, AOC/AR, p. 1. Voucher issued to CB "for South Wall of Senate Reception Room," Nov. 22, 1870, AOC Voucher Book, Works of Art, v. 1. CB to EC, May 1, 1871, and CB to EC, April 22, 1871, AOC/CO. 1871, AOC/AR, p. 3. Voucher issued to CB for "three panels consisting of figures and medallions," Nov. 23, 1871, AOC/Voucher Book.

27. EC to CB, August 15, 1872, AOC/LB. The sketch is known from a photograph. William C. Allen has suggested that the change in theme from the presidents to the cabinet may have been related to the impeachment trial of Andrew Johnson and the Senate's role in affirming the president's right to control the cabinet.

28. Julie Aronson discovered that the subjects of these frescoes were previously misidentified in *Art in the United States Capitol* based on CB's undated proposal in French describing the figures as "la Jurisprudence . . . la Force . . . la Sapience . . . la Prudence." He apparently intended to represent the four virtues and later corrected his mistake. The figures were correctly identified in early guidebooks, such as *Keim's Capitol Interior and Diagrams*, 1875, p. 26.

29. President Lincoln was described using the room on the day of his inauguration in the *Evening Star* (Washington), March 4, 1861.

30. The present Vice President's Room, S–214, is similar in shape to S–216. Documents dating from 1858 describe a plan of ceiling decoration for the Vice President's Room with plasterwork by Ernest Thomas and painted "boys" by Brumidi, which, if executed in S–214, is no longer extant. The decoration was expected to be finished by December 1859 (*Annual Report of Captain M. C. Meigs*, Oct 27, 1859).

31. DeB. Randolph Keim, *Keim's Illustrated Hand-Book Washington and Environs* (Washington: n.p., 1874), p. 31 reports that Columbus was painted from a portrait in Mexico. Ben Franklin's pose and features are related to an engraved portrait in *National Portrait Gallery of Eminent Americans* (New York: Johnson, Fry & Company), vol. 1. The profile of Vespucci was copied from a 16th-century portrait, now in the National Portrait Gallery, owned by the son of Robert Fulton [thanks to Christiana Cunningham-Adams for this discovery].

32. Eben F. Comins (b. 1875) inserted the new figures in true fresco. He wrote Architect David Lynn about the project on May 16, 1931, AOC/CO, and was paid on July 16, 1931, AOC/Voucher Books. The

records of the AOC also contain a photograph of him at work as well as one of the original cherubs, AOC/CO. Also see 1931, AOC/AR, p. 20.

33. Meigs asked for the portrait to be brought to the President's Room for Brumidi on October 28, 1859, as indicated on a note on a drawing for mirrors for the room. AOC/CO.

34. Actually, the Postmaster General did not officially become part of the Cabinet until 1829. On April 3, 1860, Brumidi is documented to have been copying a portrait of Randolph, in a letter from W.B. Franklin to Joseph Blank, the Attorney General, AOC/LB. The Knox portrait may be based on the one then in Faneuil Hall and later transferred to the Boston Museum of Fine Arts.

35. The chandelier was made by the Philadelphia firm in 1864 for $900. The eighteen gas lights were electrified in 1896, and in 1915 six arms and the twenty-four shades etched with designs were added. The crystal prisms that were added at that time have recently been removed.

36. The voucher for the leather-covered chairs is dated June 30, 1875, Secretary of the Senate, *Receipts and Expenditures of the Senate*, 44th Cong., 1st sess., Sen. Mis. Doc. 1, p. 54. Tradition holds that the large mahogany table in the center of the room was used by President Lincoln; however, inventories of the furniture in the room in the 1870s do not include it. The mahogany grandfather's clock was purchased in 1887.

37. *Keim's Capitol Interior*, 1875, p. 32. *The Book of Washington*, Washington Board of Trade, 1926–27, p. 93. Non-original cherubs painted in oil on canvas glued to the ceiling some time in the 1920s were removed during the 1994 conservation of the ceiling.

38. William D. Haley, in *Philip's Washington Described* (New York: Rudd & Carleton, 1861), describes the walls as being "in secco," p. 138. A recent scientific analysis by Christiana Cunningham-Adams shows that the lower decoration was first painted in *fresco in scialbatura*.

39. 1931, AOC/AR, pp. 20–21.

40. A detailed condition report of the room was made by Bernard Rabin in 1991. Christy Cunningham-Adams conserved the ceiling in 1994 and the walls in 1995.

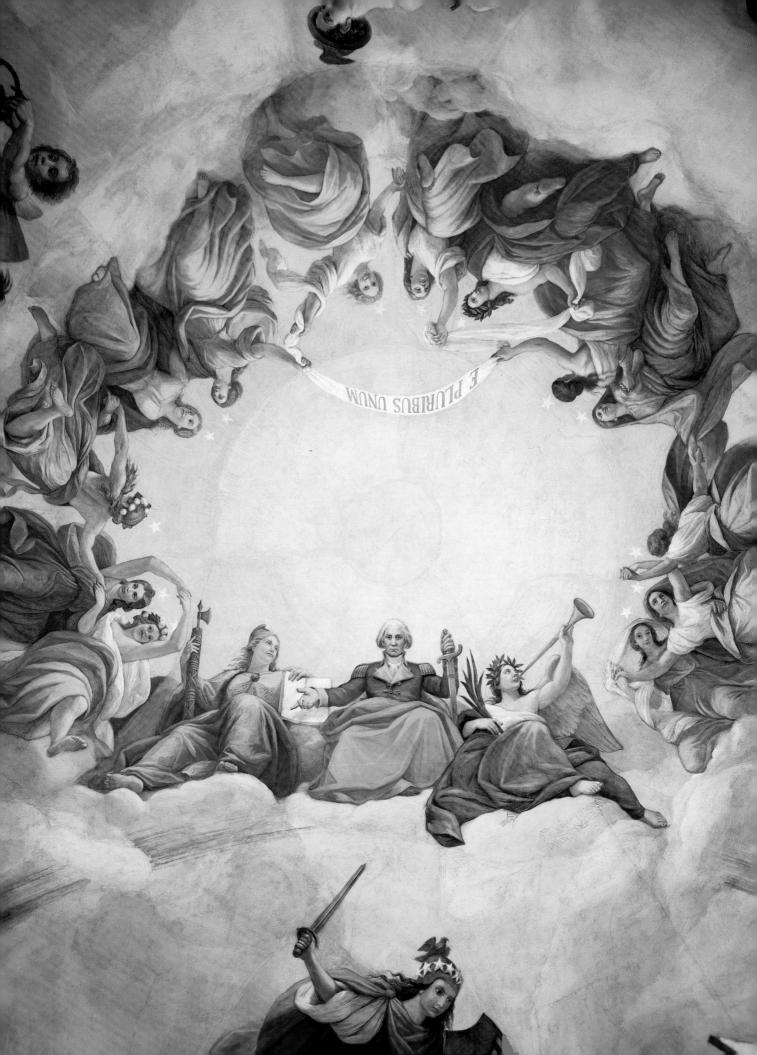

CHAPTER 9

Painting
The Apotheosis of Washington

Fig. 9–2. Union troops on the East Front of the Capitol with the dome under construction, May 1861. *Brumidi worked at the Capitol throughout the Civil War.*

Constantino Brumidi's masterpiece is *The Apotheosis of Washington* on the 4,664-square-foot canopy over the eye of the dome, 180 feet above the floor of the Rotunda (fig. 9–1). Brumidi met the challenge of designing the centerpiece of the nation's Capitol and of creating a scene that could be read clearly from the floor but would also be effective when viewed from the balcony immediately below. Brumidi's commission to paint the canopy was complicated by changes of those in authority and by politics. His battle with governmental red tape must have seemed endless, and, in fact, the final payment was made to his heirs after his death.

After his dismissal in 1859, Meigs returned briefly to the Capitol in 1861 to resume charge of the decoration, and he re-hired Emmerich Carstens as foreman of ornamental painting.[1] Even though work on the Capitol was suspended in May 1861 because of the outbreak of the Civil War, Brumidi was able to continue his mural work, even during the period from May to October, when troops camped in the Capitol (fig. 9–2). We

have no record of his personal reaction to the war or to the soldiers, who despoiled the Capitol. Senator Solomon Foot, Chairman of Public Buildings, found a way to keep Brumidi working by paying him out of the contingent fund of the Senate, and he authorized him to "repair damage to the fresco throughout the North wing of the Capitol."[2] Assisting him were Peruchi, Odense, and Long.

In April 1862, jurisdiction over the construction of the Capitol moved from the War Department to the Interior Department (at Walter's instigation) and construction resumed under Walter's direction, with the Commissioner of Public Buildings as disbursing agent. Brumidi's dealings were thus directly with Walter until the architect resigned in 1865. Meigs, however, continued his interest in the Capitol and wrote a strong letter of recommendation for Brumidi to Secretary of the Interior Caleb B. Smith, defending Brumidi's employment in preference to American painters because of his experience and skill in mural decoration.[3] Although the issue was raised, no one was able to disprove that Brumidi's qualifications to paint the canopy were superior.

On August 18, 1862, Walter wrote to Brumidi, asking him to furnish a design for "a picture 65 feet in diameter, painted in fresco, on the concave canopy over the eye of the New Dome of the U.S. Capitol."[4] Walter encouraged

Fig. 9–1. Central group of *The Apotheosis of Washington.* *The first president rises to the heavens, flanked by Liberty and Victory/Fame, encircled with maidens, and with a rainbow beneath his feet.* Rotunda.

Brumidi to study the drawings in his office of the Rotunda, as redesigned in 1859 with a canopy over the eye of the dome (fig. 9–3). This suggests that Brumidi's design for the canopy was not yet fully developed and that he added the watercolor image of his final canopy design over a tentative sketch on Walter's drawing at this time. Walter may have envisioned an apotheosis of Washington similar to the Apotheosis of St. Genevieve at the Panthéon in Paris. On September 8, Brumidi described the final design to Walter: "The six groups around the border represent as you will see, <u>War</u>, <u>Science</u>, <u>Marine</u>, <u>Commerce</u>, <u>Manufactures</u>, and <u>Agriculture</u>. The leading figures will mesure [*sic*] some 16 feet. In the centre is an Apotheosis of Washington, surrounded by allegorical figures, and the 13 original Sister States."[5] (The allegorical groups are shown at the end of this chapter; the title of the group "Manufactures" was changed to "Mechanics.")

The concept of apotheosis, the raising of a person to the rank of a god or the glorification of the person as ideal, would have been familiar to Brumidi from classical art as well as from the numerous earlier paintings or prints depicting the apotheosis of the first president, who was honored as a national icon. For example, Rembrandt Peale's painting showing Washington perched on a cloud and being crowned with a wreath by a winged cupid, engraved in 1800, may have been known to Brumidi. Other artists were still painting Washington's apotheosis at mid-century.[6] Earlier, Brumidi had made oil sketches for two other versions of *The Apotheosis of Washington* (see chapter 10).

Brumidi estimated the cost of designing and executing the work at $50,000. His design was approved by Walter and Commissioner of Public Buildings B. B. French, on the condition that he reduce the fee to $40,000. By the end of December Brumidi agreed to their terms.[7] Commissioner French had sent Brumidi's design, presumably his large oil sketch (see fig. 10–5), to Secretary Smith for approval. French then authorized Brumidi's employment on January 3, 1863, although an appropriation was still pending, so that he could begin work as soon as possible. He was convinced that there was "no artist in the United States, capable of executing a real fresco painting as it should be done, especially so important a work as the one in contemplation, except Mr. Brumidi, and, as we know from experience his excellence in that art, I do not see how we can do otherwise than employ him." He wanted Brumidi to use the existing scaffolding and hoped he could start by December 1863.[8] However, although the Statue of Freedom was erected then, only the exterior of the dome was constructed. The canopy could not be constructed until all the interior ironwork was finished, and therefore Brumidi was not actually able to begin painting until 1865.

Fig. 9–3. Detail of Walter's cross-section of the dome, 1859. *Brumidi's watercolor rendering of his final design for the Apotheosis was painted into Walter's drawing.* Architect of the Capitol.

A letter from Walter to Brumidi of March 11, 1863, following the congressional appropriation to complete the dome, served as the artist's contract to paint the fresco for $40,000, to be paid in monthly installments of $2,000—almost as much as he normally earned in an entire year (fig. 9–4). The contract price was double the total wages of $19,483.51 he had earned at the Capitol between 1855 and 1864. Even considering that Brumidi paid for supplies and any assistants out of this amount, he himself earned an enormous sum. However, he apparently did not manage his income well, perhaps having made bad investments, for when payments were halted in August 1865, with the final $10,000 reserved pending final approval of his work, he needed to borrow money from Walter and others.[9]

Before he could fulfill his contract Brumidi suffered a series of bureaucratic frustrations and delays caused by the incomplete state of the dome construction. To help

Fig. 9–4. Check cashed by Brumidi. *The $2,000 check was the first installment of the $40,000 contract for painting the fresco.* Architect of the Capitol.

Brumidi in preparing the full-size cartoons, Walter ordered a wooden structure simulating the canopy built for the artist; it was completed by the end of March 1863.[10] This enabled him to judge the effect of the curved surface on the perspective and foreshortening of the figures. On May 2, 1863, the new Secretary of the Interior, J. P. Usher, questioned the contract with Brumidi and demanded a full report. Walter sent him copies of all the previous correspondence, supporting the project so strongly that he said he would resign if it were stopped. Despite Walter's reply, Usher ordered the work stopped on May 7. Finally, in July, Usher was convinced that the fresco was part of the original dome design approved by Congress and agreed that Brumidi could resume work. The artist received his first monthly payment in August. In November, after Brumidi had been paid $10,000 for the preparation of the cartoons, Usher stopped further payments until Brumidi could begin the fresco.[11] Walter was afraid that the artist would "lose his spirit" and would be "too old to paint the picture before the place [was] ready for him." He also feared that the work might be stopped because Congress was getting impatient to see the Rotunda finished and the scaffolding removed.[12]

Finally, on December 3, 1864, after a year of waiting, the canopy was ready, and payments to Brumidi were resumed, including one for $1,000 for work on the cartoons during October 1863.[13] The speed of Brumidi's work, once he was allowed to begin painting, is remarkable, for he spent no more than eleven months filling the 4,664-square-foot surface of the canopy. Brumidi was assisted with the mortaring by government employee Joseph Beckert.[14] For preparing his materials and perhaps

painting in the backgrounds, he would most likely have used his team of Peruchi, Odense, and Long. In any case, throughout the huge fresco the style and technique appear to be Brumidi's.

The Capitol's designers had always intended to commemorate the nation's first president in the center of the building. Brumidi permanently put an image of Washington in this place of honor, after Horatio Greenough's monumental Zeus-like, toga-clad statue of George Washington (fig. 9–5), commissioned for the center of the Rotunda, had been moved from the Rotunda to the Capitol grounds in 1844. Brumidi seems to have consciously created a variation on Greenough's pose of a seated figure with the right arm outstretched and the left hand holding a sword. But he clothed Washington in his military uniform and gave him a lavender lap robe to create the effect of classical drapery (fig. 9–6). He flanked Washington with figures representing Liberty, holding the fasces, and a combination of Victory and Fame sounding a trumpet, which may allude to Antonio Capellano's relief over the entrance to the Rotunda (fig. 9–7). The thirteen encircling figures, each with a star above her head, may symbolize specific states by regions; those near Liberty, with cotton boll wreaths, clearly suggest the South.[15]

Brumidi was painting the canopy during a tumultuous period in the nation's history—a single month, April 1865, saw both the surrender of General Lee and the assassination of President Lincoln. At this time, he had finished the center group and was working on the scene below, "War" (fig. 9–8). Brumidi may have expressed his own political feelings by using

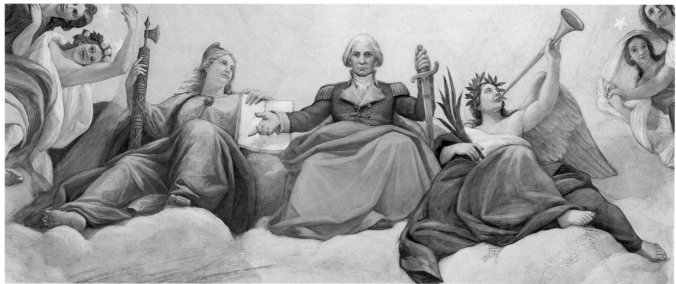

Fig. 9–5. Horatio Greenough's *George Washington* on the Capitol grounds. *In the canopy, Brumidi paid tribute to the familiar monument while varying the pose and costume. The statue is now in the National Museum of American History, Smithsonian Institution.*

Fig. 9–6. Central group of Washington with Liberty and Victory/Fame. *Washington is placed near the center of the Rotunda, looking toward the entrance on the east.* Rotunda.

Fig. 9–7. Antonio Capellano, *Fame and Peace Crowning George Washington. This 1827 relief may have inspired Brumidi to flank his Washington with winged allegorical figures, one of whom bears the trumpet of fame and palm of victory.* East central portico.

Fig. 9–8. Figures trampled by Freedom in
"War," the first lower group painted. *After fin-
ishing the central figures, Brumidi moved to this
scene.* Rotunda.

the features of the Confederate leaders on
the evil figures being vanquished by Free-
dom: Jefferson Davis as Discord, with two
lighted torches, and Alexander H. Stephens
as Anger, being struck by a thunder bolt
and biting his finger. It is possible to imag-
ine other faces as portraits as well; Brumidi
was certainly familiar with the Renaissance
tradition of depicting historic or allegorical
figures with the features of the artist's no-
table contemporaries.[16]

By May the painter was starting on the scene
to the left of "War," entitled "Science." At the
end of the month, Walter resigned, and com-
pletion of Brumidi's contract was overseen by
Walter's longtime assistant Edward Clark, who
was appointed in his place in August 1865 (fig.
9–9). The artist was forced to stop work in July
because the appropriation was exhausted. The
new secretary of the interior, James Harlan, re-
sumed payments to Brumidi only after inspect-
ing the fresco in July.

Brumidi had to make an unexpected change
in the fresco; only days after his appointment
on August 30, 1865, Clark received a letter from Meigs,
insisting that Brumidi remove the portrait of him in his
blue uniform included in the Commerce group; Brumidi

Fig. 9–9. *Edward Clark. Brumidi painted this portrait
sometime after Clark was appointed the Architect of the Capitol in
1865, based on a photograph preserved in the Lola Germon
Brumidi Family Album.* Architect of the Capitol.

129

complied, but the patch of mortar in the shape of Meigs's scraped-out head and shoulders is still visible (figs. 9–10 and 9–11).[17] Meigs, proud of his integrity and his reputa- tion for honesty in handling the construction funds, may have been disturbed by being depicted with Mercury thrusting a bag of money towards him. Ironically, Bru-

Fig. 9–10. Location of Montgomery C. Meigs's scraped-out image. *Meigs insisted that Brumidi remove his portrait, which was between the two remaining figures, from the "Commerce" group. Rotunda.*

Fig. 9–11. Photograph of Montgomery C. Meigs. *This image of the engineer in uniform was evidently the basis of Brumidi's depiction in the canopy.*

Fig. 9–12. Thomas U. Walter as Samuel F. B. Morse. *In the Renaissance tradition, the white-bearded figure in the "Science" group represents the inventor of the telegraph but has the features of Walter. Rotunda.*

Fig. 9–13. Photograph of Thomas U. Walter. *This photograph closely resembles Brumidi's portrait of Morse. Library of Congress.*

130

midi's tribute to Meigs's rival, Walter, is preserved in the features used for Samuel F. B. Morse (fig. 9–12 and 9–13).

By September 1865, Brumidi had completed all but the last scene, "Marine," and he was being pressured by Clark to complete the painting of the canopy. The artist, however, wanted to review his work after the plaster was completely dry. Realizing that he was going to need to "cover the connections of the pieces of plaster . . . giving more union to the colors at the said junctions, for obtain [*sic*] the artistic effect . . . ," he thought it best to wait until the spring, when the weather was less damp, for this last step. He also asked for the gas lights to be turned on, so that he could the judge the fresco in the light in which it would be seen.[18] He therefore requested that the scaffold be left in place. Walter, who was still involved in the project after his resignation, went up into the dome to see the picture and complimented Brumidi: "I think it will be perfect when seen from below."[19]

Despite the artist's pleas the scaffolding was taken down in early January. His masterpiece received high praise; B. B. French commented, "That picture, as a work of art, surpasses any one in the world, of the kind."[20] The *National Intelligencer* published a strongly positive review of it on January 17: "The general effect is inspiring, while the details bear close inspection and command admiration. It is almost a difficulty to realize that some of the sitting or reclining figures are not things of life . . . we do not hesitate to say that both in design and execution it is worthy of the Capitol and the nation."[21]

Meigs, now a general, came to see the canopy, and he wrote to the artist:

I find the drawing and coloring most agreeable and beautiful. The perspective is so well managed that I doubt whether anyone not well acquainted with the construction of such edifices as the Dome could determine by the mere use of his eyes the form and position of the surface which is painted. The figures appear to take their places in space with the illusion of a diorama. I am glad the country at length possesses a Cupola on whose vault is painted a fresco picture after the manner of the great edifices of the old world. I regret that the joinings of the plaster still show too plainly in the clear graduated tints of the sky the progress of each days work, but these, I trust, will disappear as the picture dries more completely.[22]

Unfortunately, the joins between the *giornate* remained clearly visible from below.

Walter also praised the work: "As to the merits of the painting I have come to the conclusion that it is a decided success." After commenting on the skill with which Bru-

midi had overcome the difficulties of the concave surface, he continued:

The coloring is not as brilliant as I expected it would be but it is evident that its atmospheric effect would not have been so good if the coloring had been stronger.—Upon the whole I am well pleased with the picture;—it is far better than the great painting by Gross [*sic*] in the eye of the Dome of the Pantheon at Paris, for which he was created a Baron, and received 100.000 francs. The latter picture is 170 feet above the floor, while that of the Capitol is ten feet higher and contains one third more surface. I studied this picture well when I was in Paris, and from it I derived the idea of the one we have in the Capitol. Our picture wants more light in the daytime. I intended to have 36 large reflectors around it so as to throw a flood of light on it from the outside upper windows; if these are introduced I think the chiaroscuro will be perfect.[23]

The reflecting mirrors were eventually installed, so Brumidi's masterpiece was well lighted both day and night (fig. 9–14).

In 1866, a booklet was published containing a description of the canopy and its symbolism by S. D. Wyeth and a photograph of Brumidi's oil sketch copyrighted by the artist. The booklet was sold in the Capitol for an unknown period and provides the only detailed explanation of the identification of the figures; because of its date, it can be assumed the descriptions came directly from the artist. Wyeth also quoted an anonymous art critic: "whether considered as regards the conceptions of the artist, the perfection of coloring and drawing, the faultless grouping, or the peculiar characteristics that adapt it to the concave surface on which it is painted, and to the great distance from which it must be viewed, the picture is a master piece of art."[24]

The bureaucratic obstacles did not end for Brumidi even after the completion and favorable reception of the fresco. First came the question of who was to approve the work. After many letters back and forth over a two-month period between architect Edward Clark, the secretary of the interior, and the Joint Committee on the Library (which was in charge of the art in the Capitol), and a supporting letter from Walter, Brumidi was finally paid $9,500, with $500 "retained until picture is properly toned and blended," for a total of $39,500.[25] Finally, thirteen years later, in February 1879, $700 was appropriated for blending the joints and building a scaffold, but the structure was never erected. After Brumidi's death in 1880, Congress gave Brumidi's children the remaining $500 owed to him.

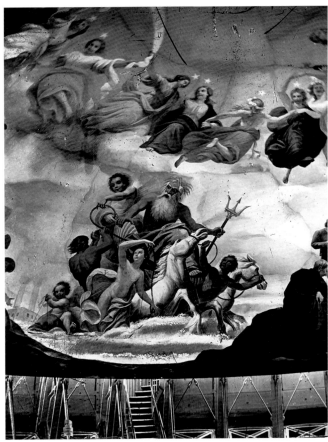

Fig. 9–14. Early photograph from the balcony. *This photograph of "Marine" shows how the space under the canopy perimeter was left open, so that light could be reflected onto the fresco from the windows in the dome. The balcony was enclosed when the Rotunda was air conditioned in the 1940s.* Brady-Handy Collection, Library of Congress.

Brumidi's crowning achievement remains the focal point of the Rotunda and the apex of the interior of the Capitol. Brumidi's canopy rivals the grand illusionistic ceilings and domes of the Renaissance and Baroque periods, such as Correggio's *Assumption of the Virgin* in the dome of Parma cathedral, Luca Giordano's *Apotheosis of the Medici Dynasty* in Florence, or Rubens's *Apotheosis of James II*. In these works, figures at the perimeter appear anchored to the ground while the saint or person being glorified rises on clouds to heaven. Similarly, Brumidi created the illusion that George Washington is rising through the clouds and the golden sky, as if the Rotunda were open to the heavens (fig. 9–15). In combining allusions to classical mythology and Renaissance and Baroque effects with references to American history and the technical achievements of his day, he had created a unique synthesis.

Conservation completed in 1988 has made its full effect visible again to millions of visitors each year (figs. 9–16 through 9–21).

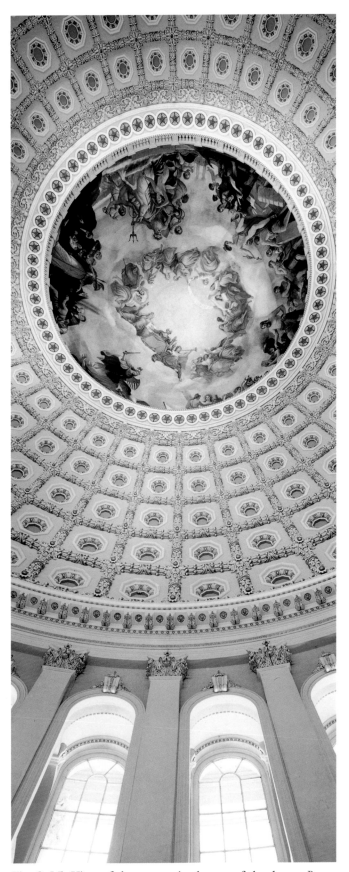

Fig. 9–15. View of the canopy in the eye of the dome. *Brumidi's fresco gives the impression that the first president is rising to the heavens.* Rotunda.

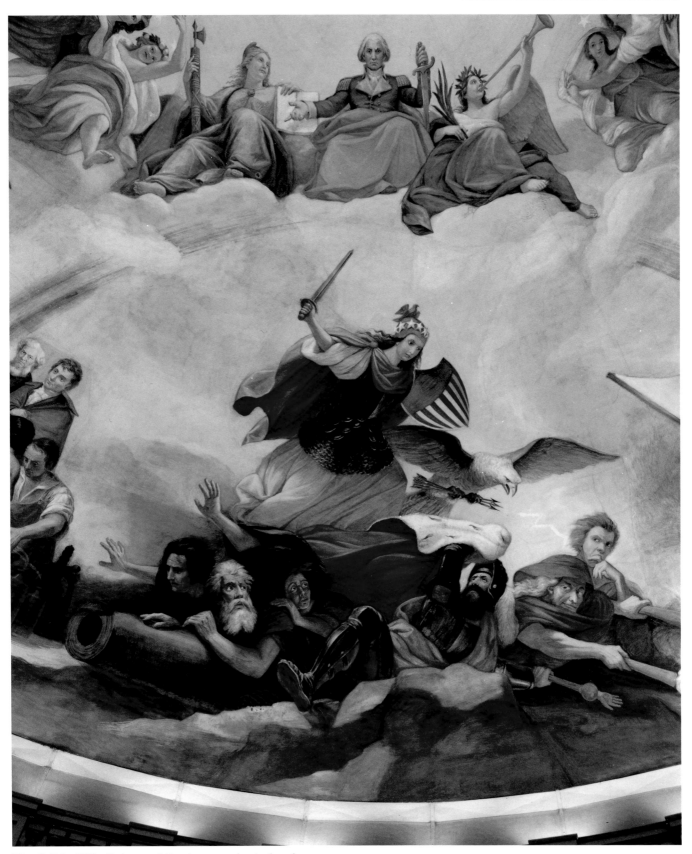

Fig. 9–16. **"War."** *Armored Freedom, sword raised and cape flying, with a helmet and striped shield reminiscent of those on the Statue of Freedom, tramples Tyranny and Kingly Power, assisted by a fierce eagle carrying arrows and a thunderbolt.* Rotunda.

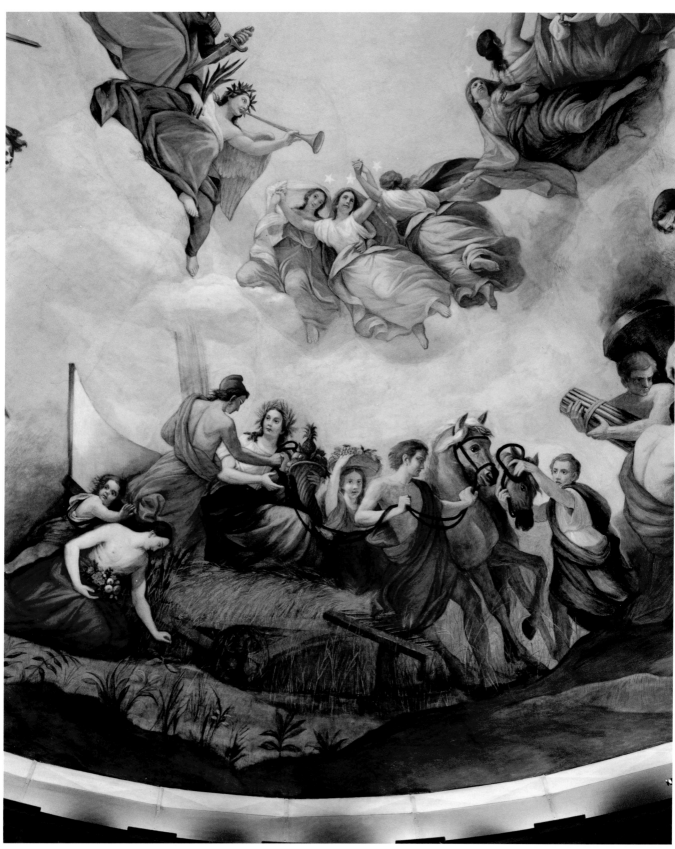

Fig. 9–17. "Agriculture." *Ceres, the goddess of agriculture, is shown with a wreath of wheat and a cornucopia, seated on a McCormick reaper. Young America in a liberty cap holds the reins of the horses, while Flora gathers flowers in the foreground.* Rotunda.

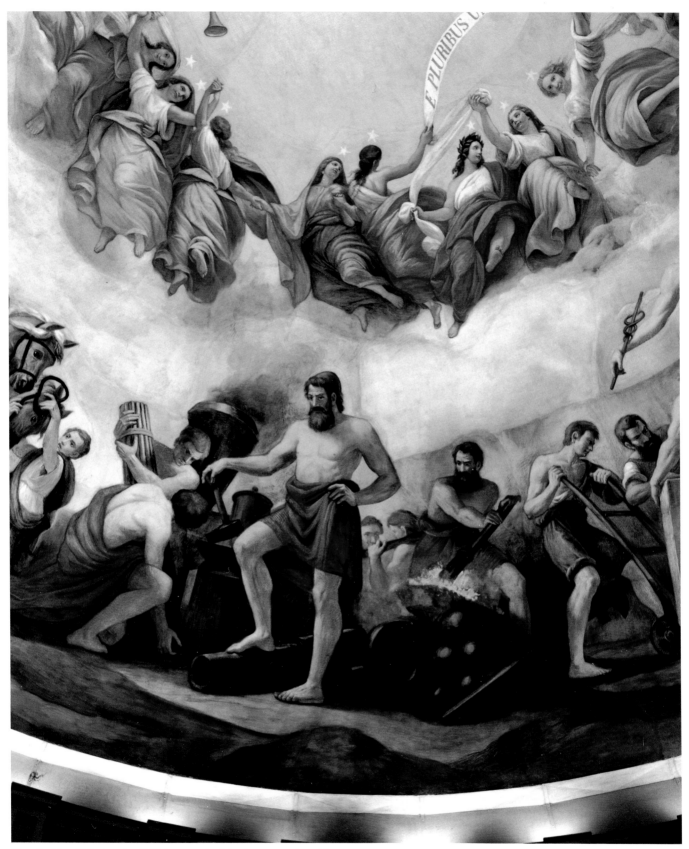

Fig. 9–18. "Mechanics." *Vulcan, god of the forge, stands at his anvil with his foot on a cannon, near a pile of cannon balls and with a steam engine in the background. The man at the forge is thought to represent Charles Thomas, who was in charge of the ironwork of the dome.* Rotunda.

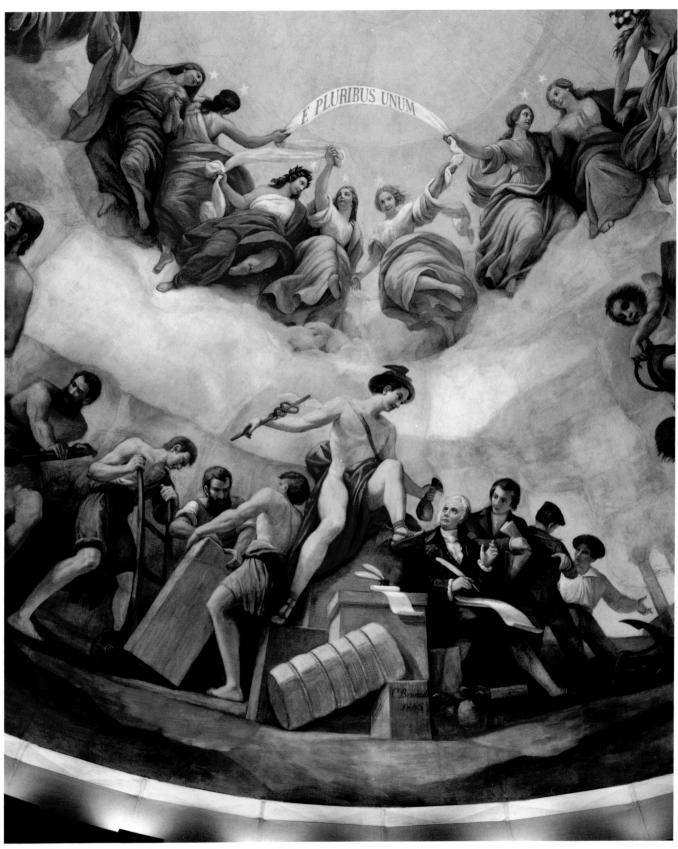

Fig. 9–19. "Commerce." *Mercury, god of commerce, with his
winged cap and sandals and caduceus, hands a bag of gold to Robert
Morris, financier of the Revolutionary War, while men move a box on
a dolly. The anchor and sailors lead into the next scene. Brumidi
signed and dated the canopy on the box below Mercury. Rotunda.*

136

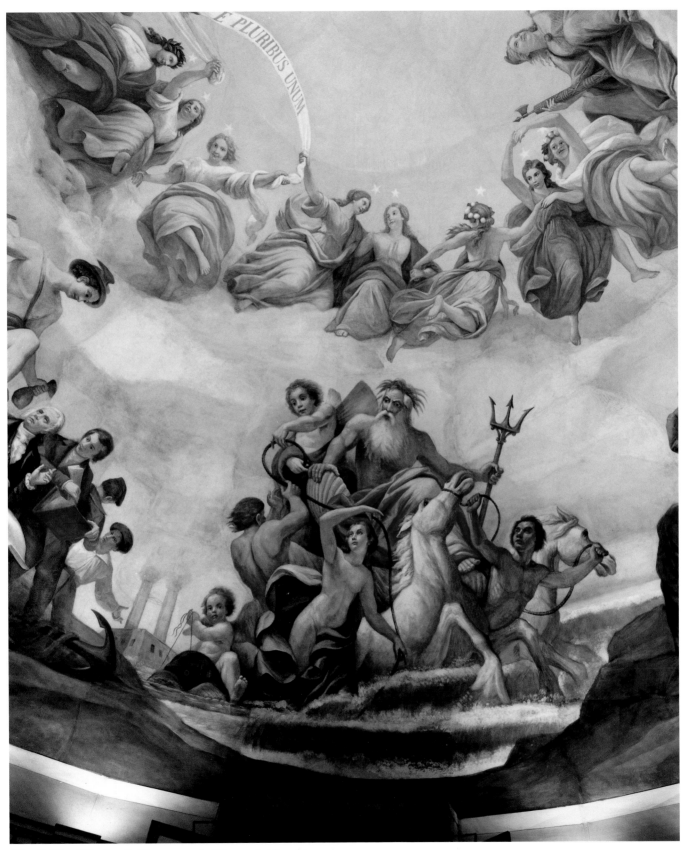

Fig. 9–20. "Marine." *Neptune, god of the sea, holding his trident and crowned with seaweed, rides in a shell chariot drawn by sea horses. Venus, goddess of love born from the sea, helps lay the transatlantic cable. In the background is a form of iron-clad ship with smokestacks.* Rotunda.

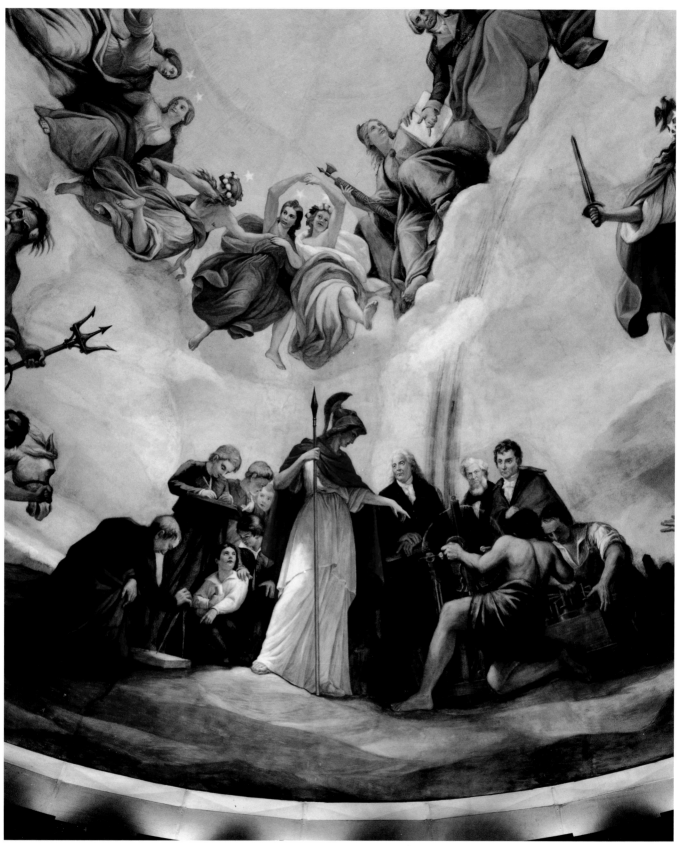

Fig. 9–21. "Science." *Minerva, goddess of wisdom and the arts of civilization, with helmet and spear, points to an electric generator creating power stored in batteries, next to a printing press, while inventors Benjamin Franklin, Samuel F.B. Morse, and Robert Fulton watch. At the left, a teacher demonstrates the use of dividers. Rotunda.*

Notes to Chapter 9

1. Oath of Office, March 9, 1861, AOC/EXT.

2. CB to MCM, June 3, 1861, AOC/CO.

3. MCM to Caleb B. Smith, June 5, 1862, NARA/RG 48 series 291, box 4.

4. TUW to CB, Aug. 18, 1862, AOC/LC.

5. CB to TUW, Sept. 8, 1862, copy of original letter in TUW Papers, LC. Clerk's copy (with height miscopied as 15 feet) in AOC/LB. During the conservation of the frescoes, Minerva, one of the tallest figures, was measured as over 15 feet in height.

6. Mark Edward Thistlethwaite, *The Image of George Washington: Studies in Mid-nineteenth-century American History Painting* (New York: Garland Publishing, Inc., 1979), pp. 190–192 and Phoebe Lloyd Jacobs, "John James Bancroft and the Apotheosis of Washington," *Winterthur Portfolio*, 1977, pp. 115–135.

7. TUW to CB, Dec. 24, 1862, AOC/LB. CB to TUW Dec. 27, 1862, TUW Papers, LC.

8. BBF to TUW, January 3, 1863, TUW Papers, LC, and AOC/LB.

9. TUW to CB, March 11, 1863, AOC/LB; TUW to CB, September 5, 1865, TUW/PA (AAA reel 4142).

10. TUW to CB, February 25, 1863, and March 30, 1863, TUW/PA (AAA reel 4141).

11. J. P. Usher to BBF, May 2, 1863, NARA/RG 48, Series 295, Register, pp. 26-27. BBF to Usher, May 4, 1863, AOC/LB. TUW to Amanda Walter, May 4, 1863, TUW/PA (AAA, reel 4141). Usher to BBF, July 7, 1863, AOC/CO, and TUW to CB, July 8, 1863, TUW/PA (AAA, reel 4141). Usher to West, November 6, 1863, AOC/CO.

12. TUW to Charles Fowler, Dec. 21, 1863, AOC/TUW Letter Book; TUW to Edward R. James, Feb. 12, 1864, and TUW to Fowler, April 4, 1864, TUW/PA (AAA, reel 4141.)

13. TUW to Usher, Dec. 3, 1864, NARA/RG 48, series 291, box 2, and AOC/ Voucher Book, Works of Art, v. 1.

14. S. D. Wyeth, "Description of Brumidi's Allegorical Painting," pamphlet excerpted from *The Federal City* (Washington: Gibson Brothers Printers, 1866), p. 116

15. Ibid., p.112.

16. George Hazleton, *The National Capitol* (New York: J. F. Taylor and Company, 1897), pp. 97-98, reports that Brumidi was accused of portraying, on the left, John B. Floyd and Robert E. Lee, and to the right, Jefferson Davis and Alexander H. Stephens, but states that he believes this unlikely. The white-bearded man looks like John Brown as the latter appears in historic photographs, but this may be only a coincidence.

17. September 3, 1865, MCM Pocket Diary, MCM Papers, LC.

18. CB to EC, September 19, 1865, AOC/CO. The situation was reported by Clark, *Annual Report of Edward Clark, Architect of the Capitol Extension*, November 1, 1865, 39–1, House Ex. Doc. No. 1, p. 811.

19. TUW to CB, November 21, 1865, TUW/PA (AAA, reel 4142.)

20. Benjamin Brown French, *Witness to the Young Republic: A Yankee's Journals, 1828-1870*, Donald B. Cole and John J. McDonough, eds. (Hanover, N.H., and London: University Press of New England, 1989), pp. 497–498.

21. *National Intelligencer*, January 17, 1866, p. 2.

22. MCM to CB, January 19, 1866, NARA/RG 48, series 290.

23. TUW to BBF from Germantown, February 17, 1866, TUW/ PA (AAA, reel 4142.) In this letter TUW states that the photographs were taken by Mr. Walker.

24. Wyeth, "Description of Brumidi's Allegorical Painting," pp. 112–115.

25. June 9, 1866, Voucher no. 23, AOC/Voucher Book, Works of Art, v. 1.

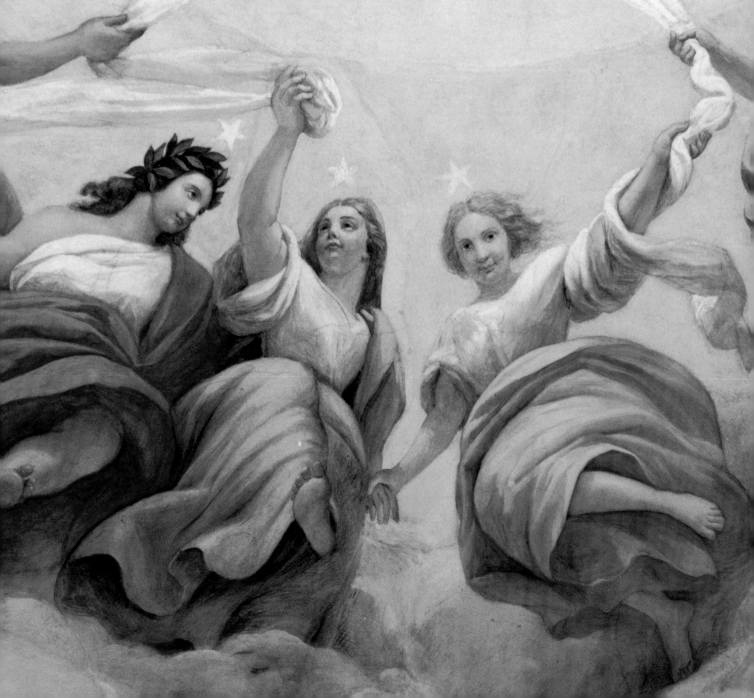

CHAPTER **10**

Symbolism in the Rotunda

FRANCIS V. O'CONNOR

Fig. 10–2. The Capitol after completion of the dome, 1866. *Brumidi could not begin painting the canopy until the dome was constructed.*

The only inscription in the Rotunda of the United States Capitol is the Latin motto *E Pluribus Unum* (from the many, one), painted in the dome by Constantino Brumidi during the Civil War (fig. 10–1). Indeed, the dome of the Capitol was erected and decorated as a symbol of the steadfastness and confidence of the Union during the height of that great insurrection (fig.10–2).[1] Brumidi submitted his design and began negotiating his commission for the dome painting during the autumn of 1862, while the Capitol was being used as a hospital for wounded soldiers. He worked on his cartoons while battles raged, from early 1863, when his commission was approved, to the end of the year. When finally, in late 1864, the canopy was installed and Brumidi was able to start painting, the war had still not ended.

Brumidi was the first accomplished American muralist in fresco. Before him, murals had been painted in oils or tempera on wood or plaster, mostly in domestic interiors, and took the form of wall panels, overmantels depicting local or fanciful scenes, or landscape panoramas.[2] Brumidi worked in an Italian stylistic tradition that went back to Raphael's walls in the Vatican and relied heavily on allegory and elaborate architectural embellishment. His corridor designs were in the Pompeian style of ancient Roman frescoes. Many American critics found this foreign style inappropriate to the central edifice of democracy (see chapter 7). But the classically inspired architecture of the newly expanded Capitol was similarly "foreign," and Brumidi's way of painting was more than suitable to its antique splendor.

The secret of Brumidi's genius, however, is not to be found so much in the style to which he was born and which he imposed at the Capitol as in his capacity to see the whole from its parts and to find an elegant overall solution to any pictorial or symbolic problem with which he was faced, as he did in the Agriculture Committee room (see chapter 5). It is plain that none of the highly skilled artists working with him at the Capitol, such as Emmerich Carstens or James Leslie, or those who came after him, such as Filippo Costaggini or Allyn Cox, could match him in this totality of skill and vision.[3] Thus an artist of Brumidi's temperament could well appreciate the aesthetic dimension inherent in the political ideal of unity that impelled his patrons and in the symbolism of raising up the dome of the Capitol to proclaim the republic's integrity in the midst of a savage and draining civil war.

Fig. 10–1. Detail of inscription "*E Pluribus Unum.*" *Maidens representing the original states hold a banner in* The Apotheosis of Washington. Rotunda.

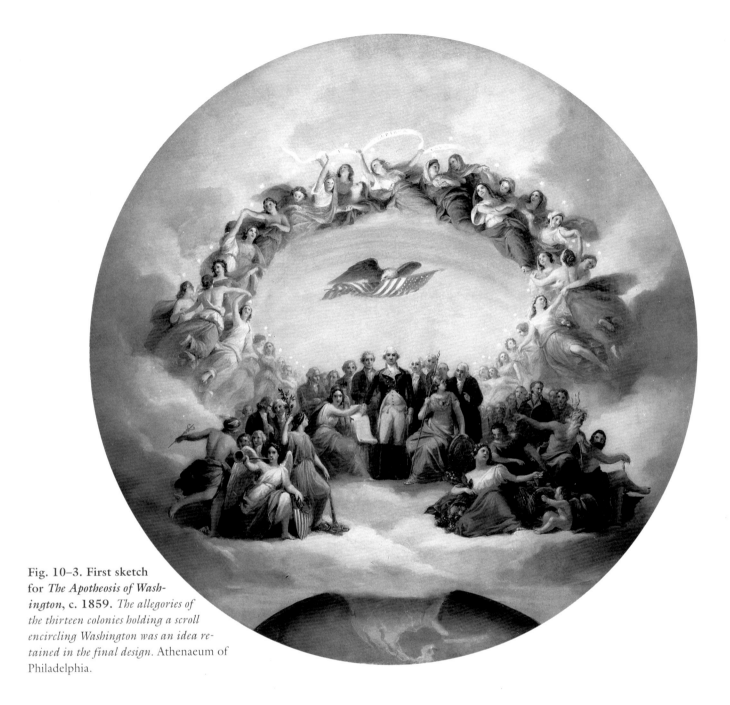

Fig. 10–3. First sketch for *The Apotheosis of Washington*, c. 1859. *The allegories of the thirteen colonies holding a scroll encircling Washington was an idea retained in the final design.* Athenaeum of Philadelphia.

The Evolution of *The Apotheosis*

It is almost possible to see Brumidi's conception of a unified symbolic program for the central space of the Capitol develop in the succession of studies he made for *The Apotheosis of Washington* in the vast canopy of the Rotunda's dome. The first study, in oil on canvas (fig.10–3), depicted Washington, his head at dead center, standing with a group of the Founding Fathers and flanked by deities and allegorical figures. Above Washington's head is an eagle holding a flag, while at the bottom can be seen the Earth, with the North American continent clearly visible.

Brumidi soon realized that this first conception, with its axial symmetry establishing a clear top and bottom,

would be seen as upside down or sideways from three of the four entrances to the Rotunda. His second sketch (fig. 10–4) attempted to achieve a greater centricity, placing an oval portrait supported by putti and flanked by allegories in the middle of the composition supported by the arc of a rainbow. Below this central group, the eagle brandishing arrows harries the forces of discord and strife, while to the right Mercury holds aloft the caduceus and, opposite, putti offer the land's abundance. The arc of the thirteen colonies, with their scroll, appears above; and above them is a firmament containing thirty-three stars. This detail plausibly dates the sketch to 1859, when the thirty-third state, Oregon, was admitted to the Union. While this was certainly a great improvement over the

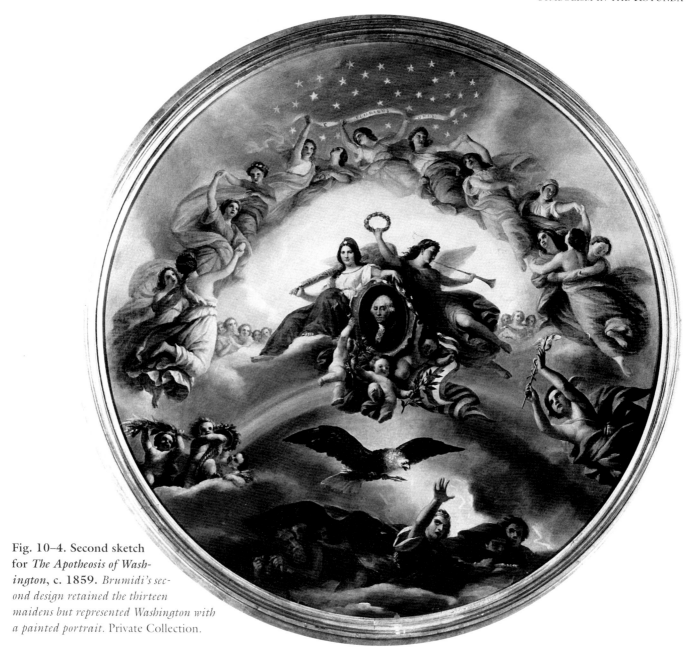

Fig. 10–4. Second sketch for *The Apotheosis of Washington*, c. 1859. *Brumidi's second design retained the thirteen maidens but represented Washington with a painted portrait.* Private Collection.

first design, it did not solve the problem of a design that would be visually coherent from all sides.[4]

While the history of Brumidi's thinking about the *Apotheosis* between 1859 and 1862, when he was commissioned to paint it, cannot be documented precisely, it can, nevertheless, be deduced with some plausibility. The third and last study for the dome design (fig. 10–5) reveals a complete spatial reconceptualization.[5] In this final study Brumidi made the crucial conceptual transition from easel painting to monumental mural, from the simple frontality and directional orientation of a conventional wall or ceiling painting to an environmental sense of the soaring space of the enlarged Rotunda. He completely reversed the field of his composition so that the

viewer would look up into the space of the apotheosis. At dead center was no longer the head of the protagonist, but a brilliant, golden sky. Washington is enthroned beneath the sky, flanked by just two allegories, at the west facing east. Above him, but reversed, is the arc of the thirteen colonies, creating a second "eye" to the dome, toward whose blinding glory all heads point, yet turn away. But even more important, he has reorganized the various historical and allegorical figures in the earlier studies into six groupings around the edge of the design in such a way that one or more would appear upright no matter from what angle the whole was viewed.

While redesigning the dome in 1859, architect Thomas U. Walter incorporated Brumidi's design into his plans

Fig. 10–5. Final sketch for *The Apotheosis of Washington,* **c. 1859–1862.** *The large oil sketch, three feet in diameter, of the final composition, now in a private collection, is shown in the photograph copyrighted by Brumidi in 1866.*

Photo: Gardner.

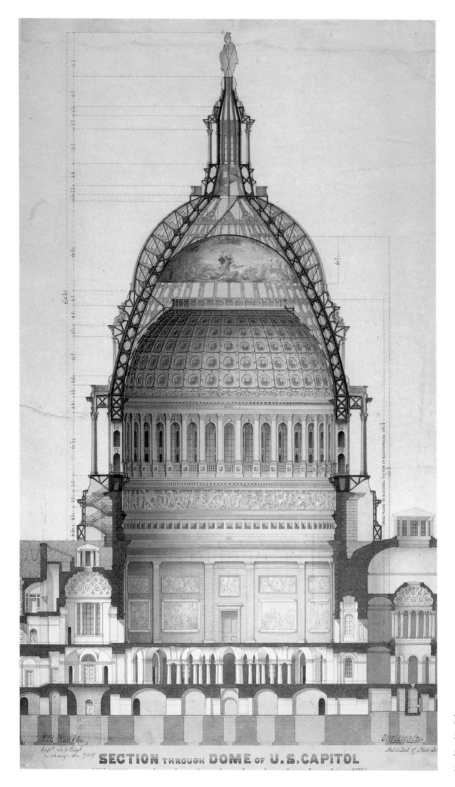

SECTION THROUGH DOME OF U.S. CAPITOL

Fig. 10–6. Thomas U. Walter, *Section through Dome of U.S. Capitol, 1859. The cross section shows Brumidi's final design for a fresco in the canopy.* Architect of the Capitol.

(fig. 10–6). His rendering of a cross section of the Rotunda with the redesigned dome clearly shows the canopy and the frieze—the latter represented by a row of figures that echo the Parthenon frieze—in relation to the eight earlier historical paintings installed in the Rotunda walls. In the drawing, two designs for the canopy mural are visible. The first is a vague generalization—a line drawing of a landscape with groups of figures and horses surrounding a central, enthroned allegorical figure. It is, however, painted over in watercolor with a depiction of Freedom and other figures identical to those Brumidi ultimately executed.[6]

Brumidi began in the spring of 1863 to work up his full-scale cartoons for the dome and to perfect his design. He spent the following year painting the nearly 5,000-square-foot concave surface. The canopy fresco was unveiled in January 1866 (see frontispiece).

145

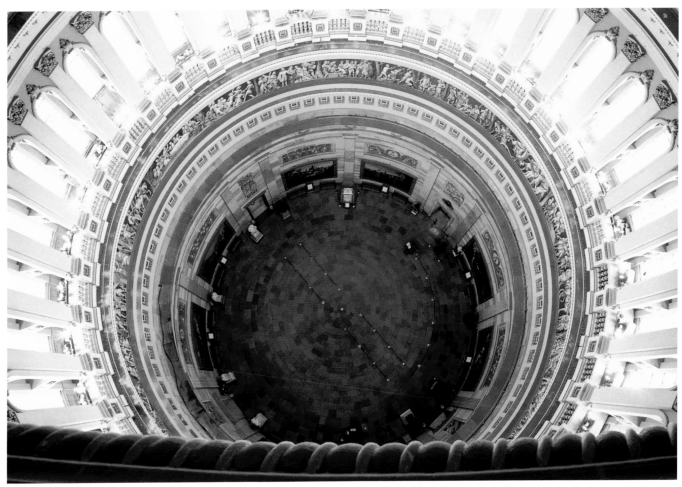

Fig. 10–7. View from the balcony to the Rotunda floor.
*Brumidi would have been aware of the total space encompassed
under the new dome.*

The Relationship of the Canopy Fresco to the Rotunda

The finished canopy permits the viewer 180 feet below to
look up into a great funnel of light, which radiates
through a vast well. From the vantage point of the bal-
cony surrounding the eye of the dome, with the great
frescoed canopy soaring 21 feet above and the Rotunda
below (fig. 10–7), it is clear that Brumidi not only solved
the technical problem of multiple vantage points, but he
also used the ribbing of the new dome to correlate his six
allegorical groups with the history paintings and sculp-
tured reliefs set in the lower walls, creating a set of formal
and symbolic relationships between his crowning creation
and the earlier works of art.

In Brumidi's time the eight historical paintings were
arranged differently than they are today.[7] The original lo-
cations and relationships are reconstructed in figures
10–8 and 10–9. (The letters and numbers in parentheses
in the following paragraphs refer to these diagrams.) The
four earlier paintings, by John Trumbull, installed on the

western side of the Rotunda, are *Declaration of Indepen-
dence in Congress* (a), *Surrender of General Burgoyne at
Saratoga* (b), *Surrender of Lord Cornwallis at Yorktown*
(c), and *General George Washington Resigning His Com-
mission to Congress as Commander in Chief of the Army*
(d). Installed later on the eastern side were Robert Weir's
Embarkation of the Pilgrims (e), John Vanderlyn's *Land-
ing of Columbus* (f), William Powell's *Discovery of the Mis-
sissippi by De Soto* (g), and John Chapman's *Baptism of
Pocahontas* (h). These works, set into the walls in huge,
carved frames similar to the overmantels of their day, con-
stituted the first public, monumental mural environment
in the country. If they seem a bit oddly composed today,
it is well to remember that they were conceived to be
seen beneath Charles Bulfinch's lower hemispherical
dome, which sprang from the entablature directly above
them, not at the bottom of Walter's 180-foot well.[8]

Also on the walls of the lower Rotunda, clockwise from
the west door, are eight alternating sculptured reliefs of

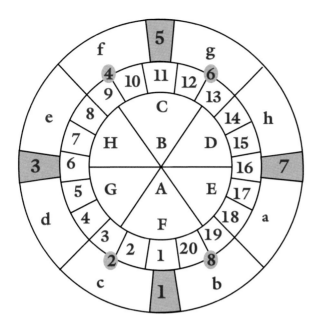

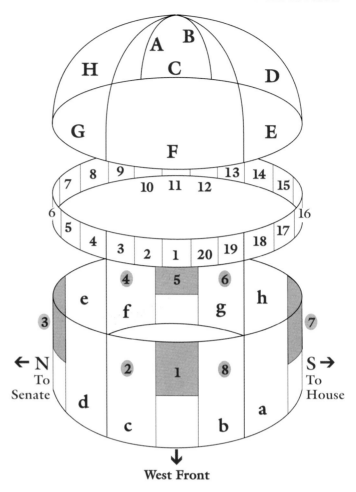

Fig. 10–8. Diagram showing the theoretical relationship of the works of art in the Rotunda. *The diagram is made as if looking down from the center of the canopy.* (See key to identify murals and relief sculptures.)

The Canopy of the Dome

A George Washington with Liberty and Victory/Fame
B Allegories of the Thirteen Colonies with Scroll
C Commerce—Mercury with Bankers of the Revolution
D Marine—Neptune and Venus with the Atlantic Cable
E Science—Minerva with Franklin, Morse, and Fulton
F War—Freedom defeating Tyranny and Kingly Power
G Agriculture—Ceres with a Reaper
H Mechanics—Vulcan forging Cannon into Railroads

The Frieze

(Brumidi's titles on the sketch, with his spelling)

1 America and History
2 Landing of Columbus
3 Cortez and Montezuma at Mexican Temple
4 Pizzarro going to Peru
5 De Soto's burial in the Mississipi River
6 Indians Hunting Buffalo
7 [missing]
8 Cap Smith and Pocahontas
9 Landing of the Pilgrims
10 Settlement of Pennsylvania
11 Colonization of New England
12 Ogelethorpe and muscogee chief
13 Lexington insurrection
14 Declaration of the Independence
15 Surrender of Cornwallis
16 Lewis and Clarke
17 Decatur at Tripoli
18 Col Johnson & Tecumseh
19 The American Army going in the City of Mexico
20 A laborer in the employ of Cap Sutter

Fig. 10–9. Diagram of the dome, frieze, historical murals, and relief sculpture. *This graphic representation shows the works of art in the Rotunda in their theoretical three-dimensional relationship.* (See key to identify murals and relief sculptures.)

The Historical Murals

a Trumbull, *Declaration of Independence*
b Trumbull, *Surrender of General Burgoyne*
c Trumbull, *Surrender of Lord Cornwallis*
d Trumbull, *George Washington Resigning his Commission*
e Weir, *Embarkation of the Pilgrims*
f Vanderlyn, *Landing of Columbus*
g Powell, *De Soto's Discovery of the Mississippi*
h Chapman, *Baptism of Pocahontas*

The Relief Sculpture

1 Capellano, *Preservation of Captain Smith by Pocahontas*
2 Causici, *Christopher Columbus*
3 Gevelot, *William Penn's Treaty with the Indians*
4 Capellano, *Robert La Salle*
5 Causici, *Landing of the Pilgrims*
6 Causici, *John Cabot*
7 Causici, *Conflict of Daniel Boone and the Indians*
8 Capellano, *Sir Walter Raleigh*

147

historical events and tondo portraits of early discoverers: *Preservation of Captain Smith by Pocahontas* 1, *Christopher Columbus* 2, *William Penn's Treaty with the Indians* 3, *René Robert Cavalier Sieur de La Salle* 4, *Landing of the Pilgrims* 5, *John Cabot* 6, *Conflict of Daniel Boone with the Indians* 7, and *Sir Walter Raleigh* 8, carved between 1825 and 1827 by Enrico Causici, Antonio Capellano, and Nicholas Gevelot.[9]

Gazing down on the Rotunda, Brumidi would certainly have been conscious of the significance of the older murals and sculptures. It is also apparent that he was aware of compass orientation, as anyone involved with an architectural environment would be. In arranging his motifs in the Agriculture Committee room (H–144), for instance, he oriented the allegories of the seasons to the cardinal points. There, Spring is placed to the ever-renewing east, Summer to the nurturing south, Autumn's fruition and death to the opposites inherent in the west's sunset, and Winter to the cold and mysterious north. This perennial directional symbolism of dawn, day, dusk, and dark plays its role in Brumidi's Rotunda program as it did in all the great mural cycles he would have known in Italy, such as Michelangelo's Sistine Chapel, where the *Last Judgment*, with its opposition of good and evil, is placed on a west wall. This sense of environmental context was an important factor in Brumidi's arrangement of the six groups of gods and goddesses in the dome.

The iconography of the canopy fresco, with its conjunctions of deities and humans, may seem strange to us today. However, in the mid-nineteenth century the personification of abstract ideas by means of figures drawn from classical mythology and the association of historical figures such as George Washington and Benjamin Franklin with these was part of the cultural vocabulary. The gods and goddesses stood allegorically for universal virtues embodied in popular historical personalities. Thus Washington sits enthroned in the pose of all-powerful Jupiter, and the great inventor and political philosopher Franklin is associated with Minerva, goddess of wisdom. The complete meaning of Brumidi's dome can be understood only in respect to these traditional attributes of the gods and goddesses and how they are related to the historical figures in their immediate context around the edge of the canopy. These iconographic meanings are also reinforced by symbolic placement both above and opposite the historical paintings and sculptured reliefs.

Washington, flanked by allegories of Liberty and Victory/Fame (*A*) (see fig. 9–1), sits enthroned above Freedom (*F*) (see fig. 9–16), who, along with a militant bald eagle holding arrows, wreaks havoc among the forces of war, tyranny, and discord. The latter are represented by figures with a cannon, a king in armor holding a scepter and an ermine-lined cape, and anarchists with torches. All

these figures are on the west surface of the canopy. They thus face the east front of the Capitol and are the first images seen when one looks up from the east door of the Rotunda. They also face Columbus, the Pilgrims, and de Soto—those who discovered and settled the land to which Washington's leadership gave liberty by means of victories such as those he and his generals won over Burgoyne and Cornwallis, above which—along with the first victory of Christian love over "heathen savagery"—they are directly situated.

Next, Ceres, the goddess of agriculture (*G*) (see fig. 9–17), is seen riding on a reaper filled with grain and attended by Young America wearing a liberty cap. She is holding a cornucopia, the traditional symbol of plenty, which is crowned by a pineapple—a rare and exotic fruit at the time. Ceres's retinue is completed by Flora, the goddess of fertility and flowers, picking blossoms in the foreground, and Pomona, the goddess of fruit, carrying in the background a basket overflowing with the earth's abundance. An image of Vulcan, god of the forge (*H*) (see fig. 9–18), dominates the following scene. His foot is set firmly on a cannon, and a steam engine is in the background. His pose and activity signify the peaceful intentions and modernity of American industry.

Both Ceres and Vulcan face south from the north surface, to the region of daily enterprise and growth, where Pocahontas, Daniel Boone, and the Declaration of Independence symbolize the planting of spiritual and political seeds and the forging of territory-spanning industry. Similarly, both preside over the sowing of democracy inherent in Washington's resigning his commission and in the Pilgrims who first tamed the wilderness, which was soon to be conquered nationally.

To the east reigns Mercury, the trickster god of opposites and of commerce (*C*) (see fig. 9–19), who faces west, toward the conflicts of warfare and surrender. In his guise as god of travelers, however, he presides above Columbus, the Pilgrims, and de Soto — while holding over all the caduceus, symbol of healing and peaceful interactions. In this respect, he is surrounded by the heaving and hauling of boxes and bales. Shipping is represented to the right by two sailors with an anchor. One of the sailors gestures to an ironclad boat in the background, which may refer to one of the great naval achievements of the Civil War, the building of the ironclad ships such as the *Monitor*. The god himself deals with one of the bankers of the Revolution, Robert Morris, to whom he offers a bag of money. Similar bags are stashed at the foot of his dais. It is interesting and amusing to note that Brumidi chose to identify himself with the god of commerce by signing his masterpiece (the inscription reads "C. Brumidi/1865") on the box next to these.

Neptune and Venus are shown together (*D*) (see fig. 9–20) in one of the most beautifully designed groupings

in the dome. The bearded god of the oceans rides his horse-drawn chariot of shells and holds the trident, while his attendants hold aloft the transatlantic cable—the communications revolution of the day—which the sea gods happily receive into their realm. Venus, draped in a blue robe, is born from the sea next to Neptune, and is attended by a putto riding a dolphin.

These sea deities, along with Minerva (E) (see fig. 9–21), are on the south surface and face into the region of northern darkness and mystery, where the Pilgrims, Penn, and Washington stand for the heroism and self-sacrifice needed to overcome an untamed continent and the temptations of political power. Below the water gods Neptune and Venus are to be found de Soto, the discoverer of a great river, and Pocahontas, the first Indian to receive the waters of baptism.

Minerva (E), the goddess of wisdom, is shown surrounded to the left by educators teaching children and to the right by famous scientists such as Benjamin Franklin, Samuel F. B. Morse, and Robert Fulton. She gestures to one of Franklin's electrical experiments with Leyden jars, the precursor of Morse's magnetic telegraph, which ultimately prompted the laying of the transatlantic cable, allegorically depicted in the contiguous scene. Symbolically, she is situated directly over the signing of the Declaration of Independence, whose wisdom engendered liberty and progress in the land.

There is thus sufficient circumstantial evidence in the symbolic relationships just described between the gods in the dome and the historical murals and reliefs below to support the argument that Brumidi was thinking in terms of a comprehensive program for the Rotunda in the manner of the many European counterparts he would have known, and similar to the carefully integrated programs he had already developed in the Capitol's various committee rooms. On this basis, one can presume that his design for the frieze was intended to be similarly integrated into his overall conception.

The Frieze of American History

As the second element of the Rotunda program, Walter and Meigs had envisioned a sculptured frieze comparable to the famous one on the Athenian Parthenon (see fig. 10–6), but the lack of a suitable sculptor after the death in 1857 of Thomas Crawford, whom Meigs had selected as the sculptor of the Statue of Freedom and of the frieze, as well as cost considerations, forced him to abandon the idea in about 1859. Brumidi conceived a painted frieze of illusionistic sculpture showing historical scenes with an impressive array of life-size figures in sepia grisaille fresco. The completion of the dome and the end of the Civil War brought to a near end Meigs's ambitious art program for

the Capitol. Brumidi himself would be sporadically employed there for the next decade. But at the end of that time the great frieze remained blank.

In 1876 Brumidi petitioned Congress to be allowed to finish the overall Rotunda program, and he was eventually permitted to begin the cartoons for his frieze in 1877. He began painting the fresco in 1878 but died in 1880 before he finished it. Filippo Costaggini was selected to complete the frieze following Brumidi's designs. But miscalculations in the projected dimensions left, from about 1895 until 1953, a 31-foot length of wall unpainted.[10] This was eventually filled by the academic muralist Allyn Cox. His somewhat anachronistic contribution honorably fills the gap, and the stylistic tensions between the three artists are noticeable only to art historians with binoculars (see foldout following chapter 11).

Today it is difficult to understand clearly how Brumidi might have intended to integrate the frieze into his overall symbolic program. There are two reasons for this. First and most obvious is that Brumidi's surviving sketch for the frieze (fig. 10–10) may not be complete and was made in 1859, twenty years before he began to paint. Second, it is plain that the selection of historical events to be shown in the frieze was not the work of the artist alone.

Concerning this last point, surviving documents indicate that both Meigs and the great history painter Emanuel Leutze contributed to the selection of subjects. In his 1855 report Meigs described his conception of the frieze as follows:

> The gradual progress of the continent from the depths of barbarism to the heights of civilization; the rude and barbarous civilization of some of the Ante-Columbian tribes; the contests of the Aztecs with their less civilized predecessors; their own conquest by the Spanish race; the wilder state of the hunter tribes of our own regions; the discovery, settlement, wars, treaties; the gradual advance of the white, and retreat of the red races, our own revolutionary and other struggles, with the illustration of the higher achievements of our present civilization. . . . [11]

In a letter to Meigs dated February 8, 1857, Leutze elaborated his scheme for a mural series throughout the Capitol, including a chronological sequence of events.[12] While Meigs rejected this grandiose conception as impractical, he must have been intrigued by the thematic information Leutze had provided, and it is plausible to assume that he discussed his ideas with Brumidi and many other historically aware individuals around the Capitol and in Washington.

In his letter Leutze listed eight divisions for a chronology: discovery, causes of emigration, emigrants, condition of the settlers, revolution, battles (through the War of

Composite Photograph
of Brumidi's Original Sketch for the Rotunda Frieze
Reconstructed by Francis V. O'Connor
(Numbers correspond to those for Frieze in figs. 10–8 and 10–9.)

1 America and History 2 Landing of Columbus 3 Cortez and Montezuma at Mexican Temple

6 Indians Hunting Buffalo 7 [missing] 8 Cap Smith and Pocahontas

11 Colonization of New England 12 Ogelethorpe and muscogee chief

15 Surrender of Cornwallis 16 Lewis and Clarke 17 Decatur at Tripoli 18 Col Johnson & Tecumseh

**Fig. 10–10. Photo composite of Brumidi's sketch for the
frieze, 1859.** *Two scenes cut out by Brumidi are reinserted here.*
Architect of the Capitol.

4 Pizzarro going to Peru 5 De Soto's burial in the Mississipi River

9 Landing of the Pilgrims 10 Settlement of Pennsylvania

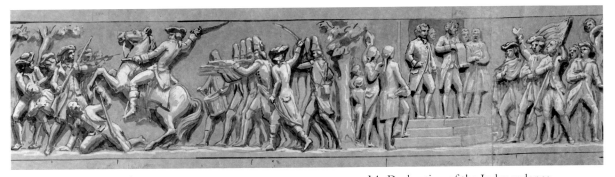

13 Lexington insurrection 14 Declaration of the Independence

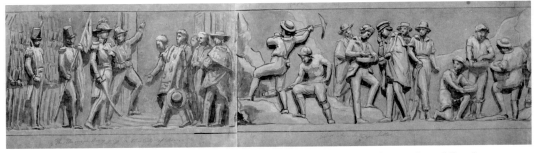

19 The American Army going in the City of Mexico 20 A laborer in the employ of Cap Sutter

Brumidi's Sequence for the Frieze of American History

Note: Numbers and titles (with Brumidi's spelling) of missing sections, as well as additional wording for unclear or incomplete titles, are supplied in brackets. The letters *M* and *L* indicate the dozen events Meigs and Leutze may have suggested to the artist.

Key Number	Inscribed Number	Inscribed Title	Date of Event	Source
1	[none]	*America and History* [*An Allegory*]		
2	[none]	*Landing of Columbus*	1492	L
3	2	*Cortez and Montezuma at Mexican Temple*	1521	M
4	3	*Pizzarro going to Peru*	1533	M
5	4	*De Soto's burial in the Missisipi River*	1542	L

Here the sketch is missing scenes 5 and 6. A tipi's tent peg can be seen in the lower right corner of Brumidi's scene 4, thus clearly placing the Indian scene following. Since the scene with Captain Smith and Pocahontas is numbered 7 in the sketch, a sixth scene is apparently missing.

Key Number	Inscribed Number	Inscribed Title	Date of Event	Source
6	5	*[Indians Hunting Buffalo]*		M
7	[6]	[Missing from sketch]		
8	7	*Cap Smith and Pocahontas*	1606	
9	8	*Landing of the Pilgrims*	1620	L
10	9	*Settlement of Pennsylvania* [by William Penn's Treaty with the Indians]	1682	
11	10	*Colonization of N England*	1620	
12	11	*Oglethorpe and muscogee chief*	1732	
13	12	*Lexington insurrection*	1775	
14	13	*Declaration of the Independence*	1776	L
15	14	*Surrender of Cornwallis*	1781	L

There is a gap between scenes 14 and 16 in the sketch; the Lewis and Clark scene fits here chronologically and numerically.

Key Number	Inscribed Number	Inscribed Title	Date of Event	Source
16	[15]	*Lewis and Clarke* [*Attacked by a Bear*]	1804–6	L
17	16	*Decatur at Tripoli*	1804	L
18	17	*Col Johnson & Tecumseh*	1813	
19	18	*The American army going in the City of Mexico*	1847	L
20	[none]	*A laborer in the employ of Cap Sutter* [during California Gold Rush]	1848	

1812), emigration to the West, and Texas and Mexico. He then made an important distinction between a historical anecdote and an event, stressing that only the latter has a consequence and is therefore significant. He noted that the paintings of Weir and Chapman in the Rotunda depicted anecdotes, since the Pilgrims' embarkation (as opposed to their landing) and the baptism of Pocahontas had no consequence per se. While he did not like Trumbull's *Declaration of Independence*, he thought it important as "a true illustration of an event." In the next sentence, however, he stated, "I wish he had painted the reading of the Declaration from the window of the Phila. St. House." This comment would not in itself be of much interest, if it were not that Brumidi actually did include this unusual subject in his sketch for the frieze. And this, along with the fact that nine of the nineteen known events Brumidi planned to depict are mentioned in Leutze's list, strongly suggest that Meigs showed this letter to Brumidi.

An analysis of the sketch for the frieze and a reconstruction of its fragments to form a complete number sequence reveal what was apparently Brumidi's original sequence of twenty events.[13] The table to the left keys these, with the numbers and titles of the scenes as Brumidi inscribed them, to the diagrams in figures 10–8 and 10–9.

While this reconstruction of Brumidi's original frieze provides a plausible picture of his original intentions, it is difficult to integrate into the overall iconography of the Rotunda. Unlike his sketches for the canopy, which, as we have seen, display a clear development, this sketch did not go through such a process. Nevertheless, it is possible to discern some general patterns of relationship between the sketch and the rest of the art in the Rotunda.

In general the scenes to the west (1 through 6 and 16 through 20), over the Trumbulls and beneath the goddesses in the dome, represent images of war, conquest, rebellion, and death. Those to the east (8 through 15), over the later historical murals and beneath the gods, represent (though not consistently) images of peace, progress, and enlightenment. More specifically, one can find conceptual if not precise symbolic relationships between events in the frieze and the murals and reliefs below.

Thus, on the west, the flanking scenes of Columbus and the 1848 Gold Rush (1 and 20) are events very much oriented to the literal West, the former having gone west to find the Indies of the east, the prospectors having done so to find gold in California. Similarly, the next contiguous scenes both relate to Mexico, and are "western" if the geographic relationship to the first colonies is considered. On the north, in the original of Brumidi's sketches, Plains Indians would have hunted buffalo (6) over the relief of Penn's treaty with the forest Indians **3**—the Native Americans being a source of infinite mystery and danger for the

Fig. 10–11. "De Soto's Burial in the Mississippi River."
Brumidi apparently planned to have the more horizontal composi-
tions over doorways to relate the frieze to its architectural setting.
Architect of the Capitol.

colonists, and thus placed appropriately (for the time's thinking) to the lightless direction. Similarly, on the south, Lewis and Clark (16) would have been seen over their illustrious predecessor Daniel Boone 7. On the east the colonization of New England (11) would have been over the landing of the Pilgrims 5, and all the flanking scenes depict events that took place "to the east" geographically.

Curious discrepancies and duplications of imagery, not to mention historical gaps, remain. The most obvious is the omission of any events between the start of the War of 1812 and the conquest of Mexico in 1847. Perhaps, from the point of view of Brumidi's patrons, there was nothing much to idealize from the burning of Washington, through the Age of Jackson, to the years tense with dispute over slavery. The fresh conquest of Mexico and the thrilling discovery of gold which laid claim to the last continental frontier were perhaps felt more suitable for depiction. And when the aged artist finally began to paint his frieze well after the Civil War, there was no one about who cared much to help with an updating, and he may well have forgotten or put aside his original intentions, in order to get something of his conception in place.

It is interesting to compare the canopy fresco with the frieze. The canopy was painted with great attention to detail because he knew it would be seen at close range from the balcony around the eye of the dome as well as from below. He was thus careful to create there a series of striking silhouettes against the sun-filled aura, so the detailed images can also be read from a distance. The frieze, however, would be seen only from afar—either from 60 or so

feet below or across the 96.7-foot width of the Rotunda by those climbing to the dome. His brushwork was therefore quite free—just enough detail to be visually legible but not enough to obscure the forms with busy work.

Brumidi was not only an artist who could see the whole situation of a wall and paint it accordingly; he was also an aging master of his craft for whom the essence of a form was more important than any detail, something his successor, Costaggini, had not mastered.

Moreover, the reconstruction indicates that Brumidi's original conception of the frieze attempted to create a formal as well as an iconographic unity with its environment. It would appear that he was trying to arrange the sequence of events so that those with a predominantly horizontal composition, such as the burial of de Soto (5) (fig. 10–11), would fall over the north and south doors, while those with a dominant triangular structure, such as the allegory of America and History (1) and the colonization of New England (11) would crown the east and west doors. When he discovered that the panels were falling out shorter than he had intended, he seems to have experimented with new scenes, such as that of Lewis and Clark (16) (fig. 10–12).[14] This arrangement would have subtly distinguished the front and back from the sides of the confusingly circular Rotunda, broken the relentless verticality of the rest of the scenes, and given a pleasing rhythm to the whole design.

Brumidi's death prevented this aesthetic unity from being realized. But it is justifiable to read his inscription in the canopy fresco—"from the many, one"—as pertaining to his artistic ambitions in this great chamber as much as it may have expressed the political sentiments and goals of his patrons. That his grand design for the Rotunda was

Fig. 10–12. "Lewis and Clark." *This scene was at some point cut out of the scroll of sketches for the frieze.* Architect of the Capitol.

left incomplete and is now obscured by the works of others does not subtract from the genius that made the attempt to bring a sense of aesthetic and symbolic unity to this central space of our national Union.

Author's Acknowledgment

I want to thank the U.S. Capitol Historical Society and Dr. Barbara Wolanin, Curator for the Architect of the Capitol, for the 1987 fellowship which enabled me to use the Records of the Architect of the Capitol (hereafter AOC) and to study Brumidi's murals—many from the scaffold of Bernard Rabin, who has crowned his career as a restorer by bringing Brumidi's great walls back to life.

The material in this essay is excerpted from my book in progress, *The Mural in America: A History of Wall Painting from Native American Times to Postmodernism,* and, where not specifically documented, is taken from Charles E. Fairman, *Art and Artists of the Capitol of the United States of America* (Washington, D.C.: Government Printing Office, 1927); The Architect of the Capitol, *Art in the United States Capitol* (Washington, D.C.: Government Printing Office, 1976); and Myrtle Cheney Murdock, *Constantino Brumidi: Michelangelo of the United States Capitol* (Washington, D.C.: Monumental Press, 1950).

Notes to Chapter 10

1. It is unclear whether the dome itself was completed in defiance of the Confederacy or because the contractors faced a substantial loss if the vast quantity of cast-iron dome elements already delivered to the Capitol grounds were not put into place. William Allen, Architectural Historian for the Architect of the Capitol, believes that the latter was the case, and that President Lincoln simply made political hay out of economic necessity (unpublished lecture, March 16, 1990) (see chapter 4). There is also evidence that the canopy was painted with similar practicalities in mind, since it had to be executed while the scaffold used to erect the dome was still in place. TUW to CB, August 18, 1862 and B. B. French to secretary of the interior, May 4, 1863 AOC/LB. None of this, however, takes away from the patriotic sentiment that helped to inspire the artist in his subject and the Union to victory.

2. There were certainly other muralists, but most of them worked for decorating firms and few had opportunities for large-scale public commissions. One exception, notable because his work was known to Meigs, was Nicola Monachesi (1795–1851), whose 1834 murals in the dome of the Philadelphia Exchange are probably among the first true frescoes painted in this country. See Agnes Addison Gilchrist, "The Philadelphia Exchange: William Strickland, Architect," in *Historic Philadelphia from the Founding until the Early Nineteenth Century* (Philadelphia: American Philosophical Society, 1953), pp. 86–95, and MCM to Gouverneur Kemble, April 24, 1854, AOC/LB, and Francis V. O'Connor, "A History of Painting in True Fresco in the United States: 1825 to 1845," in *Fresco: A Contemporary Perspective* (New York: Snug Harbor Cultural Center, [1994]), pp. 3–10.

3. Brumidi presided over what can be called an atelier (see chapter 6), and there is some evidence that Meigs encouraged this. For instance, John Durand understood from Meigs that Brumidi was willing to take pupils in fresco. Durand to MCM, January 31, 1857, AOC/CO.

154

The nature of the atelier was complex. Existing payroll records (AOC/CO) would seem to suggest that it was flourishing between 1856, when Brumidi had established himself as the premier fresco painter, and 1861, when Meigs's departure and the onset of the Civil War brought most artistic activity to a halt. During that time about eighty people were employed at the Capitol. There were roughly fifty-five "decorative" painters and twenty-five "fresco" painters, with occasional overlaps of responsibility. One gathers, however, from a number of sources, most notably from a letter from Brumidi to Meigs, that those engaged in fresco painting resented being assigned decorative tasks, CB to MCM, December 10, 1858, AOC/CO. Within this atelier Brumidi maintained pride of place, and his written communications suggest he brooked no interference from his colleagues.

4. See: Kent Ahrens, "Constantino Brumidi's 'Apotheosis of Washington' in the Rotunda of the United States Capitol," in *Records of the Columbia Historical Society of Washington, D.C., 1973–1974* (Washington, D.C.: Columbia Historical Society, 1976), pp. 187–208; see p. 196 for the dating.

5. The author discovered this long-lost work, known in an 1866 copyright photograph, in a private collection in Honolulu during a research trip in 1987. Given the closeness of its details to the finished mural, there is a slight possibility that this sketch is not so much a *modello* as a *ricordo*, in that it could have been painted after the dome was completed so that the full design could be copyrighted. This is suggested by Brumidi's letter of September 8, 1862, to Thomas U. Walter, in which he submitted his design for the dome. His description of the six allegories and the figure of Washington fits the finished work in every detail except when he says that the latter will be "surrounded by . . . figures of eminent men of the times of Washington, which latter will be likenesses," AOC/CO. More likely is the possibility that at this time a now lost oil study still included other figures around Washington in the manner of that at the Athenaeum and that the one in Honolulu is later and records Brumidi's final conception, developed while working in the dome.

6. Brumidi submitted the third sketch, or one very similar to it (see note 5), to Walter three weeks after it was requested in the fall of 1862 (indicating he was well prepared for the request). It was later approved by the secretary of the interior, and Congress appropriated the necessary funds that winter. Brumidi was authorized to proceed with the preparatory work on March 11, 1863. Later that spring, however, a new secretary of the interior questioned the commission and stopped payments. It was necessary to establish that a frescoed dome was included in Walter's original plans, and it is possible that Brumidi added a sketch to Walter's rendering at this time to support that correct contention. (While this is probably not the first doctored document in the U.S. Government's history, it could well be the first which involved a painting after the fact.)

7. In 1979 Curator for the Architect of the Capitol David Sellin, in the process of restoration of the Rotunda canvases, switched the positions of Weir's *Embarkation of the Pilgrims* (E) and Powell's *Discovery of the Mississippi by De Soto* (G). He did this to create a better aesthetic balance across the wall comparable to that of the four Trumbull paintings opposite. (Verbal communication, March 16, 1990.) The switch destroyed the relationships Brumidi made between the history paintings, his allegories in the canopy, and the historical scenes in the frieze.

8. The four large paintings on revolutionary themes on the west were commissioned from John Trumbull in 1817 and placed between 1819 and 1824. On the Trumbull paintings, see Irma B. Jaffe, *John Trumbull: Patriot-Artist of the American Revolution* (Boston: New York Graphic Society, 1975), and, on the later historical murals, Kent Ahrens, "Nineteenth Century History Painting and the United States Capitol," pp. 191–222. Con-

cerning the relationship of the historical murals to the environment of the Rotunda, it should be remembered that the original dome of the Capitol, designed by Charles Bulfinch, was modeled on that of the Roman Pantheon, and consisted of an interior hemisphere with an oculus made of a collar of stone. This was surmounted by a somewhat more elongated and quite ill-proportioned exterior dome constructed of copper-clad wood, which the architect was required to erect against his wishes to make the profile of the building more prominent. Thus the interior of the Rotunda was capped by a low dome, and the artists who painted the eight history paintings designed their works for a far more intimate space than exists today.

9. For a discussion of the sculptures, see Vivien Green Fryd, "The Italian Presence in the United States Capitol," in Irma Jaffe, ed., *The Italian Presence in American Art, 1760–1860* (New York and Rome: Fordham University Press and Istituto della enciclopedia Italiana, 1989), pp. 132–149.

10. When Filippo Costaggini completed Brumidi's frieze from his measured sketch in the late 1880s, there remained over 30 feet to go—a gap usually attributed to Costaggini's ambition to add a few scenes of his own design. Recent careful measurements of the frieze during restoration suggest another explanation, as Barbara Wolanin points out in chapter 11. This is most visible in the fact that the burial of de Soto is just to the left of the north door, rather than directly over it, as the reconstructed sketch would suggest was Brumidi's original intention. This proportional compression, which was continued by Costaggini, along with the fact that the frieze is actually about 303.5 feet long, created the gap.

11. *Report of the Architect of the Capitol*, November 16, 1855, pp. 117–118.

12. Leutze to MCM, February 8, 1857, AOC/CO.

13. Brumidi's 30-foot-long scroll sketch for the frieze was discovered in a scroll of pasted-together sheets used by him and his successor, Costaggini. Two other fragments, depicting a tipi with Indians hunting buffalo, and Lewis and Clark (fig. 10–10, numbers 6 and 16) can be shown to fit into the sequence, and one panel is missing (fig.10–10, number 7). See the composite views in figure 10–10 and frieze foldout to compare the frieze as completed with Brumidi's original intention for it. I want to thank Barbara Wolanin for first pointing out the tipi peg to the lower right of scene 5 (numbered 4 in the sketch), which placed the hunting scene following.

14. As can be seen in figure 10–10, scenes 1, 6, 11, and 16 would have fallen respectively over the west, north, east, and south doors. Scene 1, "America and History," has a decidedly triangular composition, as does scene 11, "Colonization of New England." The fifth, "De Soto's Burial in the Mississippi," is a decidedly horizontal design. It can be conjectured that, when Brumidi discovered that the last would not reach the area over the door, he experimented with the triangular tipi motif for that position, balanced by the succeeding horizontal hunting scene. Similarly, at the sixteenth panel, *Lewis and Clark*, he seems to have tried reversing this sequence of design motifs, with the horizontal bear falling over the door, flanked by the horse and rider to the left and the figures around the boat to the right. Also, these two additions (numbers 6 and 16) appear to be drawn in a looser style than the rest of the scenes, and that may indicate that they date from the late 1870s, well after the original sketch. These, along with the missing scene 7, were probably all added in an attempt to correct the growing discrepancy in the length of the frieze. (See, however, Barbara Wolanin, "Constantino Brumidi's Frescoes in the United States Capitol," in Irma B. Jaffee, ed., *The Italian Presence in American Art: 1760–1860*, pp. 153–155 and note 16, where it is argued that these additions were discarded c. 1859.) It is unclear when or why they were abandoned, but a possible reason is that Brumidi or those advising him came to see that they represented what Leutze had called "anecdotes," rather than consequential historic events.

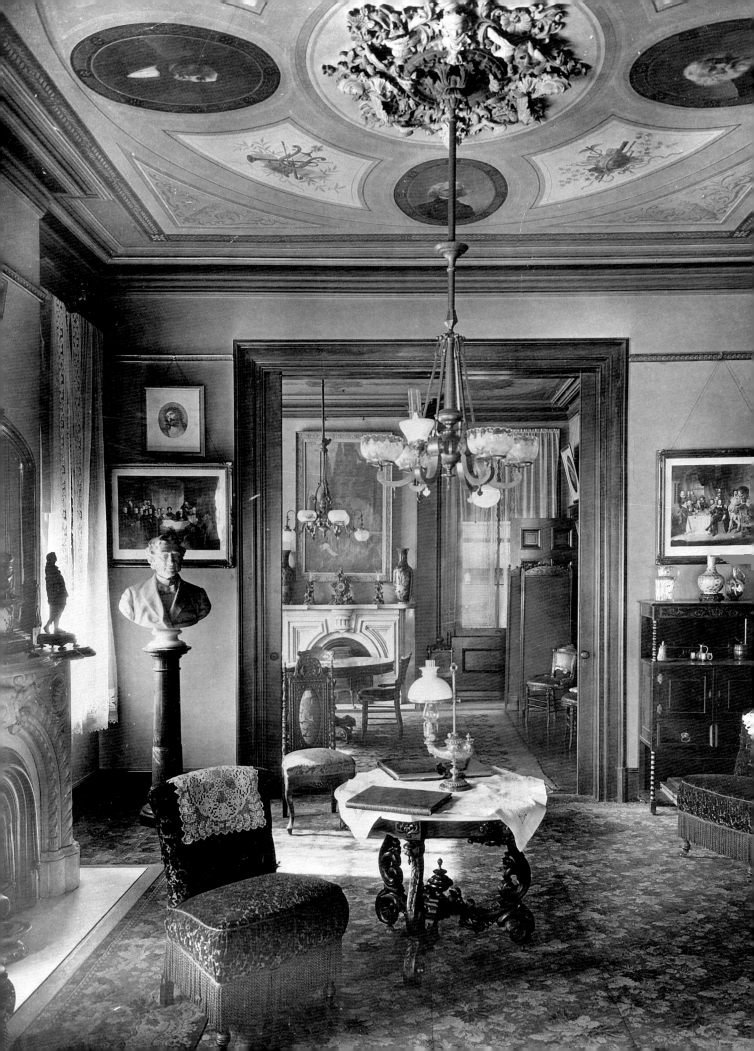

CHAPTER 11
Brumidi's Last Works

Fig. 11–2. Brumidi at the end of his life.
This print, based on a photograph, shows Brumidi with white hair and beard. Plate by C.M. Bell. Architect of the Capitol.

The artist of the Capitol spent most of the last fifteen years of his life working on projects started or designed two decades before. He also continued to undertake outside church and private commissions (fig. 11–1). It is a common misconception, started in his obituaries and continued in later accounts, that he was "almost constantly at work upon the interior of the Capitol" for twenty-five years; in actuality, his employment was not continuous.[1] He worked most intensely during his first ten years at the Capitol, when he designed and began painting his most important rooms. He was on the payroll almost continuously from April 1855 through December 1861, with gaps as long as several months during which he worked on outside commissions, developed designs, or left town in the heat of the summer. As was common at the time, he worked six days a week, averaging twenty-six days of work and $260 in pay a month.

His $40,000 commission to paint the canopy in the Rotunda was thus a major exception to his normal income. During this project, however, delays in the construction of the dome forced him to survive long periods without payment. During all of 1862, even though he was working on designs for the canopy, Brumidi received no pay for any work in the Capitol. The next year he received five $2,000 payments for preparing full-size cartoons for the fresco, and in 1864 he was paid a total of $6,000. He painted *The Apotheosis of Washington* in 1865, but was paid for only half the year. He was paid for the second half in April 1866 and finally received the balance of $9,500 in June.

Once the canopy was finished, there was a long gap before Brumidi resumed working at the Capitol. Discouraged at not being allowed to complete several rooms in the Senate, he traveled to Cuba at the end of 1866, returning to Washington in May 1867 to work on the Senate Post Office (S–211). By this time, construction of the extensions and new dome was completed, and unfinished decorative work came to a halt. No payments to Brumidi are recorded in 1868. He resumed work on the Senate Reception Room in 1869 and 1870 and continued to paint in the Capitol for most of 1871. In 1873, after another hiatus, in which he was most likely working in New York, he returned to the Capitol and began sporadically adding frescoed lunettes and portraits. For all of these projects, he was paid by the individual fresco rather than by the day. Finally, in March 1877, he began preparing the cartoons for the frieze; he continued work on this project until his death in February 1880, working at the same rate of $10 per day he had earned twenty years earlier.[2]

By this time, his hair and beard were white (fig. 11–2). He stayed remarkably active despite his age and the health problems that plagued him. Rheumatic attacks and

Fig. 11–1. Drawing room of Justin Morrill's house. *Around 1873 Brumidi painted the portraits of famous authors mounted in the ceiling in the house formerly at One Thomas Circle, Washington, D.C.* Photo: The Vermont Division for Historic Preservation.

Fig. 11–3. *Crucifixion* in St. Stephen's Church, as it looked c. 1948. *Brumidi's complex composition includes God the Father and the dove of the Holy Spirit above the central figure. At either side of the cross stand Mary and John, while Mary Magdalene weeps at its foot. In the right corner, soldiers throw dice for Christ's cloak.*

Photo: Courtesy of John Segreto.

asthma affected his mobility; they were perhaps also a factor in an apparent decline in the fluidity of composition and gracefulness of detail in some of his late work, such as *Signing of the First Treaty of Peace* and *John Fitch*. However, any impression of declining quality may equally well be due to later damage from leaks and changes made by restorers. Despite his infirmities, he was still described as "cordial, charming, enthusiastic to all with whom he was in sympathy."[3]

American Church Commissions

The major cathedrals and churches in which Brumidi painted murals are testimony to his stature as an artist. His work had been noticed by Archbishop John Hughes in Rome, and he had emigrated to the United States at a time when the growing Catholic Church was erecting buildings in many cities. His ecclesiastical commissions continued to parallel his work at the Capitol. Only once did someone mistakenly complain about his painting pictures for churches while he was being paid by the government.[4] Brumidi painted in oil on canvas for the Jesuit Church of St. Ignatius in Baltimore so that he would not have to leave Washington; his *Mystical Vision of St. Ignatius at La Storta* was dedicated in late 1856.[5] Another important Jesuit commission, for which Father Benedict Sestini recommended Brumidi, was the altarpiece for the Church of St. Aloysius on North Capitol Street, only blocks from the Capitol. *St. Charles Borromeo Giving Holy Communion to St. Aloysius Gonzaga* (see fig. 5–5) was in place for the 1859 dedication of the church, at which Archbishop Hughes spoke. Although based on a print of a seventeenth-century painting, Brumidi's composition is

more complex, and he included contemporary portraits to represent historical figures.[6]

Archbishop Hughes also spoke at the dedication of the Roman Baroque–style Cathedral of SS. Peter and Paul in Philadelphia, the largest cathedral in North America at the time. Brumidi painted the *Crucifixion* in fresco see (fig. 1–19); above it was a lunette with God the Father and the dove of the Holy Spirit, and on either side were illusionistic statues of saints. These frescoes were in place by August 1863, as were the *Assumption of the Virgin* in the dome and the tondos of the four evangelists in the pendentives, which Brumidi had painted in oil on canvas in Washington; by this time Brumidi had been paid $2,000.[7] By the time the cathedral was dedicated in 1864, he had added two large frescoes showing the Adoration of the Shepherds and the Adoration of the Magi, flanked by illusionistic statues in niches of the twelve apostles. A contemporary writer admiringly described the effect Brumidi had achieved: "They seem like niches, but they are not; and in each seems to stand a statue, but it does not. The observer is almost sure that before him stands a niche, enclosing a statue. The perspective is wonderful."[8] Although in 1863 the ability of Brumidi's frescoes to last 500 years had been touted, unfortunately, little remains visible of Brumidi's work. The central frescoes were destroyed when the apse was enlarged in 1956–1957, and the nativity scenes have been covered over and repainted several times.[9]

Brumidi's work at the Church of St. Stephen on 28th Street in New York City, like the that in Capitol Rotunda, was a crowning achievement of his late years. He was selected by Archbishop John Hughes for work at St. Stephen's before he left Rome, as he mentioned in his trial testimony in 1851.[10] Designed by James Renwick in 1850 in a modified Romanesque/Gothic style, the church was dedicated in 1854. By 1855, Brumidi showed the color sketch for the *Martyrdom of St. Stephen* to Meigs, who commented: "This cartoon is about ½ size of life and is a striking and vigorous work."[11] The fifteen-foot high *Martyrdom*, showing the saint surrounded by contorted men stoning him, completed in 1856, served for many years as the central altarpiece for the church, now renamed Our Lady of the Scapular and St. Stephen. Brumidi may have painted the murals at the entrance of the church in this period; they include figures of King David and Saint Cecilia and a Madonna and Child with John the Baptist in illusionistic niches. After the church was enlarged, between 1861 and 1865, the *Martyrdom* was moved to one side, and Brumidi painted the monumental 70-foot-high *Crucifixion* on the altar wall; he signed and dated the work "C. Brumidi 1868" (fig. 11–3).[12] Brumidi is known to have been in New York in 1870, and he wrote that he was working at St. Stephen's in 1871.[13] Brumidi probably designed the church's interior decorative program, filled with illusionistic patterns and moldings. He balanced the *Martyrdom* with an oil-on-canvas *Assumption of the Virgin*. He filled the apse walls and transept balconies with illusionistic statues of saints in niches, tondos and lunettes, and trompe l'oeil architectural elements (see Appendix C). The illusionistic scalloped rounded niches echo the frames of the paintings and the tracery of the stained glass windows. Attention is now being turned to restoring the badly damaged murals and the decorative whole.[14]

Brumidi's last known religious commissions are the *Crucifixion* he painted for the Academy of Mount Saint Vincent in Riverdale, New York, in 1873 and *The Apparition of Our Lord to St. Margaret Mary* for the Visitation Convent in Washington, D.C., in 1878. Thus it is clear that his career as a painter for churches was concurrent with that as the artist of the Capitol.

Completing the Senate Designs

Over the years, because he was working primarily on the Senate side of the Capitol, Brumidi earned the friendship and respect of many senators and Senate officials. Representative and then Senator Justin Morrill, first elected in 1855 and later chairman of the Committee on Public Buildings and Grounds, was a personal friend. Brumidi painted Morrill's portrait and also executed four oval portraits of famous authors for the drawing room ceiling of Morrill's house on Thomas Circle (see fig. 11–1); fortunately, they were saved when the house, built by Edward Clark, was demolished. The senator obtained books for the artist and visited him when he was hospitalized on Thanksgiving Day in 1874.[15] Senator Arthur P. Gorman owned one of Brumidi's sketches for the Senate Reception Room. Brumidi's friendship with Moses Titcomb, who was the superintendent of the Senate Document Room from 1844 to 1877, is shown by the portraits he painted of Titcomb and his father and his gift of his own copy of Guido Reni's *Aurora* (see fig. 1–11). Titcomb also owned Brumidi's copy of Rembrandt Peale's *George Washington*, which is possibly the study made for the President's Room (S–216). In return, Titcomb lent him money and expressed concern for Brumidi's poor health.[16] Brumidi gave Amzi Smith of the Senate Document Room his oil sketch of the *Crucifixion* for St. Stephen's Church, and he used Smith's hand as the model for Thomas Jefferson's in the Senate Reception Room.[17] Isaac Basset, a doorkeeper of the Senate, wrote: "I was very fond of the old gentleman and he of *Me* — often I went into the *rooms* when he was at work and Spent many a pleasen [*sic*] Moment in Seeing him Frescoe. . . ."[18]

Fig. 11–4. Two of four portrait medallions in former Senate Foreign Relations Committee Room. *Brumidi added illusionistic relief portraits of committee chairmen to the ceiling begun by Carstens many years before. Shown here are Charles Sumner and Henry Clay. S–118.*

At the Capitol, Brumidi worked on unfinished murals in the major rooms described in chapter 8, including the ceiling of the Senate Post Office (S–211), three lunettes for the Senate Committee on Military Affairs room (S–128), and murals in the Senate Reception Room (S–213). Each year he added frescoed lunettes in the first-floor Senate corridors, as described in detail in chapter 6.

Robert Fulton was painted in 1873; *Signing of the First Treaty with Great Britain* in 1874; *Cession of Louisiana, Bellona, Columbus and the Indian Maiden,* and *Authority Consults the Written Law* all probably in 1875; *Bartholomé de Las Casas* in 1876; and the portraits of Story, Kent, and Livingston in the north entry in 1878.

Simultaneously, he contributed frescoes to several committee rooms and offices in which decorative work had been started years earlier. For example, in 1874 he finished portrait medallions for the Senate Committee on Foreign Relations room (S–118), now occupied by the Democratic Policy Committee (fig. 11–4). Although the decoration of the room, including the illusionistic brocade panels on the walls and the eagles in tempera in the lunettes, was carried out by Emmerich Carstens in 1856, almost twenty years passed before Brumidi filled the spaces left in the ceiling for frescoes. The portraits of the four committee chairmen, Henry Clay, William Allen, Simon Cameron, and Charles Sumner, are in grisaille, to appear as classical stone relief busts in circular medallions.[19]

S–129

In 1875, Brumidi frescoed his last groin-vaulted ceiling in the Capitol for the Committee on the Library (S–129) (fig. 11–5). Befitting the nature of the committee, the subjects were science, sculpture, architecture, and painting, represented by Brumidi's typical Madonna-like female figures painted as if seen from below.[20]

Science spreads her wings, her right hand touching a blue celestial globe encircled with signs of the zodiac, her left to her chin in thought. She is flanked by a printing press and a telescope. Sculpture, holding a chisel and mallet, watches a cherub inscribing the name of the American writer Washington Irving on the pedestal of the bust she has carved. Architecture holds wooden tools and a drawing of the Capitol dome, while a cherub shows a floor plan of the Capitol. Painting holds a palette and brushes, with one cherub lifting the lid of her paint box and the other holding her oil-on-canvas portrait of the historian William H. Prescott.[21] The highly decorative borders were executed in tempera.

Many years later, in 1910, when the room was used by the Senate Military Affairs Committee, the lunettes were completed by Carl Rakemann, son of Brumidi's assistant Joseph. He added the oval portraits of Revolutionary generals George Washington, Joseph Warren, Anthony Wayne, and Horatio Gates, painted in oil on canvas. In the corners of the ornately painted ceiling are female heads over cartouches; their crudely overpainted faces are the work of an inferior restorer in the 1960s.[22]

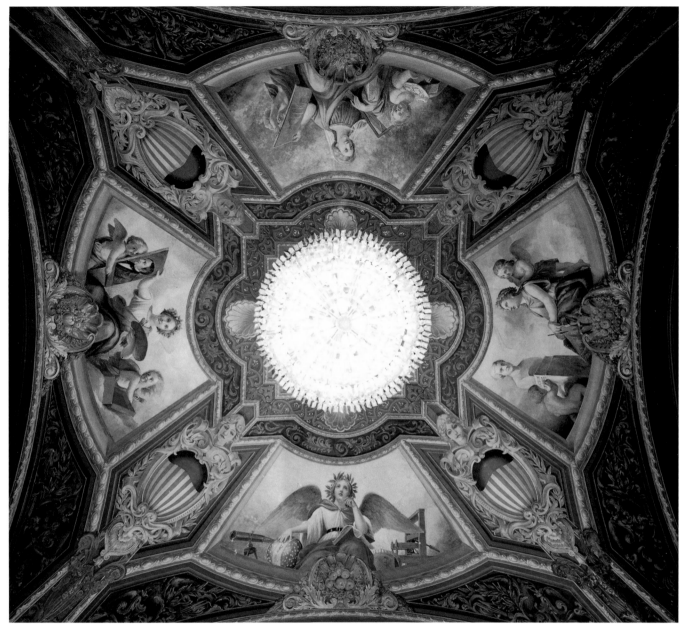

Fig. 11–5. Ceiling designed for the Senate Committee on the Library. *Brumidi painted the vaults with figures representing the arts and sciences. Faces over the shields have been repainted.* S–129.

S–212

In 1876, Brumidi completed the small but impressively decorated room off the Senate Reception Room, originally created for the Senate sergeant at arms and now used by the office of the vice president. The Civil War theme of the decorations makes the room one of the few places where Brumidi alluded to a contemporary political event, albeit in allegorical terms (fig. 11–6).

In 1862, during the war, Brumidi first submitted an estimate of $2,000 for a large historical painting.[23] The next year, he spent a month decorating the room of the

Senate sergeant at arms; he apparently painted the illusionistic reliefs at this time, with the expectation that the Union would survive and peace would return.[24] In 1866, when the chairman of the Senate Committee on Public Buildings and Grounds urged that the decoration of the room be finished during the recess of Congress, Brumidi submitted a new estimate for the large painting of $3,000, which Architect of the Capitol Edward Clark judged "unreasonably high."[25] Brumidi painted an oil sketch of the scene; he would later follow it faithfully when he was finally allowed to execute the fresco in 1876, after his petition to Senator L. M. Mor-

Fig. 11–6. *Columbia Welcoming the South Back into the Union.* *The woman representing America is accompanied by others symbolizing the North, while the South is led by Liberty.* S–212.

rill, Chairman of the Senate Committee on Appropriations, was granted.[26]

Columbia Welcoming the South Back into the Union is signed and dated "BRUMIDI 1876." Here the artist sublimated the devastation of the Civil War into a vision of smiling classical figures harmoniously grouped in a picturesque landscape. Columbia, dressed in a tunic and sandals and holding what appears to be a rudder, is grouped with two other female figures, one with a sheaf of wheat and plate of fruit symbolizing agriculture in the northern states and the other holding a caduceus, symbol of commerce. Columbia extends a hand to the South, who is dressed humbly in a toga with long flowing hair and one breast bared. She holds a bouquet of fluffy cotton bolls. She is being led by Liberty, who wears a liberty cap and has a band of stars across her chest, and is accompanied by an eagle holding the olive branch of peace in its beak. The composition seems to have been influenced by a painting by Luther Terry, an American artist living in Rome: *An Allegory of the North and South*, painted in 1858, and perhaps known to Brumidi through an engraving, includes three figures, one representing America with the others symbolizing the South and the North, dressed much like Brumidi's.[27]

The rectangular panel in the barrel-vaulted ceiling is surrounded by an illusionistic carved frame, as if it were an oil painting fixed to the ceiling. In this case, Brumidi did not show the figures as if seen from below. Below the fresco is a border meant to look like a carved stone relief, supporting shields and cupids intertwined with rinceaux of leaves and flowers. The iconography of the small rectangular imitation low reliefs was described in an early guidebook:

> On the walls are four allegorical designs in *basso relievo*: that on the E. representing Dissolution or Secession, illustrated in the breaking of the fasces or bundle of rods, while on the one side lies cotton and on the other corn, the rival products of the opposing sections of the country. On the S. is the same figure as War, with the engines of strife. On the W. the bundle of rods are again united, with the motto *E Pluribus Unum* and an eagle. On the N. the implements of war are being destroyed and exchanged for those of peace.[28]

The room was occupied by the Senate sergeant at arms until 1946 and has been assigned to the vice president since 1961.[29] The illusionistic reliefs have been heavily and darkly overpainted, probably more than once. The fresco is known to have been retouched by Charles Moberly in 1918.[30] Conservation treatment is expected to make the delicate colors of the fresco much more apparent.

Fig. 11–7. Scroll of frieze sketches being presented by Myrtle Cheney Murdock in 1961. *The scroll was later divided into individual scenes for conservation. Holding the scroll are, from left to right, Architect of the Capitol J. George Stewart, Mildred Thompson, John R. Murdock, and Mrs. Murdock.*

The Rotunda Frieze

Brumidi spent the end of his life working on the frieze that encircles the base of the dome, fifty-eight feet above the Rotunda floor. Architect Thomas Walter had envisioned the frieze as a carved stone relief. However, Thomas Crawford's estimate of $50,000 to sculpt a frieze of classical figures in marble was judged too high. After Crawford's death in 1857, other options were considered, including having a frieze cast in zinc. The idea of the frieze of historical events evidently captured Brumidi's imagination at the time Walter was designing the dome, for his 30-foot-long scroll of sketches for it is dated 1859 (fig. 11–7).[31] On the sketches, Brumidi noted the title and planned dimensions of each scene.

As detailed in chapter 10, the ideas for the scenes originated with Emanuel Leutze and Montgomery Meigs, who first envisioned the frieze as "the pre-Columbian and post-Columbian history of the continent." The pre-Columbian section was later dropped. The subjects were derived from contemporary histories of the country by George Bancroft and Francis Parkman, which emphasized early Spanish explorers and the American Revolution. For example, the buffalo skin painted with an eagle in the scene of Oglethorpe and the Muskogee Indians fits the description in Bancroft's *History of the Colonization of the*

United States.[32] In addition, Brumidi would have known William H. Prescott's *History of the Conquest of Mexico* and *History of the Conquest of Peru*, published in the 1840s. Congress debated expanding the country into Cuba and Central America, and political leaders such as Meigs's ally Jefferson Davis dreamed of extending farther into Mexico. This conception of "Caribbeanized Manifest Destiny" may be reflected in the inclusion of South American explorers in the frieze.[33]

Brumidi submitted his 1859 proposal for the frieze only days after the canopy was unveiled, but he was not allowed to begin work on it until 1877.[34] Rather than a specific authorization or appropriation by Congress, there was a verbal agreement between Edward Clark and the Joint Committee on the Library to allow the artist to work for his usual $10 a day.[35] Brumidi began preparing the cartoons for the first scenes; he was paid at a daily rate beginning in March 1877.[36] Clark reported on October 1: "The belt of the rotunda intended to be enriched with basso relievos is being embellished in real fresco representing events in our history, arranged in chronological order, beginning with the landing of Columbus. . . ."[37] Brumidi did not begin painting on the wall until the spring of the next year.

The artist made the half-size studies and full-size working drawings in his home studio, with a space the height

Fig. 11–8. Sketch for "America and History" and "Landing of Columbus." *Brumidi's small sketch was painted in black and white to give the sense of light and shadow in low relief.* Architect of the Capitol.

of the frieze marked off on his wall.[38] Once on the scaffold, Brumidi began painting, over the east door, a male figure bending to the left; this was to be the end figure in the last scene, "Discovery of Gold in California." The figure touches the first grouping of allegorical figures, "America and History" (see fig. 11–8 and frieze foldout at the end of this chapter).[39] America, wearing a liberty cap, carries a spear and shield; the Indian maiden symbolizing the untamed American continent did not appear in Brumidi's sketch. With them are an American eagle and a female figure crowned with laurel leaves representing history with a stone tablet.

In Brumidi's sketch and in the frieze itself, the scenes are visually divided from one another by trees or other vertical supports. He once pointed out: "You notice between the groups is always something interposed—a tree, a column—something which shall keep the groups distinct."[40] As painted, the story proceeds with the Spanish explorers, from "Landing of Columbus" through "Cortez and Montezuma at Mexican Temple," "Pizarro Going to Peru," and "Burial of DeSoto." The English arrive and establish themselves in the New World with "Captain Smith and Pocahontas," "Landing of the Pilgrims," "William Penn and the Indians," "Colonization of New England," and "Oglethorpe and the Indians." The Revolutionary War is summarized by "Battle of Lexington," "Declaration of Independence," and "Surrender of Cornwallis." The War of 1812 is represented by "Death of Tecumseh" and the Mexican War by "American Army Entering the City of Mexico." Brumidi intended the frieze to end with "A Laborer in the Employ of Captain Sutter," alternatively titled "Discovery of Gold

in California." He explained that his intention was to show that "the discovery of that new Pacific empire completed a cycle of National history."[41] As discussed further in chapter 12, after Brumidi's death in 1880, his unexecuted designs were enlarged and completed by Filippo Costaggini between 1881 and 1889, but a thirty-one-foot gap remained between the last and first scenes. In 1953, after many decades of debate, the frieze was finally completed by Allyn Cox with "Peace at the End of the Civil War," "Naval Gun Crew in the Spanish-American War," and "The Birth of Aviation."[42]

Brumidi painted the frieze in grisaille, a monochrome of whites and browns that creates the effect of sculptured relief. The frieze measures 8 feet 4 inches in height, including a 7-inch plain brown band hidden by the ledge below it, and is approximately 300 feet in circumference. Brumidi was extremely successful in creating the illusion of three-dimensional stone forms in light and shade; visitors to the Rotunda are often fooled into thinking they are looking at actual sculpture.

When he began painting the frieze Brumidi was seventy-two years old; debilitated by asthma, chronic diarrhea, and other ailments; and working under extremely difficult conditions. After ascending a long flight of stairs, the white-haired artist had to climb over the balcony under the windows and descend a long ladder to the small scaffold dangling almost sixty feet above the Rotunda floor (fig. 11–9). Some comfort was provided by a chair placed on the scaffold.[43] A friend petitioning that an elevator be installed for him offered a graphic description of the situation:

Fig. 11–9. Scaffold used to paint the frieze. *Brumidi's precarious scaffold was left hanging in the Rotunda for many years.*
From George Hazleton, *The National Capitol*, 1897.

. . . this wonderful old man has daily to climb up to an elevation of fully eighty feet, enter a window & then descend a ladder at least twenty five feet long to the little pent up crib where he toils. He is so aged and feeble that he requires help to reach the place, & you can easily imagine the fatigue attendant upon the mere labor of getting to and away from his work. Besides in stormy wet tempestuous weather he cannot get there at all. . . .[44]

At the end, he was hoisted up to the scaffold "seated in a little box or cage that was elevated by a rope passing through a pulley aloft in the dome," watched by crowds of people below.[45] To check the effect of his work, he would climb up the ladder and walk around to the other side of the balcony. A laborer, E. A. Martin, was assigned to help him, and Brumidi's obituary indicates that his son Laurence, then a teenager, also provided some assistance.

His work was interrupted by illness, including a hospitalization in October 1878, and by winter weather so cold that frost formed on the mortar.[46] In the summer of 1879, he had to leave the city because of his asthma, and he worked on the cartoons in the resort at Orkney Springs, Virginia. In September, when he asked to be reinstated on the payroll, Brumidi wrote to Clark that he was "much worried by the terrible future prospect of starvation as soon as my bad health prevent me to do the daily work, having Safe [*sic*] nothing in the past, when the fortune provided me with very profittable [*sic*] works. . . ."[47]

The old man worked slowly, painting half a figure a day. By April 1878, the first scene was completed. By the fall, he was working on the cartoon for the scene of Poca-

hontas. In October, the mortaring was begun for the scene of de Soto. During the cold weather, he worked on *Landing of the Pilgrims*. In March 1879, he researched details for *American Army Entering the City of Mexico*, consulting General Scott's widow and a history of the Mexican War by Mansfield.[48]

In April, he was interviewed by a reporter for the *Washington Post*, who wrote: "Probably nothing under the Capitol dome attracts so much attention and comment as the procession of figures, which has now traveled one-quarter of the way around the circle, just under the upper gallery, and pauses at the scaffold, hanging, like Mohammed's coffin, midway between the heaven and the earth, where the artist, Brumidi, is at work. . . . The probability is that nobody has ever seen him working. When he is carried up to the scaffold he sits down in a chair, and remains seated, working incessantly until it is time for him to be swung down again." Brumidi spoke of the importance of his drawings: "'I must be so close to my work—I can get no distance. I should lose all proportion if I trusted to my eyes.'" He estimated then that it would take five years for him to finish the frieze.[49]

In July 1879, he went back and retouched the cartoon for the scene showing Pizarro; at the same time, he was working on the one of William Penn and had begun sketching on the wall *Colonization of New England*. In September he began painting the eighth scene, *William Penn and the Indians*, showing the famous peace treaty in Pennsylvania.

On October 1, halfway through frescoing this scene, Brumidi nearly fell from the scaffold. His own account of the accident, told in the third person, is graphic:

... while sitting upon a temporary scaffold, and near its edge the chair turned from under him and threw him over; he caught the round of a ladder and, remained suspended by the strength of his arms for the space of fifteen minutes, till officer Lammon(s) descended from the top of the Dome to the scaffold and called two men from the floor of the Rotunda to assist in the rescue of your petitioner.[50]

The oft-told stories that Brumidi fell from the scaffold and died or that he never worked again are both untrue. In fact, he worked on the scaffold at least once again. One reporter wrote: "It is the general impression that Mr. Brumidi never recovered from the shock occasioned by his fall last summer, when he narrowly escaped a fall to the floor below, but those who are most familiar with his work at the Capitol do not attribute it to that, as he returned on the following day, and worked with unusual rapidity and energy, accomplishing more than in any other day for a long time before. That was his last full day's work, however. The approach of cold weather, to which he was always sensitive, and increasing ill health combined to confine him to the house." Another article states that he "was forced to suspend after working a short time because of nervousness. He doubts that he will be able to finish the work on which he is engaged though he thinks he can complete the cartoons on paper, so that others can transfer them to the walls."[51]

Before his death in February, Brumidi had begun sketching "Colonization of New England" and completed the cartoons up to "Battle of Lexington."[52] An obituary gave a poignant description of his last months:

Almost until the last hour he continued his work on the frescoes in the dome of the Capitol, though compelled to sit instead of standing, his hand and eye were as true and strong as ever, and the work from that point on shows no loss in spirit or excellence of execution. For months the little scaffold that clings to the wall in mid air under the dome of the Capitol has been deserted, and curious strangers, looking at the neglected cartoons hanging over the railings have been told that Brumidi would never come back to finish his frescoes. It was the dream of his life that he should come back. He wanted with his own hand to lead that historic procession round the dome till the encircling frieze should be complete.[53]

Brumidi did literally work on the frieze until the end of his life; he was paid for thirteen days of work in February, and he was working on the cartoon for "Battle of Lexington" the day before he died on the morning of the 19th.

Notes to Chapter 11

1. "Death of Brumidi, the Fresco-Painter of the National Capitol," *Evening Telegraph* (Philadelphia), February 19, 1880, p. 2.

2. Brumidi's son Laurence claimed that only one quarter of his father's annual income came from the government, see Laurence Brumidi, "History of the Frieze in the Rotunda of the Capitol, Washington, D.C.," undated manuscript, c. 1915. AOC/CO. It is possible that this was true toward the end of Brumidi's life.

3. "The Paintings and the Painter of the Capitol Rotunda," *Boston Evening Transcript*, March 4, 1880, p. 6.

4. Anonymous letter to TUW, April 8, 1857. AOC/CO.

5. CB to Rev. Benedict Sestini (in Italian), November 11, 1855; Rev. Sestini to an unnamed priest, November 20, 1856. Georgetown University Archives, Washington, D.C., Catholic Historical Manuscripts Collection.

6. A print of the same subject by Cavaliere Francesco Cairo in Milan published in *Acta Sanctorum*, Antwerp, June 1707, was discovered by Father George Anderson, S.J.

7. *A Cathedral Is Built*, Philadelphia: American Catholic Historical Society, 1964, pp. 17–19.

8. "The Great Roman Catholic Cathedral in Philadelphia," *Constitutional Union* (Washington), November 17, 1864, p. 1.

9. Because of water damage, in 1889 Filippo Costaggini covered the nativity scenes with canvas and repainted the scenes; Louis Costaggini also "restored" them in 1909, according to his letter to the Joint Committee on the Library, dated January 27, 1909. AOC/CO. The scenes have again been overpainted in recent years.

10. CB to Card. Giacomo Antonelli, October 19, 1851, ASR/SC.

11. MCMJ, January 30, 1855, A–410.

12. Alfred Isaacson, *The Determined Doctor: The Story of Edward McGlynn* (Tarrytown, New York: Vestigium Press, n.d).

13. CB at 331 4th Avenue, New York City, to Edward Clark, April 22, 1871. AOC/CO.

14. Claudia McDonnell, "Hidden Tresure," *Catholic New York*, July 17, 1977, pp. 16–17.

15. The portraits of Dickens, Hawthorne, Longfellow, and Prescott are preserved in the Morrill Memorial, Strafford, Vermont, The Vermont Division for Historic Preservation. Morrill's portrait by Brumidi is in the Justin Morrill Memorial Library Collection, Strafford, Vermont, per Gwenda Smith. EC to Justin Morrill, August 5, 1873, AOC/LB. CB to EC, November 30, 1874, AOC/CO.

16. The portrait of Moses Titcomb is at the William A. Farnsworth Library and Art Museum, Rockland, Maine. Brumidi's portrait of the Rev. Benjamin Titcomb, after Badger, is in the Portland (Maine) Public Library, see Gilbert Merrill Titcomb, *Descendants of William Titcomb* (Ann Arbor, Michigan: Lithographed by Edwards Brothers, 1969), p. 83. TUW to CB, September 5, 1865, TUW/PA (AAA reel 4242); Moses Titcomb to EC, January 10, 1879, AOC/CO. The Peale copy is mentioned in a letter from Henry Wadsworth Longfellow to Alex Longfellow, January 25, 1879, Houghton Library, Harvard University, Cambridge, Massachusetts.

17. Myrtle Cheney Murdock, *Constantino Brumidi: Michelangelo of the United States Capitol* (Washington, D.C.: Monumental Press, Inc., 1950), p. 96. Smith was one of the artist's pallbearers. "Brumidi's Funeral," *The Evening Star* (Washington), February 21, '80.

18. Isaac Bassett Papers, USSC, file 10A, 21–22.

19. "The room of the Committee on Foreign Relations has been completed, with the exception of four spaces reserved for fresco paintings." *Annual report of Capt. M.C. Meigs, in charge of Capitol Extension*, 34th Cong., 3d sess., November 1856, Sen. Ex. Doc 5. Carstens was paid for "one ornamental" on October 16, 1874, and was mentioned in DeB. Randolph Keim, *Keim's Capitol Interior and Diagrams* (Washington, D.C.: n.p., 1874), p. 55. Brumidi provided an estimate for the medallions on November 2, 1872, and was paid for the work on June 20 and November 11, 1877. However, a letter to Senator Simon Cameron from Edward Clark, September 7, 1875, mentions Brumidi as being at work in "your committee room." At the time, the Senator was on the Committee on Foreign Relations.

20. 1875, AOC/AR.

21. The oil sketch for the scene including the historian's name is at the Morrill Homestead, Strafford, Vermont.

22. Will P. Kennedy, "Moberly Restoring Brumidi Decorations at the Capitol," *Sunday Star*, August 14, 1921, pp. 1–2. A 1959 photograph shows the faces before they were crudely overpainted, AOC.

23. October 10, 1862, TUW/PA (AAA, roll 4149).

24. Brumidi was paid $249.51 for 26 days at $10 per day, minus income tax, AOC/EXT.

25. B. Gratz Brown to the secretary of the interior, July 17, 1866, NARA, RG 48, series 291, box 2. CB to EC, July 20, 1866, NARA/RG 48, series 290, box 2; EC to James Harlan, July 21, 1866, NARA/RG 48, series 290, box 2. The amount eventually paid to Brumidi for the fresco is not known.

26. The sketch from Laurence Brumidi's estate was purchased at C. G. Sloan Auction Rooms in Washington, D.C., in 1925 by Mr. H. O. Bishop. It was inherited by Mrs. McCook Knox of Washington, D.C.; she left it in 1983 to her daughter Mrs. Richard Austin Smith (Katharine McCook Knox), who put it up for auction in 1984. The sketch was published by Joshua C. Taylor, in *America as Art* (Washington: National Collection of Fine Arts, 1976), p. 15, in *Antiques*, January 1984, p. 35, and in *Katharine McCook Knox and other Collections Sale* (1932) (Washington, D.C.: Sloan, 1984), pp. 108–109. Its present location is unknown. CB to L. M. Morrill, February, 1876, NARA/ RG 46, File SEN 44A, Committee on Appropriations.

27. Greenville County Museum of Art, Greenville, South Carolina, gift of Mr. and Mrs. Charles C. Mickel. Reproduced in *Antiques*, 148 (August 1995), p. 146.

28. *Keim's Capitol Interior and Diagrams* (1874), pp. 25–26.

29. The room was occupied by the Committee on the District of Columbia from 1947 to 1958 and by the Majority Leader in 1959 and 1960.

30. Will P. Kennedy, "Moberly Restoring Brumidi Decorations," pp. 1–2, and 1918, AOC/AR, p. 5. Annual reports of the Architect of the Capitol also mention painting in the room of the sergeant at arms in 1923, 1925, and 1930.

31. The scroll of sketches, thirty feet long and thirteen inches wide, painted in watercolor on kraft paper, was donated to the Architect of the Capitol by Myrtle Cheney Murdock in 1961. She had purchased it from James H. Rove, grandnephew of Lola Kirkwood. John B. Murdock donated the three additional fragments in 1981.

32. George Bancroft, *The History of the Colonization of the United States* (Boston: Charles E. Little and James Brown, 1840), p. 421.

33. Vivien Green Fryd, *Art and Empire: The Politics of Ethnicity in the U.S. Capitol, 1815–1860* (New Haven: Yale University Press, 1992), pp. 1523.

34. January 10, 1866, NARA/RG 48, Register, and letter from Harlan to Senator Solomon Foot, January 18, 1866, NARA/RG 48.

35. Laurence Brumidi, "History of the Frieze," pp. 11–12, AOC/CO.

36. CB to EC, August 26, 1876, mentions that Brumidi has completed "Treaty of William Penn" and "Settlement of New England" and has them ready to transfer, AOC/CO. Although Brumidi's date is clearly written, he may have confused the year, for this work would logically have been done in 1878.

37. 1877, AOC/AR, p. 3.

38. "Brumidi's Life Work," *Washington Post*, April 11, 1879, p. 1.

39. The titles of the scenes used here are based on those used at the end of Brumidi's life by the artist himself and Edward Clark and in newspaper articles. However, even he and Clark referred to the scenes with a variety of names, and many variants of titles for each scene were used in subsequent publications.

40. "Brumidi's Life Work," p. 1.

41. "Death of a Great Artist," *Washington Post*, February 20, 1880.

42. The titles of the last scenes were verbally transmitted to the office of the Architect of the Capitol by Cox in 1969 and recorded in a memo, AOC/CO.

43. CB to EC, September 23, 1878, AOC/CO.

44. C. K. Marshall to Secretary Shurz, November 27, 1877, AOC/CO.

45. "Death of Brumidi: the Fresco-painter of the National Capitol," *Philadelphia Daily Evening Telegraph*, February 19, 1880, p. 2 Also described in "Brumidi," *American Architect and Building News* 5, June 11, 1879, p. 16, and "Our Washington Letter," February 4, 1879, clipping in Papers of Isaac Bassett, USSC.

46. CB to EC, September 23, 1878, AOC/CO. CB to EC, December 27, 1878, AOC/CO.

47. CB to EC, August 11, 1879, AOC/CO. CB to EC, September 29, 1879, AOC/CO.

48. "Death of a Great Artist." "History Happily Adorned," *Baltimore Sun*, April 30, 1878, reviewed the work and reported that it was about one-sixteenth complete. This shows that Brumidi's memory of the beginning of May is incorrect. CB to EC, Sept. 23, 1878 and CB to EC, March 22, 1879, AOC/CO.

49. "Brumidi's Life Work," p. 1.

50. Petition of C. Brumidi to Senate and House of Representatives for position on pay roll, November 17, 1879, AOC/CO. The watchman of the Dome who rescued Brumidi was Humphrey N. Lemon; after the artist's death, he asked to have the chair. Lemon to EC, March 20, 1880, AOC/CO.

51. "Death of a Great Artist." "The Allegorical Work at the Capitol," *Forney's Sunday Chronicle*, Oct. 12, 1874, p.4.

52. "Constantino Brumidi," *New York Tribune*, February 20, 1880, p. 5 and "Death of a Great Artist."

53. "Death of a Great Artist."

The Frieze of the Rotunda

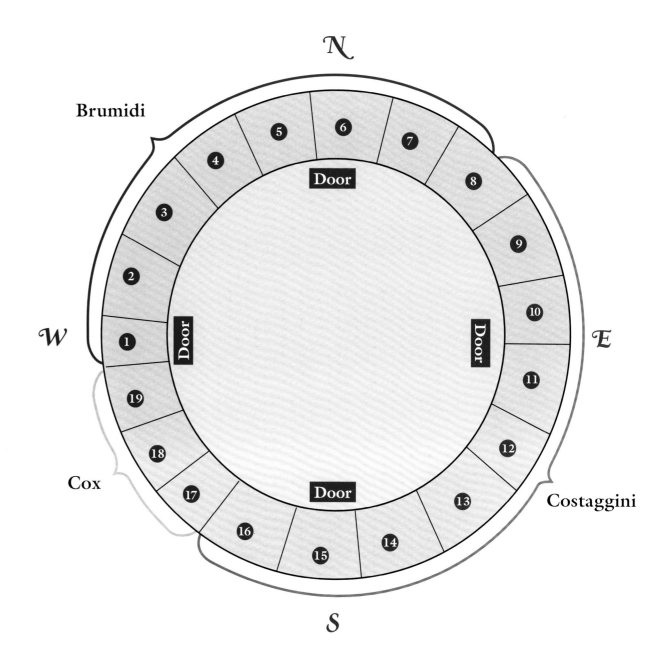

Note: This diagram shows the position of each scene in the Rotunda. The numbers correspond to those on the list that follows. The brackets indicate the selections painted by Constantino Brumidi in 1878–1880, Filippo Costaggini in 1881–1889, and Allyn Cox in 1952–1953.

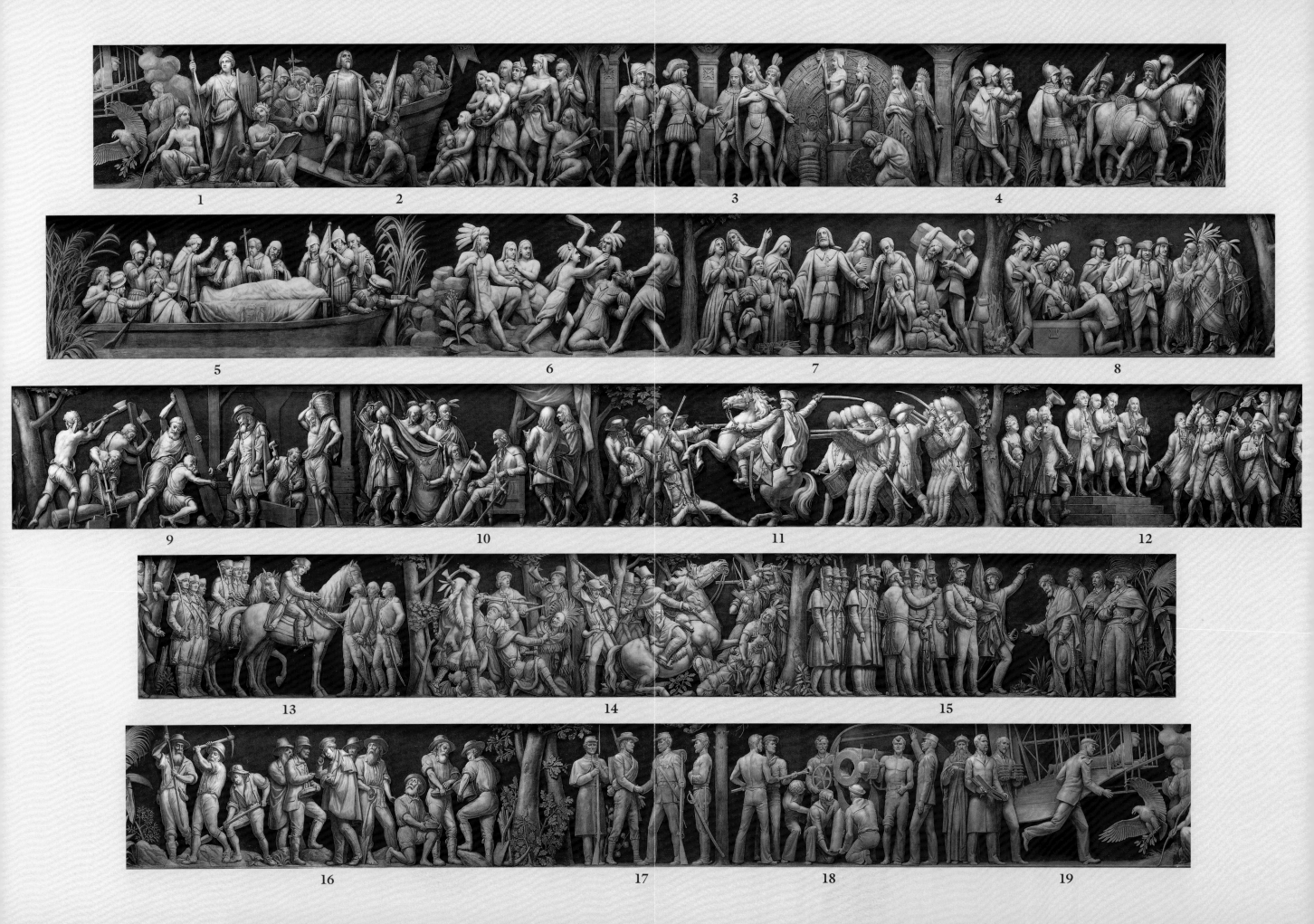

1. **"America and History."** Brumidi begins the frieze with allegorical figures. The standing woman wearing a liberty cap and holding a spear and shield and the Indian woman with bow and arrows both represent America, while History records events on a stone tablet, and an eagle perches on the fasces. The bent-over figure at the far left is the farthest-right figure in Brumidi's intended final scene of the Gold Rush.

2. **"Landing of Columbus."** Christopher Columbus debarks in 1492 from the *Santa Maria* on a plank, greeted by native Americans. This the first of four scenes of Spanish conquest. Brumidi's central figure seems to have been inspired by the statue of Columbus by Persico then at the central steps of the Capitol.

3. **"Cortez and Montezuma at Mexican Temple."** The Spaniard Hernando Cortez, conqueror of Mexico, enters the Aztec temple in 1519. He was welcomed by emperor Montezuma II, who thought Cortez was a god. The calendar stone and idols are based on sketches Brumidi made when he was in Mexico City.

4. **"Pizarro Going to Peru."** Spanish conqueror of Peru, Francisco Pizarro, leading his horse, pushes through the jungle, searching for the mythical land of gold, heading towards the eventual capture of the Inca capital Cuzco in 1833.

5. **"Burial of DeSoto."** Spanish explorer Hernando DeSoto died of a fever in 1542 while searching for gold in Florida and the territory north of the Gulf of Mexico. To protect his body from enemies, his men buried him at night in the Mississippi River, which he had been the first European to discover.

6. **"Captain Smith and Pocahontas."** Pocahontas saves Captain John Smith, one of the founders of Jamestown, Virginia, from being clubbed to death. Her father, Chief Powhatan, is seated at the left. This scene is the first showing English settlement.

7. **"Landing of the Pilgrims."** A group of Pilgrims, led by William Brewster, is shown giving thanks for their safe voyage after their 1620 arrival in Plymouth, Massachusetts.

8. **"William Penn and the Indians."** William Penn and his men point out the contents of a chest to the Delaware Indians at the Treaty of Shackamaxon in 1682. The treaty formalized the land grant in Pennsylvania and was the beginning of peaceful relations between the Quakers and the Indians. This is the last scene on which Brumidi worked.

9. **"Colonization of New England."** Early settlers cut and saw trees and use the lumber to construct a building, possibly a warehouse for their supplies. This is the first scene painted entirely by Costaggini.

10. **"Oglethorpe and the Indians."** James Oglethorpe, who founded the colony of Georgia and became its first governor, is shown making peace on the site of Savannah in 1733 with the chief of the Muskogee Indians, who presents a buffalo skin decorated with an eagle, symbol of love and protection.

11. **"Battle of Lexington."** British troops are led by Major Pitcairn, on horseback, whose men fire on colonists gathered at Lexington to stop the British from going on to Concord. This 1775 event began the American Revolution.

12. **"Declaration of Independence."** This idealized depiction shows the principal authors of the 1776 Declaration of Independence, John Adams, Thomas Jefferson, and Benjamin Franklin, reading the document to colonists in 1776.

13. **"Surrender of Cornwallis."** General George Washington, on horseback, receives the sword of surrender from Major General O'Hare, who represented Lord Cornwallis after his 1781 defeat at Yorktown, the last battle of the American Revolution.

14. **"Death of Tecumseh."** During the Battle of the Thames in Upper Canada during the War of 1812, the Indian chief Tecumseh, leader of resistance to American settlement and supporter of the British, is shown just after being shot by Colonel Johnson, on horseback. This 1813 event turned the battle in the favor of the Americans.

15. **"American Army Entering the City of Mexico."** General Winfield Scott is shown in 1847 being received by Mexicans as he enters the capital, Mexico City, during the Mexican War which followed the admission of Texas to the Union. The bearded face hidden in the tree may be Costaggini's self-portrait.

16. **"Discovery of Gold in California."** Prospectors dig and pan for gold, while in the center three men, one of them probably Sutter, examine a nugget. The 1848 discovery of gold at Sutter's Mill and the subsequent gold rush of 1849 encouraged settlers to move westward. This was the last scene designed by Brumidi and painted by Costaggini.

17. **"Peace at the End of the Civil War."** The reunion of the country after the end of the Civil War in 1865 is shown by a Confederate and a Union soldier shaking hands. The cotton plant and pine tree symbolize the South and the North. This is the first scene painted by Allyn Cox.

18. **"Naval Gun Crew in the Spanish-American War."** A gun crew prepares to fire a cannon in one of the great naval battles of the Spanish-American war of 1898, which led to the naval prominence of the United States and its acquisition of Puerto Rico and Guam.

19. **"The Birth of Aviation."** The scene includes pioneers of flight Leonardo da Vinci, Samuel Pierpont Langley, and Octave Chanute, each holding a model of his invention. Wilbur Wright steadies the wing of the *Flyer* while his brother Orville pilots their first successful flight in 1903; an eagle holding a laurel branch closes the scene.

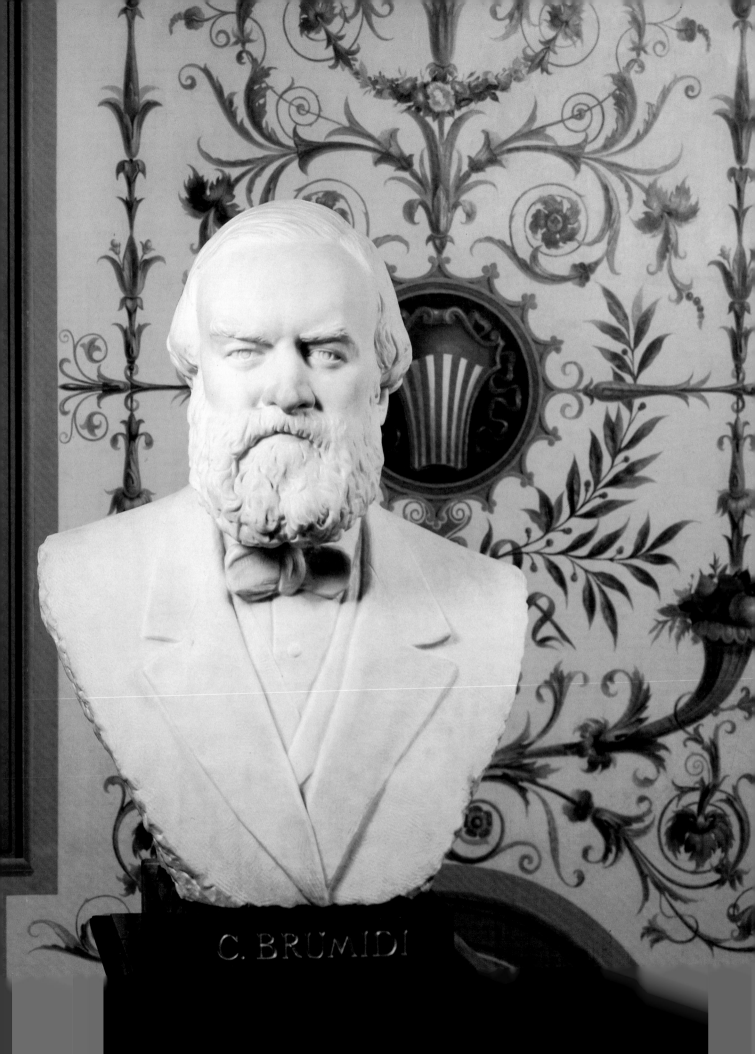

C. BRUMIDI

CHAPTER 12

Death of "the Genius of the Capitol"

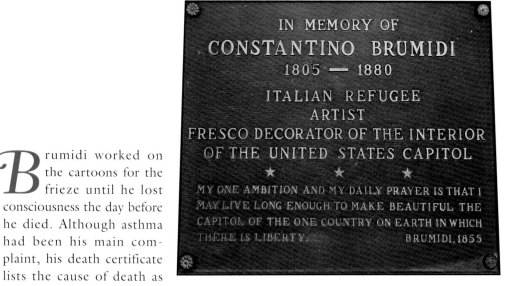

IN MEMORY OF
CONSTANTINO BRUMIDI
1805 — 1880

ITALIAN REFUGEE
ARTIST
FRESCO DECORATOR OF THE INTERIOR
OF THE UNITED STATES CAPITOL

★ ★ ★

MY ONE AMBITION AND MY DAILY PRAYER IS THAT I
MAY LIVE LONG ENOUGH TO MAKE BEAUTIFUL THE
CAPITOL OF THE ONE COUNTRY ON EARTH IN WHICH
THERE IS LIBERTY. BRUMIDI, 1855

Fig. 12–2. Commemorative plaque in Glenwood Cemetery.
*Brumidi's grave in the Germon family plot was marked in 1951
through the efforts of Myrtle Cheney Murdock.*
Photo: Theodor Horydczac.

Brumidi worked on the cartoons for the frieze until he lost consciousness the day before he died. Although asthma had been his main complaint, his death certificate lists the cause of death as "chronic Bright's Disease and uremia," that is, kidney failure.[1] His death occurred at 6:30 a.m. on February 19, 1880, at his home at 921 G Street, N.W., a three-story brick house owned by his former wife, now Lola V. Walsh. His longtime friend Father Benedict Sestini, S.J., had been called to his deathbed by his son Laurence but did not reach him in time.

At the funeral, held the next day at his house and attended by many friends, the Catholic burial service was read by Rev. J. A. Walter, pastor of St. Matthew's Church. His pallbearers were Architect of the Capitol Edward Clark, Professor Marini (L. G. Marini, in whose dancing academy, Marini Hall, Brumidi had prepared cartoons for the frieze), Ben Perley Poore (the popular reporter, *Boston Journal* columnist, clerk of the Senate Printing Committee, and, ironically, a critic of Meigs's art program in the 1850s), William McPyncheon (Edward Clark's clerk), Amzi Smith (Brumidi's friend, who worked in the Senate Document Room), and George F. W. Strieby (one of the painters who assisted him at the Capitol).[2]

Later that year, Congress paid the $500 still owed to Brumidi for the canopy to his heirs Laurence and Elena and gave $200 to Lola for funeral expenses. The authorizing bill was introduced by Senator Daniel Voorhees, who eulogized:

> He who beautifies the pathway of life, who creates images of loveliness for the human eye to rest upon, is a benefactor of the human race. He will be crowned by the gratitude of his own and of succeeding generations. In the older countries of Europe, where the profession of art has a higher rank than here, Brumidi would have had a public funeral, and his remains would have been deposited in ground set apart for persons of distinction. In England he would have had a place and a tablet in Westminster Abbey.
>
> It matters, little, however, whether we or those who come after us do anything to perpetuate his memory. The walls of his Capitol will hold his fame fresh and ever increasing as long as they themselves shall stand.[3]

He was followed by Senator Justin S. Morrill, who commented:

> Covering as he has done so much space with his fresco paintings—so difficult and so durable—it is

12–1. Bust of Brumidi against a newly conserved panel in the Brumidi Corridors. *In recent years, the artist of the Captiol has been honored by this marble portrait and by the program to conserve his murals.* United States Senate Collection.

wonder that so great a part should be fairly excellent and so little that competent critics esteem otherwise his great desire was that he might live to complete his last great work. So long had he devoted his heart and strength to this Capitol that his love and reverence for it was not surpassed by even that of Michael Angelo for St. Peter's.[4]

Senator Morrill's comparison may have suggested the epithet "Michelangelo of the Capitol," which was first mentioned by Hazelton in 1897 and later adopted by Myrtle Cheney Murdock for the title of her book. Many decades later, the Congress again recognized Brumidi's contributions by commissioning a bust of him for the Capitol (fig. 12–1).

Brumidi's American wife, Lola, buried the artist in the Germon family plot at Glenwood Cemetery alongside her parents (fig. 12–2). Brumidi had separated from Lola some time in the 1870s; by 1879, she had remarried. However, she remained concerned for Brumidi's welfare, and at the end of his life, Brumidi was living in a house she owned.[5] Legal records reveal her ownership of a number of pieces of property and her apparent business acumen. Brumidi, however, died penniless.[6] Lola later married Captain Edwin Kirkwood and moved to Richmond, Virginia; they both died in 1918. She was buried alongside Constantino Brumidi in Glenwood Cemetery.

Brumidi's will, which was filed on June 27, 1879 (but never probated), left all of his estate, including his designs, sketches, paintings, and library, to his son Laurence. Laurence Stauros Brumidi (1861–1920) (fig. 12–3) received his first training in painting from his father. By age seventeen, he had produced a copy of a painting by Guido Reni; Brumidi sent this copy to Senator Justin Morrill, who wrote, "It is quite a pleasing picture, and considering the short time he has attempted any work of this kind I think it betokens a talent of which his father may reasonably be hopeful."[7] It is puzzling that, at the time of Brumidi's death, Laurence was often called his "adopted son." Laurence studied art in Rome for five years around 1880, winning a prize medal at the Royal Institute of Fine Arts. He was bitterly disappointed in not being chosen to complete his father's Capitol frieze, but the Joint Committee on the Library finally paid him $1500 for the use of his father's sketches.[8] Laurence became director of the Kansas City Art Association and School of Design in 1888. He studied in Paris from 1893 to 1894, exhibiting work in the Salon and winning a prize. He painted portraits, landscapes, and church commissions. In 1916, however, he was judged insane and committed to St. Elizabeth's mental hospital in Washington, D.C., where he died in 1920. Laurence's obituary stated: "He was of a retiring disposition, and was a keen

Fig. 12–3. Laurence S. Brumidi as a young man. *Brumidi's son hoped to complete the frieze begun by his father.* Lola Germon Brumidi Family Album, United States Senate Collection.

student of all things pertaining to art."[9] A year before his death, in 1919, two crates he had placed in storage were discovered at the National Savings & Trust Co. They held twenty-seven oil paintings, including the final oil sketch for *The Apotheosis of Washington*, which were sold at auction in 1925.[10]

The Completion of the Rotunda Frieze

The first of several letters recommending Filippo Costaggini (fig. 12–4) as Brumidi's sucessor is dated February 20, the day after Brumidi's death.[11] Costaggini, born in 1837, came to the United States in 1870 and had extensive experience decorating churches. Edward Clark still had no funds appropriated for the work, but he agreed to accept résumés from artists with fresco experience. Costaggini said that he was recommended by Brumidi himself because they were both trained at the Accademia di San Luca in Rome. The day of Brumidi's death, a newspaper reported that Brumidi had requested Edward Clark to entrust the completion of the frieze to Costaggini.[12]

A number of other painters wrote letters expressing interest in finishing the frieze. One even proposed to redo the Rotunda completely in Victorian Gothic style.[13] However, by May, Costaggini was selected to be Brumidi's successor:

> The Joint Committee on the Library before Congress adjourned, instructed the Architect of the Capitol, Mr. Clark to give the New York fresco artist, Filippo Costaggini, a trial at completing the allegorical fresco belt in the Capitol dome left unfinished by Brumidi. No appropriation has been made for continuing the work at the point where the late artist stopped. He believes he can carry out Brumidi's idea and style in the completion of the great undertaking. If he fails, his work will be erased and another artist will be given a chance to attempt it.[14]

By September 1880 he was at work on finishing "William Penn and the Indians," for the same wages of $10 a day that Brumidi had earned.[15] Beneath the right-hand group of Indians, he wrote in pencil "F. Costaggini commincio in questo punto," to mark the point at which he started (fig. 12–5). The difference between the leg and foot painted by Brumidi and those by Costaggini is dramatic (fig. 12–6). Brumidi's strokes are almost impressionistic, just enough to create the appearance of three-dimensional forms from the floor, while Costaggini's style was tighter, more linear and detailed, with the shoe buckle carefully outlined. Brumidi's Indians were dressed almost in classical style, while Costaggini drew every bit of fringe on each costume. Consequently, his figures look somewhat flatter and stiffer than Brumidi's. He traced Brumidi's scroll of sketches onto his own twenty-four-foot scroll, and he purchased a cast of an ancient classical frieze to help create the three-dimensional effect needed.[16]

Costaggini's work was interrupted by other projects to which he was committed, partly because his pay at the Capitol was so low. After completing the scene of William

Fig. 12–4. Filippo Costaggini. *The Italian immigrant artist was recommended by Brumidi to complete the frieze because of his similar academic training in Rome.*

Penn, he worked on the frieze into 1881, progressing to the scenes entitled "Colonization of New England," "Oglethorpe and the Indians," "Battle of Lexington," and "Declaration of Independence" (see foldout). Although Costaggini worked in Philadelphia in 1882, he was at the Capitol essentially full time, as many as 250 days a year, for the first several years.

Costaggini took some liberties with Brumidi's design; the most radical change is seen in "Death of Tecumseh," for which Costaggini made a new sketch in 1884, eliminating Brumidi's small scene, "Decatur at Tripoli."[17] He signed this scene at the base of the tree to the right, and above his signature appears a hooded face, possibly a self-portrait, as if carved into the trunk of the tree (fig. 12–7). That year, Costaggini must have realized that Brumidi's sketches would not extend far enough to encircle the Rotunda. He "found that the subjects were not sufficient to fill the space owing to a miscalculation," and he began to enlarge the scale of the scenes in order to make them longer.[18] Consequently, his figures are taller than Brumidi's and his groups look more crowded. He also proposed adding a new scene entitled "Driving the Last Spike in the Pacific Railroad," but this was not approved.[19]

In 1885, Costaggini signed and dated "American Army entering the City of Mexico." In 1886 and 1887, he was painting in Lancaster, Pennsylvania, and in Philadelphia and worked only a few days at the Capitol. Finally, in May 1889, he signed and dated "Discovery of Gold in California." Tellingly, his signatures grew larger in size (fig. 12–8). Over the almost nine-year span of his work on the

Fig. 12–5. Costaggini's inscription. *Brumidi's successor wrote in Italian "F. Costaggini began at this point" where he took up work on the frieze.* Rotunda.

frieze, Costaggini was paid $16,162 for working approximately 1,600 days.[20]

As Costaggini predicted, the last figure in the scene did not meet up with Brumidi's first scene as planned, and a gap of over 31 feet remained. Costaggini was accused by some of deliberately crowding Brumidi's scenes in order to make room for his own designs. One of his chief critics was Brumidi's son Laurence, who had hoped to complete the frieze himself.

Measurements taken during the conservation of the frieze and compared to those on Brumidi's sketch show the source of the problem: although originally told that the height of the frieze was 9 feet, he actually had only 7 feet 9 inches of usable vertical space. Even including the blank band at the bottom, which is hidden by the ledge beneath it, the frieze is only 8 feet 3 inches high. Thus each of Brumidi's own scenes, retaining its original proportions, is smaller than he had originally intended in 1859.

The history of attempts to complete the frieze is long and agonizing. A resolution to allow Costaggini to complete it for $6,000 was passed in 1896. Costaggini proposed scenes showing the completion of the Union Pacific Railroad at Promontory Point and President Cleveland opening the Columbian Exposition; the next year, he created designs for scenes showing the Civil War (Sherman's army passing the review stand) and the Emancipation Proclamation (fig. 12–9), but arguments over the subjects prevented authorization of the work.[21] When Costaggini died in 1904 with the frieze still unfin-

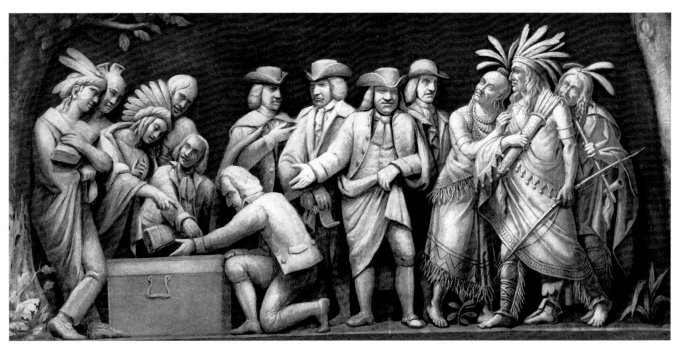

Fig. 12–6. "William Penn and the Indians." *Brumidi painted the left half of the scene, Costaggini the right. Note the different level of detail in Penn's shoes and in the costumes of the Native Americans.* Rotunda.

Fig. 12–7. The hidden portrait. *Costaggini may have painted a self-portrait over his signature in the tree trunk at the end of "Death of Tecumseh."* Rotunda.

Fig. 12–8. Signature and date on "Discovery of Gold in California." *Filippo Costaggini signed his name prominently in the last scene he completed.* Rotunda.

Fig. 12–9. Filippo Costaggini. Sketch for the Emancipation Proclamation, 1897. *None of the artist's proposed scenes were approved.* Architect of the Capitol.

ished, it had already been badly streaked by leaks during a storm in 1898 (see fig. 14–2). In 1908, another blocked drain caused further damage. Brumidi's scaffold still dangled in the Rotunda "like a huge ungainly spider."[22]

A new bill to complete the frieze was introduced in 1914. The subjects "Grant and Lee at Appomattox," "Panama Canal," and "Triumph of Aerial Navigation" were discussed. The American Institute of Architects, on the other hand, described the trompe l'oeil sculpture as "a miserable sham" and urged Congress to "condemn the whole thing."[23] The idea was finally bogged down in arguments over whether the apple tree in the Appomattox scene was historically accurate. In 1918, Charles Ayer Whipple was allowed to paint in the gap a sample scene called "Spirit of 1917" (fig. 12–10). Whipple had hoped to paint three scenes, but the poor quality of his work was evidently recognized, for he was not allowed to continue, although a joint resolution was passed in 1919 to restore and complete the frieze. In 1928, Charles Lindbergh's flight across the Atlantic Ocean was dis-

cussed as a subject for a scene. The idea of either completely replacing or completing the frieze was brought up periodically in the Congress. In 1945, Architect of the Capitol David Lynn explored the possibility of redoing the frieze in marble high relief, harkening back to Meigs's idea of almost a century before. Finally, legislation authorizing the painting of the last three scenes was passed in 1950, and funds were appropriated in 1951. In 1952, a century after Brumidi arrived in America, Allyn Cox signed a contract, and he completed his work in 1953 (fig. 12–11). In addition to cleaning the surface of the nineteenth-century frieze, he repainted the uneven dark background of all of the scenes. The entire frieze was finally dedicated on May 11, 1954.

In 1986, Congress appropriated funds to remove accumulated grime, overpaint, and streaks caused by leaking water. The conservation treatment, completed early in 1987, vividly restored the illusion of relief sculpture (see chapter 14). Damage from leaks caused by a stopped-up drain was repaired in 1994.

176

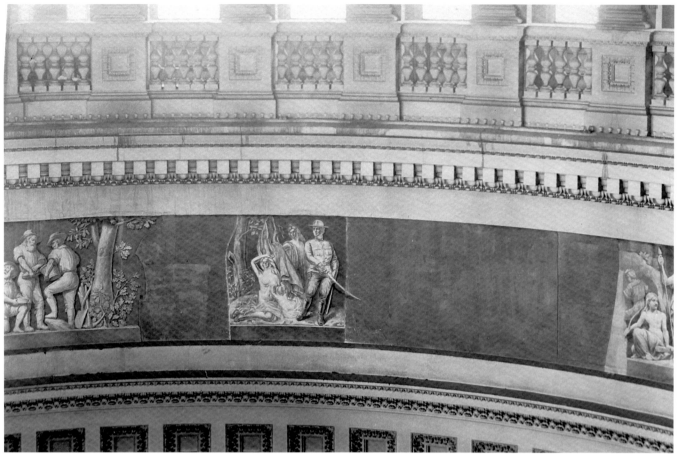

Fig. 12–10. Frieze with Charles Whipple's "Spirit of 1917."
The 1918 trial piece was not a success, for Whipple was not allowed to complete the frieze.

Photo: Underwood and Underwood.

Brumidi's Reputation

Brumidi's stature at the time of his death is shown by the number of obituaries describing his career published in the *Washington Post, Washington Star, Baltimore Sun, Philadelphia Telegraph* (both Daily and Evening), *New York Times, New York Tribune,* and *American Architect and Building News.* He was praised as "the genius of the Capitol" and as one "whose decoration at the Capitol has given him a world-wide reputation."[24]

However, at the same time, many considered Brumidi's style of painting and concepts old-fashioned. Some writers praised his technique and dedication but disparaged his artistic sense: "Signore Brumidi, whatever may be said of his design, understood his process thoroughly, and was enthusiastic and indefatigable in his work."[25] "While

Fig. 12–11. Allyn Cox at work on the frieze. *Cox is shown here retouching damage to Brumidi's fresco.*

177

Signor Brumidi's remarkable designs have caused much grief to the judicious, and infinite mirth to the irreverent, he was certainly a master of the difficult process of fresco-painting, which is the most durable known of art."[26]

The most negative criticism was published by the *Philadelphia Daily Telegraph*:

> . . . it may be said, "He was most industrious. . . . But, if the quality of his work is considered, we doubt whether those who are at all competent to judge with regard to the matter will differ among themselves as to the fact that his employment for a long term of years, in the face of repeated and emphatic protests from people who knew what good decoration was, was most scandalous.
>
> Brumidi covered several acres of the Capitol walls with his frescoes The bulk of Brumidi's work, however, is to the last degree abominable. . . . In spite of the howling—howling is the only proper word in such a connection—atrocities which he perpetuated on the Naval and other committee-rooms, on the corridors, on the Congressional halls, and on every nook and corner upon which he could lay his hands, he was permitted to paint on the interior of the dome a composition which, both in design and execution, is about as abominable as anything of that kind well could be, and at the time of his death he was engaged in "decorating" the frieze of the rotunda with an imitation bas-relief which, if anything, was worse than the artistic atrocity on the ceiling.[27]

The press took up this negative tone in discussing the question of who would finish the frieze. The *American Architect and Building News* wanted William M. Hunt or John La Farge to be considered, but was not sure Brumidi's frieze should be continued at all "if it fails as a work of art, which we believe it does," and questioned congressmen's ability to decide aesthetic questions.[28] In 1884, the publication continued its derogatory comments while Costaggini was completing the frieze: "The finishing touch is at last to be put to the painful caricature which makes the lower part of the dome in the Capitol at Washington ridiculous, by the addition of a new jumble of what are supposed to be historical subjects. . . as there was no one in Washington with energy enough to prevent him, [Brumidi] actually spent many years of his life in carrying out this dreary joke."[29]

Negative assessment continued into the early twentieth century. In 1911, critic Elisabeth Luther Carey wrote that Brumidi was "by no means unversed in the science of his craft, but no one will pretend that his decorations amount to anything as art." Although in 1919 a favorable comment appeared—"There is no question but what Brumidi will go down in history as the artistic genius of

the Capitol"—the next year, he was described as "a famous interior decorator." Brumidi's reputation also suffered from being over-dramatized: "More romance, travel and patriotic efforts entered into his career than is usually accorded to a hundred men."[30]

By the early part of the twentieth century, little accurate information about Brumidi was known, and his work was being overpainted without remorse. It is ironic that Charles Fairman could say in 1930, "In these paintings he has touched a high mark in the excellency of mural decoration of his period, or for that matter, any period," just after many of Brumidi's frescoes had been painted over by inferior artists such as Charles A. Whipple, George B. Matthews, and Charles Moberly.[31]

Although Allyn Cox cleaned the frieze while adding the last three scenes in 1953, at the time he was hired to clean and restore the canopy in 1959 he felt free to repaint Brumidi's fresco almost completely. Cox once stated his justification for this action: "In the case of the Capitol frescoes I recommended repainting. But, as I was careful to state clearly, and was understood before I began, we were dealing with paintings whose chief qualities were *architectural* and *historical*, and the job there was to preserve them as decorative and historic parts of the Capitol building, even if it did involve more repainting than is considered ethical in the best museum practice."[32]

Thus, by the 1960s, accurate evaluation of Brumidi's achievement was not possible because so much of his work had been painted over, retouched, or darkened by grime. In the 1970s, with the renewal of appreciation for Victorian architecture and decoration and the growth of historic preservation, conservation of Brumidi's work became a priority. By the time of the bicentennial of the Capitol in 1993, enough of his important work was restored to allow a valid and balanced assessment of Constantino Brumidi's remarkable art for the first time in living memory.

Notes to Chapter 12

1. Certificate of Death, District of Columbia, No. 23257, February 19, 1880.

2. Notes from February 19, 1880, from Gonzaga College Diary. "Brumidi's Funeral," *Evening Star* (Washington), February 21, 1880.

3. *Congressional Record*, 46th Cong., 2d sess., February 24, 1880, p. 1075.

4. Ibid., p. 1076.

5. In March of 1879, Mrs. Lola V. Walsh secured a loan to purchase 921 G Street, N.W., USSC/MTP. Plat Book, Glenwood Cemetery, D.C., Section Q, Lot No. 70. A "First Auditor's Certificate" dated November 10, 1880, acknowledges that a sum of $33.00 is due to Mrs. L. V. Walsh for purchasing the "burial site in Glenwood Cemetery for Constantino Brumidi deceased" NARA/RG 217. References to Edwin C. Kirkwood can be found in USSC/MTP.

6. Robert Mason, Attorney for Mrs. L. V. Walsh, to the Honorable R. M. Reynolds, First Auditor of the Treasury, November 6, 1880. Mr. Mason indicates that Mrs. Walsh has paid the burial expenses, including clothing, burial site, and undertaker fees. Mr. Mason further indicates that since Congress has approved money to cover the costs of Brumidi's burial (June 8, 1880, "AN ACT for the payment of certain moneys to the heirs of Constantino Brumidi, deceased"), Mrs. Walsh will be reimbursed by those vendors when they receive the appropriated funds. NARA/RG 217.

7. Justin Morrill to CB, June 20, 1878 , USSC/MTP.

8. A medal stamped in silver with the inscription, "Premio allo Studio" (First Prize in Studies) and on the reverse, "Regio Istituto de Belle Arti in Roma" (The Royal Institute of Fine Arts in Rome) was donated to the Architect of the Capitol by Mildred Thompson. Joint Committee on the Library, 48th Cong., 1st sess., March 19, 1884, H. Rept. 390. Report to accompany H.R. 6091.

9. "Lawrence Brumidi Dead: To Be Buried Tomorrow," November 11, 1920, AOC/CO.

10. C. G. Sloan & Co., Inc, Auctioneers, Estate Sale catalogue for the week of January 26, 1925 (Washington, D.C.).

11. E. DeMerolla, Vice Consul of Italy, Baltimore, [to EC ?] February 20, 1880, AOC/CO.

12. Filippo Costaggini to "The Honorable Members of the Committee," probably the Joint Committee on the Library, from New York in March 1880; "Art and Artists." *Evening Transcript* (Boston), February 24, 1880.

13. Edward Van Reuth created a watercolor design and a large rendering in oil on canvas showing the entire Rotunda redone with stained glass and paintings by himself. See letter from his father, Felix van Reuth, to EC, August 12, 1880, AOC/CO. The paintings were donated to the Architect of the Capitol by his grandson Arthur B. Van Reuth and other descendents.

14. *Boston Advertiser*, June 18, 1880, as quoted in Dan Estes and Charles E. Lauriat, *American Art Review*, Boston, 1880.

15. Filippo Costaggini to EC, thanking him and saying that he will be ready to begin work in the Rotunda in July as requested, May 24, 1880, AOC/CO. Moving to Washington delayed the artist's start.

16. Costaggini's pen and ink scroll, 12 inches by 24 feet 6 inches, was auctioned by his grandson at the Parke-Bernet Galleries, Sale No.

2440, May 13, 1966. The cast of the Battle of the Amazons from the Temple of Minerva was ordered by EC for Costaggini from C. Cinocchio in New York, April 18, 1881.

17. William Macleod, Curator of the Corcoran Gallery of Art, to EC, February 24, 1884, mentions the sketch being finished, AOC/CO.

18. Filippo Costaggini to G. P. Wetmore, Chairman of Library Committee, June 19, 1897, AOC/CO.

19. *American Architect and Building News*, October 18, 1884, p. 181.

20. Glenn Brown erroneously gave $10,084 as the total.

21. "Historical Frieze," *Evening Star* (Washington), May 30, 1896, and photographs of four sketches copyrighted in 1897, AOC/CO.

22. "The Abandoned Fresco of the Capitol," unidentified clipping dated February 16, 1913, AOC/CO.

23. *Journal of the American Institute of Architects*, 2, no. 9, September 1914, p. 434.

24. "Death of a Great Artist," *Washington Post*, February 20, 1880; "Death of the Artist Constantino Brumidi," *Baltimore Sun*, February 20, 1880, p. 1.

25. "Death of Brumidi, the Fresco-Painter of the National Capitol," *Philadelphia Evening Telegraph*, February 19, 1880, p. 2.

26. "The Late Constantine Brumidi," *Philadelphia Daily Telegraph*, reprinted in *American Architect and Building News*, March 6, 1880.

27. "Brumidi and His Successor," *Philadelphia Daily Telegraph*, February 20, 1880, p. 4.

28. "Brumidi's Successor," *American Architect and Building News*, February 21, 1880; "The Death of Signor Brumidi," February 28, 1880; "Brumidi's Work at the Capitol in Washington," March 27, 1880.

29. *American Architect and Building News*, October 18, 1884, p. 181.

30. "American Mural Decoration," *Woman's Home Companion*, December, 1911, p. 47; "Brumidi Paintings Found in Washington After a Search of Forty Years," *Washington Star*, November 2, 1919, pp. 6–7; "Laurence S. Brumidi Dead: To Be Buried Tomorrow," unidentified obituary, AOC/CO; "Artist is Restoring Capitol's Great Paintings," *Sunday Star* (Washington), April 13, 1919, p. 4.

31. *Congressional Record*, 71st Cong., 2d sess., January 29, 1930, p. 3.

32. Allyn Cox to Mario E. Campioli, June 16, 1963, AOC/CO.

CHAPTER 13
A Conservator's Perspective

BERNARD RABIN

In 1986, with over 50 years' experience conserving paintings in Italy and the United States, I began one of the most exciting and important projects of my life: the treatment of the frescoes by Constantino Brumidi in the Rotunda of the United States Capitol. The conservation of the 4,664-square-foot canopy with *The Apotheosis of Washington* and the 300-foot-long frescoed frieze below it dwarfed in size and scope other projects I have directed. The work in the Rotunda was undoubtedly the culmination of my career.

Even before I put my hand to the frescoes, I felt compelled to know more about the artist. Constantino Brumidi's talent is evident throughout the Capitol. That he was gifted is not unusual; I have conserved many works by technically gifted artists. However, Brumidi's work is unusual because he depicted the people and events of American history with insight and compassion. In the frieze, for example, he depicted Native Americans and Mexicans with individuality and dignity, in contrast to his successor Filippo Costaggini, who showed Mexicans as ethnographic types and Native Americans as savages.

Fig. 13–2. Conservators at work. *From left to right, Larry Keck, Constance S. Silver, Ron Cunningham, and Bernard Rabin are shown on the scaffold platform next to the over-life-size painted figures.*

The primary focus of our conservation efforts was to ensure the survival and appropriate presentation of these national artistic treasures. In executing the treatments, however, we found that we were also tracing the artist's evolution and expanding the knowledge of nineteenth-century mural technique. In a very real sense my team and I felt ourselves to be rediscovering our nation's history through the art of Constantino Brumidi.

The program to conserve and restore the murals of the Capitol was initiated by Architect of the Capitol George M. White and Curator Anne-Imelda Radice with the survey I conducted in January 1981. Based on the priorities I identified, special funds for the conservation of wall painting have been appropriated by Congress each year at the Architect's request. In addition to the conservation projects described here, I have worked on a number of other rooms and frescoes in the Capitol. In recent years, younger colleagues with expertise in fresco have carried on the work.

The major frescoes high above the floor of the Rotunda have been subject to less damage than those in accessible and heavily used areas, but nevertheless have suffered various kinds of deterioration over time. The murals in the Capitol have been altered and damaged in a number of ways. The most basic reason is that mural paintings are literally part of the architecture, and thus are sub-

Fig. 13–1. Movable scaffold used to restore the frieze. *The conservators climbed the many flights of zigzagging steps to reach the platform high above the thousands of daily visitors.*

jected to all the agents that actively degrade working buildings. Like the Capitol itself, Brumidi's art has suffered from leaks from broken pipes and clogged gutters, fires, fluctuating humidity, atmospheric pollutants and grime, a terrorist bomb, construction-related cracking, careless workers, and wear and tear from millions of visitors. In addition, overzealous early attempts at restoration resulted in removal of unstable original paint and massive repainting in the fashion of the particular restorer's time. These destructive agents often exacerbated certain weaknesses in Brumidi's technique of execution, such as the use of pigments that proved to be incompatible with, and thus poorly adhered to, the plaster.

There have been some improvements since Brumidi's time in maintaining more stable interior environmental conditions, especially the air conditioning installed in 1938. Since the 1950s, the conservation field has become more science-based, and new techniques for examining and treating works have been developed. Finally, and perhaps most important, the development of conservation as a professional discipline has mandated an ethical approach to treatments, ensuring that fidelity to the artist's work is paramount. The continuing advances in the field of conservation will make it possible to return the 200-year-old U.S. Capitol, perhaps the world's busiest historic building, to its original and unique beauty.

It is important to note that the professional conservation of historic and artistic works is a relatively new discipline. The first *Code of Ethics and Standards of Practice* for conservators was developed only a few decades ago, in 1963, by the American Institute of Conservation (AIC). The code defined conservation as including the examination, treatment, and systematic maintenance of works of art, based on scientific analysis and historical research. All steps taken are carefully documented in written and photographic form. The code, revised in 1994, now begins by stating: "The conservation professional shall strive to attain the highest possible standard in all aspects of conservation, including, but not limited to, preventive conservation, examination, documentation, treatment, research, and education."

The goals of the conservator are to preserve the object physically, to return it to its most appropriate historic and aesthetic appearance, and to provide a plan for long-term stability and preservation. To answer the questions that arise during treatment, the conservator must call upon the expertise of scientists, archivists, and art historians. Like a physician, the conservator endeavors to "do no harm." Treatment must be sensitive to and respectful of the artist's original intent. I believe it is much better to leave a slight layer of grime than to take the risk of altering or removing original material. Reversible materials are used in any reconstructions, so that the original materials are never permanently altered. Visual reintegration, sometimes called "retouching," is now referred to as "inpainting" because it is limited, as much as possible, to restoration of small areas of lost paint when performed by professional conservators. Fortunately, because of advances in the control of interior environments, the frescoes of the Rotunda will remain stable for generations.

The conservator's responsibility is to examine and study each inch and brushstroke of the painting in order to preserve the integrity and aesthetic impact of the artist's work. Conservation thus requires an unusual rapport between the long-dead artist and the conservator.

My first challenge in conserving the frescoes was to conduct preliminary examinations of the murals, which in themselves required challenging logistical measures. To inspect the frieze I had to lower myself from the balcony in a bosun's chair hanging fifty-eight feet above the floor. For the treatment itself, a movable scaffold was erected (fig. 13–1). It provided us access to the entire frieze. My full-time assistants in the conservation of the frieze were Larry Keck and Constance S. Silver, with Ron Cunningham and Susan Mason working for shorter times (fig. 13–2).

In planning for the treatment of the canopy, it was not possible to reach the curved surface to inspect it closely or to conduct tests ahead of time; I was able to make some rudimentary spot cleaning tests only at the lowest edge of the fresco by using a pole from a ladder on the balcony. Therefore, I approached the canopy with trepidation, not knowing the problems that we would find. Because a space frame across the balcony would not have provided complete access to the fresco and was more costly, a carefully designed scaffold was built from the floor of the Rotunda, its weight transferred to the massive columns in the crypt below (fig. 13–3). A passage was left through the scaffold for access across the Rotunda. I requested a small elevator for transportation of equipment, supplies, and personnel, particularly for myself in light of the fact that I was past retirement age. (At one point, the plans for the elevator were nearly scuttled when the Architect of the Capitol discovered that the previous restorer, Allyn Cox, had walked up.) The ride took at least eight minutes; my youthful crew often found they could beat it by walking up the stairs, between the inner and outer domes.

On the platform at the top of the fixed scaffold, smaller rolling scaffolds were provided to enable my team, which consisted of Larry Keck, Constance S. Silver, Perry Hurt, and Todd Overturf, to reach all levels of the concave canopy (fig.13–4). Because there is no plumbing at the top of the dome, special pumps and drains were designed so that the murals could be cleaned with water.

With any large-scale project, delays are always possible. A unique consideration of working in the Rotunda of the

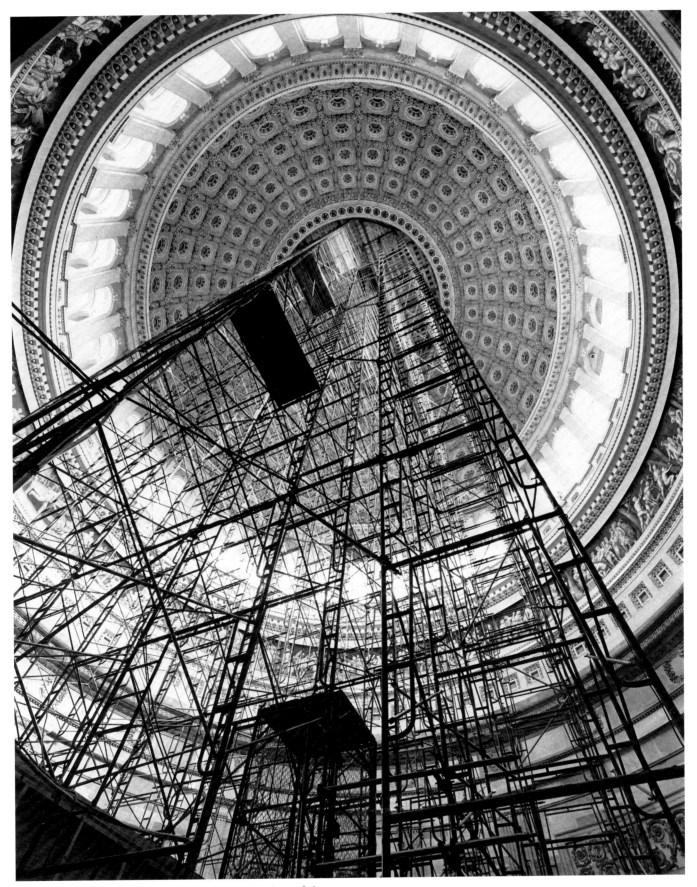

Fig. 13–3. Scaffold constructed for the restoration of the canopy. *The 150-foot-high structure supporting a wooden floor at the base of the fresco filled much of the Rotunda for a year.*

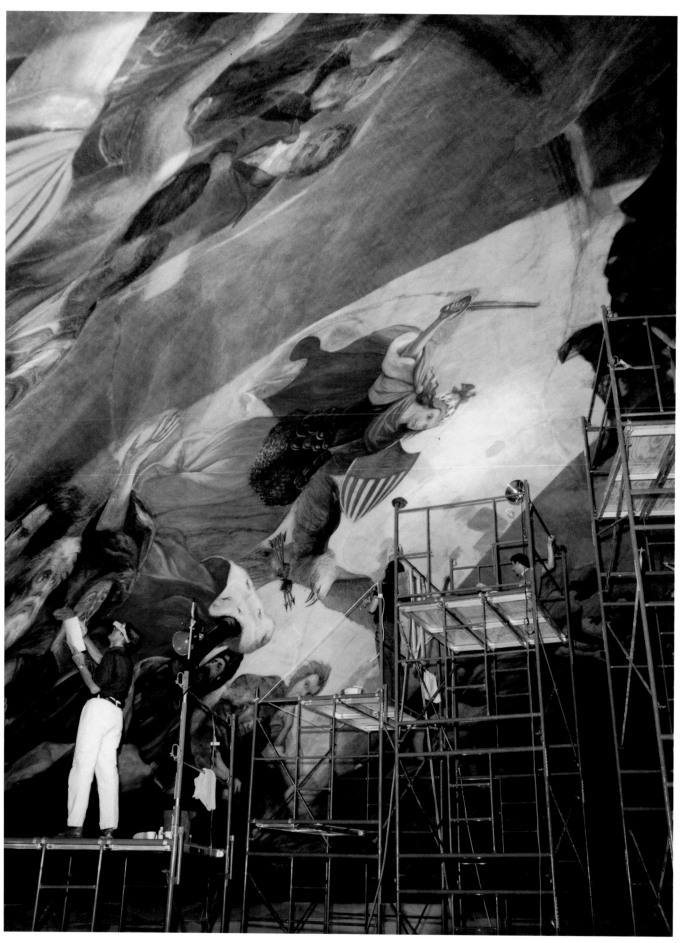

nation's Capitol was its ceremonial function. If an important person, such as one of the four living presidents, had died, the scaffold might have had to be dismantled to permit the remains to lie in state. Fortunately, our fears of such an eventuality were groundless.

Interestingly, our project coincided with the conservation of the frescoes by Michelangelo in the Sistine Chapel. Keenly aware of the controversy and misunderstandings surrounding that treatment, we kept Congress and the press informed through periodic press conferences and by inviting them to view the restored canopy up close before the scaffold was removed. We brought in as consultants internationally respected conservators, including Sheldon Keck, who with his wife, Caroline, was founder of two major conservation programs in the United States, and Paolo and Laura Mora, chief conservators at the Istituto Centrale del Restauro in Rome and coauthors of *Conservation of Wall Paintings*. The Moras inspected the canopy before, during, and after conservation; they provided us with valuable peer review, confirming that the treatment we selected was fully appropriate. They also provided important insight into the cleaning of the most heavily overpainted areas in room H–144, the

former Agriculture Committee Room. They were with us on site for several weeks during an extended stay in Washington. I was gratified by the Italian experts' enthusiasm for Brumidi's talent and skill and by their comments on how hard-working and dedicated they found my team. Dr. Robert Feller, of the Mellon Institute, Carnegie-Mellon University, in Pittsburgh, also reviewed the conservation materials we used.

The conservation analysis and treatment were supported by research into the extensive records of the Architect of the Capitol. Statements by Brumidi and early photographs were critical to our efforts to restore the original intent of the artist as closely as possible. Architect of the Capitol George White remained personally involved in the project. He viewed the work at the top of the dome in progress and approved decisions about goals and treatment. Dr. Barbara Wolanin, Curator for the Architect of the Capitol, and Tom Ward, Supervising Engineer of the Capitol, supplied unlimited support in coordinating all aspects of the undertaking. Functioning as a team, we brought our best professional judgments to bear while returning visual integrity to the frescoes.

Fig. 13–4. Rolling scaffolds atop the fixed scaffold. *The conservators could reach all parts of the curved canopy from the platforms at varying heights.*

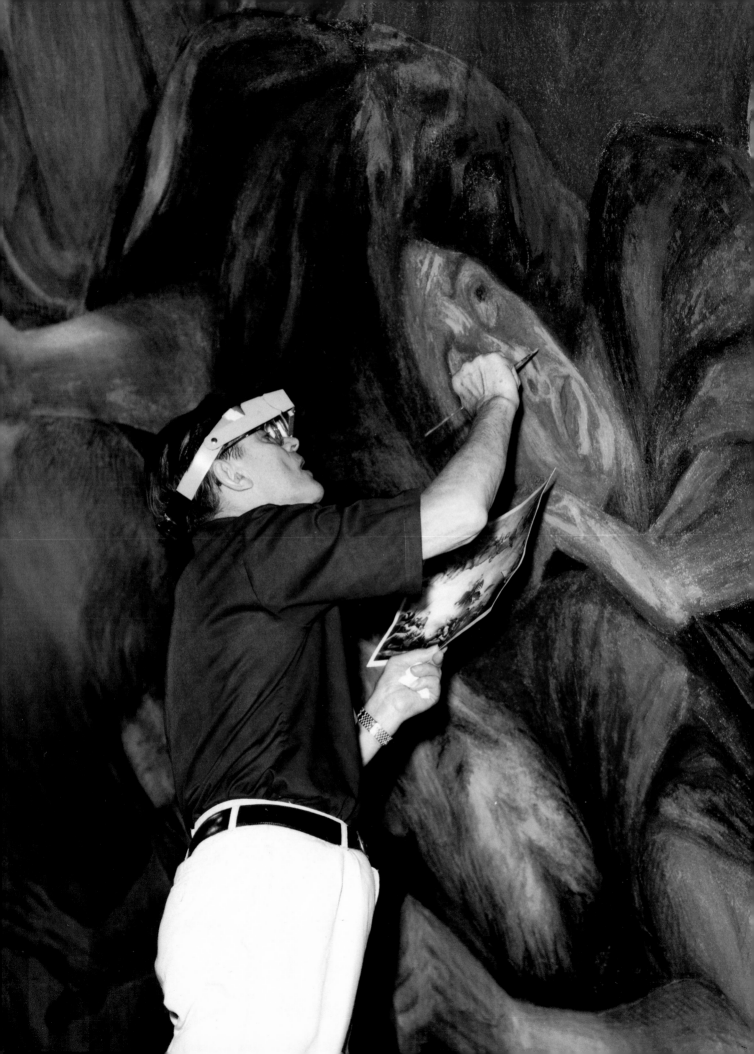

CHAPTER 14
Conserving the Rotunda Frescoes

BERNARD RABIN AND CONSTANCE S. SILVER

Fig. 14–2. Early photograph showing water damage to the frieze. *Major leaks had disfigured "Colonization of New England" and other scenes by the end of the century.*

From Glenn Brown, *History of the United States Capitol*, 1902.

Brumidi's frieze and canopy in the Rotunda were the two most challenging and dramatic of the fresco conservation projects undertaken in the Capitol in recent years (fig. 14–1). This conservation makes a full appreciation of Brumidi's artistic techniques and achievement possible. The intent of this chapter has been to make complex restoration processes understandable, including the kind of research and debate that is necessary in professional conservation, with technical information included in the notes for those who are interested in more detail. The illustrations provide samples of the kinds of photographic documentation and diagrams that are included in the full conservation reports.

gini, who continued it from 1880 to 1889; and Allyn Cox, who completed it in 1953 (see chapter 11.) All three artists worked in true fresco, although each artist executed his section in a slightly different technique and style, presenting an unusual conservation problem (see foldout).

The frieze begins 58 feet above the floor, in a shallow cove 8 feet 3 inches high and slightly over 303 feet in circumference. The Rotunda to this height is composed of the original masonry walls built in the 1820s with brick and rubble fill. The structure behind and above the frieze, begun in 1856, is brick and cast iron.

It was clear, even before inspection at close range was possible, that the frieze was in serious need of conservation. Leaking rainwater had left unsightly streaks and white deposits on several areas as early as the 1880s. A photograph published in 1902, only twenty-five years after Brumidi began painting, showed that almost one-third of the existing frieze had already been streaked and marred by extensive leaks (fig. 14–2). Several areas were disfigured by white patches, thought to be salts transported by moisture in the plaster. Documented recurrence of leaks in certain locations prompted growing concern. Recently, in 1994, the gutter system was modified to prevent future damage.

Once the scaffold was in place, the problems could be assessed more fully. So heavy had the infiltration been at

The Frieze

Executed between 1877 and 1953, the frieze on the belt at the base of the dome in the Capitol Rotunda incorporates the work of three artists: Constantino Brumidi, who began it in 1877 and worked until 1880; Filippo Costag-

Fig. 14–1. Bernard Rabin inpainting losses. *The conservators used archival photographs to guide the reconstruction of damaged forms. The water-based paint they used can be easily removed if so desired in the future.*

187

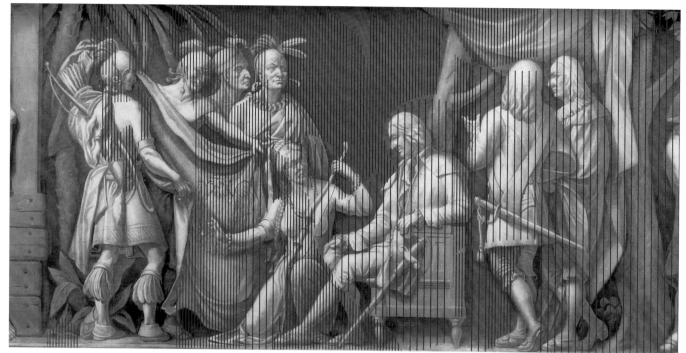

Fig. 14–3. Diagram showing the deterioration of the painted surface of "Oglethorpe and the Indians." *Before conservation treatment was begun, existing conditions were carefully recorded.*

Etching Streaks

times that both the paint and the surface of the plaster had been etched, probably because the first leaks had occurred before the fresco had thoroughly cured. Fortunately, we found that the plaster remained well adhered to the wall of the cove. However, we saw considerable deterioration of the painted surface, indicative not only of water but also of some inherent weaknesses in the techniques of execution, of ill-advised human interventions, and of ambient agents (fig. 14–3).

For reasons not clearly understood, the brown pigment of the background, especially in Brumidi's sections, was powdering or poorly bonded to the *intonaco*, the top coat of plaster. In other frescoes in the Capitol, such earth tones, made of naturally occurring minerals, also suffer from this lack of adhesion. We also observed two unusual features of the paints Brumidi and Costaggini had used. Many areas that should have been white highlights were rather gray, while other areas, primarily in the dark shadows, had become milky. We hypothesized that the gray areas were actually details applied *a secco* after the plaster was dry, with lead white in oil paints. When used on plaster, lead white can darken over time. We also hypothesized that the milky areas in the dark paints were dark oil paints applied to the dry fresco, which had cracked and turned opaque in the presence of water.

To understand the composition of the frieze, we removed fourteen small samples for laboratory analysis.[1]

The results confirmed our hypotheses. The frieze was basically executed in a true fresco technique with a limited but characteristic palette composed of earth pigments, such as naturally occurring iron oxides. However, as we suspected, some details were added after the plaster was dry. Lead white in an oil medium was identified in the now gray highlights, and oil paint was found in many of the painted shadows. Visually, it was clear that the *a secco* details are integral to the composition and consistent with the artists' styles and not elements added by a later restorer. An additional cause of discoloration discovered only during the course of treatment was a gray deposit on the surface of the fresco. Historical research confirmed that from 1866 to 1906 the dome had been lighted by 1,083 gas jets, some of which were placed directly under the frieze.[2] The gray deposit was very likely a residue from the burning coal gas, which contains sulfur pollutants and deposits a particularly tenacious and potentially damaging grime.

In addition to these problems, we saw that some alterations were made in 1953 by Allyn Cox when he cleaned and overpainted parts of the frieze prior to executing the final three sections. He correctly assessed that the frescoes had become obscured by grime and that it would be ill-advised to match the final three sections to darkened adjacent surfaces. Although not a trained conservator, Cox carried out a remarkably safe cleaning method, and he left

188

Fig. 14–4. Group of Native Americans in "Oglethorpe and the Indians" shown before conservation. *In badly damaged areas, Allyn Cox used his imagination to reconstruct forms.*

Fig. 14–5. Group of Native Americans in "Oglethorpe and the Indians" shown after conservation. *The professional conservators consulted historic photographs of the frieze for accuracy.*

189

a detailed report of the methods and materials he used. Cox cleaned the fresco with water, which removed considerable surface grime. However, he was not able to remove the tenacious oily gray deposit, which visually obscured and weakened the precise relationship of dark shadows and light highlights that make the frieze appear to be three-dimensional. To compensate for this, he reinforced many of the darks and lights. He also repainted the brown background completely and created his own details in areas where the fresco was badly damaged. He sprayed areas of flaking paint with a casein medium in an effort to stabilize them, but this consolidant apparently contracted over time, adding to the instability of the fresco.

Treatment

One of our primary objectives was the physical conservation of the frieze, such as the stabilization of the flaking surface. Removal of accretions was equally important for the frieze to be legible both as a pictorial narrative and as an integral component of the Rotunda's interior architecture. Our treatment had to incorporate cleaning methods that were effective and safe for the work of each artist and to maintain harmony and continuity from section to section. These goals were complicated by the three distinct artistic styles and the varying aging properties of the materials.

We learned as we worked our way around the frieze, and we stopped to reassess after the treatment of the first five scenes. We began by removing heavy surface dust with a soft brush. The figurative areas were then cleaned with water and the highlights were further cleaned with a special dry, eraser-like Wishab sponge. Cox's repainted brown background was left in place, but streaks and uneven areas were feathered and blended with gouache, high-quality poster paint to which an acrylic emulsion was added to provide binding strength. This served to consolidate and make the background less sensitive to any future leaks. Stains, discolorations, and losses in the figurative areas were inpainted with reversible acrylic paints.

As discussed above, we learned that the fresco did not look as bright as we had expected because the oily gray deposit from the old gaslights remained on the surface. Cleaning tests proved that highly diluted aqueous ammonium hydroxide, gently applied through Japanese tissue, could safely remove the deposit. Care was taken to ensure uniformity from section to section. After conserving the whole frieze, we returned to Brumidi's first five sections and treated them with this cleaning method to ensure visual continuity.

We were successful in removing Cox's casein-based overpaint from the figures and from the background. Although streaked and abraded in some areas, the original

Fig. 14–6. Detail of face in "Pizarro Going to Peru."
Brumidi's use of impasto white highlights gives the frieze an added sense of depth. Photo: Rabin & Krueger.

paint was generally intact. The lighter tone of the original brown background and its many natural irregularities actually enhance the trompe l'oeil effect, making the cove appear more realistically as a three-dimensional architectural surface. The deeply etched streaks in the brown background were inpainted in high-quality poster paint with added acrylic medium.

Extensive reconstruction was required only at scene 10 (see fig. 14–3). Here Cox had reconstructed some damaged areas by extrapolating from the fragmentary forms that remained (fig. 14–4). By consulting archival photographs, we were able to restore more correctly Brumidi's original details (fig. 14–5).

The disfiguring efflorescence in some areas, particularly in scene 16, proved to be calcium sulphate dihydrate, a soluble salt, which caused some loss of paint and friable

Fig. 14–7. Diagram of the *giornate* in "William Penn and the Indians." *The number and configuration of the sections of plaster on which Brumidi painted each day were recorded as part of the conservation treatment. In this section, Brumidi's small sections to the left contrast with Costaggini's larger ones to the right.*

plaster. We softened and removed the deposits with water, consolidated the plaster, and inpainted the small areas of loss.

At scene 16, Costaggini's final section, and at scene 17, Cox's first section, the scaffold was placed so that the frescoes of both artists could be examined and treated simultaneously to evaluate the contrast between the nineteenth- and twentieth-century frescoes after cleaning. We concluded that Cox had executed his three scenes in tones that are somewhat darker and grayer than Brumidi's and Costaggini's frescoes because he had matched his paints to the appearance of the nineteenth-century frescoes as obscured by the grimy gray film. Removal of heavy dust from Cox's section and a modified cleaning of Costaggini's final figures produced a harmonious transition.

Discovery

Brumidi's sections are executed in a classic high Baroque technique. The plaster is rough and sandy; the pigments, with additional lime, applied in a noticeable impasto. Brumidi also employed transfer techniques that had become common in the Renaissance and Baroque periods in Europe. Nail holes, some with nails still in them, indicate where he had tacked his cartoons to incise outlines in the damp *intonaco*. He employed the transfer techniques called *puntini* and *spolvero*, which produce dotted lines (see chapter 3), especially in areas with complex elements such as the intricate Aztec calendar. He generally painted the heads and hands, the most complex and expressive components of the body, on individual *giornate*. Transfer techniques are less numerous on the bodies. Close examination reveals the work of a secure and spontaneous artist, who boldly painted shadows and highlights (fig. 14–6).

Both technically and artistically, Costaggini departed from Brumidi's richer and more spontaneous Baroque style and sculptural approach. His plaster is smoother, mixed with less sand. Costaggini's style is linear, detailed, and rather hard-edged, the pigment thinly applied on a very white, smooth, and rather brittle plaster.

Costaggini also relied heavily on a variety of transfer technique—incisions, *puntini*, and *spolvero*—to ensure the precise and somewhat rigid execution of a myriad of details. Thus his *giornate* tend to be rather large and predictable, most probably laid out in precise relationship to the cartoons (fig. 14–7).

In the final three sections of the frieze, Cox imitated Costaggini's more illustrative style. His *intonaco* is quite smooth; his *giornate* are large and predictable in form. Cox used the *spolvero* technique of transfer. To create an appropriate backdrop for the Wright brothers' airplane he reconstructed as clouds the first element of Brumidi's composition, a mountain intended to be at the end of the scene showing the Gold Rush.

Fig. 14–8. First area on the canopy cleaned. *Bernard Rabin is dwarfed by Freedom, whose vibrant colors were uncovered beneath heavy layers of grime.*

Once the conservation treatment was completed, the work of the three artists appeared to be an integrated whole, and Brumidi's intended illusion of relief sculpture in light and shade was greatly enhanced. In addition to knowing that all loose areas were consolidated and damage correctly repaired, we had gained a new appreciation of Brumidi's skillful technique and mastery of form.

The Canopy

The Capitol Rotunda is a magnificent symbolic space for which Brumidi's canopy fresco is the climax, demonstrating his mastery in merging monument with monumental art. Viewed today after conservation, the dome is alive with color, movement, and drama. Before treatment, however, darkening from grime, disfiguring heavy dark lines between the sections of plaster, extensive overpainting, and inconsistencies in the fresco's surface destroyed the intended effect of three-dimensional space. Thus, conservation was a high priority.

Facing us was a complex web of possibly interrelated factors, including the mechanical structure of the canopy, variations in technique or materials, alterations made by the artist, accretions of dirt and grime, and the effects of cleaning and restoration work carried out by Allyn Cox in 1959. Archival research, scientific testing, examination of current conditions, and the conservation skills of our team all contributed to the comprehensive treatment program. Work began in July 1987 once the enormous scaffold was constructed.

The first step was to carry out cleaning tests. The amount of grime darkening the fresco was even greater than we expected. Even with the first simple water cleaning, the sky changed from dark gray to yellow white (fig. 14–8). As on the frieze, we found a layer of tenacious grime from the burning of the coal-gas jets that illuminated the dome for forty years.

To identify possible mechanical causes for the fresco's deterioration, we studied the structure of the dome. The canopy, which provides the fresco's structural support, consists of a curved framework holding cast-iron laths suspended from the cast-iron structure of the outer dome. A core sample showed that the first rough plaster coat (*arriccio*) was pushed between the slots, creating a wedgelike plug that holds the plaster in place. This rough coat has sand of large particle size and at least three types of fibrous fillers to enhance its tensile strength.[3] Analysis of the finer top coat (*intonaco*) confirmed that Brumidi used the traditional true fresco mixture of lime and sand in a 1:3 ratio.[4] The composition of the plaster appeared to be consistent and therefore not a cause for the deterioration of the painted surface in the lower areas.

We hypothesized that the deterioration was caused by fluctuations in humidity, pollutants from the gas jets, and moisture that may have collected in the past at the base of the dome. Documentation indicated that the condition of the dome and the interior climate of the Rotunda had been unstable from the beginning. As early as 1870, the dome required constant maintenance to prevent corrosion and leaks.[5] Until approximately 1940, when the clerestory was sealed during the installation of air conditioning, the base of the dome remained open, exposing the fresco, especially its lower registers, to extreme changes in temperature and humidity. During the conservation project, temperature and humidity were monitored and found to be generally stable, thanks to the air conditioning.

During the conservation treatment, we analyzed Brumidi's working methods by recording and studying the *giornate* that we identified (fig. 14–9). Brumidi transferred his full-size cartoons to the wet plaster by incising the outlines of the figures. As in the frieze, many holes from the tacks or nails he used to hold the paper can still be seen at close range. In some areas, we could tell by the way the plaster overlapped which section was done first. A fresco painter logically begins at the top of the composition and works to the bottom to avoid damage to and drips on finished sections. Brumidi started near the apex of the canopy, above the face of George Washington. At first his *giornate* were small and consistent, with divisions occurring right at the figures so that he had adequate time to paint all of the details while the plaster was still curing. At the lower edge of the canopy, as the figures themselves became larger, and, perhaps in a rush to finish, the *giornate* became larger, the quality of the drawing and painting broader and less detailed. The poor adhesion of the pigment could have been caused by the plaster having cured too much before it was applied. Brumidi's technique of transferring his cartoons also changed from incisions to pounces.

The central circular section of plaster at the apex appears to have been inserted after the surrounding areas were completed; it overlaps the other sections with ragged edges, and its color does not exactly match the adjacent areas. One of the last *giornate* reworked outlines a figure removed from the grouping of "Commerce," now known to have been a portrait of Montgomery C. Meigs. At Meigs's request, his face was partially scraped off and painted over, but its location is still slightly visible. Brumidi signed and dated the fresco 1865 at the bottom of this group (see fig. 9–19).

The many dark lines around the *giornate* appeared inconsistent with what we knew of the fresco tradition and of Brumidi's other work. Typically, it would be the artist's intent to have the joins between *giornate* appear

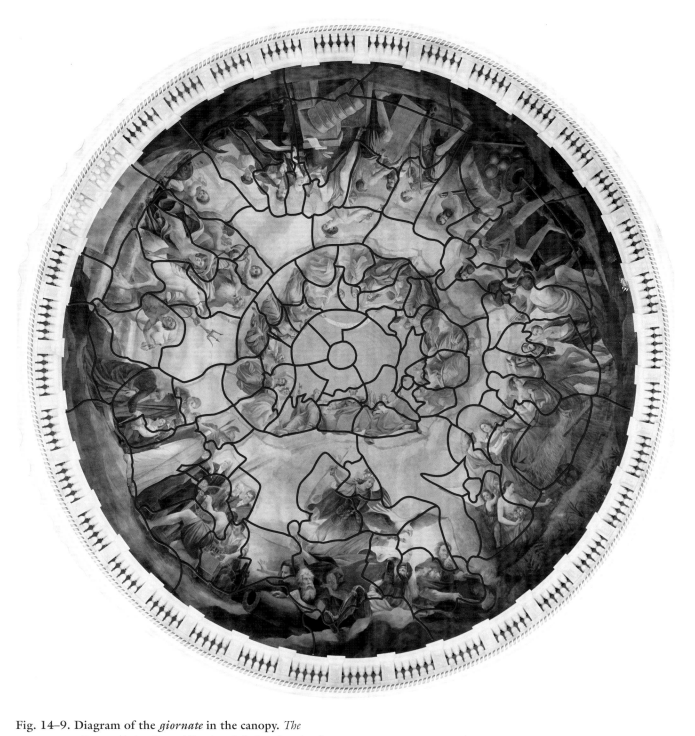

Fig. 14–9. Diagram of the *giornate* in the canopy. *The conservators discovered that Brumidi painted the* Apotheosis of Washington *on 120 sections of plaster.*

invisible. Before the treatment began, archival research was undertaken to compile graphic and written records that might provide evidence of Brumidi's original intentions for the fresco and of its appearance as actually painted. This research encompassed the artist's original oil sketches, correspondence, and reports (as described in chapters 9 and 10). We also relied on maintenance

records for the Capitol and Allyn Cox's report on his work in 1959.[6]

Brumidi's final oil sketch (see fig. 10–5) shows that he intended an expansive atmospheric sky at the top of the canopy. Archival photographs from 1866, 1881, and 1904 confirm his fidelity to this design, although some dark lines at the *giornate*, especially in the central sky,

Fig. 14–10. Brumidi's hatch marks. *The artist tried to reduce the prominence of some of the joins by scratching lines across them in the plaster.* Photo: Rabin & Krueger.

were already evident in the earliest photograph (see fig. 9–14). During the treatment, we observed that Brumidi attempted to tone or blend the lines between *giornate* in some places (fig. 14–10). In other places, he may have channeled the joins out in preparation for filing them later. These observations are consistent with the artist's letters and the Architect of the Capitol's annual reports, which reveal that Brumidi intended the *giornate* to be invisible and that he planned to blend them further.

Brumidi wrote on September 19, 1865, to Architect of the Capitol Edward Clark:

> . . . I am working at present the last group, and for the next week I have finish to put in color every figure upon the fresh mortar.

> That remain to do for the completion of it will require only five, or six weeks, but must do it in the proper time, when the mortar will be perfectly dry, and the colors do not any more changement.

This last work will cover the connections of the pieces of plaster, put up in sections at every day, and giving more union to the colors at the said junctions, for obtain the artistic effect.

> It is general rule in doing this kind of work to avoid the damp atmosfere [*sic*] of the winter season, but I will do this last finish as soon as the weather will permit, early in the spring, as alway [*sic*] I have done in every other painting in real fresco in the Capitol, and everywere [*sic*].[7]

Two entries from the annual reports of the Architect, one year apart, further confirm Brumidi's intention to minimize the visibility of the joins between the *giornate*:

> (1865) The picture over the eye of the dome is all painted in, but the artist is unwilling to have the scaffolding removed until the plastering is thoroughly dry, and the picture toned. As it will be at times viewed by

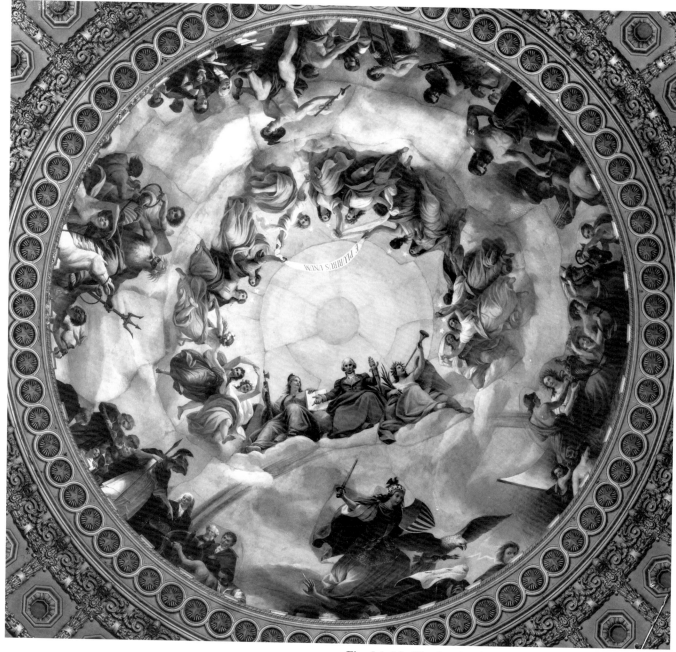

Fig. 14–11. *The Apotheosis* at the turn of the century. *Over time, grime accumulating in the joins made the* giornate *more prominent*. Photo: Detroit Photographic Co., 1904.

gas-light, he wishes to have the opportunity of trying it by this light before dismissing it from his hands.[8]

(1866) Although the fresco picture over the eye of the dome has been exposed to view by taking away the scaffolding, it is not finished, as the artist intends to soften down the harshness at the joinings of the plastering. He was under the impression that these imperfections would disappear when the surface became dry. He holds himself in readiness to do the proper toning and blending whenever the scaffolding is in place for the painting of the vault of the rotundo.[9]

As explained in chapter 9, Brumidi was never provided a scaffold in order to do this work. By 1904, the *giornate* had become even more visible throughout the fresco (fig. 14–11). Photographs taken after the 1959 restoration offer a radically changed image. The *giornate* lines in the central sky had been painted out, thus appearing lighter at first, but they subsequently darkened even more with time. In addition, a sun, darker yellow than the sky, occupied the apex (fig. 14–12).

The archival and visual evidence clearly showed that Brumidi did not intend the *giornate* to be dark and ob-

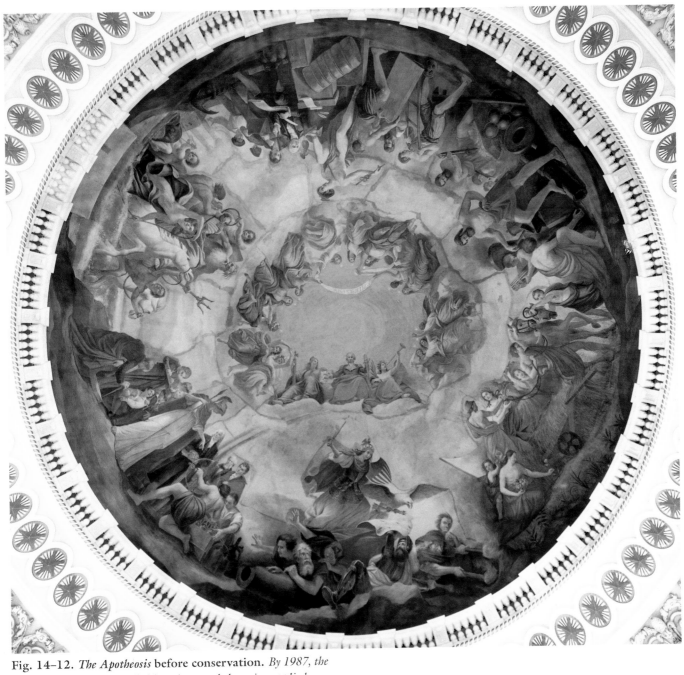

Fig. 14–12. *The Apotheosis* **before conservation.** *By 1987, the forms and colors were dulled by grime, and the paint applied between the* giornate *in 1959 had darkened and become extremely disfiguring.*

trusive. High-magnification examination of samples taken from the dark joins between the *giornate* provided further confirmation. They showed four distinct layers: the *intonaco*, Brumidi's frescoed pigment layer, Brumidi's retouching, and Cox's 1959 overpaint.[10]

Allyn Cox was a muralist, not a trained conservator. He did what many painters do best, and that is to paint. No professional guidelines for conservation existed in his time. By today's standards he repainted much more than was necessary, covering large areas of undamaged original surface. He believed it was not safe to clean the fresco, and his

colors were mixed to match those darkened by grime. Where he found Brumidi's paint to be flaking and the plaster in the central section friable, Cox brushed off the loose material and repainted areas as he thought best, evidently without reference to archival photographs. Fortunately, the overpaint he used was water soluble, rather than oil-based, and he left a detailed written report of the steps he took.

As we have seen, tests showed that the plaster remained perfectly adhered to the structure of the canopy, but Brumidi's pigments were not adhered in some places, a condition not normally found on true frescoes.

197

An important question to resolve was the medium, if any, in which Brumidi mixed pigments he applied *a secco*, that is, after the plaster was dry, which would be more fragile than the true fresco. To answer this question, nine microsamples of the layers of *intonaco* and paint were examined by autofluorescent staining to test for the presence of proteins, carbohydrates, and oils. Unfortunately, because much of the original fresco had been sprayed with a casein and lime mixture by Cox in 1959, the samples showed evidence of protein: casein is derived from milk. It was therefore difficult to draw firm conclusions about Brumidi's medium.

There were, however, two significant findings. First, flaking green paint from one figure untouched in 1959 showed no evidence of any organic media, suggesting that Brumidi did not paint any major areas *a secco*. In this case, the flaking surface appeared to be due to an inherent flaw in the fresco technique, possibly because of the use of an unstable, clay-containing pigment. Second, Brumidi's paint on the joins between the *giornate* gave a positive test for protein that was distinctly different in comparison with that for the 1959 overpaint. This is a strong indication that Brumidi toned at least some of the joins *a secco*, that is, with an organic binder.

Pigment analysis confirmed Brumidi's traditional fresco palette of earth colors, largely based on hematite, ocher, and terre verte, with anhydrite white. The blue is ultramarine, presumably synthetic. The analysis also revealed in some samples titanium white, a pigment that was not commercially available until about 1920, thus clear evidence of areas repainted by Cox in 1959.

Finally, we analyzed the pollutants from the ring of gas jets, which, combined with moisture, would have been particularly damaging. The coal gas released large amounts of particulate matter and incompletely burned hydrocarbons, which were deposited as a thick and tenacious blue-gray soot on the fresco similar to that found on the frieze below.[11] Sulfur oxides, produced by the combustion of most hydrocarbon fuels, can produce sulfuric acid in the presence of water, such as condensation. The resulting sulfuric acid will react with the plaster, weakening it.[12]

Fig. 14–13. Area where loose plaster had been brushed off. *The conservators found numerous areas, especially in the brown and green drapery, where little original pigment remained, leaving white plaster.* Photo: Rubin & Krueger.

Armed with these data, we developed a course of treatment. Fragile surface areas were consolidated. The disfiguring surface grime and sooty deposit were removed with a diluted solution of ammonium bicarbonate after several cleaning tests were carried out.[13] Then Cox's 1959 overpaint, which had matched the uncleaned fresco, was removed with dampened natural sponges. However, it could not be cleaned off in areas where removal would damage Brumidi's surviving original paint. The restoration also in-

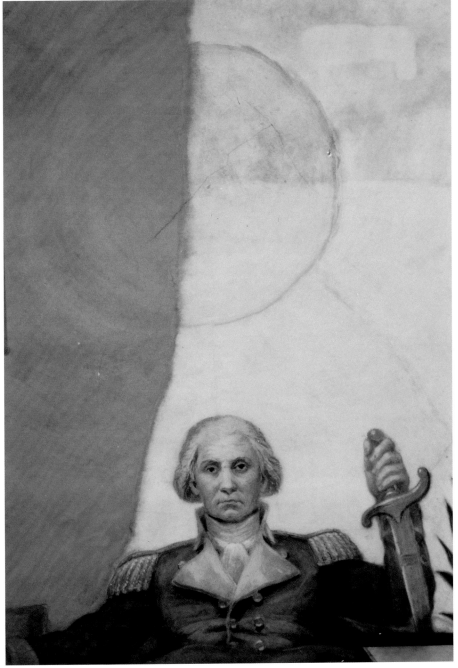

Fig. 14–14. Apex of the canopy in various stages of cleaning. *The surface of the fresco was cleaned as many as three times in order to gently remove various types of grime and overpaint. Here, the false sun is partially removed.*

Most areas were cleaned at least three times. One of the most dramatic moments of treatment was the removal of the sun that Cox had mistakenly created at the apex of the canopy. As we removed the dirt, the water-soluble dark yellow overpaint came away as well (fig. 14–14). It was startling to have the sun disappear. Our consultant, Paolo Mora, who was certain that Brumidi's first section of plaster at the apex of the dome had been entirely misinterpreted in the 1959 restoration, looked up and exclaimed, "Ah! At last we see the true sky." There is always a thrill of discovery when a conservator uncovers the original intent of the artist.

With guidance from archival photographs, the damaged areas were inpainted with watercolors (see fig. 14–1). Where passages of original color proved water-soluble, they were reintegrated with colored artist's chalk, which could be easily removed if necessary but which blended well with the fresco. Harmonizing the monumental figures, which measure up to 16 feet in height, required that we step back frequently to gain perspective on our work. We noticed that Brumidi slightly elongated the lower part of his figures so that they would look in proper proportion when viewed from below. Each area, and indeed each figure, had different conservation problems. Some figures, such as Washington, were almost perfectly intact. Other areas, such as Victory/Fame's green drapery, were intact but fragile and could not be completely cleaned. Where removal of the overpaint was not possible in the most damaged areas, it was retouched with materials that can be clearly distinguished from the original and easily removed in the future.[14]

Visual reintegration was the most challenging problem of this conservation project because so many figures had been seriously damaged and inaccurately reconstructed during the 1959 treatment. Brumidi himself inadvertently complicated our problems because he often deviated from his own incised outlines during the actual painting of the figures. Consequently, pre-1959 photographs, especially a set located in the photo archives of

volved careful cleaning of the fragments of original surface in the most damaged areas, which provided the key to Brumidi's original colors for the inpainting of these areas of loss (fig. 14–13). When confronted with Cox's overpaint of the fragile Brumidi color beneath, we had to search creatively for a successful cleaning method. By first applying mineral spirits to the affected areas and then delicately removing the overpaint with water, we were able to preserve Brumidi's original work.

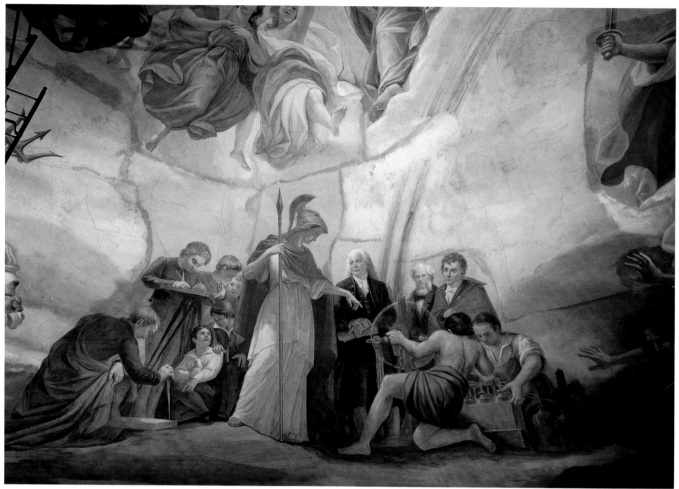

Fig. 14–15. "Science" before conservation. *The legibility, three–dimensionality, and beauty of each scene were marred by dark grime, the darkened overpaint outlining the* giornate, *and stiffly repainted drapery.*

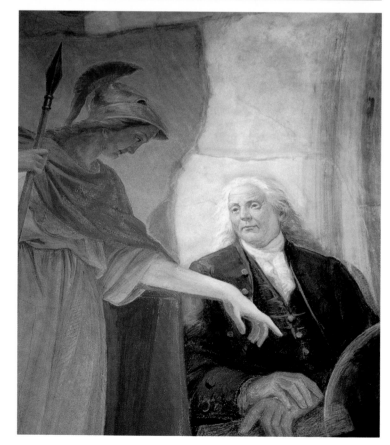

Fig. 14–16. "Science" during conservation. *Cleaning, mainly with water, revealed Brumidi's vibrant colors, especially in the delicately painted rainbow. The contrast with the uncleaned areas, at left, was striking.*

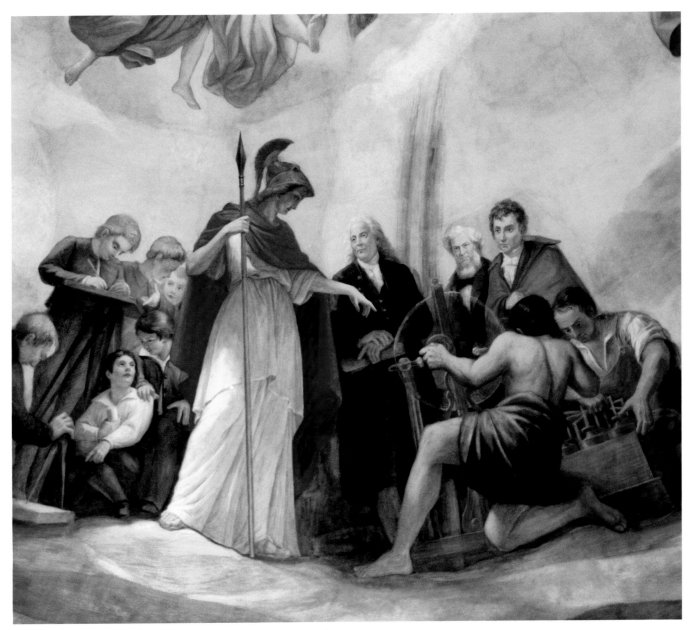

Fig. 14–17. "Science" after conservation. *The figures seemed to come alive after treatment, when the entire fresco regained its clarity and harmony.*

the National Geographic Society, were invaluable for the visual reintegration of damaged figures.

As the cleaning progressed, we no longer saw dark gray skies and muddy colors (fig. 14–15). The fresco became luminous and bright, section by section, layer by layer (fig. 14–16). Even after inpainting damaged areas, the lines between the *giornate* remained aesthetically distracting. However, extensive overpainting of an artist's original work, even to cover up his original mistakes and difficulties, is not an ethical solution. Working with Architect of the Capitol George White and Curator Barbara Wolanin, we arrived at a balanced approach. Mr. White suggested we retain the physical evidence of the *giornate*

while reducing the amount of contrast. To achieve this end, the joins in the light sky areas were slightly blanched and blended with chalk. As a result, the fresco can be read as a whole, as Brumidi intended (fig. 14–17).

Until the scaffold was removed and the fresco viewed under normal light conditions, we could not be sure that the retouched and repaired areas would be invisible. To our gratification, our treatment was successful, and we were thrilled to see the integrity of the composition was restored, from the grandeur of the entire composition (see frontispiece) to the mastery evident in the individual bold brush strokes (fig. 14–18).

Fig. 14–18. Detail of "Science." *A close-up view of the cleaned fresco leads to an appreciation of the varied types of hatched strokes Brumidi used to enhance the sense of space and three-dimensional forms.*

Notes to Chapter 14

1. The analysis was carried out by McCrone Associates in 1986.

2. A vivid description of the gaslight system is provided by Dr. John B. Ellis, in *The Sights and Secrets of the National Capitol* (Chicago: Jones, Junkin & Co., 1869), p. 77:

> Descending as we came, we pause in the gallery under the fresco to notice the ingenious arrangements of the gas-lights. Four hundred and twenty-five burners are arranged in a circle around the base of the canopy, at distances of one inch apart, and over each one passes an incombustible wire connected with an electrical battery placed between the outer and inner shells of the dome, near the stairway, on our right as we go down. . . . A pressure on one of the knobs opens a valve, and allows the gas to flow up to the burners, and a touch upon an adjoining knob causes an electric current to flash along the copper wire over the burners, and in an instant the whole dome is a blaze of light. The effect of this illumination is very fine. The light falls brightly over every object, and when seen from without the dome seems almost on fire.

3. The sample contained two hair-like fibers, apparently horsehair, and the chaff of grain.

4. X-ray diffraction analyses were carried out by Gregory Cavallo, American Museum of Natural History, New York City, June 1987.

5. "Such painting as was necessary to keep the joints tight and prevent corrosion has been done, and the inner portion kept clean by laborers paid out of the appropriations for repairs. Some comments have been made on the continual expenditures of money to keep in repair a dome made of such indestructible material as iron, but when the expansion and contraction of that material, between heat and cold, is considered, it may be easily understood why constant care and watchfulness is necessary." 1870, AOC/AR, p. 5.

6. Allyn Cox, "Technical Report on the Condition of the Canopy Fresco in the Rotunda of the National Capitol, and the Restoration Work Carried out there in 1959." July 14, 1959, AOC/CO.

7. CB to Edward Clark, September 19, 1865, AOC/CO.

8. *Annual Report, Architect of the Capitol Extension*, November 1, 1865, p. 5.

9. Ibid., November 1, 1866, p. 2–3.

10. The stratigraphy of the dark joins of the *giornate* was studied by the highly sensitive techniques of scanning electron microscopy (SEM) and energy dispersive x-ray spectroscopy (EDS). The analyses were carried out by Dr. Robert Koestler in August 1987.

The elements detected in each layer were as follows: (1) *intonaco*: Ca, S, Si, Fe (each less than 5%), Mg (less than 1%); (2) Brumidi pigment layer: Si, Ca, S, Fe (each less than 5%), Ti (contamination from Cox overpaint); (3) Brumidi's retouching: Ca, S, Si, Mg (each less than 5%); (4) Cox's overpaint: Ca, S, Ti, Mg, Si (each less than 5%), Fe (less than 1%).

11. Color infrared photographs of the surface following cleaning tests provided some indication of the concentration of sooty accretions that had become fixed on the fresco. Scanning electron microphotographs of small samples from the same areas before and after cleaning revealed the nature of the surface accretion, small particulate matter that is consistent with sooty pollution. Most of this accretion was removed during the 1987–1988 conservation project. Analyses were carried out by Dr. Robert Koestler in August 1987.

12. The corrosive action of sulfuric acid on calcium carbonate (lime) materials, such as plaster, produces gypsum (calcium sulfate dihydrate). Gypsum is a soft and water-sensitive material; when found in this manner, it reduces the cohesive strength of the plaster.

13. Fragile areas were consolidated with a brushed application of a 5 percent solution of Acryloid B 72 in toluene. AB 57, which contains both sodium bicarbonate and ammonium bicarbonate, is a standard cleaning agent for frescoes. However, during tests on the canopy, it acted too energetically. The ammonium bicarbonate component provided effective cleaning with controllable action.

14. The unstable and overpainted figures presented several difficulties. The 1959 overpaint could not be left visible because the colors no longer matched the cleaned adjacent areas of the fresco. However, the overpaint had become tenaciously attached to and embedded in unstable paint and *intonaco*. Thus, separation of the overpaint from the original, without causing further damage to surviving original paint, remained a constant and difficult problem.

These areas of unstable and overpainted original paint were treated by brushing them with mineral spirits, followed by an application of water and/or a dilute solution of ammonium bicarbonate. The mineral spirits provided a semi-impervious layer over the original paint, protecting the original while the overpaint was removed. The mineral spirits evaporated out of the fabric of the fresco. However, in most areas some overpaint was left on the surface, to avoid further abrasion of the surviving original paint. The overpaint was visually reintegrated with reversible watercolors and artist's chalk.

In the most damaged and unstable areas, most of the overpaint was left intact, gently cleaned with a sable brush and Wishab sponge, and visually reintegrated.

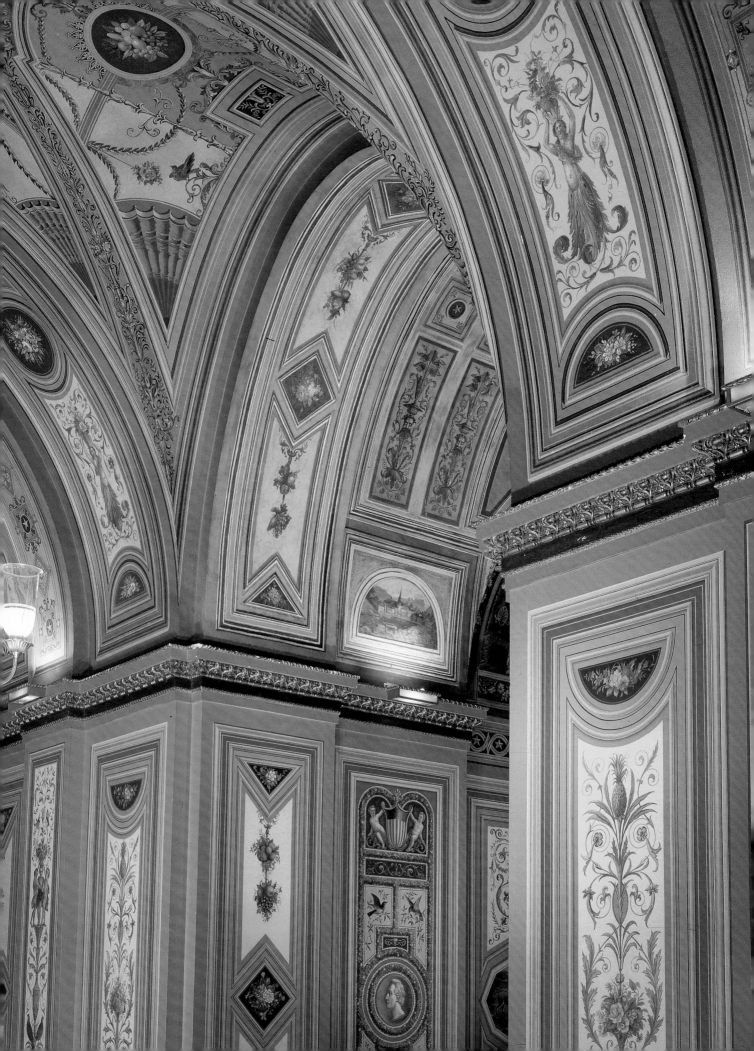

CHAPTER 15

The Process of Change
in the Brumidi Corridors

CHRISTIANA CUNNINGHAM-ADAMS AND GEORGE W. ADAMS

Fig. 15–2. Test removal of overpaint. *In comparison with the overpainted areas, the original painting is higher in quality, with the details of the black-headed grosbeak and vine delicately and accurately painted on a white background.*
Photo: Cunningham-Adams.

The ornate decoration of the Brumidi Corridors has long dazzled visitors in its sheer complexity. The variety of motifs and the masterly compositions are tributes to Brumidi's skill and experience as an artist, historian, and designer (fig. 15–1). Yet, despite the years and highly skilled labor that Brumidi and his assistants devoted to its execution, the decoration that resulted appeared at best only extremely elaborate. We found it puzzling that the high quality of Brumidi's execution technique elsewhere was not evident throughout the corridor decoration, and that close-up, the minute details of the decoration appeared crude and awkwardly painted in muddy and inharmonious colors. The meticulous skill and craftsmanship that might be expected in the painting of such an important decoration were mysteriously absent. In examining and testing many of the painted images very closely, we concluded that the uppermost layer of paint we

were looking at was not the original but extensive inexpert repainting (fig. 15–2). We discussed our suspicions with Barbara Wolanin, Curator for the Architect of the Capitol, and were subsequently contracted by that office in 1993 to undertake a one-year technical study of the corridor decoration.

The 1993 study confirmed that the unsettling qualities that distract from the extraordinary beauty of the Brumidi Corridors are the result of changes made subsequent to their creation (fig. 15–3). We discovered that the original paintings lay essentially intact buried under repainted layers, that they are of extraordinary beauty and executed in a rare and sophisticated technique, and that they can be recovered by removal of the overpaint (fig. 15–4). We arrived at these conclusions by working backwards through time. Beginning with the topmost layer, and analyzing and removing layer by layer until we reached the original, we were able to reconstruct what had happened to the decorations.

Apparently by accident and misunderstanding, the overpaint introduced changes that destroyed both the details and the original sweeping integrity of the design. Other changes in execution medium and lighting compounded the disruption. In the course of our study of the corridors, we used techniques such as laboratory analysis

Fig. 15–1. Main Corridor at North Entry before conservation of the walls. *Over time, repainting of the walls obscured the light backgrounds, vivid colors, and delicate details, and the harmony with the ceiling vaults was lost.*

Photo: Cunningham-Adams.

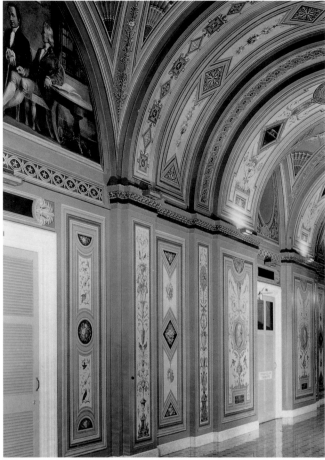

Fig. 15–3. Section of the North Corridor. *Overpainting over the years darkened and coarsened the original decoration of the walls, leaving the borders a murky green and the background fields yellow.*

Photo: Cunningham-Adams.

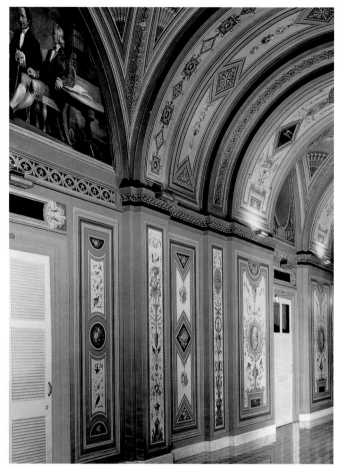

Fig. 15–4. Section of the North Corridor with computer enhancement. *A computer-generated image predicts the appearance of the corridor when returned to its original colors. Note the airiness of the light panel backgrounds, the suggestion of stone structure in the walls, and the visual unity of wall and ceiling.*

Photo: Cunningham-Adams.

of execution medium and pigment types; infrared and ultraviolet fluorescence photography; reflectance spectrophotometry; archival research, including photographs preserved in the Curator's Office; and long and frequent discussions with Capitol personnel familiar with the recent maintenance of the building. But the most important tools were frequent reflection on, and discussion of, the import of each new clue we found. The windows we opened through the overpaint at carefully selected sites confirmed, in context, the hypotheses we were continually refining. Our study also revealed a great deal about the process of change, which proved to be a coherent tale in which each little step was reasonable by itself, but which led more or less steadily away from the original scheme at a quickening pace.

At the curator's request, we devised a restoration plan that will restore the corridors' original aesthetic character and safeguard them from future transformation through the use of techniques such as reflectance spectrophotometry. The restoration plan was approved by Congress, and

the ten-year project was begun with a pilot phase funded for 1996. In the initial phase of the project, the large sections of original surface that were uncovered fulfilled the promise of our research (fig. 15–5) and provided the final confirmation of our hypothesis of the process of change. The metamorphosis we had slowly unraveled proved to be an exemplary case study of the gradual transformation sometimes imposed on a work of art that can camouflage the artist's intent and take the art out of its proper place in time and art history.

Change in Palette

The process of change in the Brumidi corridors started with a shift of palette toward yellow and brown. It is apparent that since they were originally painted between 1857 and 1859, the wall paintings, which are the most vulnerable to constant damage, have been worked on many times. In addition to the repair of numerous

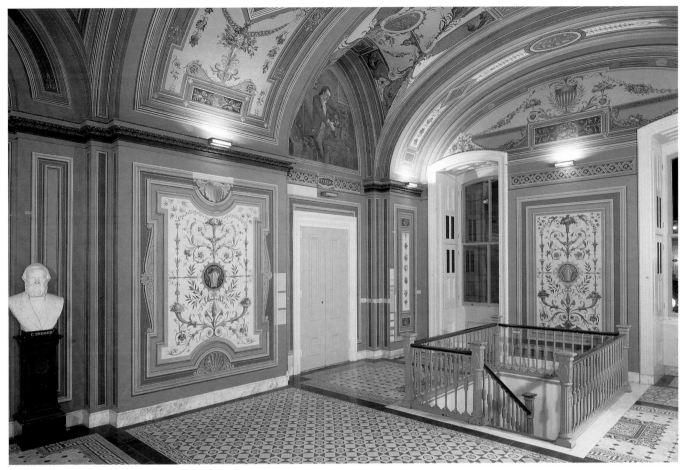

Fig. 15–5. Patent Corridor with two conserved panels.
Exposure of the first large sections of original paint layers in the initial phase of the corridor restoration produced bright, limpid colors that dramatically contrast with the untreated panel to the right.

Photo: Cunningham-Adams.

scratches, nicks, and gouges, it appears that approximately every twenty years, instead of being cleaned of accumulated dirt, the murals were repainted to freshen them up. With newly dirtied colors matched in each new repainting, the palette gradually darkened. Brumidi's own restoration of the wall paintings in 1861 may have been the first of the six major restoration treatments we identified. In the first two treatments, the paintings were retouched in color, technique, and style very similar to those of the original. As time distanced restorers from the original execution, however, understanding of the original intent was lost and distortions were introduced. With time, the drift accelerated as the two important constraints against change were diminished. One was memory of the original scheme, which faded with time and changes in personnel. The other constraint lost was the understanding of the harmony and traditional meaning of the entire original classical scheme. As the colors of the walls were shifted away from the colors of the ceilings toward darker browns, the original relationship between the

walls and ceilings became obscured. Because of discolored varnish and/or changes in taste, green was introduced into the wall panel surrounds, further weakening this unity and increasing the likelihood of further change. By the 1960s, the unity of the corridors had been so obscured that a new lighting system was designed to illuminate the ceilings as separate visual entities from the walls, creating a sharp division at the top of the cornice molding. Not long after that, the cornice molding was painted with darker colors to match the walls.

The change in the walls is far greater than the change in the ceilings, because the walls were more subject to damage and thus were more frequently overpainted. However, although the ceilings have only a thin layer of overpaint, and some original work remains visible, the color of the overpaint was chosen to match discolored varnish on the walls, so that the overall palette of the ceilings is also substantially altered.

The history of this evolution can be seen in the paint stratigraphy. The *scala* (a graduated exposure revealing the

207

Fig. 15–6. Test window showing the gradual color shift in overpaint. *This* scala *through layers of overpaint at the edge of the trompe l'oeil molding shows nine major paint layers. They shift from the lowest, original, layer of stony light gray to muddy green.*
Photo: Cunningham-Adams.

paint layers step by step) (fig. 15–6) confirms what one would expect: there was no sudden, dramatic change of color, but rather a gradual process of drift, which varied in different areas. For example, in the northern end of the Main Corridor, the wall panel surrounds are presently a chocolate color. Visually, this region now seems utterly unconnected to the adjacent North Corridor, but it originally had the same colors as the North and West Corridors.

The colors found in the original decorations (such as the Pompeian red and sapphire blue) are, not surprisingly, the same as those found in the ancient Roman murals that inspired Brumidi, and they are also found in the Minton floor tiles. The light gray borders of the wall panels originally suggested carved stone moldings. As the palette drifted, it lost its meaning within the traditional decorative vocabulary. For example, the original blue fields have become dark green, through the yellowing of varnish over time or from repainting to match the yellowed varnish, effectively disconnecting these areas visually from the blue in the floor tiles, and the light gray borders have become pea green.

Yellow overpainting in the panel background fields encroached on the outlines of the birds and animals, obscuring their original accurate details. In some areas, the figures have been completely repainted.

Execution Techniques

Brumidi's original choice of execution technique was just as important to his intended effect as his choice of colors. Our study showed that he chose three particular techniques to create the combined effect he desired in the corridors. Each was selected for the texture, color absorption, and reflectance it would produce, and for its effect in concert with the other two techniques. The concealment of these effects with overpainting had done much to reduce the decoration's original quality.

Brumidi used primarily three different execution techniques on the walls and ceilings in the Senate corridors. First, the lunettes that Brumidi painted himself were executed in *buon fresco*, in which pigments moistened with water are applied to wet mortar and become incorporated

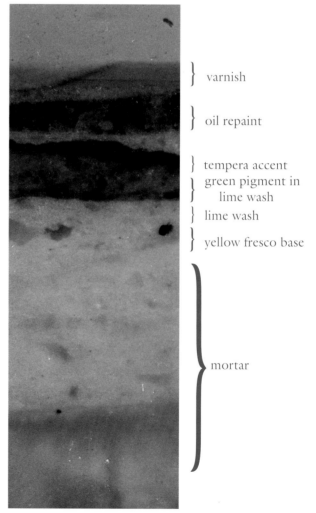

varnish

oil repaint

tempera accent
green pigment in
 lime wash
lime wash
yellow fresco base

mortar

Fig. 15–7. Sample taken from a panel detail seen through a microscope. *This photomicrograph shows the layers of mortar, lime wash fresco, and accent color, surmounted by several layers of repaint and heavy, yellow-tinted varnish.*
Photo: Ulderico Santa Maria and Cooperativa Punta Terra.

in the mortar as it cures, leaving the texture of the rough mortar visible. The corridor ceilings were executed in tempera, a paint formed of pigments mixed in a water-soluble binding medium such as glue or gum. The surface of the tempera painting has a somewhat chalky, velvet appearance that adds the appearance of depth to the painting and looks similar to fresco from a distance. A third technique we discovered in our study is the relatively rare *fresco in scialbatura*, or lime wash fresco technique. The corridor walls, erroneously thought to have been painted originally in oil, are primarily executed in this fresco technique, in which successive layers of pigment were applied to lime washes brushed onto the surface of fresh mortar (fig. 15–7). The resulting effect is a crystalline structure with the slightly transparent appearance of a smooth, colored stone. The matte surface enhances the illusion of three-dimensionality. In some places, the pale, transparent colors of some details were heightened and intensified by the addition of tempera over the surface of the *fresco in scialbatura*. It is not possible to prove absolutely whether these additions were part of the original painting technique or part of an early restoration.

Since the turn of the century, all of the repainting of the corridor has been done in oil. The effect of this medium, especially when covered by the yellowing varnish applied for protection, is to distort colors and create a high gloss that weakens the effectiveness of the original trompe l'oeil with its softly painted shadows. Heavy layers of varnish further flatten the three-dimensional illusion, which makes some visitors believe they are looking at wallpaper.

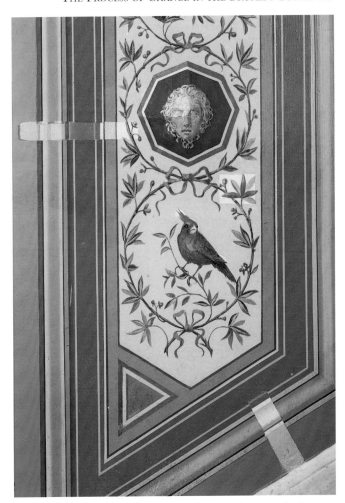

Fig. 15–8. Panel in main corridor with early test windows.
The discovery of the much lighter colors and delicate details showed the value of uncovering Brumidi's original designs.
Photo: Cunningham-Adams.

Stylistic Drift

Finally, a change in painting technique led to a change in style. The original trompe l'oeil was painted freehand, giving it a softness and vitality of appearance that was complementary to the soft texture of the original medium and the soft, limpid colors of the original palette. The trompe l'oeil moldings presently visible, however, have largely been painted with edge guides or with masking tape. Although the difference is subtle, the effect is great. The human eye is very sensitive to sharp lines, and the sharp lines of the present trompe l'oeil distract the eye and weaken the appearance of the other decoration. At the same time, the delicate shading used to create the illusion of depth in the original trompe l'oeil has been coarsened, partly as an inevitable result of this change in technique. Combined with the effect of the change in medium from lime wash fresco to oil, this coarsening greatly flattened the appearance of the wall. In all of the test windows we opened, a marked shift in the proportions of the trompe l'oeil molding components is visible. Removal of the overpaint in layers revealed that the shift came about gradually, each new layer of overpaint deviating only slightly from the layer before it.

In the course of the changes in palette, medium, and painting technique, the liveliness of the ancient Roman and Renaissance design became leaden, as elements were rigidly replicated without understanding of their original reference and so were robbed of their original decorative spirit. The magnitude of the changes that have occurred over the years can be directly seen by comparing the present appearance with the original work that lies beneath (fig. 15–8). The process of change began as the white (now yellow) central field was repainted, at first with some pains to avoid overpainting the decorative flora and fauna. But here and there, the overpaint encroached onto the detail so that, over time, overpainting of the entire decorative element became necessary.

Fig. 15–9. Comparison of overpainted acanthus leaves. *In the corridors, the acanthus leaves range from three-dimensional forms that appear to be growing (left) to crude and flat outlines resulting from heavy-handed overpainting.*
Photo: Cunningham-Adams.

On the overpainted surfaces, the stylistic drift can be seen in samples of acanthus, which appear frequently in the corridors. The drift is so conspicuous throughout the Senate wing that the painted acanthus leaves can be used as an indicator of the amount of change that has occurred in any section of the hallways since that section was first painted (fig. 15–9).

A study of the birds of the Brumidi Corridors also offers insight into changes in the decorative scheme because each was intended to portray accurately a creature whose actual appearance is known to us. The birds obviously were painted with skill and with the intent to be faithful to nature; therefore, even though painted by different hands and at different times, they can be used to measure the degree of stylistic change. The corridors can be seen as an ecosystem in which the natural processes of evolution, interbreeding, and genetic leaps remain active as a result of overpainting. Generally the birds show a tendency toward the appearance of their corridor neighbors, as if by cross-species interbreeding; natural forces seem to encourage shrinking and coarsening of appendages and outline; occasionally a grand mutation occurs. Just as DNA divergence forms a measure of evolutionary distance, the divergence of these birds from their natural models forms a good measure of the degree of overpainting that has been applied to them and probably, therefore, to the surrounding decoration (fig. 15–10). In the first phase of the restoration in 1996, panels decorated with daisies and roses were restored to reveal a wide variety of more colorful flowers such as hydrangea, poppies, hibiscus, and morning glories; the daisies and roses painted over them in the 1930s repainting reflect the American tastes of that period (fig. 15–11).

Fig. 15–10. Varied conditions of overpainted birds. *The original birds of the corridors, such as the blue macaw at left, were painted with the accuracy of good ornithological illustration of the period. In areas subject to damage, birds have "mutated" through repainting. The belted kingfisher, for example, has lost its distinctive crest and gained a sparrow's tail.*

Photo: Cunningham-Adams.

Fig. 15–11. Details of floral panel before and after conservation. *The heavy oil overpainting of the uppermost layer (left) showed stiff, leaden flowers of unspecific character. Underneath them were found delicate and brilliant morning glories, poppies, and hibiscus (right) on the original paint layer, which needed only minor repair.*

Photo: Cunningham-Adams.

Lighting

In the course of time, at least two major renovations of the corridor lighting system were made. The first was the introduction of electric lighting; the second was a renovation of the electrical system the 1960s, a period when reflected lighting was gaining popularity. These changes were undoubtedly necessary, and they achieved appropriate overall light levels. But they brought with them some unfortunate results—in particular, a large imbalance between the illumination of the ceiling and the illumination of the walls (fig. 15–12). This imbalance severely disrupts the original visual unity of the ceilings and walls and makes the cornice a harsh dividing line between the surfaces, compounding the effect of the changes in palette and execution medium on the walls.

This imbalance was almost certainly not present with the original gas lighting system. When it was replaced with electric lighting, the fixtures on the cornices of the Patent, North, and West Corridors were simply bare bulbs in pairs and triplets at an angle above the horizontal. Although not aesthetically desirable, such fixtures would have resulted in fairly even distribution of light in a transverse vertical plane and much less contrast between the walls and ceilings, as confirmed by photographs from the 1950s.

Before the present fixtures were installed in the 1960s, the Central Corridor was lit with small glass globes at the groins. Although this lighting system had a number of disadvantages compared to the present system, it is interesting to note how clean the vista appears in early photos without the disruption of the present chandeliers.

Conclusion

The study of the corridors strengthened our belief in some philosophical precepts in conservation analysis of wall paintings. One is trust that the artist will have considered and incorporated all the elements of the environment in his design, so that lighting and execution medium are as important to the final effect as subject matter or palette. Each element in a complex such as the Brumidi Corridors must be examined in light of an understanding of the whole. Conservation and historical judgments cannot be made on the basis of personal or contemporary taste. One must trust that the original was aesthetically satisfying. We began the study with respect for Brumidi and an expectation of finding excellence. We were surprised only that the genius and integrity of the corridor design were so much greater even than we expected, and that so many new riches can continually be found in his work.

Fig. 15–12. Effect of modern lighting. *The light reflecting ten times brighter on the ceiling of the corridors than on the walls exaggerates the visual separation of the two elements.*

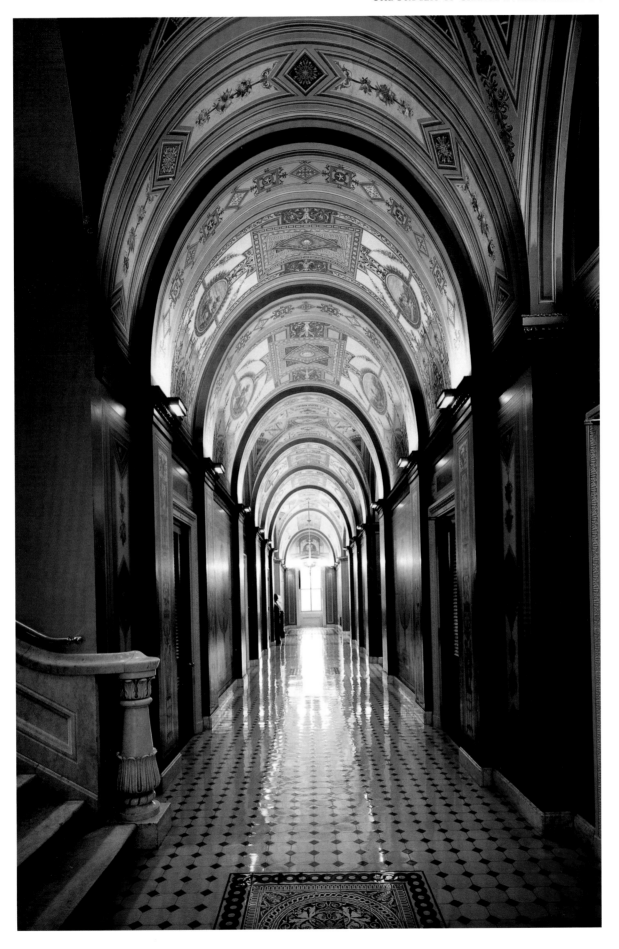

APPENDIX A:

Brumidi's First Fresco

Fig. A–1. Diagram of *giornate* in *Calling of Cincinnatus from the Plow*. Lines indicate divisions between the sections of mortar. The numbers indicate the order in which Brumidi painted the sections; they are keyed to the descriptions from Meigs's journal.

Patches indicating corrections

Edges of *giornate*

Conservators' Introduction

BERNARD RABIN AND CONSTANCE S. SILVER

The description of Brumidi at work in the room for the House Committee on Agriculture (H–144), recently discovered in the transcription of Montgomery C. Meigs's private journal, appears to be unique in the history of art. Although there have been several "how-to" manuals that explain the step-by-step execution of a fresco, beginning with the Roman architect Vitruvius, Meigs's journal is the only known eye-witness description of a frescoist actually at work.

For the conservator, the transcriptions bring us close to the artist and make us feel a part of the creative process. Although some of the sections Brumidi chopped out and replaced were evident to us while cleaning the fresco, it was very interesting to learn how many changes he made day by day. The journal entries suggest the conditions of cold and damp under which he had to work; in fact, there was even a danger of the plaster freezing.

Meigs's observations are borne out by what we found on the wall in the configuration of the *giornate* and in the way Brumidi built up his pigments as one would when using oil paint. We learn that Meigs was initially disturbed by how bright the blue was when first applied; Brumidi knew that it would dry to a lighter shade. The journal gives us a very rare account of the dynamic process of creating a fresco, which normally can only be studied as a *fait accompli*.

215

Excerpts from the Journals of Montgomery C. Meigs

The Journals are among the Papers of Montgomery C. Meigs, Manuscript Division, Library of Congress. They were transcribed from archaic Pittman shorthand by William Mohr for the U.S. Senate Bicentennial Commission. These selections describe Meigs's introduction to Brumidi and the execution of the frescoed lunette of *Calling of Cincinnatus from the Plow* in room H–144.

1854

Dec. 28 Mr. Stone stopped today to see me about an Italian painter named—I forget. He has been in Mexico lately, painting a church, is from Rome, which place, like all his countrymen, according to their own account, he left for political reasons. Mr. Stone said he had told him that I could not employ him without seeing anything of his work. And he had offered to paint a small piece if I would give him a room, a piece of fresh wall as a sample of what he could do. After some conversation carried on in bad French on both sides, I gave him the size and shape of the lunette filling the elliptical arch at one end of my office, and he promised to make and send to me a design for an allegorical painting of agriculture, supposing that the room might be occupied by the Committee on Agriculture at some future day. He spoke very confidently of his own skill, said there was no fresco painting in America, only tempera. He said he had a picture to paint for a church and another for a hotel. He said he would be here in March and paint his specimen, but I told him that the determination of these things rested with Congress and that the legislators went away in March, so that if he wished them to see his painting, he had better do it earlier. Upon this, he laughed and said that the church would be there always, Congress would pass, and he would paint this first. He is a lively old man with a very red nose, either from Mexican suns or French brandies. Is an *élève* [pupil] of some Roman academy, knows Crawford, the sculptor. Was employed with many other artists in the decoration of the house of the banker Toroni [Torlonia] in Rome, which he says is very splendid, painted in fresco. There was with him another man, a handsome young man, either French or Italian, I did not understand which, who is a bronze worker. For him, I had nothing. He acted as interpreter for us whenever the painter failed to understand my bad French or I failed to comprehend his, which was about as bad.

1855

Jan. 24 I received a visit also from the fresco painter, Brumidi, who brought his sketch in oil of Cincinnatus at the Plow. It is good and shows skill in drawing and composition and coloring, much greater than I expected. He is to begin it in fresco in about a week, taking a week to make his cartoons full-size.

Jan. 30 I took Mr. Stone today through the workshops. The old gentleman was much interested. He said that I had done 10 years' work since I had been here. I took him to see the cartoon drawing by Mr. Brumidi. He is not much advanced, the cold weather interfering with his colors. He has taken a house on Delaware Avenue, within one square of the Capitol, for his work I sent him today a marble slab to rub his colors upon, and sent a bucket of lime for his white, as the other, he says, froze.

Feb. 12 I went also with Mr. Brumidi, the painter in fresco, to look at his cartoon, which he had finished. I did not think that he had carried out the promise of his sketch. He has not carefully enough studied the figures. They are carelessly drawn and are therefore out of drawing. His priest is too short for his head. One of his warriors is not standing correctly. And there are other faults in the picture more visible where it is drawn in black and white only than in the colored sketch which he worked from. I pointed out some defects, which he did not seem to be quite pleased at my doing. I told him that he would have many critics, as the American painters would all look with jealousy at him and at his works and that they would find all the fault they could.

Feb. 14 Mr. Brumidi came today to make preparations for the painting of his fresco. The first operation is to wet thoroughly for several days the rough coat of plaster upon the wall. This was done twice today. He says that the common sand used in the mortar is as good as any for the final coat of plastering, or "intonaco." I

told Mr. McFarlane to prepare himself by getting the necessary tools to do the plastering for the painter as he goes on with his work.

The lime used in the last coat should be kept a long time in pots; so, soon as the weather gets favorable, I must have a large quantity slacked (slaked) and run into the cellars to be used in our decorated walls.

Feb. 19 Monday. Today Mr. Brumidi began his fresco of 'Cincinnatus Called from the Plow to be Dictator.' I made Mr. McFarlane, the master mason, do the plastering for him. This coat of lime and sand was laid upon a small part, perhaps a yard [square], in the lower left-hand corner of the picture. This was laid and smoothed by common mason's plastering trowel. Brumidi went over it with a broom and water till he got a somewhat roughened surface. The ground of this plaster was laid last summer, and as a hot stove has been burning, with the wind in the room this ground has got very dry. It was well floated when put on, so that the surfaces are quite true and have an advantage over many of the walls in Italy which have fine and indeed great works painted upon them.

After the coat of plaster was ready, Brumidi proceeded to mix his palette very deliberately. He used the common artist colors—terra di siena, umber, ochres, smalt, cobalt. These were all mixed with lime which has been slaked for some days into a paste. This lime, like all his other colors, are kept in pots of various sizes, placed for convenience in a wooden box of about 30″ x 18″ x 9″. Water enough was mixed with that to leave some free water floating at the top of the pot. To make his palette, he takes a spatula and pours out of it every color he wished and pours the lime, mixed that upon a slab of marble to the tint he wanted. The color of the tint changes as it dries, an advantage of the effect. He had a brick upon which he dried his brush from time to time; and as that did not dry quick enough, he afterwards went out and brought in a lump of umber. The tint applied to this seemed, from its powerful absorptive quality, to sink in at once, and the change of color was quite remarkable. I was surprised to see him painting so deliberately and also to see him use his colors with so much impasto. He laid them on, it appeared to me, just as they are used in oil painting. The color did not

seem to sink in as quick as I had expected. I asked him if his sky was not going to be too blue, for he laid it in very thick with some blue, either smalt or cobalt. He said no, that he feared rather that it would prove too light, "troppo chiaro."

He began about 10 1/2 a.m. and continued to paint, with the interval during which he went home to dinner until I left the office at 4 p.m. I left him at work. The part of his picture which he was at work upon is a left-hand corner, which conveys a distant view of some building and the Tiber, with a boat in which the deputation has come to offer an insignia of the dictatorship to Cincinnatus. A man sits upon the stern of the boat, and a fine figure stands upon the gunwale. The sky, when I left it, was as intensely blue as it could well be made by cobalt. I shall look with interest to see the changes which drying will make in its color. The hand and forearm of the moving figure, with a bundle of fasces upon his shoulder, are in the part of the picture which he was painting upon. When I left him, he had merely put the first tint on this hand and arm, and I do not suppose that he touched that again; and he will therefore, I expect, scrape that all the while this morning.

Feb. 20 Brumidi finished yesterday the hand which I thought he would erase. Today he had the outline of the next figure, putting in upon the fresh plaster, or intonaco. He painted, however, only one of them, that to which the hand and arm done yesterday belonged. This figure has some force but is not an important figure in the composition, being in the background. The parts of the work done yesterday begin already to come out with much more force and clearness that they did at first, and they begin also to show spots of irregular color. This is owing to the unequal drying of the mortar. The dark blue sky looks a light cobalt, and the background figures are getting much more visible than they were. For tomorrow, he expects to make the bust and head and body of the next figure, the one leaning upon the fasces. I am surprised to see so much time spent upon the painting. He worked till sunset today without any inconvenience from drying of the intonaco. The work is gone over and over again with the same freedom of retouching and the same thickness of color that

is used in oil painting. In fact, the process seemed to be precisely the same.

Feb. 21 I found that Brumidi had finished the first lictor yesterday, so that this morning he had a piece of plaster put in for the next figure, which is the second lictor. Of this, he only attempted the upper half of the figure, with sky and tree branches above it. This being more in the front of the picture that the other, required a more careful finish, and he completed this part of the painting by sunset. The work has much force, and the part begun first, though now only 3 days old, already begins to show much improvement in clearness and beauty. The mortar seems to set very hard, and it will make a durable wall, and the picture will be as durable as the wall itself.

④

⑤

Many visitors came in to look at the fresco painter, among others Senator Douglas, who came to look at the dome and to show it to a friend. I told him of the painting, and he was delighted to have the opportunity to explain it to his friend, who had seen the frescoes of Rome. He said he was very glad to see that I was going to fresco the walls.

Feb. 22 Washington's Birthday. A busy day for me. Many visitors to look at the fresco painting and the dome.

⑥

The fresco painting gets on rapidly. I found this morning that the lower part of the figure of the second lictor was laid in with the first tints when I reached the office. This figure, I believe, was completed by sunset. I was too much occupied for the last few hours of the day to look at it closely. He included in the part he laid in a foot of the priest. The work thus far looks very strong and forcible.

⑦

Feb. 23 Brumidi today undertook the tree and the head and robe of the armed man in the background, between the priest and the lictor. He said when I left the office at 4 p.m. that he had undertaken too much and would be obliged to content himself with the figure and erase the tree at night, to be painted again tomorrow.

⑧

⑨

Feb. 24 Brumidi has now completed his fresco as far as the priest in white and has made his right foot and the lower part of his dress, which is in shadow. He cut out today the face and part of the 2nd lictor, which did not please him,

⑩

⑪

⑫

and repainted it. A drop or two of water also had trickled in the plaster over the foot which was finished yesterday, and he said he should be obliged to cut that out and repaint it.

Feb. 25 I have stayed at home today in consequence of a cold, which has nearly deprived me of the power to speak at all, caught in the office because of the damp and cold while Brumidi is painting his fresco.

Feb. 27 The fresco begins to show itself much better than it did. The figure of the lictor is coming out in a striking manner. I found this morning that Brumidi had erased all that he painted yesterday. He said that the intonaco dried too fast for him and he did not get it finished. He had painted the white robe of the priest. He painted it all today above the fold which runs from the right foot obliquely up, leaving the shadow part below unpainted. It is well done and looks already very well.

⑩

⑬

March 1 I had many visitors today to look at the dome and at the fresco, both generally admired. The figure of the priest is finished, and today Brumidi put in the upper part of the Senator, who points to Rome and appeals to Cincinnatus to come to the help of this country, with the sky and background belonging to this figure. He painted this with more care than any figure yet, and the head is put in with a delicacy and beauty which has surprised me. It looks like one of Sully's delicately painted heads. The undergarment is finished, the left hand and arm not yet begun. Brumidi said today that after painting in oil for some time, his hand was a little out and first thought he would repaint some of the first parts of the work. After he finishes, he will cut them out and repaint them.

⑭

⑮

March 7 [Congressman Richard H. Stanton] saw the painting of Brumidi, which he has not seen before; for although he has been into Mr. Walter's room, he has not been into mine. He was much delighted with it. Went up to the scaffold.

March 9 Brumidi has now got so far with his picture that today he painted the driver of the oxen. The greater part of the picture is thus finished.

⑯

March 14 Mr. Brumidi has finished his picture, except the head and bust of the boy in the corner.

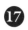

He is waiting for this till I can take Monty as the model for it. Louisa asked him to put him in, and he said that he was a good model and he would make it a portrait. Today was so damp and dark that I did not like to take him to the place. Some little changes will be made in two parts of the picture which were painted first. It was 5 years since he had painted in fresco, and his hand was a little out of practice.

March 15 I took Monty to the office today, and Mr. Brumidi used him as the model to paint the boy in the corner of his picture. He did not make a likeness but only a sketch which is a boy of Monty's character. This completes the picture, except some re-painting which he proposes to do in the first parts of it.

March 16 Fresco painting is now completed, except that Mr. Brumidi today took out the land-scape at the left which he painted the first day, and repainted it. As he began upon Monday, after he works upon the picture in making little repairs, tomorrow it will be just 4 weeks' work all together.

March 17 Mr. Corcoran came with his daughter and another lady to look at the fresco painting today.

March 20 I had this morning a visit from the Secretary of War. He went over the shops and looked at the work. He authorized me to offer to Mr. Brumidi $8 per diem.

March 30 I forgot to mention, by the way, in this book that Brumidi has made a sketch—"skitch," he calls it—for the ceiling of the room in which he has painted the Cincinnatus. He has made a beautiful division of the work and put into the 4 arches the 4 seasons. I think that it will make a very beautiful room when finished.

April 2 I had a visit from Mr. Stanton, Dick, this morning. He came to take another look at the painting of Cincinnatus, which he pro-fesses to admire very highly.

April 7 Miss Noah, with her brother, with some other persons in her train, came today to look at the fresco. I introduced her to Brumidi. Took her to see the dome drawing as it is now. We then went to Brumidi's painting room to look at the cartoons he is making for the ceiling of the committee room of agriculture.

April 18 I went to see the work of Brumidi, and Casali, the former has made and finished the first of the half-size cartoons for the ceiling. He has one other nearly done and a third is begun. I do not think he works as fast as in the first picture.

April 21 Brumidi is at work upon his cartoons.

May 19 [President Pierce and Secretary Davis] had come in for a moment to see me and look at the picture.

May 28 Mr. Huntington, the painter, came to see me and the Capitol. I took him over the work, showed him Brumidi's designs and cartoons, with which he was pleased.

June 6 Mr. Brumidi announced his completion of the cartoons for the room, and I have ordered the scaffold to be put up for him tomorrow.

June 11 The scaffold is up in my room for the purpose of painting the walls, but it seems that some of the plaster has got loosened from the bricks by the driving of nails and plugs for the boards which I had put up to hang specimens upon. So that it will be necessary to take from the wall this part of the plaster. I have con-cluded to change my office into the back room till these paintings are finished.

1856

April 1 I believe I will finish the painting of the agri-cultural room and report it to the depart-ment as ready for occupation. Then let his committees fight for it.

April 11 The painted chamber, the agriculture room, is finished and cleaned out. The key has been sent by the secretary to the Speaker of the House of Representatives. I think that what-ever committee takes possession of it will have a hard time with the public who throng to see it.

July 25 I went today to the committee room to meet the committee on expenditures upon public building, as I had been told by the Chairman, Mr. McMullen, that he intended to call them to conference this day and wished me present. They were called in the room of the Committee on Agriculture, the frescoed chamber. Only two Members, in-cluding the Chairman, assembled, so that as there was no quorum, there was no business

done. The fresco painting, if thought by some extravagant, is evidently popular with the Members.

Sept. 5 I wrote today to the Clerk of the House of Representatives to ask him to cause the person left in charge of the room in the south wing to attend to his duty so far as to keep the room open. So many persons come to look at it from a distance and find it closed that we are annoyed by their complaints.

Brumidi's Assistants and Fellow Painters

The names of these mural painters have been compiled primarily from Capitol Extension time books and other lists made between 1856 and 1861. Spelling variations are found in the ways their names were recorded; the version believed to be correct is listed first, with variants in brackets. Some of the painters worked for only a few months; others were on the payroll for many years. A few, including Emmerich Carstens, Joseph Rakemann, and George Strieby, returned to work at the Capitol later.

Constantino Brumidi was the only artist who worked in true fresco and the only one who painted historical scenes, large allegorical figures, and portraits. The term "fresco" on the lists was used loosely to designate the painters performing the highly skilled mural painting that included small figures, animals, flowers, and other elements. Some of the men listed as "decorative" painters specialized in painting borders, and others also performed gilding or scagliola work. The men listed here were all more highly skilled than the plain wall painters who were also on the payrolls.

The asterisk (*) indicates the painters for whom biographical information has been found; biographical summaries follow this listing.

Aquillon, Alfred	(decorative)
Badger [Bagger], John	(decorative/fresco)
Bakerman, James	(decorative)
*Baumgras [Baumgrass], Peter	(decorative)
Beckert, Adolf	(decorative)
Belshaw, William J.	(fresco)
Bem[?]i, Antoine	(decorative)
Bense, L.O.	(decorative)
Bergman [Bergmann, Berzman], Bernhart	(fresco/decorative)
Biese, Ferdinand	(decorative)
*Bisco, Camillo	(fresco)
Bitalani, G.	(fresco)
Bryen, James O.	(decorative)
Buse, F.	(decorative)
*Carstens, Emmerich	(foreman of decorative painters)
Casadir, Antonio	(decorative)
Columbus, C.J.	(decorative)
Davis, William	(decorative)
Dempf, Antony [Anton]	(fresco)
Fiedler, Otto	(fresco/decorative)
Fontucie, Joseph	(decorative)
*Franze, Louis	(fresco)
Gainor, John F.	(decorative)
Geier, Urban	
Goette [Goethe, Gorthe], Louis [Lewis]	(fresco/decorative)
Harris, James	(fresco)
Herman, Henry	(fresco/decorative)
Hugot [Hergot], V. [Francis]	(decorative/gilding)
Hurdle, Albion	(decorative)
Inasy [Iuice, Imery], Louis [Lewis]	(decorative)
Jack, George	(fresco/decorative)
Keating, John	(decorative)
Knapp, William	(decorative)
Kroger [Kreger, Kreeger], Fritz	(decorative)
Lahayne [Lahayney], Charles	(fresco)
Lahayne [Lahaien], Otto	(decorative)
Lamb, James	(decorative)
Lankau, Leopold	(decorative)
Lecourlee [Lacourli, Lacourbi], Victor [Victa]	(fresco)
*Leslie [Lesley], James	(fresco)
Liemons, Derk	(decorative)
McCoy, Robert	(decorative)
Mercer, Prosper	(decorative)
Michaelson, Ernest	(decorative)
Molinari, E.	(decorative)
Nafflen, Paul	(fresco)
*Odense, Ludwig	(decorative)
*Oertel, Johannes A.	
Oxenham, A.	(fresco)
*Peruchi [Veruchi], Albert	(fresco)

Peters, John E.	(decorative)
Pfant [Plant, Plantz], Nathaniel [Nat, Nath]	(decorative)
*Rakemann [Rakerman, Rakeman], Joseph	(fresco)
Raklert, Herman	(decorative)
Rapp, William	(decorative)
Rastner, Charles	(decorative)
Robetsek, William	(decorative)
Roeth [Roath], Frederick	(fresco/decorative)
Rofsi, Alfonso	(fresco)
Rosenbaum, Ch. [P]	(decorative)
Sack, G.	
Schio [Scio], Peter	(fresco)
Seely, John M.	(decorative)
Shutter, Hurbert	(decorative)
Siemons, Derk R.	(decorative)
Smidt, Peter	(decorative)
Soutucie, Joseph	(decorative)
Springer, William	(decorative)
Stauby [Strauby, Staub], Joseph	(decorative)
*Strieby [Striby], George	(decorative)
Tonesi, Angelo	(decorative)
Trassy, L.	
*Uberti, Joseph	(decorative)
Walslayer, F.	(decorative)
*Walther [Walter], Henry	(decorative)
Weir, Robert	(decorative)
Wullschlager	

Baumgras, Peter, 1827–1904. Born in Germany, he studied at the Royal Academy in Munich and in Dusseldorf. After emigrating to the United States in 1853, he came to Washington, D.C., in 1857. He joined the Washington Art Association and worked and taught in Washington until 1877, when he moved to Illinois.

Bisco, Camillo, dates unknown. Bisco was employed in the Capitol as a "fresco" painter from October 1856 to January 1858. He assisted Brumidi in the decorative or ornamental painting in several important rooms, including the Senate Library ceiling (S–211), the Senate first-floor corridors, and the Senate Naval Affairs Committee room (S–127). In the Senate Military Affairs Committee room (S–128), he painted the borders that framed Brumidi's battle scenes. He was fired because Brumidi told Carstens he had seen him loafing.

Carstens, Emmerich A., 1823–1902. Born and trained in Germany, Carstens came to New York in 1851 and established a successful decorative painting business. In 1854, he was invited by Captain Meigs to become foreman of decorative painters for the Capitol extensions. He accepted the offer in January 1856 and worked until he was fired in 1859 by the new secretary of war. He returned to work at the Capitol from 1861 until 1898. He designed ornamental decoration for rooms such as the Senate Judiciary Committee room (S–126) and supervised the painting in many rooms, including the House and Senate Chambers. In the 1870s, he painted murals in S–118 and the ceiling of the north entry. Carstens also provided decorative designs for the White House, Patent Office, Pension Office, Interior Department, and Smithsonian Institution.

Franze, Louis, dates unknown. Franze was recruited by Brumidi, who had seen his work in New York, and was employed as a "fresco" painter in the Capitol from October 1856 to February 1857. He worked for 156 days with Brumidi in the Agriculture Committee Room (H–144), and he claimed that he had the ability to create his own designs and to execute Brumidi's.

Leslie, James, d. 1860. Apparently trained in England, Leslie was a highly skilled decorative painter and was considered an independent artist. He first approached Meigs in 1855 and began his employment at the Capitol in 1856. Leslie designed and painted the murals in the Committee on Territories room (H–128), trophies in the Senate Committee on Military Affairs room (S–128), the House Post Office ceiling (H–124), and walls and ceilings in the Senate first-floor corridor. Leslie died of typhoid fever in 1860.

Odense, Ludwig, dates unknown. Odense was employed at the Capitol from 1856 to 1862. The German decorative painter worked closely with Brumidi, who came into conflict with Carstens over who had authority to supervise him. Odense worked with Brumidi at Walter's house in Philadelphia in 1863.

Oertel, Johannnes Adam, 1823–1909. Born in Germany and trained at the Polytechnical Institute in Nuremberg, Oertel emigrated to the United States in 1849 and settled in New York. Meigs employed him in January 1857, first asking him to make designs for the Senate Library (S–211) and then assigning him to design the state seals for the glass skylight of the House of Representatives. Oertel resigned in 1858, after discovering Brumidi already painting in S–211 and other rooms. His letter of complaint was published and helped stir up support for an art commission. Later he became a Protestant minister known for his religious painting. He died in Austria.

Peruchi, Alberto, dates unknown. An Italian, he worked as a decorative fresco painter from 1856 to 1862. He assisted Brumidi in the Senate corridors and Senate Post Office (S–211), where he specialized in arabesques as well as small figures. He worked with Brumidi in the Capitol in 1861 and 1862 and at Walter's house in Philadelphia in 1863. Peruchi was included in Brumidi's 1866 estimate to complete the Senate Post Office (S–211).

Joseph Rakemann, 1832–1917. Rakemann was born in Germany and at age 14 was apprenticed to a house painter in a neighboring town. He came to the United States in 1856 and applied for a job as painter at the Capitol, where he worked, specializing in painting flowers, between 1857 and 1861. Rakemann eventually opened his own business, but in 1901, at age 69, he returned to oversee extensive redecoration of the Speaker's Lobby.

George F.W. Strieby, 1841–1908/9. Born in Germany, Strieby emigrated to the United States in 1853. He worked at the Capitol as an apprentice from 1857 to 1859. He later worked alongside Brumidi in the 1870s, becoming a friend, to whom Brumidi left his desk.

Joseph Uberti, dates unknown. A witness for Brumidi when he filed his final naturalization papers, Uberti worked with Brumidi at the Capitol between 1857 and 1858 and at Walter's house in 1863.

Henry Walther, c. 1822–1913. Born in Prussia, Walther worked under Carstens in both the Capitol and the White House from 1857 to 1859. He specialized in flowers and fruit. Walther was a partner in a Washington paint store and later worked at the Smithsonian Institution.

List of Known Works
by Constantino Brumidi

Note: This list includes only works known to have been executed by Brumidi himself. Dates are given where known through documentary evidence. Subjects of murals in each room are listed clockwise starting with the north. "Estate sale" refers to the paintings from the Brumidi Estate sold at Sloan's Art Galleries, Washington, D.C., the week of January 26th, 1925. Information about additional works and current locations is sought and will be added to the database in the Curator's Office, Architect of the Capitol.

Historical/Allegorical Subjects

Murals and Related Sketches

District of Columbia

UNITED STATES CAPITOL

H–117: House Members' Dining Room
(Moved from House Chamber)

Cornwallis Sues for a Cessation of Hostilities Under a Flag of Truce,
 1857 (Fig. 7–3)
Fresco, 7 ft. 11 ½ in. x 10 ft. 10 in.
Signed: "C Brumidi Artist Citizen of the U.S."

Preliminary sketch:
 Cornwallis and Washington
 Formerly collection of Mrs. Ashmun Brown

H–144: House Appropriations Committee Room
(Originally House Agriculture Committee Room)

Ceiling: The Four Seasons (Winter, Spring, Summer, Autumn), 1855,
 (Fig. 5–10)
Fresco with gold leaf

Walls: Relief portrait of Thomas Jefferson with allegorical figures over *Harvesting Grain with a McCormick Reaper* (Fig. 7–7)
Calling of Cincinnatus from the Plow, 1855 (Fig. 5–11)
Signed and dated: "1855/ C. Brumidi"
Relief portrait of George Washington with allegorical figures over *Cutting Grain with a Sickle* (Fig. 5–1)
Calling of Putnam from the Plow to the Revolution (Fig. 5–12)
Fresco

Preliminary sketch:
 Calling of Cincinnatus from the Plow and *Scene with Allegorical Figures,* 1855
 (Fig. 5–8)
 Oil on canvas, 16 x 19 ⅞ in.
 Estate of Edna Wilson Macomb

Rotunda

Canopy: *Apotheosis of Washington*, 1865 (Frontispiece)
Central group (Fig. 9–1)
"Agriculture," "Mechanics," "Commerce," "Marine," "Science," "War" (Figs.
 9–16 to 9–21)
Fresco
Signed and dated: "C Brumidi/1865"

Preliminary Sketches:
 Apotheosis of Washington, c. 1859 (Fig. 10–3)
 Oil on canvas, 24 ⅞ in. diameter
 Athenaeum of Philadelphia

 Apotheosis of Washington, c. 1859 (Fig. 10–4)
 Oil on canvas, 34 in. diameter
 Private collection

 Apotheosis of Washington, c. 1859–1862 (Fig. 10–5)
 Oil on canvas, 35 in. diameter
 Private collection

Frieze: "America and History," "Landing of Columbus," "Cortez and Mon-
 tezuma at Mexican Temple," "Pizzarro going to Peru," "Burial of De Soto,"
 "Captain Smith and Pocahontas," "Landing of the Pilgrims," "William Penn
 and the Indians" (Foldout)

Preliminary Sketch:
 Sketch for the Frieze, 1859 (Figs. 10–10, 10–11, 11–7, 11–8)
 Wash and watercolor on brown paper, 13 in. x 30 ft.; divided during conservation
 Signed and dated: "C. Brumidi 1859"
 Architect of the Capitol, gift of Myrtle Cheney Murdock

Fragments:
 Lewis and Clark (Figs. 10–10, 10–12)
 Wash and watercolor on brown paper, 13 x 19 in.
 Architect of the Capitol, gift of John B. Murdock

 Indians Hunting Buffalo (Fig. 10–10)
 Wash and water color on brown paper, 13 x 14 in.
 Architect of the Capitol, gift of John B. Murdock

 Horse and Buffalo Heads (Fig. 10–10)
 Wash and water color on brown paper, 13 x 15 in.
 Architect of the Capitol, gift of John B. Murdock

 Buffalo Body (Fig. 10–10)
 Wash and water color on brown paper, 9 ¼ x 5 ½ in.
 Architect of the Capitol, gift of John B. Murdock

Brumidi Corridors, First Floor, Senate Wing

North Entry: *Justice Story, Chancellor Kent, Chancellor Livingston*,
 1878 (Fig. 6–19)
Fresco

North Corridor Walls: *Jonathan Trumbull, Silas Deane, Daniel Morgan, Joseph
 Warren, Israel Putnam, Richard Montgomery, Horatio Gates, Thomas Jefferson,
 Thomas Mifflin, Benjamin Franklin*
Oil on plaster

Zodiac Corridor: 12 Signs of the Zodiac, c. 1860

West Corridor Walls: *John Hancock, John Jay, Francis Hopkins, Robert Morris,
 Robert Livingston, Charles Thomson, Roger Sherman, Charles Carroll*

East Elevator Lobby (covered): Six grisaille lunettes with figures representing Justice, Prudence, War, and Peace and two profiles being crowned by Fame and Victory in medallions flanked by cherubs in rinceaux

Patent Corridor

S–116: Over door: *Robert Fulton*, c. 1873 (Fig. 6–23)
Fresco

Preliminary Sketches:
Robert Fulton (Attributed to Brumidi)
(Illus. in Thomas Hamilton Ormsbee, *Collecting Antiques in America*, 1962, pp. 130–131)

Robert Fulton
Oil on canvas, 10 x 20 ½ in.
Estate sale, no. 579
(Illus. in *Sunday Star* (Washington), Nov. 2, 1919, p. 7)

S–117: Over door: *Benjamin Franklin*, c. 1873
Fresco

Preliminary Sketch:
Benjamin Franklin (copy of Duplises)
Oil on canvas, 22 x 27 in.
Estate sale, no. 576

S–118: Over door: *John Fitch*, c. 1876
Fresco

Preliminary Sketch:
John Fitch
Oil on canvas, 12 ⅛ x 12 ⅛ in.
Inscribed on verso: "Presented to Mr. James A. Briggs, 1876"
Western Reserve Historical Society, Cleveland, Ohio

S–118: Senate Democratic Policy Committee Room
(Originally Senate Foreign Relations Committee Room)
Walls: *Henry Clay, Simon E. Cameron, William S. Allen, Charles W. Sumner*, 1874 (Fig. 11–4)
Oil on plaster

Over door: *Signing of the Treaty of Peace with Great Britain*, 1874 (Fig. 6–24)
Fresco

S–124: Over door: *Cession of Louisiana*, c. 1876 (Fig. 6–25)
Fresco

Preliminary Sketch:
The Louisiana Purchase
Oil on canvas, 10 ½ x 21 in.
Private collection

S–127: Senate Appropriations Committee Room
(Originally Senate Naval Affairs Committee Room)

Ceiling: *Neptunus, Amphitrite, Aolus, Venus, Oceanus, Thetis, Nereus*, and *America* (Figs. 6–7, 6–8)
Fresco

Walls: Nine female figures holding naval and marine implements (Fig. 6–10)
Oil on plaster

Preliminary Sketches:
Design for Naval Affairs Committee Room, 1856 (Fig. 6–6)
Watercolor on paper, 27 x 28 ¼ in.
Signed: "C. Brumidi"
Architect of the Capitol

Cartoon for Fresco (Maiden with Pearls) (Fig. 6–11)
Photograph, Architect of the Capitol

Cartoon for Fresco (Maiden Holding a Sextant)
Photograph in Montgomery C. Meigs Photo Album, Architect of the Capitol

S–128: Senate Appropriations Committee Room
(Originally Senate Military Affairs Committee Room)

Ceiling: Small scenes: *Battle of Lexington, Boston Tea Party, Death of General Mercer, Death of General Montgomery, Surrender of Cornwallis, Death of Tecumseh, Battle of Sagg Harbor,* unidentified Revolutionary battle (Fig. 8–12)
Fresco

Walls: *Death of General Wooster, 1777,* 1858 (Fig. 8–17)
Boston Massacre, 1770, 1871 (Fig. 8–15)
Storming of Stony Point, 1779, 1871 (Fig. 8–18)
The Battle of Lexington, 1858 (Fig. 8–13)
Washington at Valley Forge, 1778, 1871 (Fig. 8–14)
Fresco

Preliminary Sketches:
The Battle of Lexington and *Death of General Montgomery,* c. 1857 (Fig. 8–11)
Oil on canvas, 21 ⅛ x 27 ⅛ in.
Estate of Edna Wilson Macomb

General Mercer's death by bayonet stroke and *Storming of Stony point, General Wayne wounded in the head, carried into the fort,* c. 1857 (Fig. 3–6)
Oil on canvas, 21 ⅛ x 27 ⅛ in.
Estate of Edna Wilson Macomb

General Wooster at Ridgefield mortally wounded, is carried out of the field, and *The Americans at Sagg Harbor, burned twelve brigs and sloops and with him many prisoners,* c. 1857
Oil on canvas, 21 ⅛ x 27 ⅛ in.
Estate of Edna Wilson Macomb

Over door: *Bellona, Roman Goddess of War,* c. 1875 (Fig. 6–26)
Fresco

S–129: Senate Appropriations Committee Room
(Decorated for the Senate Committee on the Library)

Ceiling: *Sculpture, Architecture, Painting, Science,* c. 1875 (Fig. 11–5)
Fresco

Preliminary Sketch:
Painting
Oil on canvas, 14 ½ x 28 in.
Justin Smith Morrill Homestead, Strafford, Vermont

S–131: Over door: *Authority Consults the Written Law.* c. 1875 (Fig. 6–27)
Fresco

S–132: Over door: *Columbus and the Indian Maiden,* c. 1875 (Fig.6–29)
Fresco

S–134: Over door: *Bartholomé de Las Casas,* 1876 (Fig. 6–31)
Oil on plaster

S–211: Lyndon B. Johnson Room
(Originally Senate Post Office)

Ceiling: *Geography*, 1858 (Fig. 8–5)
Physics, 1867 (Fig. 8–9)
History, 1867 (Fig. 8–6
Telegraph, 1867 (Fig. 8–7)
Four groups of three caryatid figures (Fig. 8–4)
Fresco

Preliminary Sketches:
*Telegraph [American Welcoming Europe: The Completion of the Laying of the
 Transatlantic Cable]*, c. 1862–1866 (Fig. 8–8)
Oil on canvas, 14 x 24 ⅛ in.
United States Senate Collection

Design for ceiling of the Senate Library, 1857 (Fig. 8–2)
Signed: "C. Brumidi"
Photograph, Library of Congress, Prints and Photographs Division

The Three Graces (illus. Murdock, p. 79)
Oil on canvas
Formerly Collection of Mrs. Ashmun Brown

History
Formerly Collection of Mrs. Ashmun Brown

Physics
Formerly Collection of Mrs. Ashmun Brown

S–212: Office of the Vice President
(Originally Room of the Sergeant at Arms)

Ceiling: *Columbia Welcoming the South back into the Union*, 1876 (Fig. 11–6)
Fresco
Signed and dated: "Brumidi/1876"

Walls: *Implements of War Destroyed, Secession and Products of North and South,
 War and Strife, Rods United—"E Pluribus Unum"*, 1863
Fresco

Preliminary Sketch:
Columbia Welcoming the South Back into the Union, c. 1866
Oil on canvas, 10 ¾ x 16 ⅝ in.
Private collection

S–213: Senate Reception Room
North ceiling: *Liberty, Peace, Plenty, War*, 1869 (Figs. 8–20, 8–26)
Fresco

North walls: Marble figures and curtains, c. 1871
Oil on plaster

South domed ceiling: *Cherubs, Prudence, Strength, Justice, Temperance*, 1858
 (Fig. 8–25)
Fresco

South wall: Marble figures and curtains, 1870 and c. 1871
Washington with Jefferson and Hamilton, 1872 (Fig. 8–28)
Oil on plaster

Preliminary Sketches:
Adams, Jackson, Vanburn [sic] (Fig. 8–23)
Pencil on paper, 15 in. x 9 ½ in.
Architect of the Capitol

S–213: Senate Reception Room
 Preliminary Sketches:—Continued
 Prudence
 Formerly collection of Mrs. Harvey Hunt

 War
 Oil on canvas, 13 ½ x 8 ½ in.
 Estate sale, no. 574

 War, Peace, Sciences and Industrial Arts, c. 1858 (Fig. 8–21)
 Oil on canvas, 16 ⅜ x 24 in.
 Estate of Edna Wilson Macomb

 Washington, Adams, Jefferson (Fig. 8–22)
 Pencil on paper, 15 x 9 ½ in.
 Arthur J. Phelan Collection

 George Washington with Jefferson and Hamilton, c. 1872
 Oil on canvas, 14 x 12 ¾ in.
 Sold at Sotheby's, New York, January 30, 1975, no. 522.

S–216: President's Room

 Ceiling: *Religion, William Brewster, Americus Vespucius, Executive [Authority],*
 Liberty, Christopher Columbus, Benjamin Franklin, Legislation (Figs. 1–10,
 3–2, 8–32, 8–33, 8–34, 8–35)
 Fresco with tempera borders

 Walls: Cherubs with symbolic objects (Fig. 3–12)
 Henry Knox, Alexander Hamilton, George Washington with allegorical figures
 (Figs. 8–29, 8–37, 8–38), *Thomas Jefferson, Edmund Randolph, Samuel Osgood*
 Oil on plaster
 Signed and dated: "C Brumidi 1860"

 Preliminary Sketch:
 Design for the Vice President's Room [sic](Fig. 8–30)
 Pencil on paper
 Photograph, Architect of the Capitol

Rome, Italy

PALAZZO TORLONIA, Piazza Venezia (demolished 1900–1901)
 Throne Room (Figs. 1–9, 2–6)

VILLA TORLONIA, Via Nomentana (Fig. 1–5)
Theater
 Numerous scenes and figures in the seventeen rooms attributed to him.
 Salon-foyer: *Ajax of Oileus and Cassandra in Athena's Temple*
 Tempera on plaster
 Signed and dated "Brumidi 1844"

 The Judgment of Paris 1845 (Fig. 1–13, 2–8)
 Signed and dated "Brumidi 1845"
 Tempera on plaster

Vatican City

Vatican Palace
 Eleventh Bay of Third Loggia (with Domenico Tojetti):
 Senectus Mala, restored 1840–1842 (Fig. 2–3)
 Senectus Bono, restored 1840–1842 (Fig. 2–4)
 Fresco

Paintings

The Aurora (after Guido Reni) (Fig. 1–11)
Oil on canvas, 27 x 53 in.
Dartmouth College Museum and Galleries, Hanover, New Hampshire
Gift of Moses Titcomb, 1879H

The Aurora (after Guido Reni)
Sold at Adam A. Weschler and Son, May 22–24, 1970

Ceres
Oil on canvas, 22 x 27 in.
Estate sale, no. 564

Child with Grapes
Oil on canvas, 29 x 24 in.
Estate sale, no. 580

Dawn (after Thorwaldsen)
Oil on canvas, 36 in. diameter
Justin Smith Morrill Homestead, Strafford, Vermont

Father Time (unfinished sketch)
Oil on canvas, 36 x 29 in.
Estate sale, no. 561

The Five Senses, c. 1863
Estate sale, no. 577

The Five Senses, c. 1863 (copy)
Formerly collection of Olivia and Ida Walter

Freedom, c. 1853
Oil on canvas, 37 ¼ x 25 in.
Architect of the Capitol, donated through the United States Capitol Historical
 Society by Howard and Sara Pratt, 1994

King, Bishop and Courtiers
Oil on canvas, 7 ½ x 9 in.
Estate sale, no. 568

Liberty, 1869
Oil on canvas (oval), 62 $^{15}/_{16}$ x 50 ⅞ in.
Gift of the Shaklee Corporation, 1981
The White House Collection

Plenty, c. 1853
Oil on canvas, 39 x 26 ¾ in.
Architect of the Capitol, donated through the United States Capitol Historical
 Society by Howard and Sara Pratt, 1994

Progress, 1853 (Fig. 5–4)
Oil on canvas, 47 ½ x 48 in.
Architect of the Capitol, donated through the United States Capitol Historical
 Society by Howard and Sara Pratt, 1994

Sleeping Cupid by Brindi [probably Landi]
Oil on canvas, 29 x 36 in.
Estate sale, no. 571
Formerly collection of Mrs. Harvey Hunt

Sleeping Cupid (another copy of above)
Oil on canvas, 28 ½ x 36 in.
Estate sale, no. 572
Formerly collection of Mrs. Harvey Hunt

Paintings—Continued
Union, 1869
Oil on canvas, (oval), 62 ⅞ x 50 ½ in.
Gift of the Shaklee Corporation, 1981
The White House Collection

Drawings

Bronze Railing, Private Stairs, c. 1857
Pencil on paper, 20 ⅜ x 11 ⅝ in.
Architect of the Capitol

Brumidi Album (Fig. 3–14)
Signed : "C. Brumidi"
Library of Congress, Prints and Photographs Division, gift of
 Mrs. M.B. Mayfield, 1924

Design for a Panel of a Dome
Pencil with red ink on paper, 6 ⅞ x5 ⅝ in.
Athenaeum of Philadelphia

Drawing for Clock for Senate Chamber
Clock designed by Thomas U. Walter, figures and ornaments by Brumidi
Photograph in Montgomery C. Meigs Photograph Album, Architect of the
 Capitol

Drawing for Clock for Senate Chamber
Photograph in Montgomery C. Meigs Photograph Album, Architect of the
 Capitol

Ladies Waiting Room, North Wing, c. 1856 (Fig. 3–5)
Pencil sketch on Walter drawing
Photograph, Architect of the Capitol

Room No 64 & 65 Legislative Business
Pencil on paper, 15 ⅜ x 11 ¾ in.
Architect of the Capitol

Sketch in Black and White (Sculptural)
Estate sale, no. 578

Sketch Sculptural Group
Estate sale, no. 562

*Sketches of Ceilings of Corridor Connecting N. Wing with Main Building also
 South Wing proposed by Mr. Brumidi*
Pencil on paper, 26 ⅜ x 20 ⅞ in.
Architect of the Capitol

RELIGIOUS SUBJECTS

Murals, Altarpieces, and Related Sketches

Baltimore, Maryland

St. Ignatius Catholic Church
 Altarpiece: *The Mystical Vision of St. Ignatius at La Storta,* 1856
 Oil on canvas, 12 x 7 ft.

Boston, Massachusetts

Immaculate Conception
 Murals attributed to Brumidi

St. Aloysius Catholic Church
 Altarpiece: *St. Charles Borromeo Giving Holy Communion to St. Aloysius Gon-
 zaga*, 1859 (Fig. 5–5)
 Oil on canvas, 181 x 109 in.

 Tondos on west wall, apparently replaced with copies:
 St. Mary Magdalen de Pazzi at the Death of St. Aloysius
 Young St. Aloysius Taking the Vow of Virginity Before the Blessed Mother and Child

 East wall over doorway: *Madonna*
 Oil on canvas, oval

 Preliminary Sketch:
 Aloysius Gonzaga Receiving Holy Communion from St. Charles Borromeo, c. 1858
 Oil on canvas
 Private collection

Visitation Convent Chapel
 see: *The Apparition of Our Lord to St. Margaret Mary*, below

Mexico City, Mexico

Cathedral of La Asuncion de Maria
 see: *La Santísima Trinidad (The Holy Trinity)* below

New York, New York

Our Lady of the Scapular and St. Stephen
(formerly St. Stephen's Catholic Church)

 Crucifixion, (Fig. 11–3)
 Oil on plaster
 Signed and dated: "C Brumidi 1868"

 Apse: Illusionistic sculpture in niches *S Petrus, S Paulus, S Gabriel, S Michael*

 Tondos with figures, lunettes with illustionistic arches
 Side altar: *The Martyrdom of St. Stephen*, 1856
 Oil on canvas mounted on board
 Signed and dated: "C. Brumidi 1856"

 Side altar: *Assumption of the Virgin*
 Oil on canvas
 Signed and dated: "C. Brumidi 1868"

 Side chapel: *Sacred Heart*
 Oil on canvas

 Transept balconies: *Ascension* (not in Brumidi's style), *Christ in the Temple*
 (overpainted)
 Niches with female saints: *S. Agnes, S. Monica, S. Brigita, S.Teresea, S. Rosa Limaus*
 Niches with male saints: *S. Vincenzio a Paulo, S. Franciscus Salesius, S. Francescus
 Assissus, S. Patritus, S. Augustinus*

 South entrance wall: *S. Cecilia, David, Madonna and Child with John the Baptist*

 Attributed to Burmidi: Fourteen stations of the cross
 Oil on canvas

Philadelphia, Pennsylvania

Cathedral Basilica of SS. Peter and Paul
 East wall, behind main altar (destroyed 1956–1957)
 Crucifixion, 1863 (Fig. 1–19)
 God the Father and Dove of the Holy Spirit, 1863
 Fresco

Cathedral Basilica of SS. Peter and Paul—Continued
Dome: *Assumption of the Virgin*
Oil on canvas

Pendentives: *Four Evangelists*
Oil on canvas

North transept: *The Nativity (Adoration of the Shepherds)*, 1864
Fresco, 16 x 25 ft.; covered by oil-on-canvas copy by Louis Costaggini, 1909,
 and again repainted

South transept: *Adoration of Magi*, 1864
Fresco, 16 x 25 ft.; covered by oil-on-canvas copy by Louis Costaggini, 1909,
 and again repainted

Transept walls (destroyed 1956–1957)
The Twelve Apostles, 1864
Fresco?

Riverdale, New York

College of Mount Saint Vincent
Crucifixion, 1873
Oil on canvas
Signed and dated: "C. Brumidi 1873"

Rome, Italy

Palazzo Torlonia, Piazza Venezia (demolished 1900–1901)
Torlonia family chapel, 1840–1842 (Fig. 2–7)
Holy Trinity with Alexander Torlonia and Saints
Apostles and Old Testament prophets
Fresco

Sanctuary of the Madonna dell'Archetto
Dome: *Immaculate Conception* (Fig. 2–1)
Fresco

Pendentives: *Wisdom, Prudence, Strength, Innocence* (Fig. 2–13)
Fresco

Paintings

Adoration of the Magi
Oil on canvas, 25 ½ x 15 in.
Estate sale, no. 581

The Apparition of Our Lord to St. Margaret Mary, 1878
Painted for Visitation Convent Chapel, Washington, D.C.
Moved to Holy Trinity Church, Washington, D.C. in 1919
Removed from the wall
Oil on canvas, 10 x 6 ft. (originally 17 ft. in height)
Collection of Drs. Harry and John Fournier

La Asunción de la Virgen (The Assumption of the Blessed Virgin Mary)
Oil on canvas, 100 x 72 in.
Exhibited in Mexico City, 7th Annual Exposition of the Academia Nacional de
 S. Carlos de Mexico, January, 1855, #73

Crucifixion, c. 1854
Oil on canvas, 23 x 25 in.
Formerly collection of Mildred Thompson

Holy Family with the Trinity (in Egypt), c. 1870
Oil on canvas, approx. 9 x 4 ft.
St. Aloysius Catholic Church

Madonna and Child (copy of Raphael's *Madonna della Sedia*)
Oil on canvas
Collection of Mr. and Mrs. Robert F. Young

Madonna and Child with St. Francis and St. Roche
Oil on canvas, 47 ½ x 25 in.
Gonzaga High School, Washington, D.C.

Martyrs in a Landscape (Fig. 3–13)
Oil on canvas, 23 ½ x 39 in.
Architect of the Capitol, gift of Mr. Zeake W. Johnson, Jr., in memory of his
 wife Theodosia McK. Johnson

Mary Magdalene
Oil on canvas, 22 x 27 in.
Estate sale, no. 567

La Purísima Concepción (The Immaculate Conception) (full figures)
Oil on canvas, 59 x 40 in.
Exhibited in Mexico City, 7th Annual Exposition of the Academia Nacional de
 S. Carlos de Mexico, January, 1855, #22

La Purísima (The Immaculate Conception) (half figure in an oval)
Oil on canvas
Exhibited in Mexico City, 7th Annual Exposition of the Academia Nacional de
 S. Carlos de Mexico, January, 1855, #24

Saint Paul
Oil on canvas, 6 ½ x 14 ½ in.
Estate sale, no. 565

Saint Peter
Oil on canvas, 6 ½ x 14 ½ in.
Estate sale, no. 566

La Santísima Trinidad (The Holy Trinity)
Oil on canvas, 34 x 25 in.
Exhibited in Mexico City, 9th Annual Exposition of the Academia Nacional de
 S. Carlos de Mexico, December, 1856, #70

La Santísima Trinidad (The Holy Trinity)
Oil on canvas, 111 x 79 in.
Exhibited in Mexico City, 9th Annual Exposition of the Academia Nacional de
 S. Carlos de Mexico, December, 1856, #93

La Virgen con el Niño en los brazos (The Virgin with the Christ Child in her Arms)
Oil on canvas, 29 x 23 in.
Exhibited in Mexico City, 7th Annual Exposition of the Academia Nacional
 de S. Carlos de Mexico, January, 1855, #47

Woman Praying
Oil on canvas, 16 x 20 ½ in.
Estate sale, no. 575

Sculpture

Rome, Italy

Weld-Clifford Chapel, San Marcello al Corso

Crucifixion
Two Angels
Marble

Expulsion of Adam and Eve from Paradise
The Holy Family at Nazareth
Adoration of the Shepherds
Pietà (Fig. 3–15)
Marble, low relief

Portraits

Doña Elena Basadre
Oil on canvas, 39 x 31 in.
Exhibited in Mexico City, 7th Annual Exposition of the Academia Nacional de
 S. Carlos de Mexico, January, 1855, #161

Emery Bemis, 1852
Oil on canvas, 35 ⅝ x 28 ⅝ in.
Signed and dated: "C. Brumidi 1852"
National Museum of American Art, Smithsonian Institution
Gift of Dr. and Mrs. Roy C. Benton

Susan Pickering Bemis
Oil on canvas, 35 ⅝ x 28 ¾ in.
National Museum of American Art, Smithsonian Institution
Gift of Dr. and Mrs. Roy C. Benton

Mother Bennitt (possibly Mrs. Abraham Bennitt)
Oil on canvas, 30 x 26 in.
Collection of Howard and Sara Pratt

Portrait of a man (probably George S. Bennitt)
Oil on canvas, 40 x 33 in.
Collection of Howard and Sara Pratt

Portrait of a woman (probably Mrs. George S. Bennitt)
Oil on canvas, 40 x 33 in.
Collection of Howard and Sara Pratt

Lola Germon Brumidi, c. 1860 (Fig. 1–17)
Oil on canvas, 23 ½ x 19 ½ in. (oval)
Collection of William R. and Audrey O. Greever

Salmon P. Chase
Oil on canvas, 30 x 25 in.
Museum Connecticut History, Hartford, Connecticut

Children Holding an Orange, 1852
Oil on canvas, 29 ¾ x 25 in.
Signed and dated: "C. Brumidi 1852"
Sold at Christy's, New York, Jan. 25, 1985, no. 28 (illus. in catalog)

Edward Clark
Oil on canvas, 35 ½ x 28 ½ in.
Architect of the Capitol

Mrs. Edward Clark with Watson Clark
Formerly collection of Charlotte Clark

Twin Daughters of Edward Clark
Formerly collection of Charlotte Clark

John Thomas Clements (illus. in *Washington Post*, May 9, 1952, p. 12)
Formerly collection of Mr. and Mrs. Charles H. Tompkins

Eliza Goldsmith Clements (illus. in *Washington Post*, May 9, 1952, p. 12)
Formerly collection of Mr. and Mrs. Charles H. Tompkins

Charles Dickens
Oil on canvas, 29 x 20 in.
Removed from ceiling of Justin Morrill House, Washington, D.C.
Justin Smith Morrill Homestead, Strafford, Vermont

Benjamin Franklin
Oil on canvas, 26 ¾ x 21 ¾ in.
Corcoran Gallery of Art
Gift of Mr. and Mrs. Donald F. Bliss as a memorial to Louis D. Bliss

Eveline Fessenden Freeman (Mrs. Edward Clark), 1853 (Fig. 5–3)
Oil on canvas, 37 x 29 in.
Signed and dated: "C. Brumidi 1853"
Architect of the Capitol
Gift of United States Capitol Historical Society

Benjamin Brown French
Oil on canvas, 34 x 27 in. (oval)
Collection of Peter S. French

James A. Harlan
Oil on canvas, 30 x 24 in. (oval)
Iowa Department of History & Archives, Des Moines, Iowa

Nathaniel Hawthorne
Oil on canvas, 29 x 20 in. (oval)
Removed from Justin Morrill House, Washington, D.C.
Justin Smith Morrill Homestead, Strafford, Vermont

Andrew J. Joyce
Oil on canvas
Mr. and Mrs. George Gardner Herrick

Mrs. Andrew J. Joyce
Oil on canvas
Mr. and Mrs. George Gardner Herrick

Henry Wadsworth Longfellow
Oil on canvas, 29 x 20 in. (oval)
Removed from Justin Morrill House, Washington, D.C.
Justin Smith Morrill Homestead, Strafford, Vermont

Justin Smith Morrill
Oil on canvas, 35 ½ x 28 ½ in.
Morrill Memorial Library, Strafford, Vermont

Samuel F. B. Morse
Oil on canvas, 11 x 10 ⅞ in.
Corcoran Gallery of Art, Washington, D.C.

Dr. John Norris
Oil on canvas, 38 ½ x 28 ½ in.
Private collection

William J. Norris
Sold at Sotheby Parke-Bernet

Portraits—Continued

Mrs. William J. Norris
Oil on canvas
Mr. and Mrs. George Gardner Herrick

William H. Prescott
Oil on canvas, 29 x 20 in. (oval)
Removed from Justin Morrill House, Washington, D.C.
Justin Smith Morrill Homestead, Strafford, Vermont

Pope Pius IX, c. 1847 (Fig. 2–9)
Oil on canvas, 96 ½ x 67 in.
Seminario Maggiore al Laterno, Vatican Museums, Vatican City
Gift of Cardinal Gabriele Ferretti, 1847

Portraits of popes: fifteen models for mosaics for St. Paul's Outside the Walls, Rome
(Fig. 2–10)
Oil on canvas
Vatican Museums, Vatican City

Roger Brooke Taney
Oil on canvas, 29 ½ x 24 ½ in.
Museum of Connecticut History, Hartford, Connecticut

Benjamin Titcomb (after Joseph Badger)
Oil on canvas
Portland Public Library, Maine

Moses Titcomb
Oil on canvas, 30 x 25 in.
William A. Farnsworth Library and Art Museum, Rockland, Maine

Copy of Titian's Daughter
Formerly collection of Dr. Edward C. Morse

George Washington
Oil on canvas, 21 x 27 in.
Estate sale, no. 570

Woman in White Cape (Lola Brumidi)
Oil on canvas, 25 x 30 in.
Estate sale, no. 573

Domestic Decorative Work

District of Columbia
"The Maples" (later Friendship House) 619 D St. Southeast, Washington, D.C.
 Ballroom
 Commissioned by Senator John Clayton of Delaware after 1856
 Subjects unknown
 Decorations destroyed 1937

Germantown, Pennsylvania
Thomas U. Walter House, Germantown, Pennsylvania, 1863 [demolished]
 Interior decoration, subjects unknown

Urban Design

Project for the Broadway Rail Road, 1862 (Fig. 3–16)
Pencil on paper
Athenaeum of Philadelphia

Chronology of Constantino Brumidi's Life and Work

(COMPILED WITH JULIE A. ARONSON)

Note: Events in italics are provided for context

1805 **July 26.** Born in Rome, Italy, the only surviving child of Stauro Brumidi of Greece and Anna Maria Bianchini of Rome, owners of a coffee shop at number 26, Via Tor de' Conti.

c. 1818 Begins a fourteen-year study of art at Accademia di San Luca (Academy of St. Luke), headed by Antonio Canova. Studies sculpture with Bertel Thorwaldsen and painting with Vincenzo Camuccini.

1821–1823 Wins prizes at the academy, including a fifth prize for his copy of a sculpture of Apollo, a second prize for his copy of a painting of a cupid by Gaspare Landi (former teacher at the academy), and a commendation for his copy of a painting by Landi. Signs a student petition to have life models.

1829 **April 25.** Death of his father.

1832 **June 30.** Marries Maria Covaluzzi, a widow, age 35.

 August 15. Birth of his daughter, Maria Elena Brumidi (known as Elena).

1836 Begins work for the Torlonia family. For Alessandro Torlonia in the Palazzo Torlonia, Piazza Venezia, he paints a frieze with the glory of Constantine and the family coat of arms in the throne room. For Marino Torlonia, decorates a neogothic chapel in the park of the Villa de Porta Pia at an unknown date.

1837 **August.** Death of his mother.

 Commissioned to create a sculpture for the Weld-Clifford Chapel in church of San Marcello al Corso; chapel dedicated in 1842.

1838 **June.** Death of his wife.

 October 17. Marries Anna Rovelli, age 16.

1840 With Domenico Tojetti, restores the eleventh bay and the end wall dedicated to Pope Gregory XVI in the third Loggia of the Vatican Palace, under the supervision of Camuccini and Filippo Agricola.

 Paints frescoes in the neogothic family chapel designed by G.B. Caretti on the third floor of the Palazzo Torlonia, Piazza Venezia. Also paints Roman stories in the galleries on the second floor.

1841 *Construction of the theater of the Villa Torlonia begins.*

1842 **January 19.** Birth of his son, Giuseppe Antonio Raffaello Brumidi.

 March. Work on the Third Loggia completed.

 September. Commissioned to decorate a new building, presumably the theater, in the Villa Torlonia, Via Nomentana.

1844/1845 Signs and dates two scenes in the theater of the Villa Torlonia. Was probably in charge of all of the extensive mural decoration.

1846 *Pope Pius IX takes office and introduces democratic reforms.*

 Proposes a new avenue from the Quirinale, the pope's palace, to the Vatican, with a monumental bridge and a triumphal arch in honor of Pope Pius IX. At an unknown date, works in the Quirinale.

1847 **March.** Creates a lithograph honoring the pope.

 July 5. Civic guard of citizens aged twenty-one to sixty authorized by the pope.

 Serves as a captain in the civic guard.

 December. Petitions the pope to be named assistant to Agricola, the inspector of public paintings in Rome. Request denied because the position did not exist.

 Paints portrait of Pope Pius IX, of which he makes a number of copies.

1848–1850 Paints fifteen oil portrait studies of early popes as models for the frieze of St. Paul's Outside the Walls (executed in mosaic between 1851 and 1872).

1848 **May 11.** Requests appointment to the position of assistant superintendent of sacred apostolic palaces; request supported by the pope but not granted.

September. Tries to resign from the civic guard.

November 15. Pope flees Rome after assassination of prime minister Pellegrino Rossi.

1849 *February 9. Declaration of the Roman Republic, followed by the election of a triumvirate.*

April 12. French troops land at Civitavecchia, preparing to attack Rome.

May 3. As a captain of the civic guard, removes articles for safekeeping when ordered to seize the Monastery of S. Francesca Romana and others to house troops.

June 4. French troops enter Rome.

July 17. Applies to the Roman Republic for a position.

1850 *April 12. Pope restored to power by French troops. Cardinal Giacomo Antonelli named Secretary of State.*

Paints frescoes in the Church of the Madonna dell' Archetto (dedicated May 31, 1851).

Has a studio in the parish of S. Maria de' Monti.

In contact with John Hughes, archbishop of New York, and American priest John Norris about decoration of St. Stephen's Church.

1851 **February 4.** Arrested and imprisoned in connection with revolutionary activities.

February 22. Pleads innocent to accusations of stealing church property.

June 4. Asks to leave for the United States to decorate churches as planned before arrest. Is moved to a harsher prison and suffers ill health.

June 11. Thomas U. Walter appointed Architect of the Capitol. Edward Clark comes to Washington, D.C., to be his assistant.

July 4. Cornerstone for the Capitol Extension laid.

October/November. Requests permission from the Secretary of State and the French general to leave for the United States.

December. Trial on charges stemming from revolutionary activities. Found guilty in spite of supporting testimony.

1852 **January 2.** Sentenced to eighteen years in prison.

January 31. Sentence reduced by two-thirds.

March 21. Released from prison after pardon by the pope.

September 18. Arrives in New York City.

November 29. Files document of intent to become a United States citizen in Court of Common Pleas, New York City.

Signs and dates portrait of Emery Bemis of Boston and Cambridge, Massachusetts.

1853 *March 23. President Franklin Pierce transfers jurisdiction over the Capitol from the Department of the Interior to the Department of War, headed by Jefferson Davis.*

March 29. Montgomery C. Meigs appointed Supervising Engineer of the Capitol Extension.

Signs and dates portrait of Eveline F. Freeman of Massachusetts and tondo *Progress* for the Bennitt family of New York.

1854 **May 5.** In Mexico City, painting a Holy Trinity for the Cathedral.

November. Meigs tries to persuade Emmerich Carstens to come from New York to be foreman of decorative painters.

December 12. Leaves Mexico for New Orleans in the company of "Mary Brumidi" and bronze worker Federico Casali.

December 28. At the Capitol in Washington, D.C., is introduced to Meigs, who suggests he paint a sample fresco in a lunette in his office, intended for the House Committee on Agriculture (H–144).

1855 **January.** Living at 308 Delaware Avenue [N.E.], between B and C streets, near the Capitol.

January 29. Exhibits paintings in Mexico City.

February 3. Congress appropriates $100,000 for a new dome for the Capitol.

February 19. Having prepared an oil sketch and cartoon, begins to paint the fresco of Cincinnatus (H–144).

Completes a color sketch for *Martyrdom of St. Stephen* for St. Stephen's Church in New York City.

March 17. Finishes Cincinnatus fresco.

March 20. Secretary of War Jefferson Davis inspects the fresco and authorizes Meigs to employ Brumidi at $8.00 per day to continue work and to pay him retroactively.

March 30. Has finished sketch representing the Four Seasons and begins working on cartoons.

November 9. Has completed the ceiling and all but the Putnam lunette (H–144).

December. American Party (Know Nothings) at its height in the 34th Congress.

Submits proposal in French listing subjects for the Senate Reception Room.

1856

April 1. Has completed frescoes in Agriculture Committee Room (H–144).

July 28. Submits three sketches for paintings in the Senate Reception Room (S–213).

August 6. Meigs approves design for the Ladies Waiting Room (S–313A) [not executed].

August 20. Meigs approves the sketch for the room of the Committee on Naval Affairs (S–127).

October. First article criticizing use of foreign artists at the Capitol appears in The Crayon.

By November. Work in the Naval Affairs Committee Room (S–127) in progress.

November. Washington Art Association founded by Horatio Stone.

December 4. Installs oil-on-canvas altarpiece in St. Ignatius Church in Baltimore.

December. Exhibits *Holy Trinity* in Mexico City.

Signs and dates *Martyrdom of St. Stephen* for St. Stephen's Church, New York City.

1857

Dispute begins between Walter and Meigs over the superintendency of the architecture and the decoration in the Capitol.

February 16. Submits designs for the proposed Senate Library (S–211); is requested to design the House Chamber ceiling and Senate desks and chairs.

March 7. Newly inaugurated President James Buchanan appoints John B. Floyd Secretary of War.

March 27. Requested by Meigs to design railings for the private staircases.

April 3. Pay raised to $10.00 per day.

July. Death of his friend Frederick Casali, head of the Capitol bronze foundry.

October-December. Paints *Cornwallis Sues for Cessation of Hostilities* in House Chamber and signs it: "C Brumidi Artist Citizen of the U.S."

November 12. Files final naturalization papers in U.S. Circuit Court, District of Columbia.

December 16. House of Representatives meets in new hall.

1858

Living at 63 Indiana Avenue [N.W.].

Completes one lunette and one corner group in Senate Post Office (S–211) and two of five lunettes in room of Senate Committee on Military Affairs (S–128).

Decorative painting ongoing in first-floor Senate corridors.

March 20. Memorial to Congress requesting the foundation of an art commission is drafted and signed by 127 artists at National Art Association convention.

April. Conflict with Johannes Oertel over the painting of the Senate Library (S–211).

April 30. Appropriations for Capitol construction expired and workers discharged.

May 19. Proposed amendment to the Capitol appropriation specifies that a committee of three artists appointed by the president recommend designs for approval by the Joint Committee on the Library.

May 28. Jefferson Davis defends Meigs and Brumidi's decoration during debate in Senate.

May 31. Memorial of artists presented to the House, which forms a select committee of five members to consider it.

June 12. Civil Appropriation Bill passed, with a provision that no expenditures for sculpture or paintings could be made without the approval of the committee of three artists and the Joint Committee on the Library, with the ex-

ception of the work in progress by Crawford and Rogers.

By November 15. Completes frescoes in the spandrels of the southern domed section of the Senate Reception Room (S–213).

December. Clashes with Emmerich Carstens, foreman of decorative painters, over superintendence of workers.

1859 **March 3.** Signs sketch depicting scenes of American history for a fresco in illusionistic sculptural relief for the Rotunda frieze.

"American Artists," report of House select committee, recommends formation of art commission.

March 17. Carstens dismissed by Secretary of War.

May 15. Art Commission appointed by the President; members are Henry Kirke Brown, James R. Lambdin, and John F. Kennsett.

June 6. Pays for the burial of Clara Scarselli Brumidi, age 36, born in Rome.

June 15. First meeting of the Art Commission.

October. Meigs reports that decorative painting in the first-floor Senate corridor is almost complete.

October 3. Altarpiece installed at St. Aloysius Church in Washington.

November 1. Meigs relieved of duty and replaced by William B. Franklin.

December 1. Work on the Capitol suspended except for some painting in the corridors.

December 9. Date inscribed on Thomas U. Walter's drawing of section of new dome, which includes a canopy for a fresco by Brumidi.

1860 Listed in census as living at 485 D Street North [N.E.] with eighteen-year-old English woman, undoubtedly Lola Germon.

Signs and dates murals in the President's Room (S–216).

February 22. Art Commission submits a report highly critical of foreign treatment of the Capitol decoration.

June 20. Art Commission abolished.

July 1. Work on the Capitol resumes.

1861 *February 27. Meigs ordered by Secretary of War to resume charge of the Capitol Extension.*

March. Carstens sworn in as "Foreman of Ornamental Painting."

April 12. The Civil War begins. Troops stationed at the Capitol from April 18 through May.

May 12. Birth of his son, Laurence Stauros Brumidi.

May 15. Work on the Capitol extensions suspended, although ironwork on dome continued.

June 13. Meigs appointed Quartermaster General of the Army.

August-December. Paid out of Senate Contingent Fund, along with the assistants, for decorating Senate corridors and repairing other decoration in Senate wing.

1862 Living at 128 Second Street West [N.W.].

April 16. Jurisdiction over Capitol shifted from War Department to Interior Department under Caleb B. Smith.

April 30. Work on extensions resumed.

May. Signs and dates a proposal for an elevated railroad on Broadway in New York City.

August 18. Walter requests a design for the canopy fresco.

August 31. Capitol used as a hospital for troops through October.

September 8. Submits a design with the description of the *Apotheosis of Washington* and requests $50,000.

October. Estimates cost of completing rooms in the Capitol. In Philadelphia at end of the month.

December 17. Agrees to accept $40,000 for the canopy fresco.

1863 **January 3.** Proposal for the canopy fresco accepted for $40,000.

February-May. Decorating Walter's new house in Germantown, Pennsylvania, with several assistants from the Capitol.

March 11. Notified to proceed with the cartoons for the canopy in real fresco.

March 30. Carpenters finish wooden model of Rotunds canopy made to assist Brumidi in preparing cartoons.

May 16. Draws figures of Vulcan and Ceres for the clock designed by Walter for the Senate Chamber.

May. Contract questioned by Secretary of Interior I. P. Usher; Brumidi ordered to suspend operations.

July 7. Secretary of Interior agrees to resumption of work on the canopy fresco.

November 6. Completes cartoons for the canopy for a payment of $10,000 total; pay suspended until construction of the dome is further advanced.

1864 Decorates the Cathedral of SS. Peter and Paul in Philadelphia with frescoes and murals.

November. Lola Brumidi purchases house at 128 Second Street West [N.W.], where they live together until 1870.

December 3. Ironwork of the canopy complete and ready for fresco.

Paints in fresco in the Sergeant-at-Arms Room (S–212); central ceiling panel remains unfilled.

1865 **May 16.** Walter notes completion of the center group of the canopy fresco and the commencement of Science group.

May 26. Walter resigns, three days after being placed under the Commissioner of Public Buildings.

July 15. Appropriation for the dome exhausted, but Brumidi continues to work.

August. Sends painting *The Five Senses* to Walter's family.

August 30. Edward Clark appointed Architect of the Capitol Extension and New Dome.

September 3. Meigs asks that his portrait be removed from the Commerce group in the canopy fresco.

September. Painting last group on the canopy; fresco is signed and dated 1865. Expresses concern about the junctures between the sections of plaster. Clark recommends payment.

October. In Philadelphia.

1866 **January 9.** Scaffolding for canopy fresco dismantled during the following week.

June 9. Paid balance of the contract price, subtracting $500, to be paid when joints between the giornate are toned and blended.

July. Prepares estimates after Chairman of the Senate Committee on Public Buildings and Grounds requests that unfinished rooms (S–211, 212, and 213) be completed. Edward Clark objects to higher prices.

July. In Philadelphia through September.

November 19. Secretary of Interior seeks congressional authorization for frieze.

1867 **January.** In Havana, Cuba.

March 29. Has returned to Washington and is working in the Capitol.

By November 1. Ceiling of Senate Post Office (S–211) completed.

1868 No work at the Capitol documented.

Signs and dates monumental crucifixion mural and *Assumption of the Virgin* in St. Stephen's Church, New York City.

1869 Paints *Liberty* and *Union* in oil on canvas for the entrance hall of the White House.

By November. Adds four frescoes to Senate Reception Room (S–213).

1870 Takes mortgage on house at 128 2nd Street, N.W.; Lola Brumidi living at 326 A Street, S.E.

June. In New York. Sends designs for lunettes of the Senate Reception Room (S–213). Says he will be in Washington in July.

November 22. Paid for painting chiaroscuro figures on south wall of Senate Reception Room (S–213).

1871 **April.** In New York working at St. Stephen's Church.

October 19. Paid for three frescoes of the American Revolution to complete decoration of Senate Military Affairs Committee Room (S–128).

Nov. 23. Paid for painting chiaroscuro figures in the three lunettes in the Senate Reception Room (S–213); spaces designated for portraits remain vacant.

Visited by his daughter Elena, who lives in Rome.

1872 **August-September.** In New York working at St. Stephen's Church.

1873 **May 26.** Paid for mural of Washington, Hamilton, and Jefferson on south wall of Senate Reception Room (S–213).

September. Working in dining room of Senator Justin Morrill's house.

November 28. Paid for Robert Fulton fresco in lunette in the Patent Corridor, first floor of Senate wing.

Signs and dates *Crucifixion* for Academy of Mount Saint Vincent, Riverdale, New York.

1874 **June 21.** Paid for four monochrome profile portrait medallions in Senate Committee on Foreign Affairs Room (S–118).

August. Lives temporarily at Marini Hall (914–916 E Street), where he works on cartoons. Has "rheumatic attack" in his knees, affecting his ability to walk.

By November 1. Has completed fresco *Signing of the First Treaty of Peace with Great Britain* in corridor outside Committee on Foreign Affairs Room (S–118).

Thanksgiving. Hospitalized, possibly for rheumatism.

1875 **May.** Asked to make portraits for library of Senator Justin S. Morrill's house.

By November 1. Completes two frescoes in Senate first-floor corridors: *The Cession of Louisiana* outside the Committee on Territories Room (S–124), and *Bellona* outside the Military Affairs Room (S–128).

Also paints frescoes on ceiling of the Committee on the Library Room (S–129).

Paints lunettes of *Columbus and the Indian Maiden* and *Authority Consults the Written Law* in the west corridor.

1876 Signs and dates the ceiling fresco *Columbia Welcoming the South Back into the Union* in the Senate Sergeant-at-Arms Room (S–212).

February. Painting the lunette *Bartholomé de Las Casas* (S–133) in oil in the west corridor, first floor of Senate wing. Petitions to be allowed to finish uncompleted rooms.

May. Completes lunette depicting John Fitch in the Patent Corridor.

1877 **March.** Put back on the payroll at $10.00 per day to paint the Rotunda frieze.

May. Begins work on cartoons for the frieze.

1878 Living at 911 G Street, N.W.

April. Paints first scene of frieze.

August 24. Paid for frescoes of Justice Joseph Story, Chancellor James Kent, and Chancellor Robert Livingston in Senate wing north entrance.

September. Scaffold for the frieze being adjusted. Begins the Pocahontas cartoon. Plagued by health problems, possibly hospitalized.

Begins being hoisted up daily to frieze by a cage on a pulley.

By October 15. Has completed cartoons for the DeSoto segment of the frieze and is continuing work on Pocahontas cartoon.

December 27. Asks to suspend work on the frieze during cold weather.

Paints *The Apparition of our Lord to St. Margaret Mary* for the Visitation Convent, Washington, D.C.

1879 Living at 911 G Street, N.W., with his son Laurence. The former Lola Brumidi, now Mrs. Walsh, purchases the house at 921 G Street, N.W.

June 27. Files will, leaving all possessions to his son Laurence.

July. Continues to work on cartoons for the frieze, but due to asthma cannot ascend to the scaffold.

Early August. In Orkney Springs, West Virginia, on doctor's orders, works on frieze cartoons.

October 1. Nearly falls from the scaffolding while painting the frieze, but returns to paint the next day.

November. Petitions to be placed back on the payroll for cartoons. Works on cartoons of Oglethorpe and Lexington.

1880 **January.** Works 27 days on cartoons for the frieze.

February 19. Dies in his home at 921 G St., N.W. Buried in Germon family plot at Glenwood Cemetery.

March. Filippo Costaggini asks to succeed Brumidi on the frieze.

June. Congress divides the $500 due Brumidi between his children Laurence and Elena.

Bibliography

Principal Archives and Manuscript Collections

Philadelphia

Thomas U. Walter Papers, The Athenaeum of Philadelphia.

Rome

Accademia di San Luca, Archivio. Archives of the Academy of St. Luke.

Archivio Storico del Vicariate di Roma. Historical archives of the vicariate of Rome.

Archivio di Stato di Roma (Palazzo della Sapienza). Archives of the city of Rome.

Archivio Segreto Vaticano (Vatican City). Vatican archives.

Washington, D.C.

Records of the Architect of the Capitol.

Jesuit Archives, Georgetown University.

Benjamin Brown French Papers; Montgomery C. Meigs Papers, Manuscript Division, Library of Congress.

Papers of the Commissioners of Public Buildings, National Archives and Records Administration.

Records of the Department of the Interior, National Archives and Records Administration.

U.S. Circuit Court Records, District of Columbia, National Archives and Records Administration.

Mildred Thompson Papers, United States Senate Collection.

Newspapers

Baltimore Sun

Baltimore Star

Congressional Globe (Washington)

Constitutional Union (Washington)

Daily Critic (Washington)

Daily Graphic (New York)

Daily Mercury News (New Bedford, Massachusetts)

Daily Evening Transcript (Boston)

Evening Telegraph (Philadelphia)

Evening Star (Washington)

Evening Intelligencer (Washington)

National Intelligencer (Washington)

New York Times

New York Tribune

New York Evening Sun

New York Herald

Philadelphia Record

Washington Times-Herald

Washington Post

Washington Star

Published Sources: Books, reports, and articles

Ahrens, Kent. "Constantino Brumidi's 'Apotheosis of Washington' in the Rotunda of the United States Capitol." *Records of the Columbia Historical Society of Washington, D.C. 1973–1974* (1976): 187–208.

Aikman, Lonnelle. "U.S. Capitol, Citadel of Democracy." *National Geographic* 102 (August 1952): 143–190.

Allen, William C. *The Dome of the United States Capitol: An Architectural History.* Washington D.C.: Government Printing Office, 1992.

Amadei, Emma. "Il piu Piccolo Santuario mariano de Roma: La Madonna dell'Archetto," in *L'Urbe,* 12 (1949): 2, 15–18.

Apolloni, Marco, Alberta Campitelli, Antonio Pinelli, and Barbara Steindl. "Villa Torlonia: L'Ultima Impresa del Mecenatismo Romano." *Ricerche di Storia dell'arte,* 28–29 (1986).

———. *Villa Torlonia: L'ultima Impresa del Mecenatismo Romano.* Rome: Istituto Poligrafico e Zecca dello Stato, 1997.

Architect of the Capitol. *Art in the United States Capitol.* Washington, D.C.: Government Printing Office, 1978.

———. *Annual Reports.* Washington, D.C.: Government Printing Office, 1867–1947 and 1976– .

"Art in Washington." *The Round Table* (New York), February 20, 1868.

"Art Desecration of Capitol." *Cosmopolitan Art Journal* 2 (1858): 134–135.

Barker, Virgil. *American Painting: History and Interpretation.* New York: Macmillan Company, 1950.

Berryman, Florence S. "Artists of Washington." *Records of the Columbia Historical Society* 50 (1952): 215–233.

Birchfield, James. "Brumidi's Church Paintings." *Washington Sunday Star Magazine*, January 27, 1957.

Brown, Simon. "Letter from Mr. Brown." *New England Farmer* (Joel Nourse, Proprietor), June 25, 1856.

Brown, Glenn. *History of the United States Capitol*. 2 vols. Washington, D.C.: Government Printing Office, 1900, 1902.

"Brumidi: Artist and Citizen of the U.S.A." *The Link* 30 (June 1972): 5–9.

"Brumidi." *American Architect and Building News* 1 (1876): 144.

"Brumidi, Constantino." In *Dictionary of American Biography*, ed. Allen Johnson and Dumas Malone. 2d ed. New York: Charles Scribner's Sons, 1958, 2:184–185.

"Brumidi, Constantino." In *Allgemeines Lexikon Der Bildenden Kunstler von der Antike bis zur Gegenwart*, ed. Ulrich Thieme and Felix Becker. Leipzig: E.A. Seeman Verlag, 1911, 5:118.

"Brumidic." *Art Digest* (August 1930): 9.

"Brumidi's Successor." *American Architect and Building News* 7, February 21, 1880.

Campitelli, Alberta, and Barbara Steindl. "Costantino Brumidi da Roma a Washington. Vicende e opere di un artista romano," *Ricerche di Storia dell'arte: Pittori fra Rivoluzione e Restaurazione*, 46 (1992): 49–59.

"Capitol Dome Restoration." *American History Illustrated* (April 1988): 8.

Checchetelli, Giuseppe. *"Una giornata di osservazione nel Palazze e nella Villa di S.E. il Principe D. Alessandro Torlonia."* Rome: Tipografia di Crispino Puccinelli, 1842.

Cole, Donald B. and John J. McDonough, eds. *Benjamin Brown French. Witness to the Young Republic: A Yankee's Journal, 1828–1870*. Hanover and London: University Press of New England, 1989.

Cosentino, Andrew J. and Henry Glassie. *The Capitol Image: Painters in Washington, 1800–1915*. Washington, D.C.: Smithsonian Institution Press, 1983.

Courtais, Henri G. "A Blind Approach to the Removal of a Fresco." *Studies in Conservation* 8 (February 1963): 10–19.

Cox, Allyn. "Completing and Restoring the Capitol Frescos. Part I: The Rotunda Frieze." *Museum News* 39 (February 1961): 14–18.

De Camillis, Lamberto. *La Madonna dell'Archetto, Storia del piu' piccolo santuario Mariano di Roma*. Rome: Edizione Soc. Promotrice Di Buone Opere, 1951.

De Terreros, Manuel Romera, ed. *Catalogos de las Exposiciones de la Antiqua Academia de San Carlos de México, 1859–1898*. Mexico: Imprenta Universitaria, 1963.

Diamond Jubilee of St. Aloysius Church Washington, D.C., 1859–1934. Washington, D.C.: W. F. Roberts Co., 1934.

"Costantino Brumidi." In *Dizionario Biografico degli Italiani*. Rome: Istituo della Enciclopedia Italian, 1960, 1972.

Documentary History of the Construction and Development of the United States Capitol Building and Grounds. Washington, D.C.: Government Printing Office, 1904.

"Domestic Art Gossip." *The Crayon* (May 1857): 155–156.

Fairman, Charles E. *Art and Artists of the Capitol of the United States of America*. Washington, D.C.: Government Printing Office, 1927.

———. "Art of the Italian Artist in the United States Capitol." Extension of Remarks of Hon. Fiorello H. LaGuardia. *Congressional Record*, 71st Congress, 2d sess. January 29, 1930: 1–4.

———. *Works of Art in the United States Capitol Building, Including Biographies of the Artists*. Washington, D.C.: Government Printing Office, 1913.

Fournier, Harry and John Fournier. *Constantino Brumidi, The Michelangelo of the United States Capitol from Filiatra Messinias Greece*. Athens, Greece: E. O. B. Scarab Publishers, 1988.

"Frieze in Dome of Capitol Must be Completed." *Christian Science Monitor*, June 1913: 434–435.

Frary, I. T. *They Built the Capitol*. Richmond, Va.: Garrett and Massie, 1940.

Frese, Joseph R. "Federal Patronage of Painting to 1860." *Capitol Studies: U.S. Capitol Historical Society* 2, no. 2. Washington: U.S. Capitol Historical Society, 1974.

Fry, Smith D. *Thrilling Story of the Wonderful Capitol Building and Its Marvelous Decorations*. N.p., 1911.

Fryd, Vivien Green. *Art and Empire: The Politics of Ethnicity in the United States Capitol, 1815–1860*. New Haven: Yale University Press, 1992.

Haley, William D., ed. *Philip's Washington Described*. New York: Rudd and Carleton, 1861.

Hazelton, George, Jr. *The National Capitol. Its Architecture, Art and History*. New York: J. F. Taylor and Company, 1897.

Henderson, Helen W. *The Art Treasures of Washington*. Boston: L. C. Page and Company, 1912.

Jervis, A.V. "Costantino Brumidi," *La Pittura in Italia: L'Ottocento*. Milan: Electa, 1991.

Keim, DeB. Randolph. Keim's *Capitol Interior and Diagrams: A Complete Guide to All Parts of the Capitol*. Washington, D.C.: N.p., 1874.

———. *Keim's Capitol Interior and Diagrams: A Complete Guide to All Parts of the Capitol*. 3rd. rev. ed. Washington, D.C.: N.p., 1875.

———. *Keim's Illustrated Hand–Book Washington and Its Environs: A Descriptive and Historical Hand-Book to the Capital of the United States of America*. 3rd ed. Washington, D.C.: M'Gill and Witherow, Printers and Stereotypers, 1874.

———. *Keim's Illustrated Hand-Book: Washington and Its Environs: A Descriptive and Historical Hand-Book to the Capital of the United States of America*. 7th ed. Washington, D.C.: N.p., 1875.

Kloss, William. *Art in the White House: A Nation's Pride*. Washington, D.C.: White House Historical Association, 1992.

Leupp, Francis E. *Walks About Washington*. Boston: Little, Brown and Company, 1915.

Lilli, Maria Sofia. *Aspetti dell'arte neoclassica: Sculture nelle Chiese romane 1780–1846*. Rome: Istituto Nazionale di Studi Romani, 1991.

Marinacci, Barbara. *They Came from Italy. Stories of Famous Italian-Americans*. New York: Dodd, Mead and Company, 1967.

Maroon, Fred J. *The United States Capitol*. New York: Stewart, Tabori & Chang, 1993.

McGrory, Mary. "Artist Without Honors." *Washington Sunday Star Pictorial Magazine*, April 10, 1949.

McMahan, Virgil E. *The Artists of Washington, D.C., 1796–1996* 1, Washington, D.C.: The Artists of Washington, 1995.

Miller, Lillian B. *Patrons and Patriotism: The Encouragement of the Fine Arts in the United States, 1790–1860*. Chicago: The University of Chicago Press, 1966.

Mora, Paolo, Laura Mora, and Paul Philippot. *Conservation of Wall Paintings*. London: Butterworths, 1984.

Murdock, Myrtle Cheney. *Constantino Brumidi: Michelangelo of the United States Capitol*. Washington, D.C.: Monumental Press, Inc., 1950.

Nazzaro, Pellegrino. "Costantino Brumidi: the Great Artist of the Nation's Capitol," U.S. Bicentennial, the Italian-American Contribution." *La Parola Del Popolo* 26 (September–October 1976).

———. "L'Arte di Costantino Brumidi a Roma e Washington." *Stati Uniti D'Europa* 3 (May–June 1982) and 4 (July–August 1982).

O'Connor, Francis V. "A History of Painting in True Fresco in the United States: 1825 to 1945." *Fresco: A Contemporary Perspective*. New York: Snug Harbor Cultural Center, 1994.

———. "The Murals by Costantino Brumidi for the United States Capitol Rotunda, 1860–1880: An Iconographic Interpretation." In *The Italian Presence in American Art: 1860–1920*, ed. Irma B. Jaffe. New York and Rome: Fordham University Press and Istituto della Enciclopedia Italian, 1992.

Oertel, J. F. *A Vision Realized: A Life Story of Rev. J. A. Oertel, D.D., Artist, Priest, Missionary*. Boston: Christopher Publishing House, 1928.

Peclaris, P. B. "Constantinos Brumidis: The Greek Painter Who Decorated the U.S. Capitol." *Hellenic Review* 4 (April 1963): 19.

Rider, Fremont, ed. *Rider's Washington: A Guide Book for Travelers*. New York: Macmillan Company, 1924.

Roose's Companion and Guide to Washington and Vicinity. Washington, D.C.: Gibson Brothers Printers, 1880.

Scott, Pamela. *Temple of Liberty*. New York: Oxford University Press, 1995.

"Sketchings: Art on the Capitol, Washington." *The Crayon* (October 1858): 296–296.

"Sketchings: The Capitol-Extension." *The Crayon* (October 1856): 311–312

Soria, Regina. *American Artists of Italian Heritage, 1776–1945: A Biographical Dictionary*. London and Toronto: Associated University Presses, 1993.

Taylor, Joshua. *America as Art*. Washington, D.C.: National Collection of Fine Arts, Smithsonian Institution, 1978.

"The Decoration of the U.S. Capitol." *The American Architect and Building News* 7, March 27, 1880.

"The Late Constantine Brumidi." *The American Architect and Building News* 7, March 6, 1880.

"The Death of Signor Brumidi." *The American Architect and Building News* 7 February 28, 1880.

Tighe, Josephine Gillenwalter. "Brumidi, Michelangelo of the Capitol." *Fine Arts Journal* (August 1910): 106–115.

"Two Paintings Which Formerly Decorated the White House Have Recently Come to Light." *Antiques and Arts Weekly*, June 23, 1978.

U.S. Congress. "Constantino Brumidi." *Congressional Record*, 46th Congress, 2d sess., February 24, 1880: 1075–76.

———. *Dedication of the Bust of Constantino Brumidi.* 90th Cong., 2d sess., H. Doc. 321.

———. *Lawrence S. Brumidi: Report. [To Accompany Bill H.R. 6091].*48th Congress, 1st sess., March 19, 1884, H. Rept. 930.

———. *Report of the Secretary of War.* 33 Cong., 2d sess. November 16, 1855. H. Exec. Doc 1.

———. *Report of the Select Committee on the Memorial of the Artists of the United States.* 35th Cong. 2d sess., March 3, 1859. H. Report 198.

———. *Report of the U.S. Art Commission.* 36th Cong., 1st sess. February 22, 1860. H. Exec. Doc. 43.

———. *Reports on Capitol Extension and New Dome.*

Weigley, Russell F. "Captain Meigs and the Artists of the Capitol: Federal Patronage of Art in the 1850's." *Records of the Columbian Historical Society of Washington, D.C., 1969–1970.* Washington, D.C.: Columbia Historical Society, 1971.

Wolanin, Barbara. "Constantino Brumidi's Frescoes in the United States Capitol." In *The Italian Presence in American Art, 1760–1860,* ed. Irma B. Jaffe. New York and Rome: Fordham University Press and Instituto della Enciclopedia Italian, 1989: 150–164.

Wright, Peter B. "The Decorations in the Capitol Dome: A Protest Against the Proposed Method of Completing Them." *Journal of the American Institute of Architects* 2 (September 1914): 434–435.

Wyeth, Samuel D. *Description of Brumidi's Allegorical Painting Within the Canopy of the Rotunda.* Washington, D.C.: Gibson Brothers, Printers, 1866.

———. *The Federal City or Ins and Abouts of Washington.* Washington, D.C.: Gibson Brothers, 1865.

———. *The Rotunda and Dome of the U.S. Capitol.* Washington, D.C.: Gibson Brothers, 1869.

Index

*Pages in **bold** refer to illustrations*

250